To my genius friend Ann
from your genius friend
Herman about one of our
genius heroes who I
hope you will enjoy
having in your library.
Happy 40th Birthday
1994

"fate loves
the fearless"

welcome to the
decade of love

♡ herman

THE GENIUS OF CHARLES JAMES

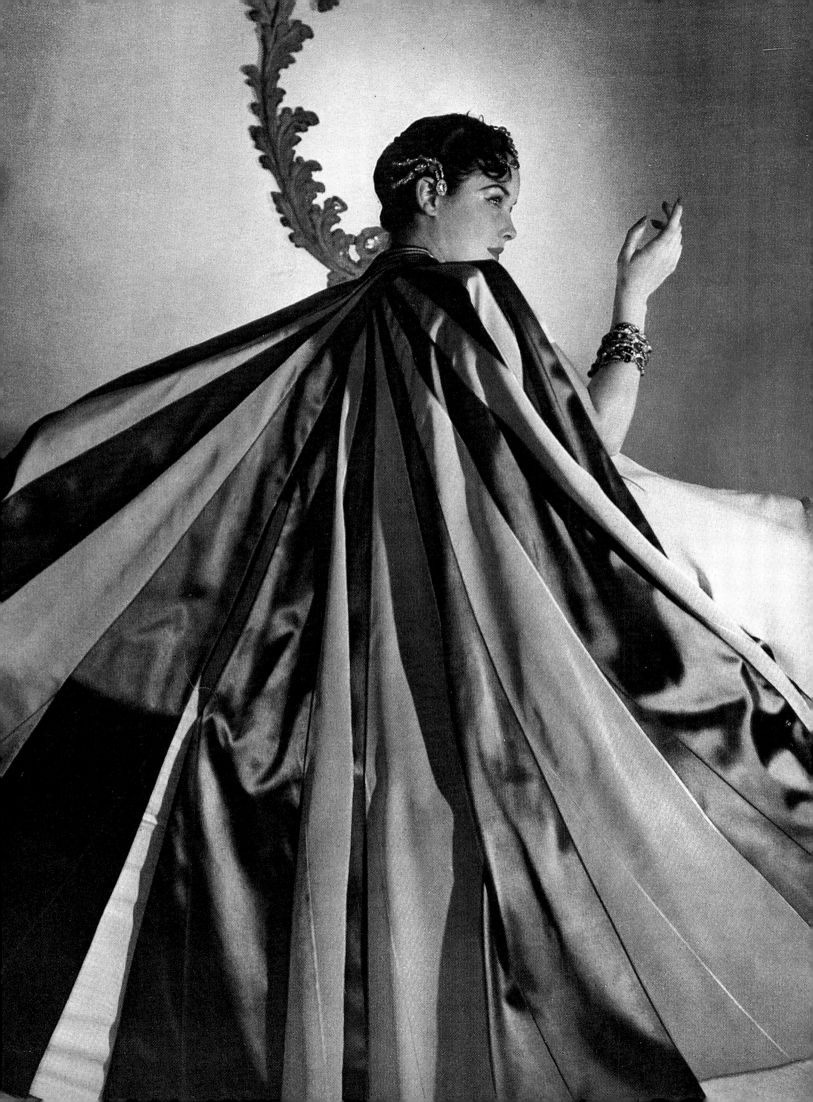

THE GENIUS OF CHARLES JAMES

Elizabeth Ann Coleman

Publication concept developed in association with
Brian Rushton

THE BROOKLYN MUSEUM

Holt, Rinehart and Winston

Published for the exhibition
The Genius of Charles James
The Brooklyn Museum
New York
October 16, 1982 — January 16, 1983
Chicago Historical Society
Illinois

*This exhibition was made possible with the aid
of grants from the William Randolph Hearst
Foundation, and the National Endowment for the
Arts in Washington, D.C., a Federal agency.*

Frontispiece:
Designed initially in 1937, this evening mantle has become one of the
garments most readily identified with Charles James. It combines his
color sensitivity, his mathematical precision, and his use of the unique
— in this case two wide-sweeping wings of cabana stripes constructed
from a selection of pre-World War I ribbons unearthed by James in a
Parisian market. (Cat. no. 374).
U.S. VOGUE/PHOTO: HORST P. HORST/1940

Illustration page 6:
Cecil Beaton, James's longtime friend and companion in the field of
fashion, captured in this sketch both the chaos and the regimentation of
the James workroom established at the request of Elizabeth Arden in
her Fifth Avenue beauty emporium. The evening dress in the
foreground is "La Sirène" (cat. no. 48).
U.S. VOGUE/DRAWING: CECIL BEATON/1944

Designed and published by The Brooklyn Museum, Division of Publications
and Marketing Services, Eastern Parkway, Brooklyn, New York 11238. Printed
in the USA by the Falcon Press, Philadelphia.

Hardcover edition available
in the United States from
Holt, Rinehart and Winston
383 Madison Avenue
New York, New York 10017

and in Canada from
Holt, Rinehart and Winston, Limited
55 Horner Avenue
Toronto, Ontario
M8Z 4X0 Canada

Quotation on page 8: Henry James, from *The Middle Years* in *The Novels
and Tales of Henry James*, vol. XVI. Copyright 1909, Charles Scribner's Sons;
copyright renewed 1937, Henry James. Reprinted with permission of Charles
Scribner's Sons.

Photographs:

Courtesy **HARPER'S BAZAAR.** Copyright © 1933, 1934, 1935, 1936, 1937,
1938 by National Magazine Company Limited. All rights reserved.

Courtesy **HARPER'S BAZAAR.** Copyright © 1933, 1934, 1936, 1937, 1938,
1939, 1940, 1941, 1943, 1945, 1946, 1947, 1948, 1949, 1950, 1951, 1952, 1953,
1954, 1955, 1956 by The Hearst Corporation. All rights reserved.

Courtesy **HOLIDAY.** Copyright © 1946, 1949 by Travel Magazine, Inc.
All rights reserved.

Courtesy **TOWN & COUNTRY.** Copyright © 1948, 1949, 1950, 1951, 1953,
1956 by The Hearst Corporation. All rights reserved.

Courtesy **VOGUE.** Copyright © 1936, 1937, 1938, 1940, 1944, 1945, 1946,
1947, 1948, 1949, 1950, 1951, 1952, 1953, 1954, 1955, 1956, 1957 by The
Condé Nast Publications, Inc. Copyright © renewed 1964, 1965, 1966,
1968, 1972, 1973, 1974, 1975, 1976, 1977, 1978, 1979, 1980, 1981. All rights
reserved.

Library of Congress Cataloging in Publication Data

Coleman, Elizabeth A.
 The genius of Charles James.

 Bibliography: p.
 Contents: The clothes / Elizabeth Ann Coleman —
The background / Elizabeth Ann Coleman — The man /
William Cunningham — [etc.]
 1. Fashion — Exhibitions. 2. James, Charles
d. 1978. I. Title.
TT502.C64 1982 746.9'2'0924 82-14633
ISBN 0-03-062588-2
ISBN 0-87273-092-1 (pbk.)

Contents

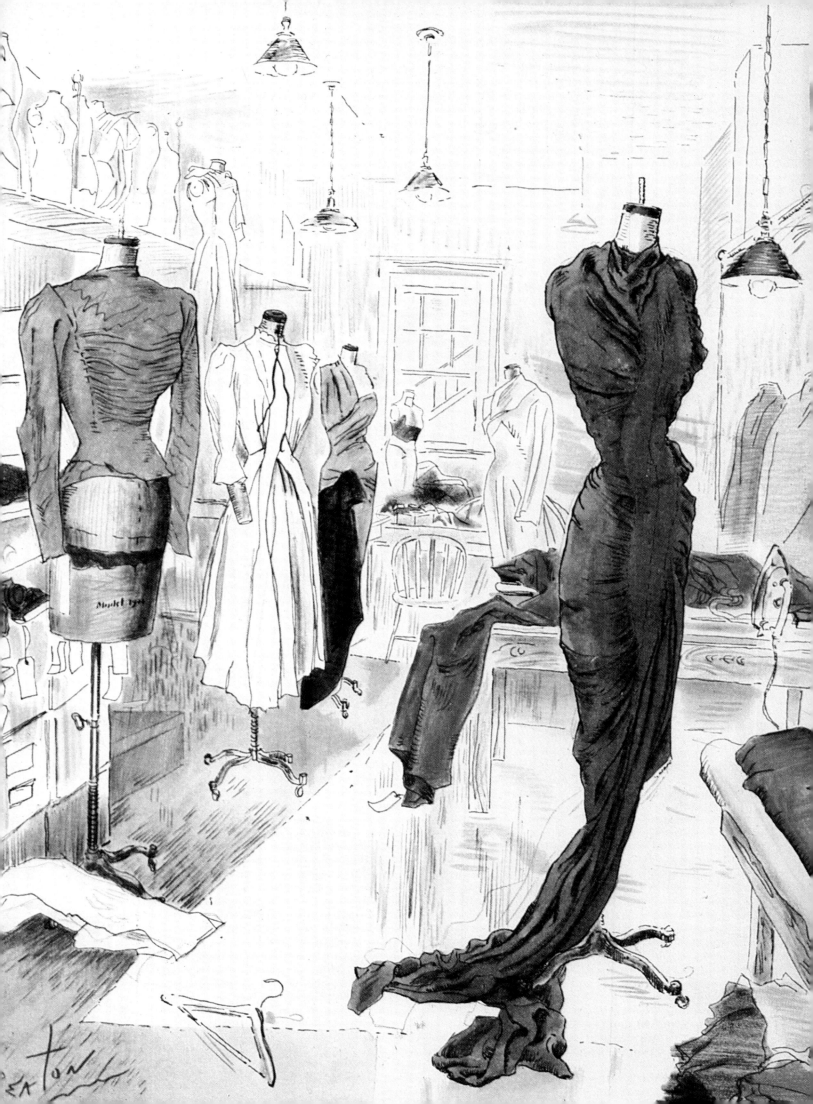

Foreword

Michael Botwinick
Director
The Brooklyn Museum
New York

In an industry where complex personalities are very much the norm, Charles James stands out as one of the most complicated, contradictory and difficult. As a figure in the fashion world he was at one and the same time a precocious radical, yet heir to a classical tradition. Decades before the emergence of the marketing of designer names, James saw this as a route to greater impact and exposure. Yet no designer has worked as close to the spiritual center of the couturier's profession. In the making of clothes, he was an artist involved in a passionate collaboration with material, form, and an inspirational client.

Over the years, even as he worked for and won the loyalty and support of some of the world's most distinguished women, he unerringly destroyed almost every working and social relationship with his erratic habits, eccentric attitudes and fluorescent temper. He was an atrocious businessman yet he devised an elegant and sound means for utilizing the IRS business- and charitable-donation deductions to place his gowns in museums and still keep his clients happy.

We approached this project with some trepidation. Passions still run very deep over Charles James. James loved flowers, using them to express affection, displeasure, beauty — even naming his garments after them. This book, and the exhibition it accompanies, we consider to be our bouquet to him. He, after all, fashioned the flowers; we have merely composed them into an arrangement in the hopes of bringing his conception of fashion, line and color into sharper focus.

The Museum's holdings of Charles James are the largest of any public collection. James himself gave and enriched the collections here. His friends and clients, like Millicent Rogers, Mrs. Cornelius Vanderbilt Whitney, the Ryersons, the Runnells, and Mrs. Harrison Williams, all saw to it that our unique collection grew stronger.

Charles James died in the fall of 1978. Almost since then the Department of Costumes and Textiles at The Brooklyn Museum has been involved in the preparation of this retrospective. The project has been nurtured by Elizabeth Ann Coleman, Curator of Costumes and Textiles at The Brooklyn Museum. In this extraordinary assemblage, she has justified the wide-ranging cache of material and made the Museum's collections again more meaningful.

James tried his hand at all areas of design, but it is his creations for evening attire that established the height of feminine elegance for thirty years. The exhibition presents the finest and most important of these designs. In order to display and project to best advantage James's unique sense of line, color, and construction, The Brooklyn Museum turned to Adel Rootstein Ltd. for the specially devised mannequins. The understanding of Ms. Rootstein and her staff, especially Nellie Fink and Michael Southgate, has made simple what is normally a difficult task.

Many generous and concerned individuals, sister institutions, and publishing houses on both sides of the Atlantic have gone out of their way to be of assistance. These friends and colleagues, both of the Museum and of Charles James, will find the sincerity of their dedication to this undertaking documented herein. Special acknowledgment must be made to family members, Frances James Klin, Nancy Gregory James, and the late Jane Shearman, and to friends of the James family such as Florence Lowden Miller, Marit Guinness Aschan, and sisters Louise Krell and Katharyne Chandler, who shared treasured recollections. Many other friends of James — clients and colleagues — shared memories: everything from running up and down fire escapes to avoid James's torrential temper to the satisfaction of producing an extravaganza featuring James's clients modeling his gowns. Among those who shared liberally we count Vera Maxwell, Mary Jane Russell, Marta Raymond, Eleanor Lambert, Ray Diffen, Shannon Rodgers, Lee Pilcher, Robert Riley, Arnold Isaacs (Scaasi), Mary Ann Crenshaw, Sunny Bradfield, Muriel Bultman Francis, Halston, Homer Layne, and Alice Topp-Lee.

Three people whom Charles James held in special regard have been called upon to record their personal reactions to his genius: Anne, Countess of Rosse, Austine Hearst and Bill Cunningham. All, in their turn, shed warm, revealing light on the subject with insightful essays. Brian Rushton did a masterful job in conceiving and producing this publication.

We are grateful to Elizabeth Jachimowicz, Curator of Costume at the Chicago Historical Society, for her contribution to this project. Our own Costume and Textiles Department staff, Carol Krute, Polly Willman, Marina Kovalyov, Mary Ann McCabe, and research volunteers Edith Bishop, Cynthia Sirko, Adele Filene, Ann Plogsterth, and Charlotte Rubin have made truly dedicated contributions to a complex undertaking. We would also like to thank Nancy Reynolds for her efforts. We are most grateful to the National Endowment for the Arts and the William Randolph Hearst Foundation for their support.

It must fairly be said that this is a project that could not have been realized in James's lifetime. He was too tragically tormented by a private set of demons to have ever allowed such a thing to come to pass. We hope now to give to his work the broad reception and recognition that is his due, but for which, when offered during his lifetime, he never had the inner peace to reach out and accept.

CHARLES JAMES

————————————Elizabeth Ann Coleman

Introduction

There is no denying that the personality of Charles James was as overwhelming as his works. The candid recollections of those who knew him — whether clients, colleagues, or fellow couturiers — reveal a man who purposefully and selectively obscured elements of his personal evolution while attempting to create a niche for himself in art history. James believed that his garments were works of art and that their ultimate destination, after their useful life in the wardrobes of some of the world's best-dressed women was over, should be museum collections. To this end, he was obsessed with documenting his work; however, in contrast to the precision that was the hallmark of his designs, for a variety of personal reasons — some, perhaps diabolical — his documentation represents a less than accurate picture of his development.

At times in his life, James, a perfectionist, was both short of money and short of time. To cope with these problems, he would "borrow back" a garment from one client and make it "available" to another, on those occasions when he found himself without funds for essential materials for the second item, or when he was unable to deliver a promised gown for a gala evening because he was not yet satisfied with it. While he seems to have begun attributing style numbers to his works in earnest in the 1940s, he inserted many of his earlier designs when he revived them later; thus, his own seemingly painstaking records do not present a true chronology. A complete style numbering system for the output of Charles James may never be possible — not least because in many areas, deliberately or accidentally, he often confused dates, names, and places.

Irrespective of other "facts," the fact of James's creative genius is irrefutable, both visually and intellectually. Because he was the *enfant terrible* of his profession, many have undervalued his contribution, but one need only peruse his roster of clients to see that through his salons passed an international, sophisticated, demanding, and glittering group. Many women he dressed were the taste-makers of their time, and the remarks of his contemporaries show that associates viewed him with awe, admiration, and affection — in addition to exasperation and bafflement.

Among his best-known and fashionable clients, his major benefactor, the beauteous Millicent Rogers, who placed her James collection in The Brooklyn Museum in recognition of its artistic importance, is one of the few who failed to leave any sort of reminiscence about his place in her life. In an ironic reversal of custom, it was James who recorded an appreciation of her: Writing her obituary in *American Weekly,* he praised as inspiration and guide the woman who "knew as no one else did how to bring out the best of my talent as a creator of fashion."

"It *is* glory — to have been tested, to have had our little quality and cast our little spell. The thing is to have made somebody care. . . . We work in the dark — we do what we can — we give what we have. Our doubt is our passion and our passion is our task. The rest is the madness of art."

Nancy Gregory (Mrs. Charles) James *quoting her former husband's favorite passage from Henry James, The Middle Years.*

"Charles James felt there was not enough money in the world to buy his garments."

Mary Jane Russell

"[Our first meeting was] in a town house with a double drawing room. There was an ornate Victorian sofa which James had draped in a cloud of tulle and [he] was lying in that cloud like a little bird. He talked a stream and was one of the first to talk about fashion as one would talk about art."

Eleanor Lambert

"I knew Charles James from 1927 or '28, when he ran up and down the Southampton Beach in beautiful robes showing his millinery on his head."

Diana Vreeland

"When you make dresses the way he does, it costs a fortune and you don't make out."

Pauline Trigère

"Mr. James is madly in love with cut . . ."

Mainbocher

"It was always accepted by my family that Charlie was a genius . . . his repartee and quick wit became respected in the family. He had a warmth and compelling presence even though he was slight and seemed short."

Marit Guinness Aschan

"The curtain never went up in a Charles James workshop . . . he was an absolute devil."

Ray Diffen

"Charles James was masochistically destructive, yet he saw himself as the creator, while other New York designers were copiers."

Cathalene Bernatschke

"He would far rather work and rework a beautiful dress ordered for a certain party than have that dress appear at that party."

Diana Vreeland

"Charles James is not only the greatest American couturier, but the world's best and only dressmaker who has raised it from an applied art form to a pure art form."

Balenciaga

"Charlie is like a lyre in the wind, any tune can be played upon him to which he will respond."

Cecil Beaton

"Quite articulate in expressing himself about design in America, . . . Charles James stands for beauty in fashion, shape in clothing, and adventure in the use of color."

Eleni Epstein

"There is no one in this country or elsewhere who could come close to your sun. . . . A single James creation is worth the whole output of a 7th Avenue year's work."

Galanos *in a letter to Charles James.*

"His dream was to dress the best in the world."

Halston

"You can't catch Niagara in a tea cup."

Robert Riley *on Charles James*

"Charlie escaped from the chores of life by episodes which were like the acts of trapezists in the circus."

Sir Francis Rose

"James loved working in chaos — lots of talk and noise — and he had as many as eight working on a single garment; once he had ripped it apart from top to bottom, a self-calming effect could be witnessed on his self-destructive vein."

Arnold Scaasi

"A non-conformist about business hours and all electricity except that generated by himself."

Lois Long

"We hope everything is going well for you, but we . . . especially I as Secretary of the Foundation . . . would like to have your address."

Muriel Chandler *in a letter to Charles James, care of a third person*

"Il s'appelle une maison de couture, mais c'est une maison de torture."

Philippa Barnes *recalling the remarks of a cutter*

"Charles James has the courage and devotion to look for the difficult solution."

Jean de Menil

". . . faceted beyond account, a perfectionist who wanted and demanded the best."

Sunny Bradfield

"He was sometimes so entranced by the shape he was 'sculpting' over one's own shape that when the dress arrived finished it was impossible to get into it. It existed on its own. Much time was then spent in discerning the proper relationship between shapes."

Mary St. John Hutchinson

"You wouldn't want me any other way."

Charles James to **Marta Raymond**

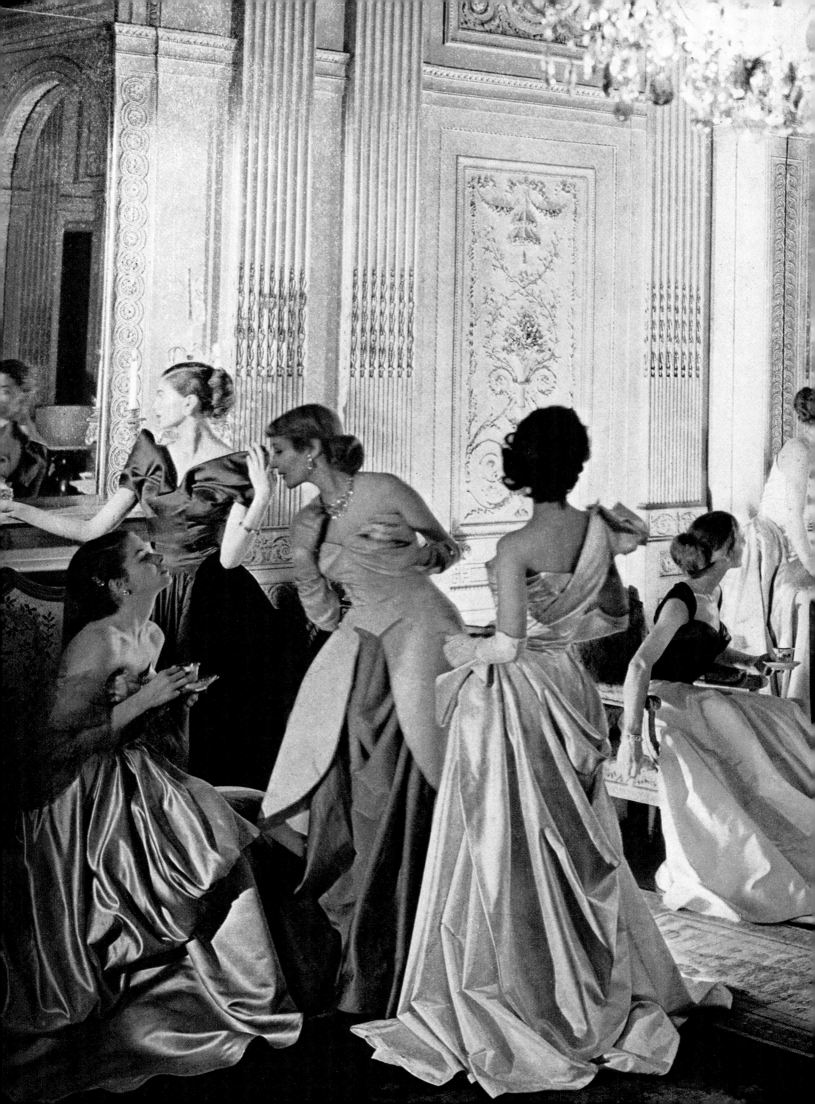

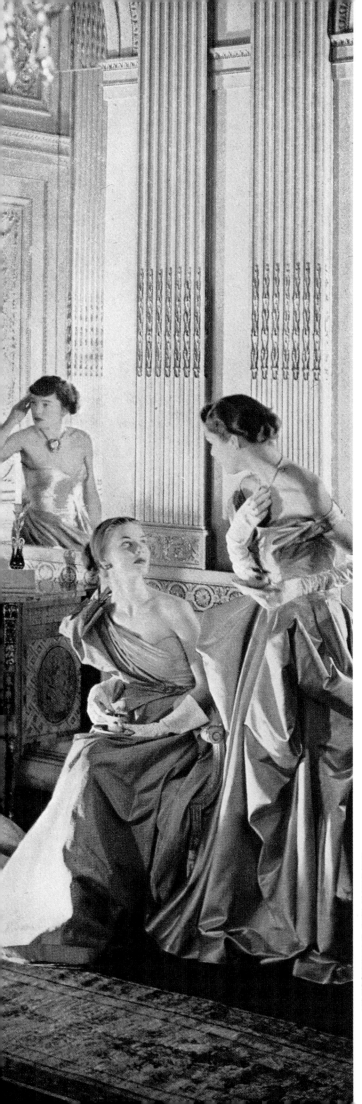

U.S. VOGUE/PHOTO: CECIL BEATON/1948

CHARLES JAMES

Elizabeth Ann Coleman

The Clothes

For over thirty years, from the late 1920s to the end of the 1950s, to be dressed by Charles James marked a client as a woman of adventuresome taste (and financial security). Although he continued to design remarkable garments until his death in 1978, he is best remembered for his earlier works. The greatest number of his masterpieces lie within the category of gowns for formal attire, some of which are captured in this fashion illustration of 1948 by the camera of Cecil Beaton (left to right, cat. nos. 49, 30, 72, 79, 73, 36, 79, 69).

Although designed over a period of more than ten years, the gowns are stylistically homogeneous, projecting, singly and in combination, an aura of timeless aristocracy. While James enjoyed a reputation among discriminating clients as early as the 1920s, at the time of the Beaton photograph he was just beginning to attain major recognition.

To Charles James, the public presentation of his clothes was as important as their creation. As frequently as possible, he was present during photographic sessions, and he worked with some of the leading fashion photographers of his day.

Throughout James's creative years, the bond established during school days with Cecil Beaton remained strong. Beaton documented his observations through a variety of means — camera, sketch pad, pen-and-ink — and frequently he also imposed his own aesthetic statement on their joint endeavors. The snow-white walls and ice-white mirror and chandelier of the neoclassical surroundings here provided Beaton with a vividly elegant yet almost neutral background against which to photograph a bevy of James's most provocative ball gowns. The inherent classicism in the clothes themselves is also brought out by Beaton's camera. Folds of satin seem to imitate the linear definition achieved in stone, wood, metal, or bone sculpture. Yet we all know these fabrics to be pliable — indeed, soft as silk. As in sculpture, these are not random lines; each was carefully contemplated in the construction of the gown — a mathematical problem solved with calipers and equations. Taken individually, each of the gowns is a strong statement; grouped, an artist's palette is awash with color of the most refined tones. There is no weak link.

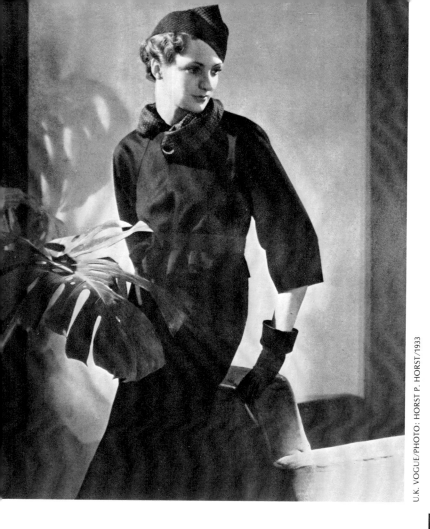

years in the fashion world primarily shaping felt hats. His first real publicity came in 1930 and included a two-page photo spread in *U.S. Vogue*, in which his friends Tilly Losch (facing page; cat. no. 536; and Marianne Van Rensselaer (see photograph, p . 79; cat. no. 537; modeled his hats for Cecil Beaton. Beaton, a recent *Vogue* contributor, had sparked the magazine's interest in the designs of his young friend. In Chicago, London, and New York, James at this time worked under the name "Boucheron."

Throughout his working career James sought the prestige associated with being a couturier and the financial rewards, as he saw them, of designing for quantity production. Around 1933 Nicolls Couture, of H.J. Nicolls & Co., Regent Street, London, offered his untailored spring suit, made-to-measure for twelve guineas (above, cat. no. 285). Draped and twisted around the neck and tucked through the buttonholes is a spotted handkerchief. Quite possibly this is an initial version of his renowned ring scarf (cat. no. 588).

The employment of the new was always a challenge to James; in 1933 he took the zipper and spun it around the torso by inserting it in his "Taxi" dress, originally designed in 1929–30 (right; cat. no. 132). In the United States, this dress was sold in the first-floor sweater department at Best & Co. Packaged in sealed cellophane envelopes, it was made in two sizes, an early attempt by James to demonstrate that detailed sizing was not essential if a garment was designed correctly.

James had begun his career as a milliner in Chicago in 1926 with a tiny shop on Oak Street and seems to have spent his first

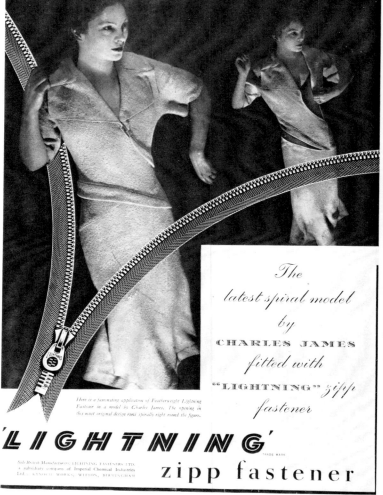

The latest spiral model by CHARLES JAMES fitted with "LIGHTNING" zipp fastener

Here is a fascinating application of Featherweight Lightning Fastener in a model by Charles James. The opening in this most original design runs spirally right round the figure.

'LIGHTNING' zipp fastener

Sole British Manufacturers: LIGHTNING FASTENERS LTD. a subsidiary company of Imperial Chemical Industries Ltd., KYNOCH WORKS, WITTON, BIRMINGHAM.

12

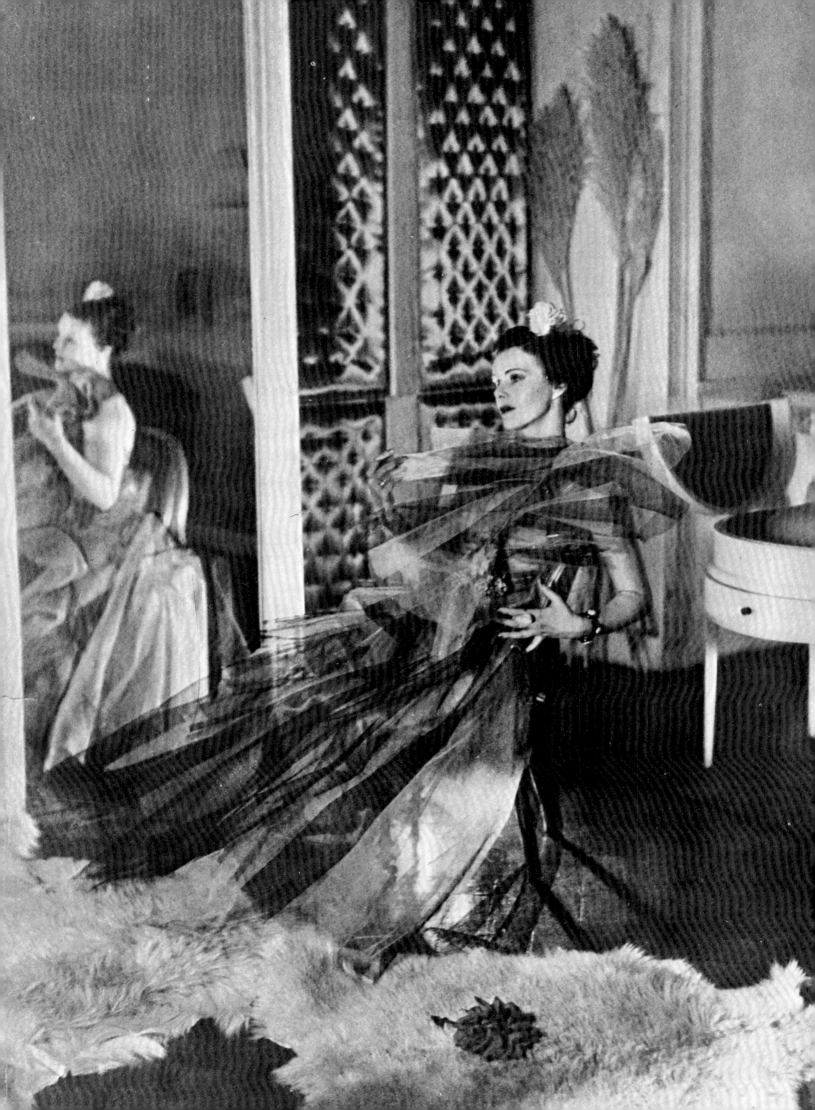

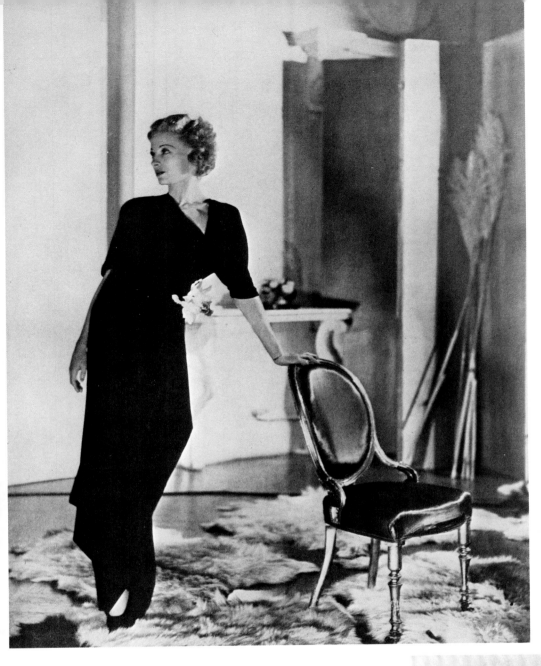

Spiral draping continued to intrigue James, as the severe evening dress with slit front skirt sheath indicates (below; cat. no. 21). Here we see the first appearance of the unique hand fan James devised, in this instance, "two scarlet magpie wings." The caption for the drawing of the "magnificent" evening wrap (cat. no. 363) provides a rare mention of patterned fabric in association with a James garment: "a rich brocade, either apple green coloured with flowers, or black and gold." The enormous dolman sleeves were designed to be pushed back from the wrists; the dip of the collar in the back echoes the line of the pouched back and the short, pointed train.

Swathed in spirals of pink and black tulle, Mrs. Ronald Armstrong-Jones (later Anne, Countess of Rosse) poses in James's Bruton Street salon (facing page; cat. no. 17). James was in attendance at the photography session and devised the coiffure on the spot, to blend both with the gown and with the setting, as he assured his client. The walls of the salon were covered with tufted pale blue satin, and "moderne" and French Second Empire furniture competed for attention with the skins covering the highly finished floor. In the photograph of the actress June Hart (above), at that time appearing as a dancer in the Cochran revue *Streamline,* more details of the salon are recognizable, including a swan-neck–supported pier table and a high screen, against which rests a cluster of fans from South Asia. James was probably present at this shooting session as well, for at the waistline of the black velvet gown which winds around like a sari (cat. no. 16), there is a cluster of two orchids, flowers of special appeal to the designer.

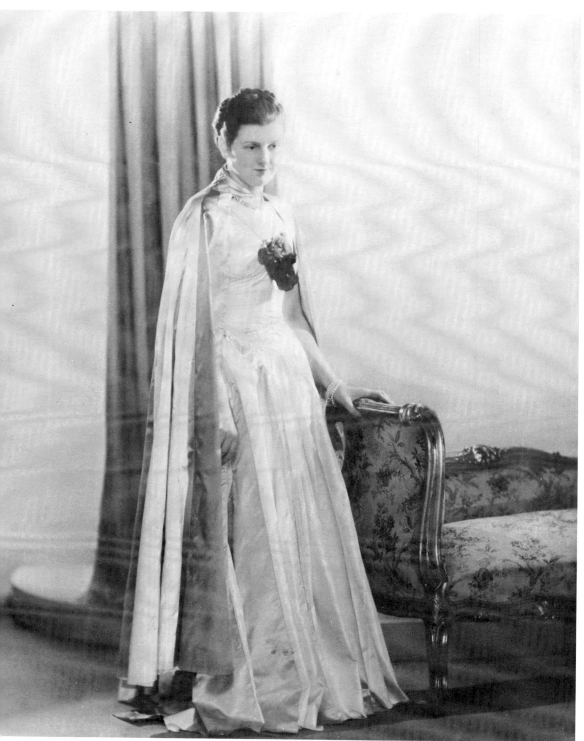

James made many variations on his ribbon ball dress, initially created with millinery ribbons by Colcombet of St. Etienne (the finest French ribbons were woven in St. Etienne, near Lyons, the center of silk weaving). It is said that Paul Poiret gave James the idea for this dress, a version of which is worn by Marit Guinness Aschan (left; cat. no. 36). Palest pastels of paper taffeta ribbons rustle lightly in the deceptively simple yet mathematically brilliant execution of the skirt, in which extended ribbon points taper from ten inches at the hemline to one-sixteenth inch at the waist. The cape construction is an elongation of the bifurcated skirt, but in Jamesean manner, the color scheme is one of dramatic contrast (cat. no. 374).

James created a third ribbon garment for Mrs. Aschan, seen opposite (facing page; cat. no. 31). Here, it is modeled by Joan Fontaine for *U.S. Vogue*. Described as a creation of "the London designer," Charles James, the summer gown was constructed of Colcombet ribbon "for the fragmentary bodice which echoes that corselet feeling currently enchanting Paris" and "a vaporous mousseline skirt draped at the knees."

The "Poetic Mantles" (overleaf, pages 18, 19) were part of James's first presentation made to the trade in Paris, 1937 (cat. nos. 368–371). A number of them were fabricated from pre-World War I grosgrain millinery ribbons by Colcombet. The rigidity of the fabrics made draping almost impossible, although these were created at a time when fluidity was highly prized in apparel design. On location in Paris, Cecil Beaton set the models, who included the actress Ruth Ford, against a background by the artist Christian Bérard, a friend of both the photographer and the designer.

PHOTOGRAPHER UNKNOWN/1937

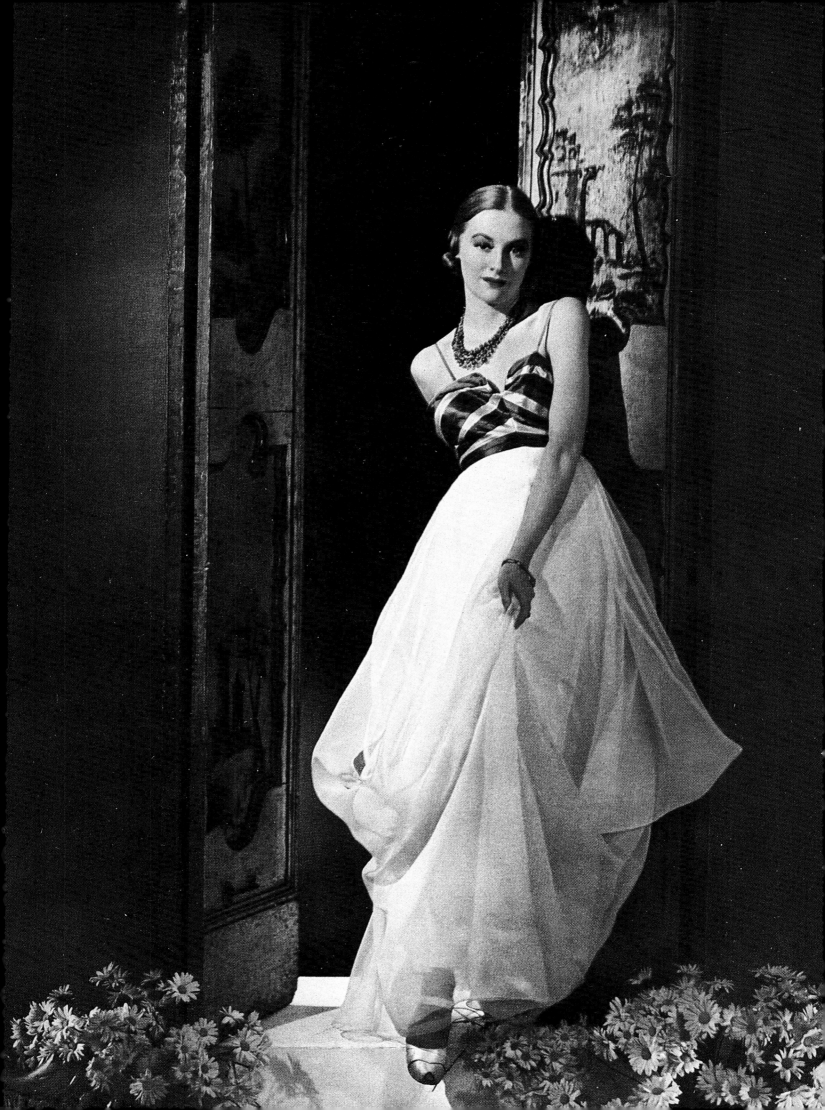

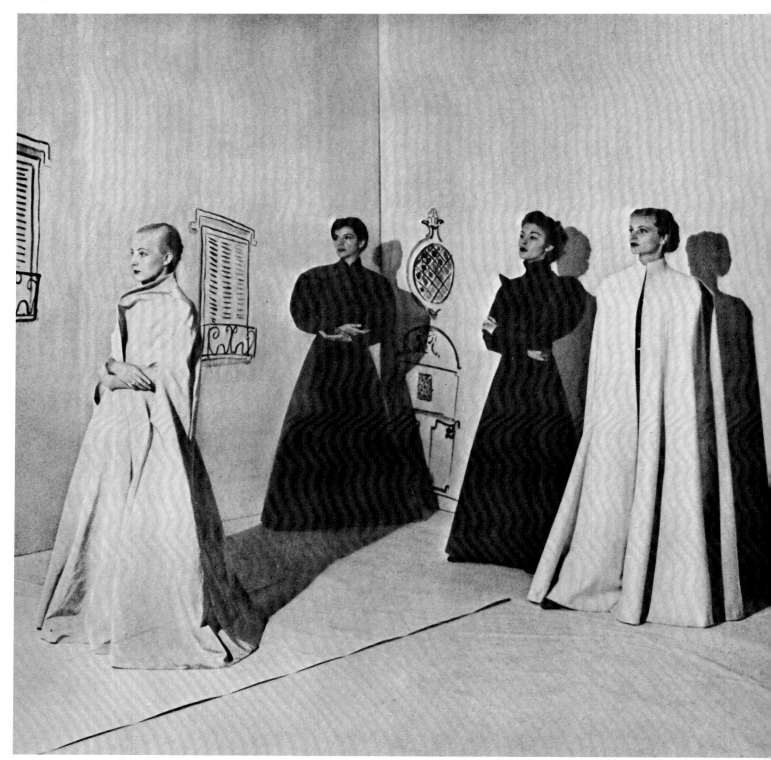

U.S. VOGUE/PHOTO: CECIL BEATON/1936

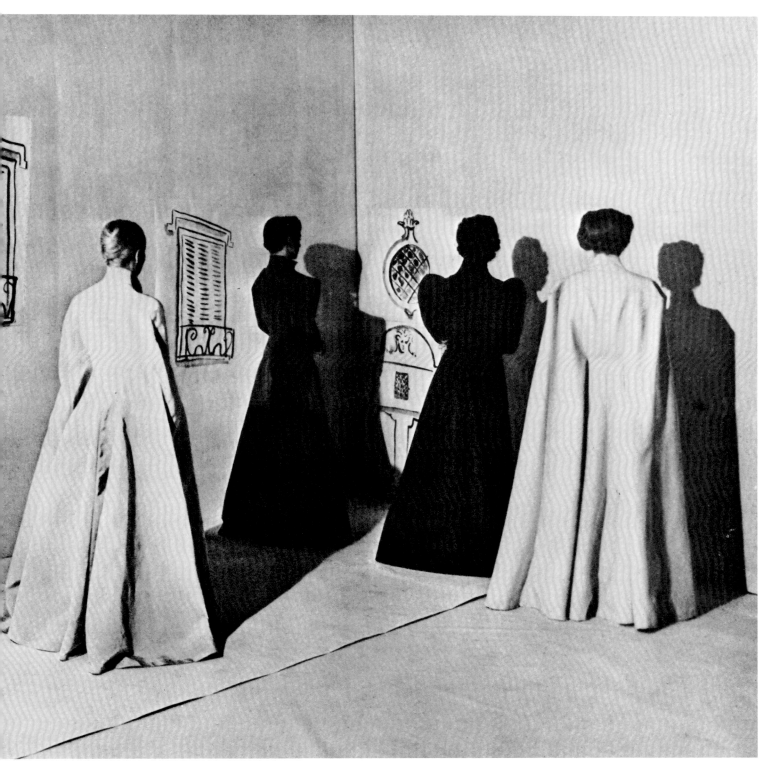

19

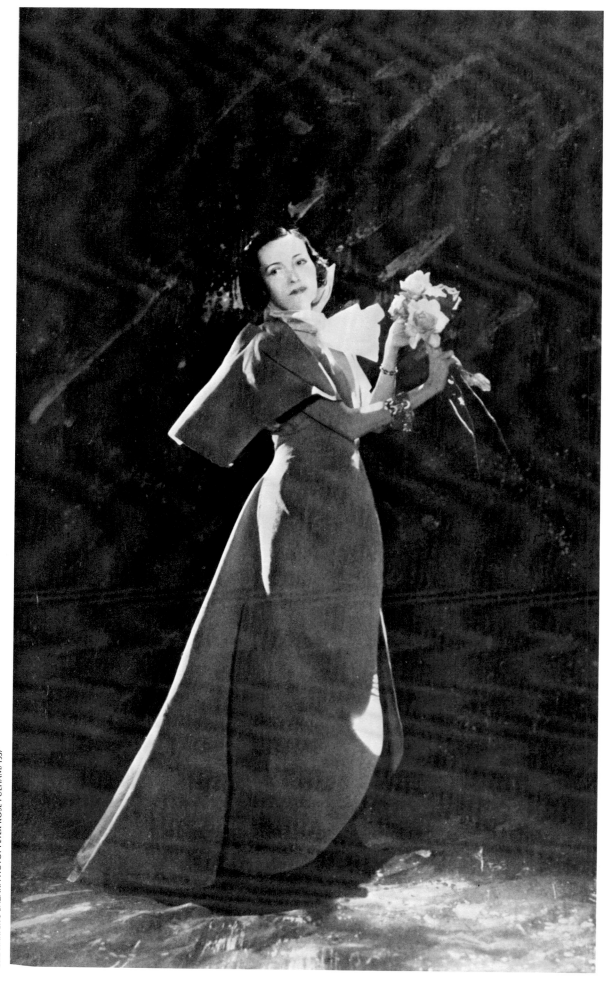

At first glance, the published caption to the image at left seems as light and frivolous as the stunning wrap (cat. no. 366): "Lady Charles Cavendish wears a finished Charles James product — a coat in light-blue grosgrain with wings at the back, perfectly designed to suit her gay and piquant personality." One wonders, knowing of James's frequent inability to provide a completed garment for a specific occasion, whether the word "finished" was chosen particularly to highlight the luck of the former Adele Astaire, or whether it is just a word into which more than necessary is being read.

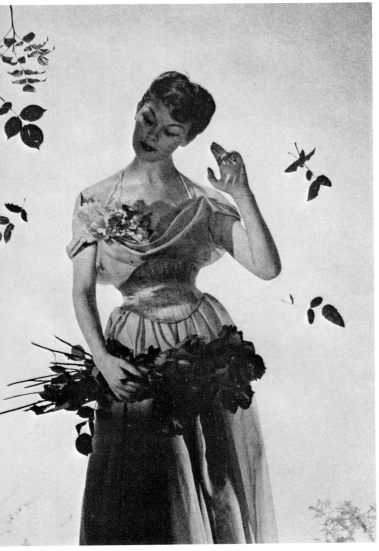

U.S. VOGUE/PHOTO: CECIL BEATON/1937

U.S. HARPER'S BAZAAR/PHOTO: GEORGE PLATT LYNES/1937

The period of the 1860s — Second Empire, mid-Victorian, Civil War — fascinated the peripatetic James, perhaps because it was just receding from living memory. "La Sylphide" evening dress (above, left; cat. no. 37) carries a back-lacing, boned 1860s corselet as a decorative accessory, in imitation of the "girdle of the graces," a decorative corselet of the period. James would employ a similar concept in later waistbands, based on his historical researches. The gown was perhaps named in recognition of its slender and graceful lines and lighter-than-air organza buoyancy, restrained only by the satin corselet.

The "Tulip" evening coat (above, right; cat. no. 375) was more a winter than a spring blossom. It was offered in heliotrope velvet undershot with blue and a pink satin lining, in black faille with jet-black silk lining, and a black faille lined with lime green — colors one hardly associates with tulips, the symbols of spring.

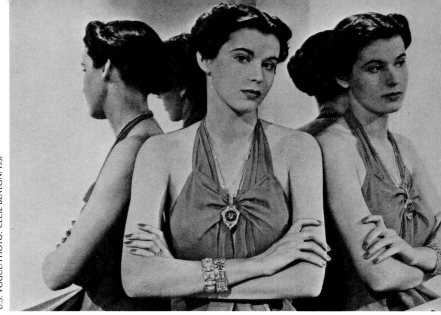

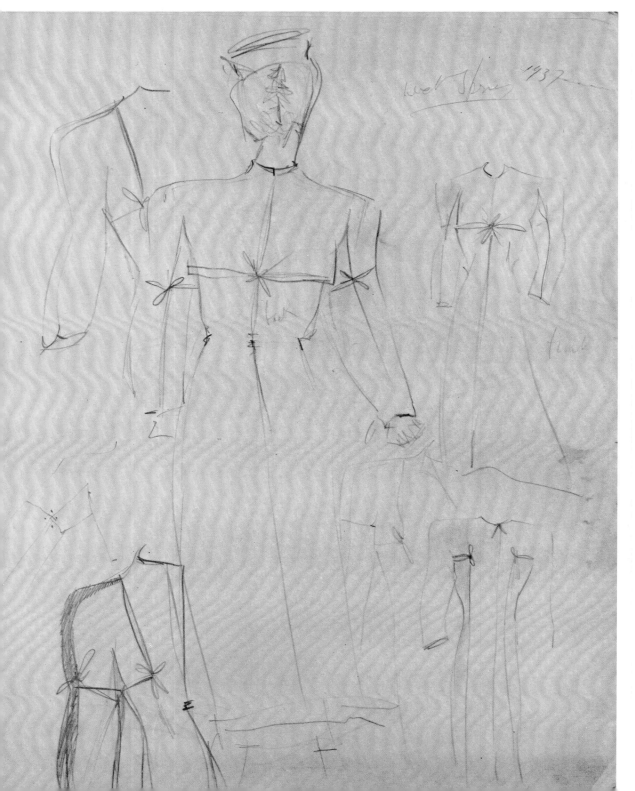

James achieved contemporary classical elegance in a 1937 evening dress (above; cat. no. 39). Constructed from only three pattern pieces, its brevity of cut has been praised. The long, full, circular skirt, trailing slightly in back and slit to the knees in front, is draped through a bustline knot to form a halter neckline. In London, one version, in fuchsia crepe de chine, was modeled under an orange cape; no doubt the audience was stunned by such a daring palette.

In contrast to this free-flowing evening dress, James's sketches of day dresses in 1937 show that he was also working on structured garments with rigid, broad shoulders (left; cat. no. 143). Although he claimed never to have "stooped" to including shoulder pads in his garments, a few extant examples of his work contradict this assertion.

One of the most outstanding "contradictions" — although the padding here is something more than a "shoulder pad" — is James's stunning creation of 1937 (right; cat. no. 378), described as "the newest, most deliciously feminine of evening jackets, . . . quilted and padded like the jackets of Chinese princesses. Charles James makes this one of white satin with a thick soft roll round the edges and down sleeves." Created in Paris for Mrs. Oliver Burr Jennings, James filled the jacket with eiderdown, and certainly the (almost concentric rows) of stitch holes make a statement about his search for perfection. His friend Salvador Dali heralded the jacket as the first soft sculpture, and James himself suggested that his design inspired the Air Force quilted jackets of World War II, better known as bombardier jackets. Although the jacket was offered by Hattie Carnegie, James claimed that his initial garment was the only one executed.

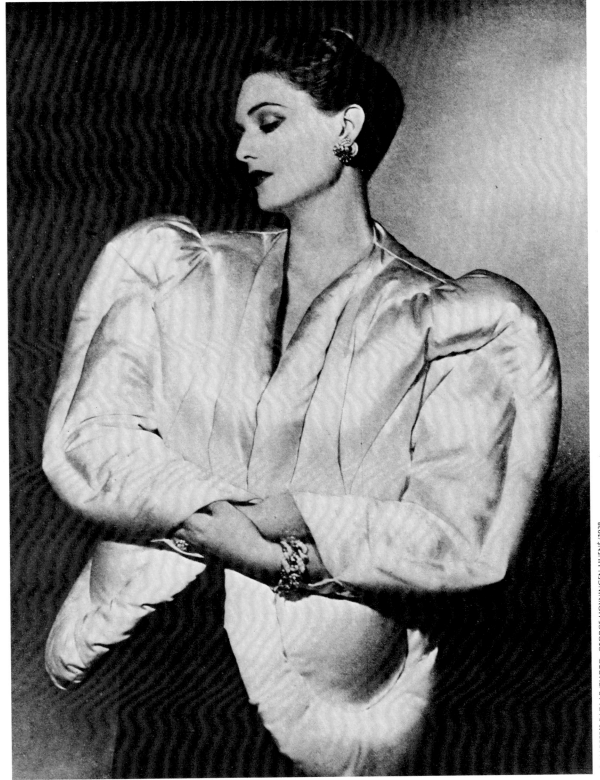

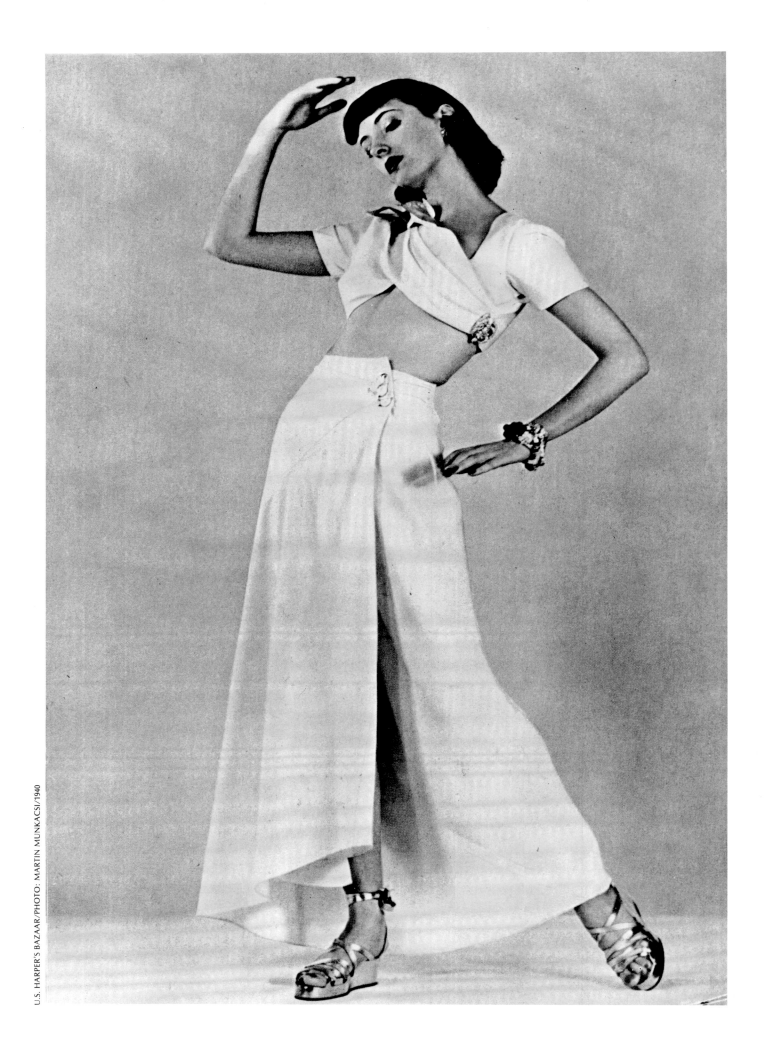

U.S. HARPER'S BAZAAR/PHOTO: GEORGE HOYNINGEN-HUENE/1941

One of the outstanding designs associated with James is the brilliantly cut "Figure-8" skirt (facing page; cat. no. 50). Contemporary fashion writers seemed to be at a loss to describe the impact of the design; the caption to this photograph simply reads: "Bare-ribbed dress carried to the heights of daring with a sarong skirt wrapping the legs, in an ingenious figure 8. Made of icy-white Celbrook. It's not a beach dress, but only for night in the South. A Charles James Dress." The

skirt, cut on the bias from a single pattern piece in a shape not unlike a kidney bean, is self-attached in front in rudimentary fashion. James conceived the idea for a Fashion Group showing organized by Diana Vreeland.

While the "Figure-8" skirt may mark the highpoint in James's design of leg-wrapping garments, from 1933 he worked on the construction of culottes, and his solutions for these bifurcated garments were to be as varied as their application. Very few were considered suitable leisure attire. They were always advertised as "cut by the inventive scissors of Charlie James. Shorts that must be seen to be believed. On the surface, they're shorts in back only — the front is a skirt, buttoned across in gold. Underneath, they're shorts all the way around." Two views of culottes are shown above (cat. no. 238), both in white rayon ripcord. In the more formal version (left; cat. no. 223), "one leg is slimly trousered, the other is wrapped in a skirt-like fold, hooked well across the dividing line in front." This was one of the first models, seen in black silk faille, that James showed Bergdorf Goodman on his return to the United States in 1939. Reportedly, he caused quite a stir when he modeled his own line before an astonished Andrew Goodman.

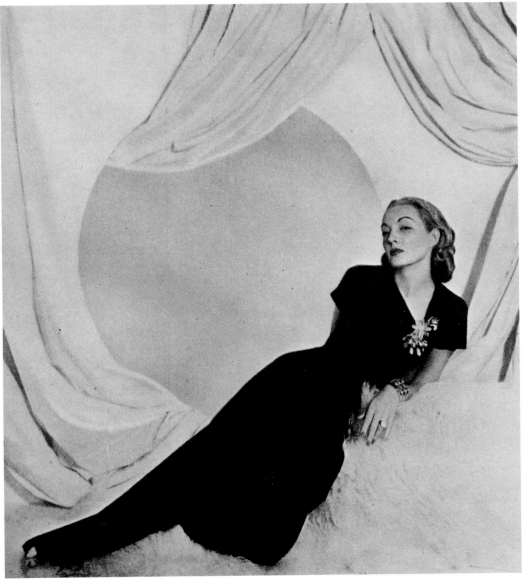

U.S. HARPER'S BAZAAR/PHOTO: GEORGE HOYNINGEN-HUENE/1940

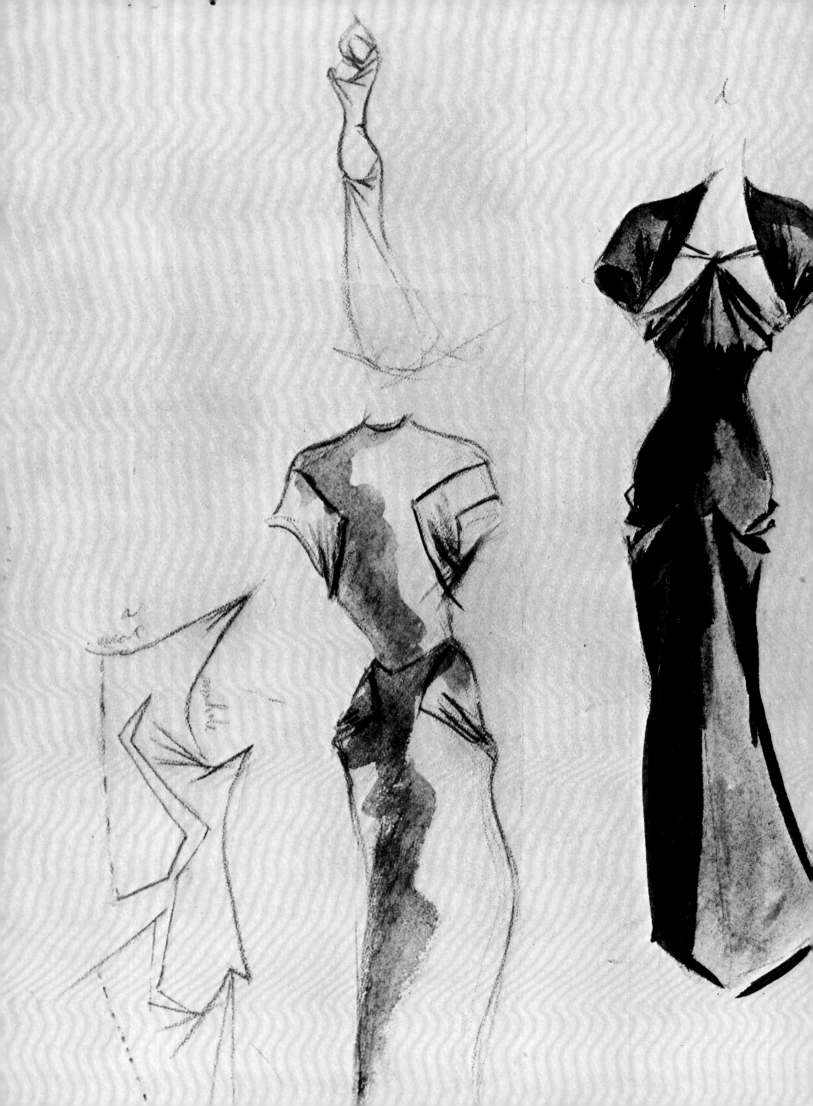

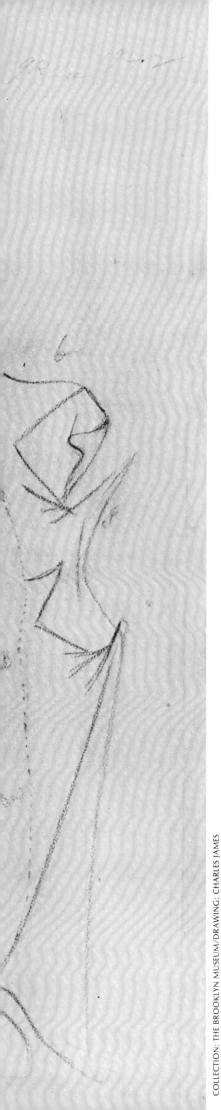

COLLECTION: THE BROOKLYN MUSEUM/DRAWING: CHARLES JAMES

Although he designed little for the stage after the 1930s, many of James's later models and clients were theater personalities. In 1942, he made sketches for an evening gown for Gypsy Rose Lee (facing page; cat. no. 53), demonstrating his ability to create plastic forms of classical proportion from elements based on precise formulas. In 1943, Dolores del Rio, swathed in sealskin-lined satin (below; cat. no. 383), modeled an evening coat as cooly icy in appearance as it was warm in fact — the sort of ambiguity James relished.

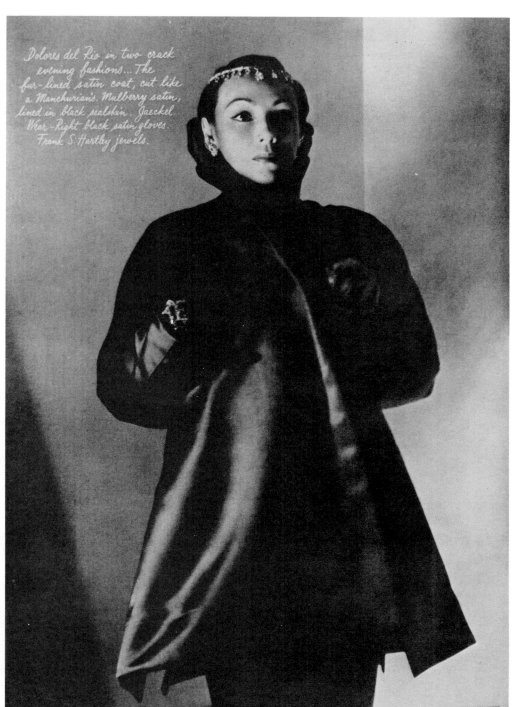

Dolores del Rio in two crack evening fashions... The fur-lined satin coat, cut like a Manchurian's. Mulberry satin, lined in black sealskin. Jaeckel. Wear-Right black satin gloves. Frank S. Hartley jewels.

U.S. HARPER'S BAZAAR/PHOTO: GEORGE HOYNINGEN-HUENE/1943

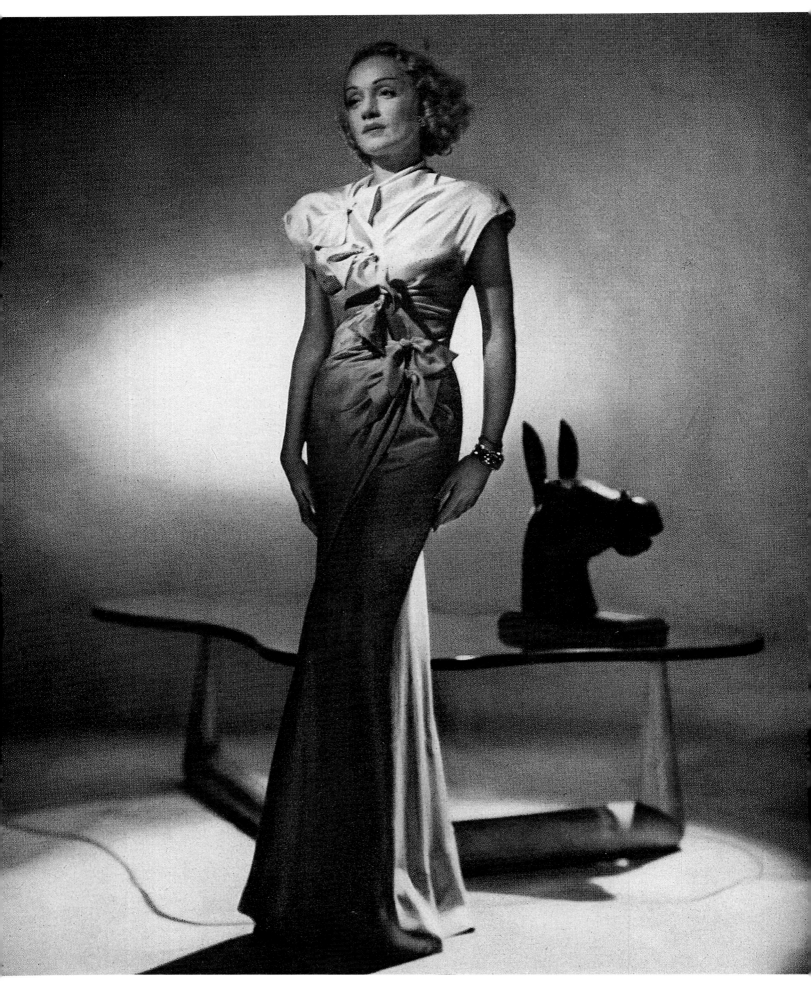

U.S. VOGUE/PHOTO: JOHN RAWLINGS/1944

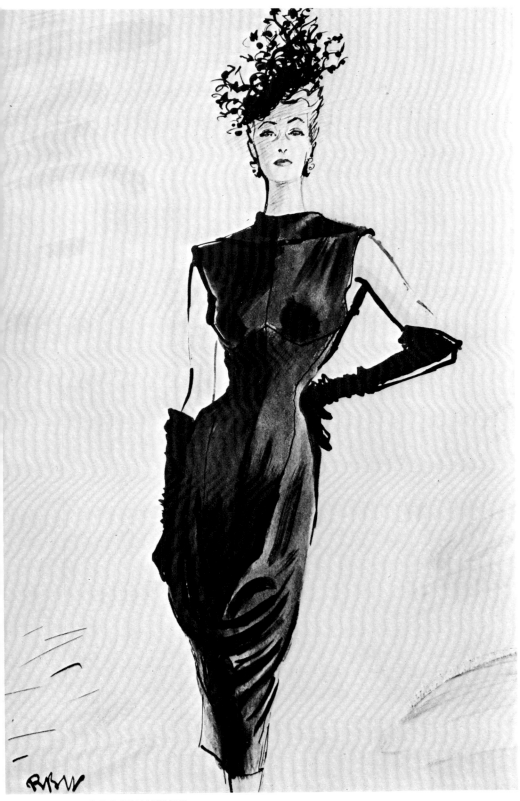

U.S. VOGUE/DRAWING: R. B. WILLAMETZ/1944

Perhaps by choosing a classic beauty, Marlene Dietrich, to model a dinner sheath he considered a classic, James hoped to establish not only his own name but that of Elizabeth Arden as a classic in couture (facing page; cat. no. 5). This image was part of the promotion for Arden's first couture collection; the dress had been introduced over a decade earlier in London.

Another garment shown at the Arden opening in 1944 had been originated in 1928 and reintroduced in London five years later (left; cat. no. 1). The earlier versions had been floor length. James placed his designs on the market not just for a season or even for a year, but for decades, marking him as a visionary, one who contradicted the dictum that "fashion" is the shock of the new.

The Arden salon, designed by
James, is seen on page 31. Despite
wartime construction restraints, the
room is filled with such Jamesean
touches as a crystal chandelier,
bountiful window dressings, and a
"naturalistic" item or two — such as
the shell-inspired vase and the coral
pedestal-supported table in the
window bay. James was to maintain a
similar style in each of his own salons.
The evening dress on the far right
(page 31) is captured by Cecil Beaton
in his sketch of the Arden workroom
on page 6; the central gown illustrates
James's passion for hip-line drapery
(cat. no. 57); the pyramid-shaped wrap
on the left was the prototype for
numerous negligees for Millicent
Rogers (cat. no. 226).

After leaving Arden's employ in
1945, James opened his own salon at
699 Madison Avenue, where one of
his primary early clients was the
fashion columnist "Austine," who was
also the Countess Igor Cassini and
later Mrs. William Randolph Hearst, Jr.
She is seen modeling an evening
gown in the new salon (right; cat.
no. 60), with its view into the
workroom and the elaborate
pedestalled urn that became a virtual
trademark in his showrooms. The
metal-covered horn stool and the
satin-covered chair are other
decorative features that often appear
in James's salons.

James's virtuosity with fabric — his
comprehension of its versatility and of
how color, fiber, texture, and pattern
can alter the impression of a design —
permit a single design to appear to be
two different coats (overleaf, page 32;
cat. no. 386). The short evening coat is
made of golden yellow faille lined
with ice-blue or aqua satin — "jewel
colors, tapered to a high, high collar,
with a new amplitude . . . to wrap
closed or to swing free and wide over
any amount of evening dress." The
informal coat was created at the
suggestion of Carmel Snow, editor of
Harper's Bazaar, for a cover (overleaf,
page 33). It is described as a "stand-
out coat cut from two woolen steamer
blankets and tailored with great flair.
Of bold-faced plaid in shock colors —
orange and wine and cobalt blue." Its
success was immediate, and James
later developed a street-length
version.

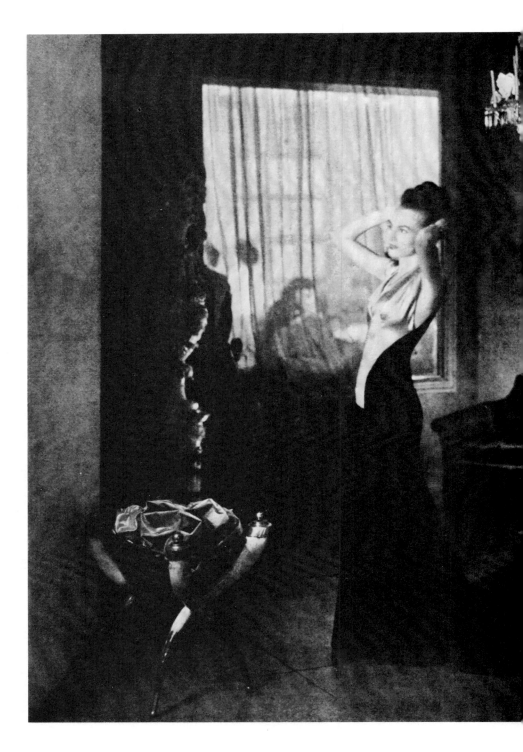

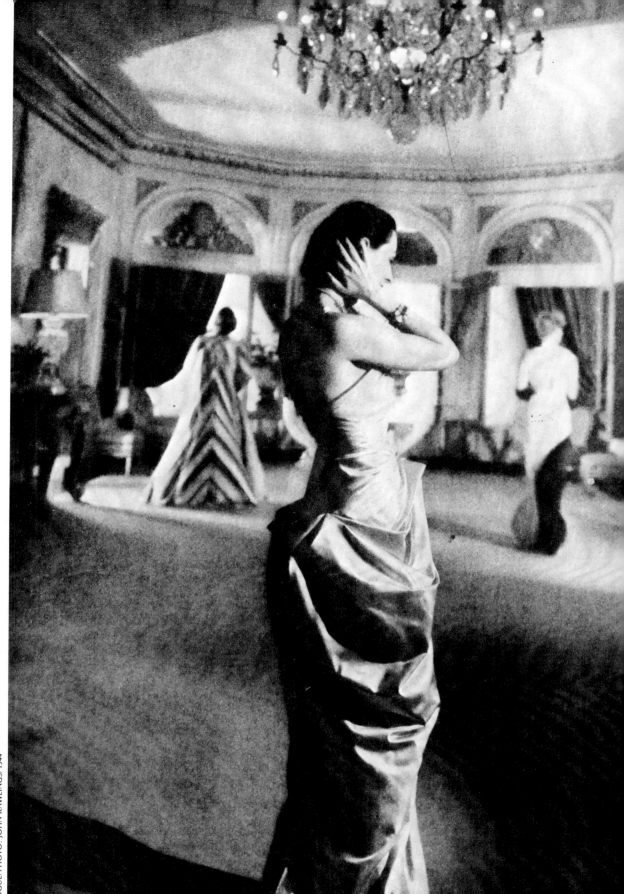

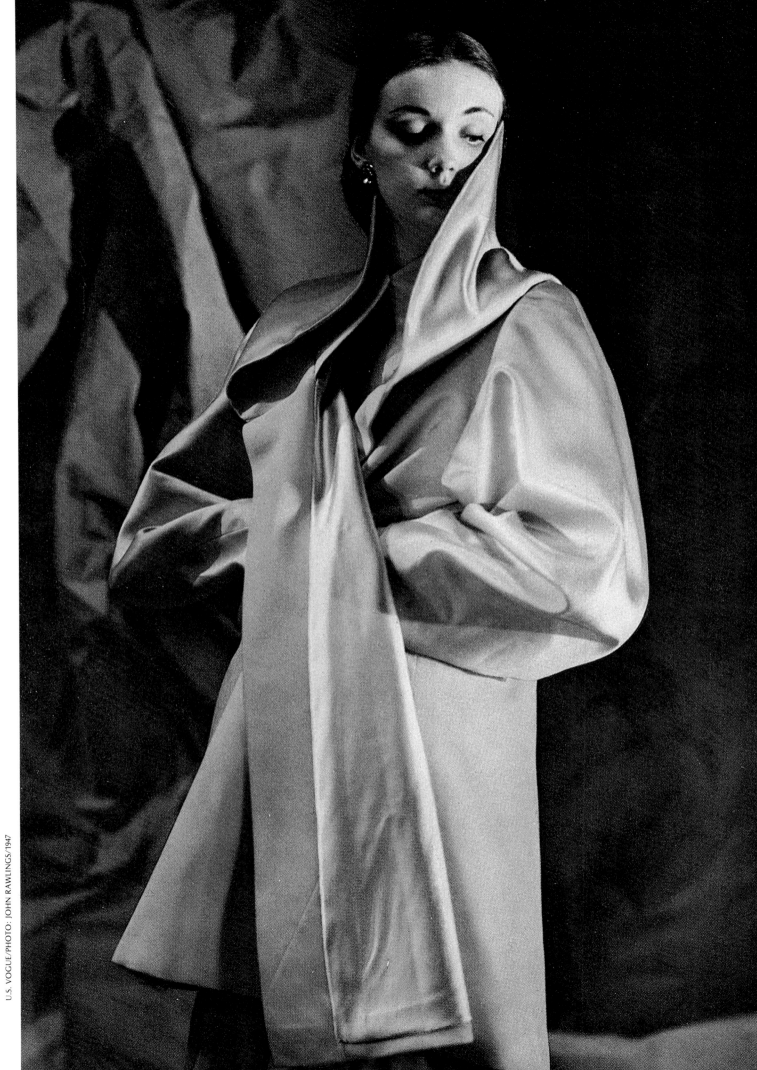

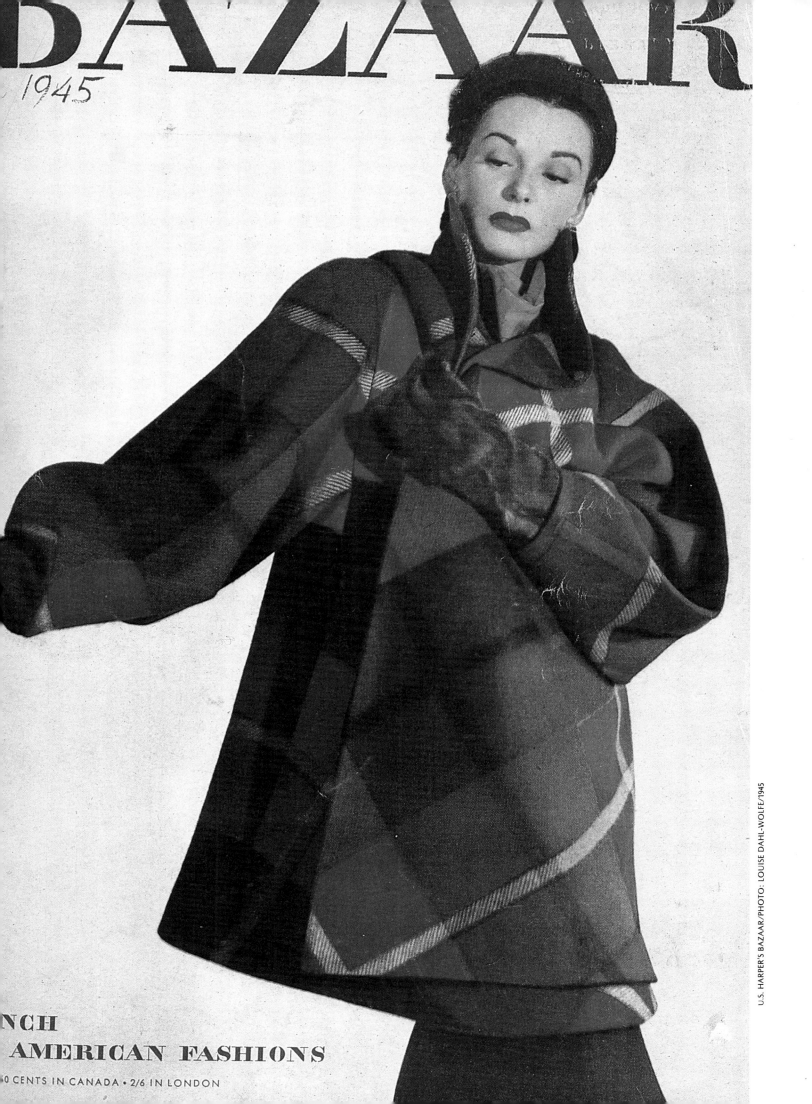

BAZAAR

1945

50 CENTS IN CANADA

NCH

AMERICAN FASHIONS

0 CENTS IN CANADA • 2/6 IN LONDON

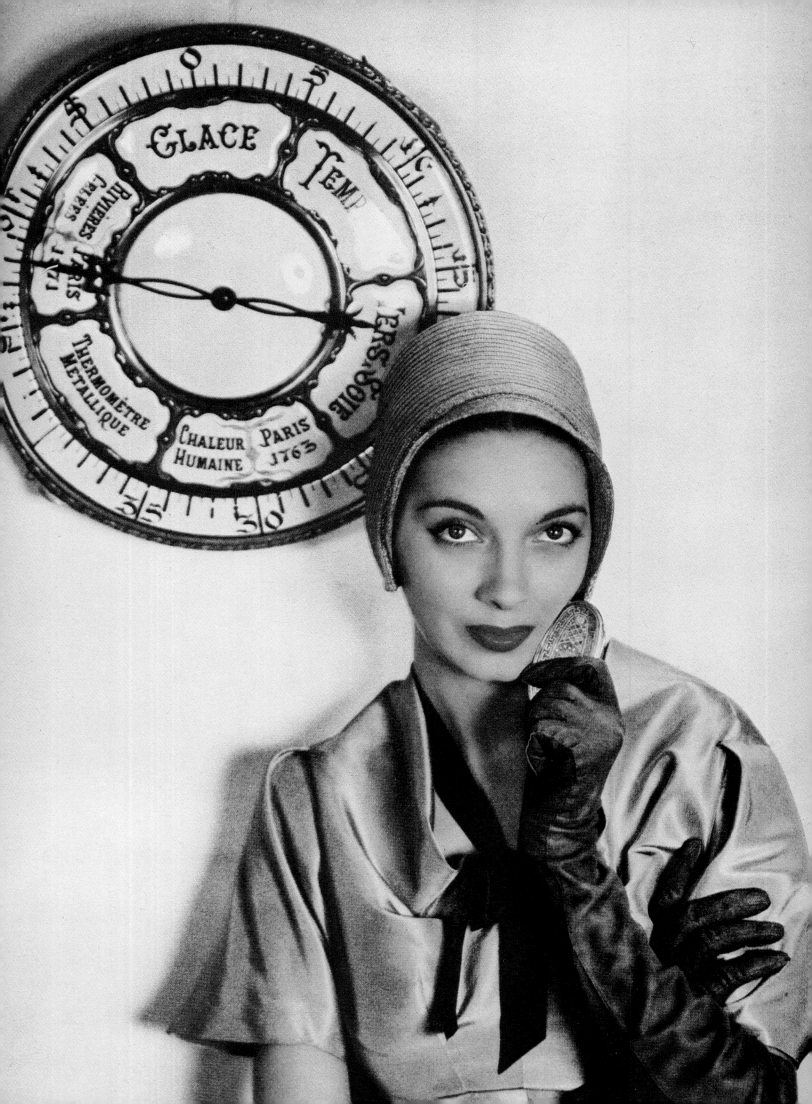

The silver faille restaurant dress appeared with the caption "metals are back from the wars" (facing page; cat. no. 153). Originally, the dress was created in Florentine silk taffeta curtain fabric from one of James's favorite suppliers, the decorator Rose Cummings. Its many variations included a full-length wedding gown. The heart- or lobe-shaped detail is emblematic in James designs.

In 1947, James, assisted by his student Miguel Ferreras, executed a dolman wrap by cutting and pinning directly on the client, Lily Pons (below, left; cat. no. 392). In characteristic fashion, James then sketched the coat on a large sheet of ledger paper — material he used in quantity to record workroom notes, financial transactions, finagling, and personal letters. The coat became a workhorse in James's design stable, first being offered to private clients, then,

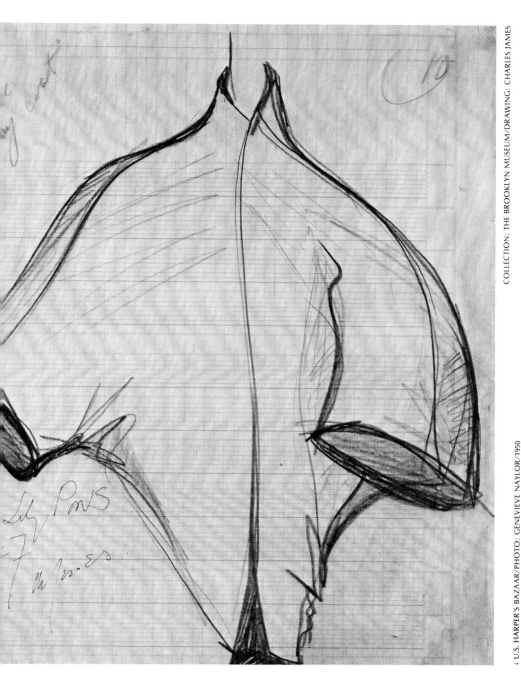

COLLECTION: THE BROOKLYN MUSEUM/DRAWING: CHARLES JAMES

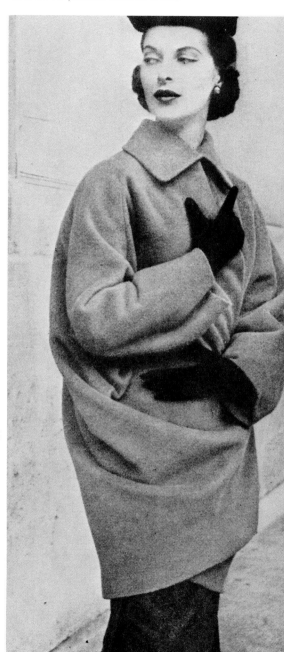

U.S. HARPER'S BAZAAR/PHOTO: GENEVIEVE NAYLOR/1950

through Charles James Services, being sold by Lord & Taylor in 1950 (above, right). Marketing was done by William Popper in 1952. In 1956, Charles James Manufacturers perfected the design for mass production, but only twenty were "reproduced" (as James would have put it). About 1958, a self-lined evening version was completed in bright-gold silk-damask drapery fabric from the Chicago apartment of Mrs. Potter Palmer II.

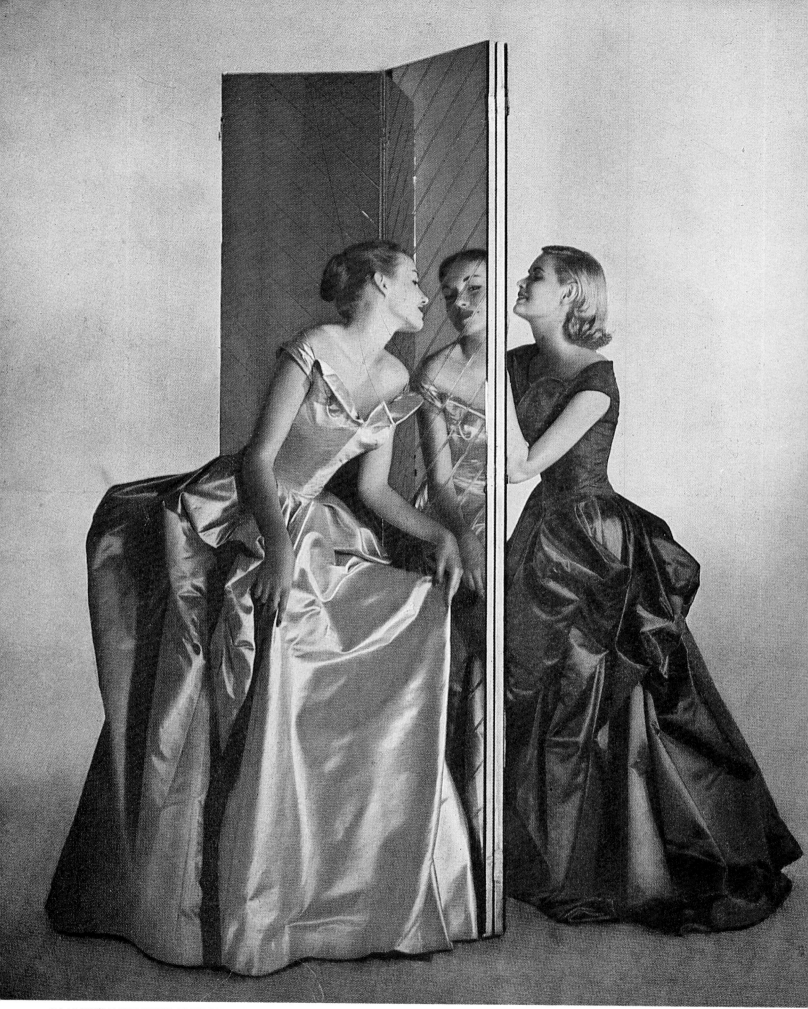

U.S. HARPER'S BAZAAR/PHOTO: LOUISE DAHL-WOLFE/1948

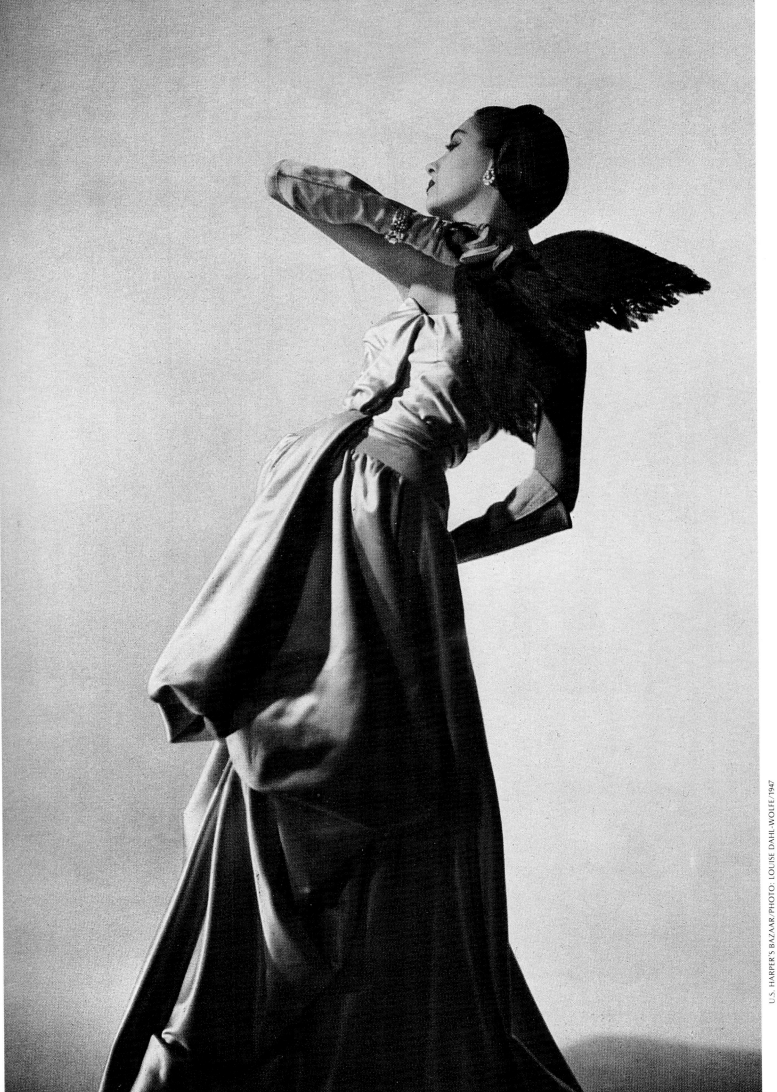

Charles James's evening gowns were widely praised for their exquisite color, fabric, and cut. On page 36, two versions of the left-hand gown (cat. no. 68), executed in sea-green Benedictine silk satin and laurel green silk satin and silk faille from Ben Mann, show the master's hand at work. The design of the draped and pouffed gown in cerulean satin (page 37; cat. no. 49) was begun in Paris in 1939, and James continued to work on it until 1943. The bodice, in either strapped or strapless versions, is created from a single pattern piece. Both gowns also appear in the Cecil Beaton salon photograph (pages 10–11).

The gown at top right, this page (cat. no. 73) is shaped like an inverted flower, with a stem of eggplant and petals of apricot tipped with black, executed in three of James's favorite fabrics, faille, velvet, and satin. The gown below (cat. no. 79) was described as "so intricately shaped, so marvelously massed into drapery that every angle presents a new silhouette". This stunning line is enhanced by waterlily shades: green taffeta and pale green-yellow satin.

On the facing page (cat. no. 55), in the rapturous words of a fashion copywriter of 1947: "Spring pink. A shadow of itself. Pink, a semi-tone of pink dimmed to a reflection of fabric; Charles James's timeless satin dress, with all the pale colouring of a sea shell; pale satin, shoulder-folded, draped over the hips." James asserted that the dress could be worn by women of any age. Here it is modeled with two characteristic Jamesean accessories, the feather fan and the illusion stole.

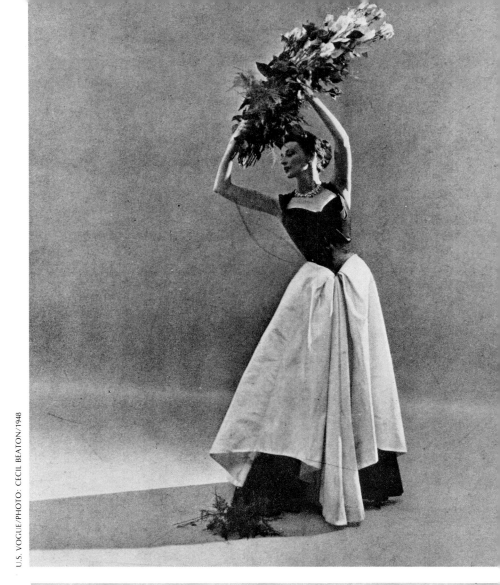

U.S. VOGUE/PHOTO: CECIL BEATON/1948

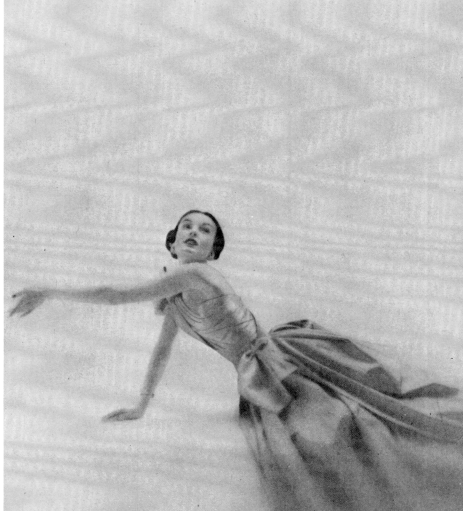

U.S. HARPER'S BAZAAR/PHOTO: RICHARD AVEDON/1948

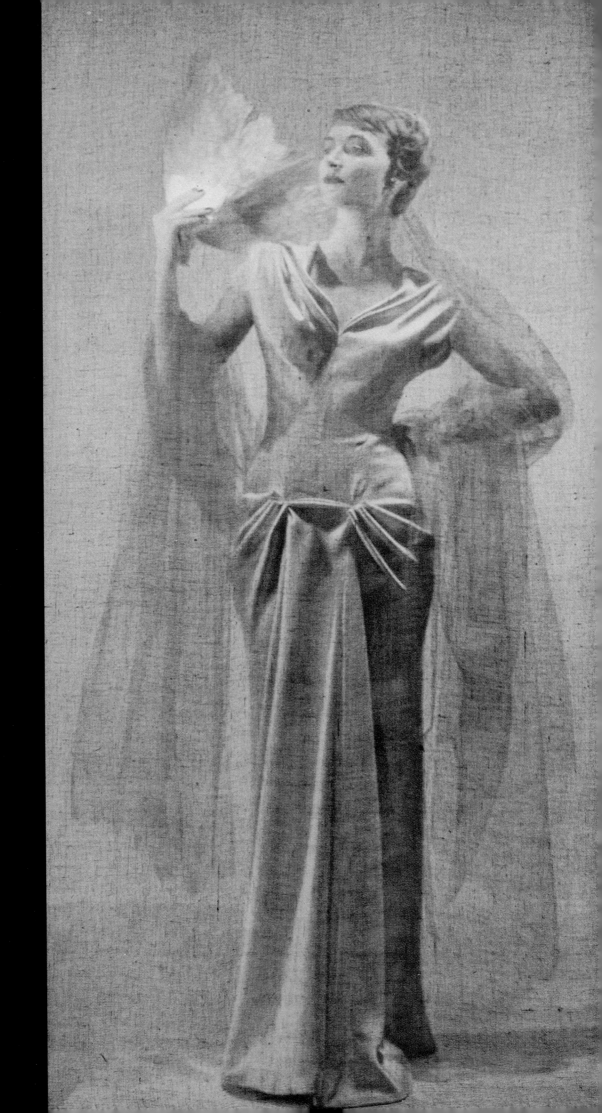

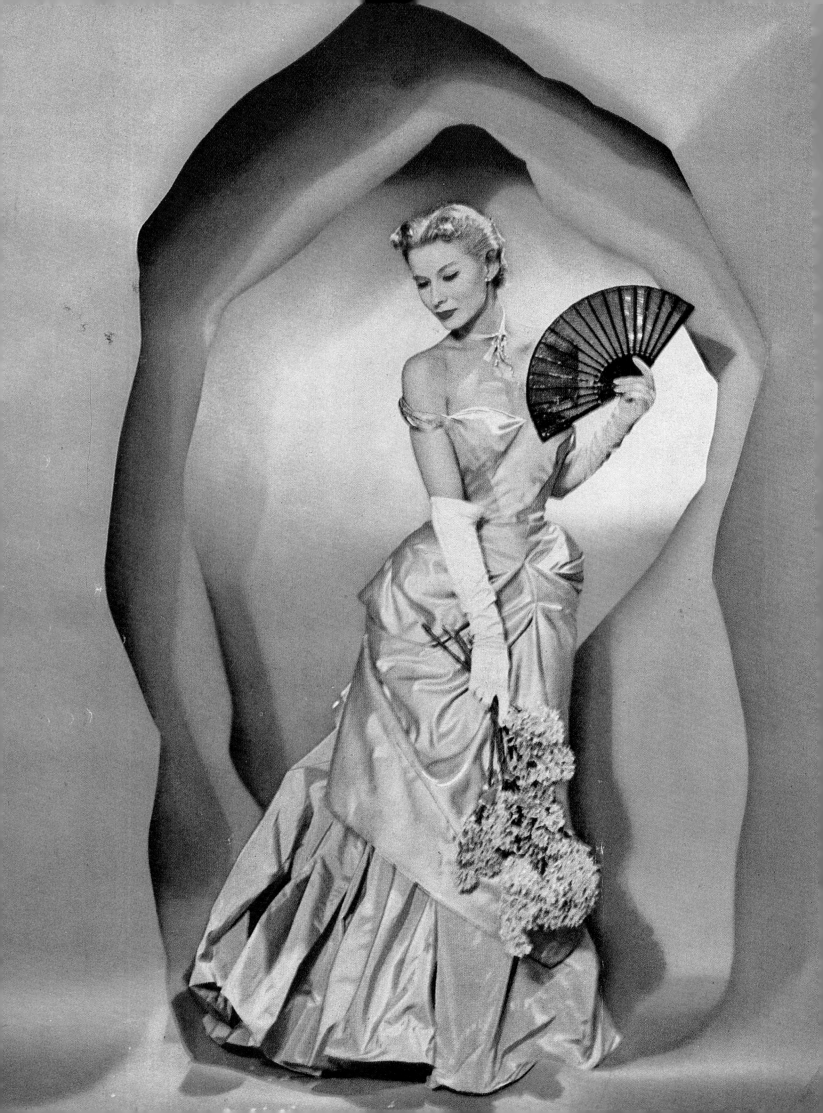

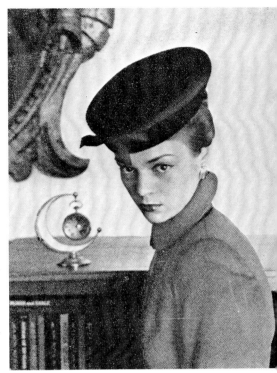

Lavender satin and ice-blue taffeta appear in this version of a 1949 evening dress (facing page; cat. no. 81), which James executed in numerous fabrics and colors. Together with cat. nos. 55, 68, and 96 (page 48), it was featured in a highly elegant series of advertisements for Modess, some of which were photographed by Cecil Beaton.

Beaton may have felt that the only way to capture the black faille suit with envelope peplum and wraparound skirt, worn with matching headpiece (based on a Yugoslavian cap), was to include the creator, too (left; cat. no. 304). In the published photograph, James works alone on the details of the hemline.

In the late 1940s, there was a resurgence of interest in James's millinery. He revived from the 1930s a tilted beret, based on the design of a French sailor's hat, which he had originally introduced at a masquerade in New York City (above; cat. no. 543). James modeled all his own hats — surprisingly well.

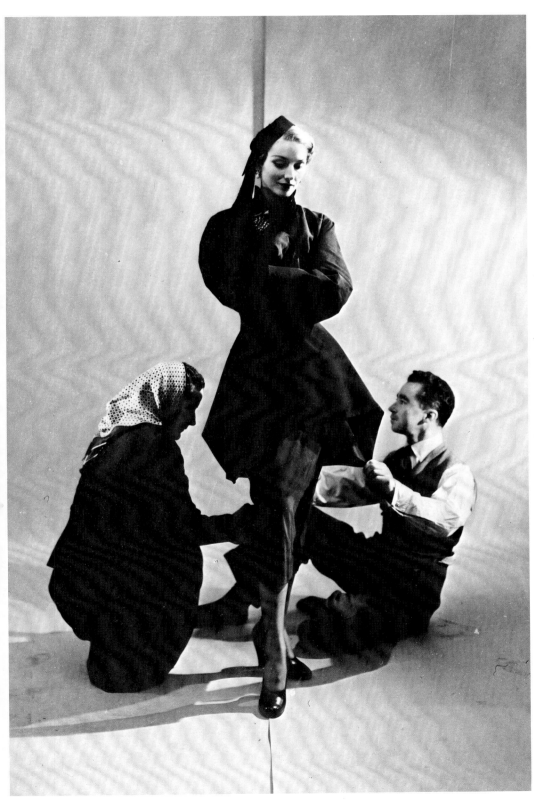

Unique on many levels was the relationship between James and his premiere client, Millicent Huddleston Rogers. Their association began in the 1930s when she and many of her friends first visited the London salons. Millicent Rogers was a style setter. She possessed a nearly perfect figure for her day and had an unparalleled eye for clothes. An admiring friend has observed: "She could pick a rug up off the floor, don it, and look ravishing." Her chameleon-like elegance was expressed through her selection of couturiers: Schiaparelli, Mainbocher, Valentina, and James. Each of them had as much of an

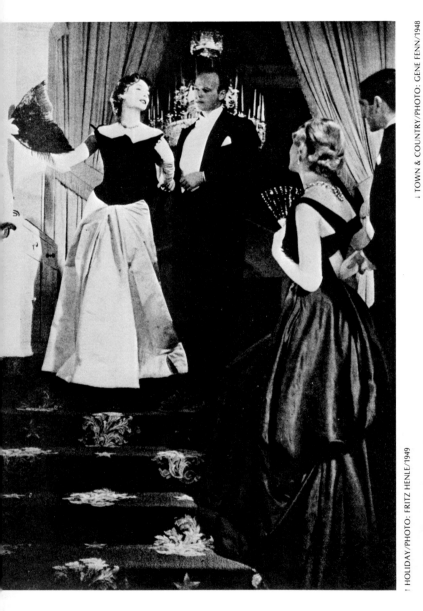

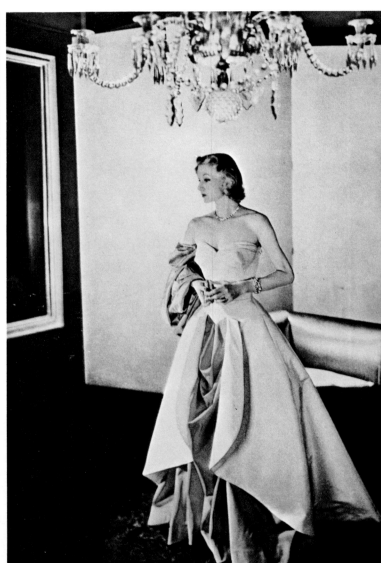

TOWN & COUNTRY/PHOTO: GENE FENN/1948

HOLIDAY/PHOTO: FRITZ HENLE/1949

individual statement to make as their client, and she wore all their creations with equal panache. She also had an affinity for Austrian dirndls and Southwestern American attire and design. Some of the latter she interpreted in designing and fabricating her own stunning jewelry, such as the necklace she wears in the photograph on the facing page. In this instance it is hard to say whether the skirt and blouse ensemble by James (cat. no. 246) or the jewelry is the greater artistic achievement.

The frenzy of the association began at the close of World War II and was only to diminish when her ill health and death separated them. In numerous instances James acknowledged Rogers's contributions to his designs. Perhaps their partnership culminated in The Brooklyn Museum's "Decade of Design," a 1948 exhibition that showcased garments James had either

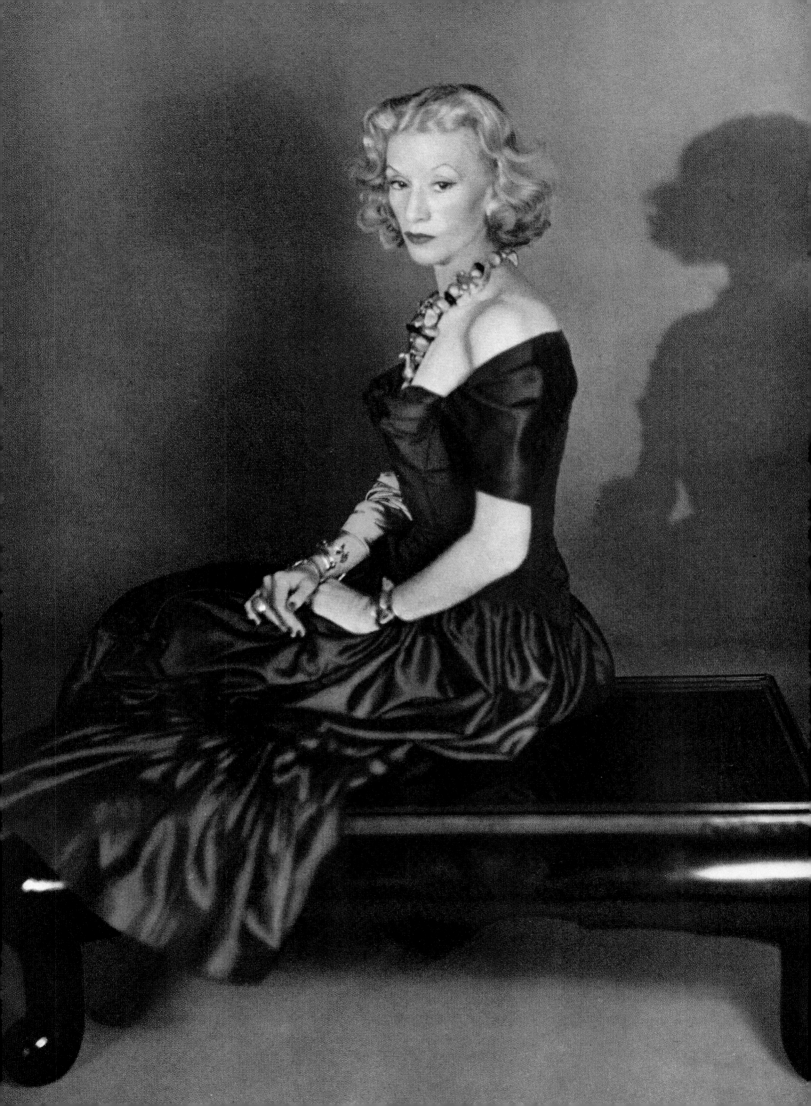

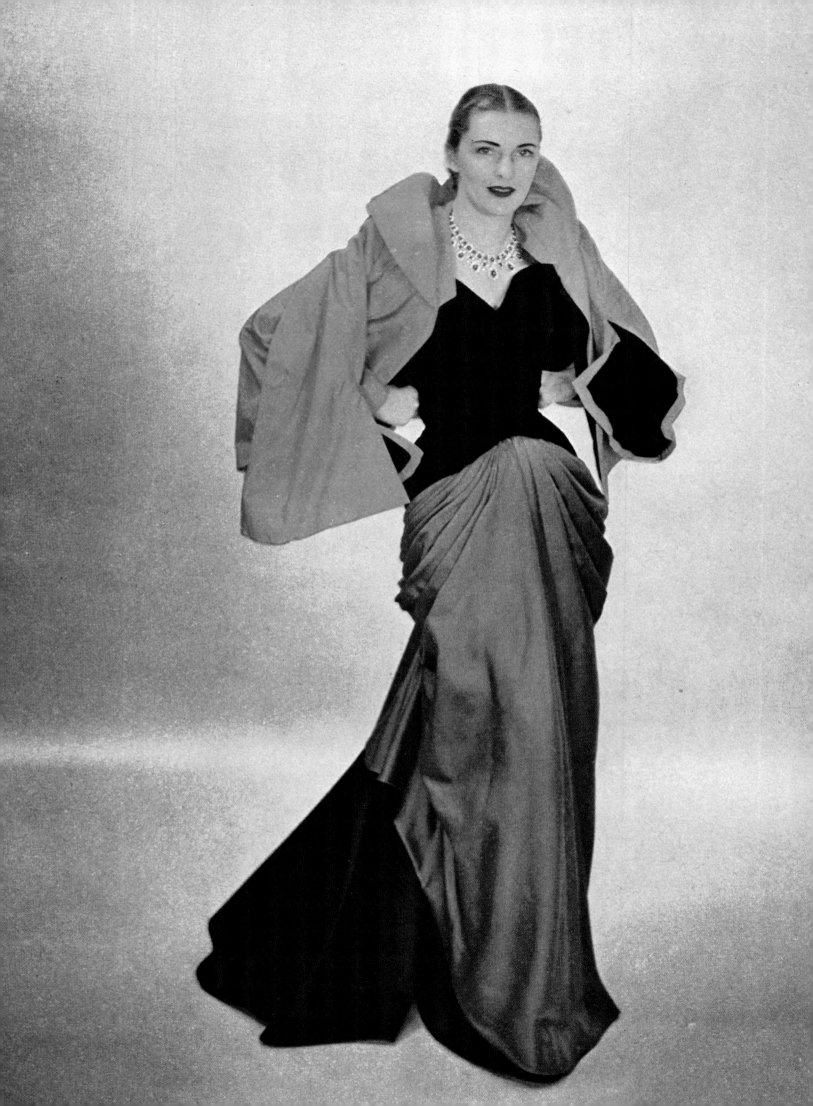

created or made for her over the preceding decade. The following year, 1949, Mrs. Rogers, in recognition of James's standing as an artist, made a large donation to The Brooklyn Museum of original garments, copies, half-muslin models, and muslin and paper patterns. Until the end of her life in 1953, she added to the collection, and her sons, Paul and Arturo Peralta-Ramos, gave numerous garments from her estate to the Museum, including pieces by James.

As a Standard Oil heiress her financial position was secure, as an inimitable woman of style her taste was unassailable, and as a client and patron of James her role in his creativity and production was matchless. From gloves to belts to gowns, she had them all from James — gloves like those on the pair of models photographed on page 42, left, or a gown like the black satin and velvet one in the same picture (cat. no. 70), seen here with another evening dress of James design (cat. no. 77). In Mrs. Rogers's dress, James has married two of his cutting trademarks: rigid geometrical forms and fluid asymmetrical folds. In the adjacent photograph (page 42, right), Mrs. Rogers is pictured in James's salon at 699 Madison Avenue. The window overlooking the workroom is to the left, and in front of the screen, cream satin upholsters the rolled arm cornered chair. Under the crystal chandelier James painted the floor black. Mrs. Rogers wears a strapless eighteenth-century-inspired ballgown (cat. no. 72). James worked out the overdress of flesh faille with its fitted and padded structuring, while Rogers suggested the saffron Catoir peau de soie draped underskirt. This design was completed in 1947, as was the gown seen from front and back perspectives (this and facing page; cat. no. 71). It too was initially designed for Millicent Rogers. The back view again shows her in James's salon, this time posing against the screens. As initially executed for Mrs. Rogers, the "Bustle" gown has a boned black velvet bodice, a stiff slipper-satin skirt and a tied-back overdrapery of tobacco brown charmeuse, which terminates with a rosette over a horsehair cul. For another client he utilized upholstery fabric originally ordered by King Leopold of Denmark to decorate a residence; the fabric had found its way to Rose Cummings's shop where it caught Charles's eye. On the facing page, the supremely confident and elegant Mrs. Leland Hayward takes a stand in her version of the "Bustle" dress, draped with the intense gold of a James wrap (cat. no. 397), which frames a brilliant necklace of diamonds and emeralds. Mrs. Hayward seems to sum up all James hoped to achieve.

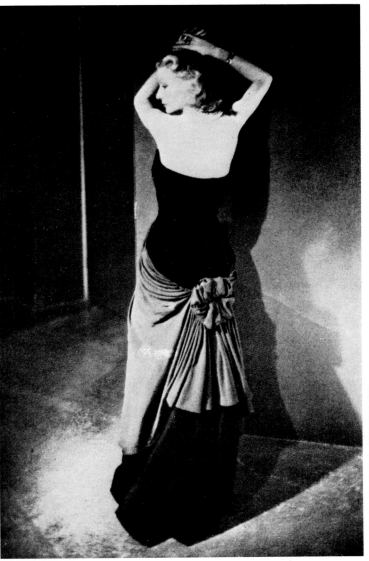

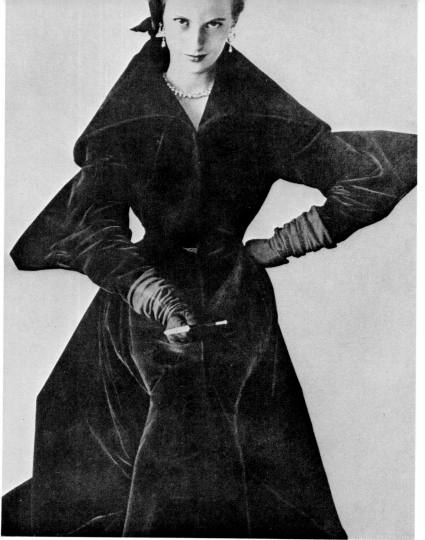

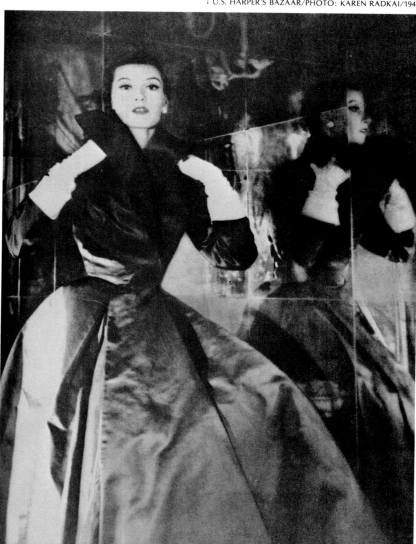

For an evening wrap (top left; cat. no. 398), Millicent Rogers chose the garnet velvet full-length coat cut with a flourish, with its own angles, sleeve akimbo, and a willowy waist. The angularity represents James's interpretation for Mrs. Rogers of the styles of the 1830's period, which she encouraged Mainbocher to work on for her, too. The quasi-historical translations of the two designers are as different as their basic personalities. When in motion a hint of the bright gold faille lining alludes to brilliant autumnal shades.

After his evening gowns, it is considered that James's most notable achievements are his designs for outer wraps. Evening and day attire were merged in a coat/coat dress that James worked over for a number of years (bottom, left; cat. no. 384). The photograph shows a heavy black Catoir satin street-length theater coat. Whether executed in wools or silks, the garment appears to have been presented in black with a red lining. Whatever the color combination, the sharp in-and-out shape is enhanced by a skirt widened by pleated godets, which flair out and open when in motion.

James made a documentary pencil sketch of a Chesterfield style coat while staying at the Hotel Lancaster in Paris in 1949 (facing page; cat. no. 395). Attention is drawn to the central axis he created down the page and to the fact that while the bust- and waistline appear to be casually drawn, they are precisely placed in a mathematical ratio to the total length of the garment.

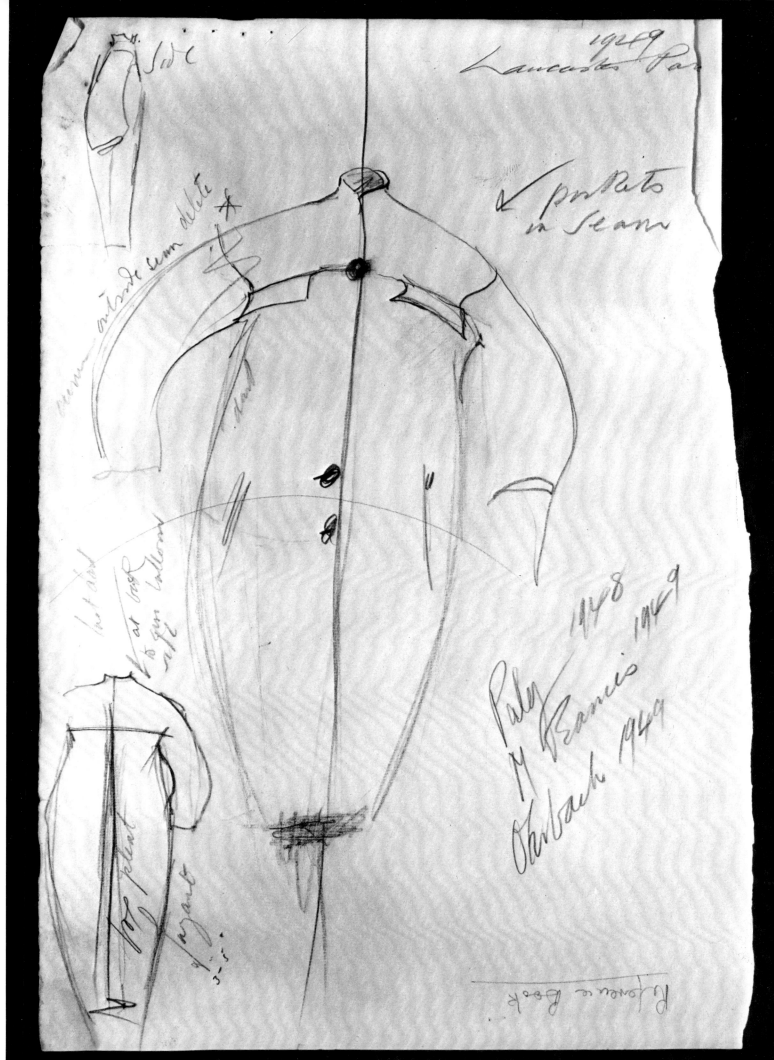

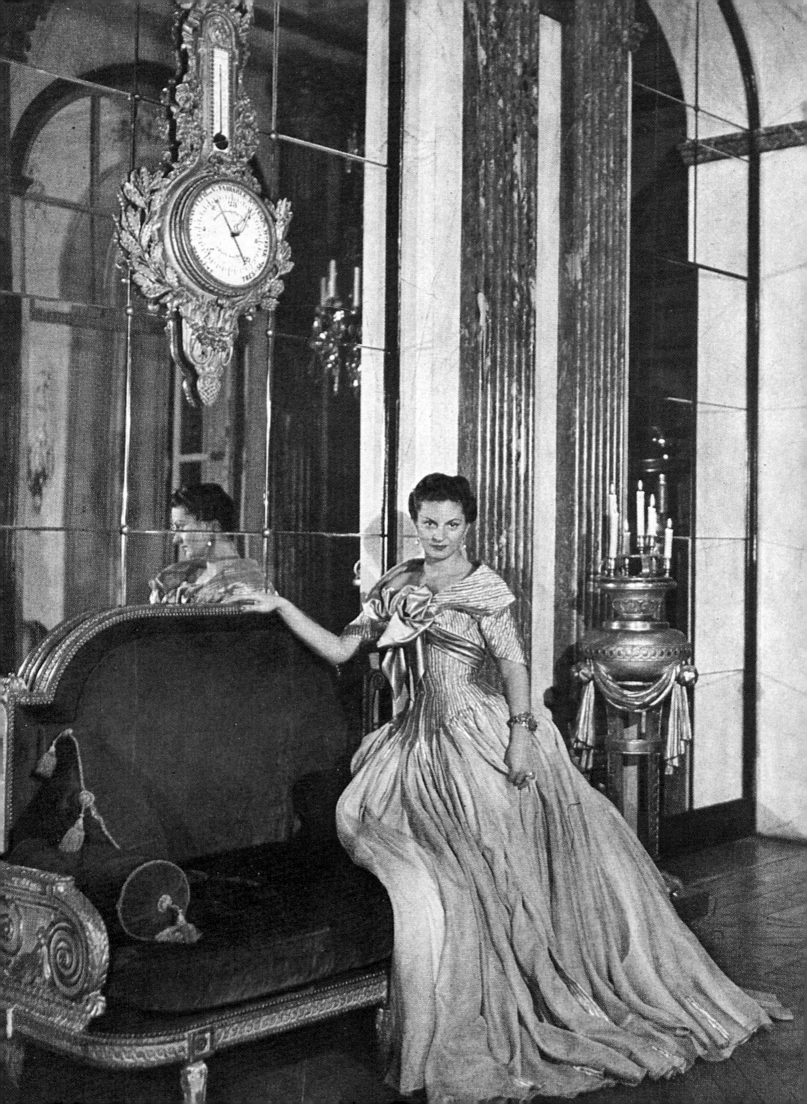

Intricate and flamboyant gowns associated with the early 1950s are exemplified by the dress James created for Mme. Arturo Lopez-Willshaw to wear to commemorate the opening of the ballroom of her house in Neuilly, near Paris (facing page; cat. no. 96). Posed in her gallery, Mme. Lopez-Willshaw is seen in "hundreds of yards of ribbed gold military braid, which, having formed the sleeves and corsage, spread like fingers down onto the sixty-eight

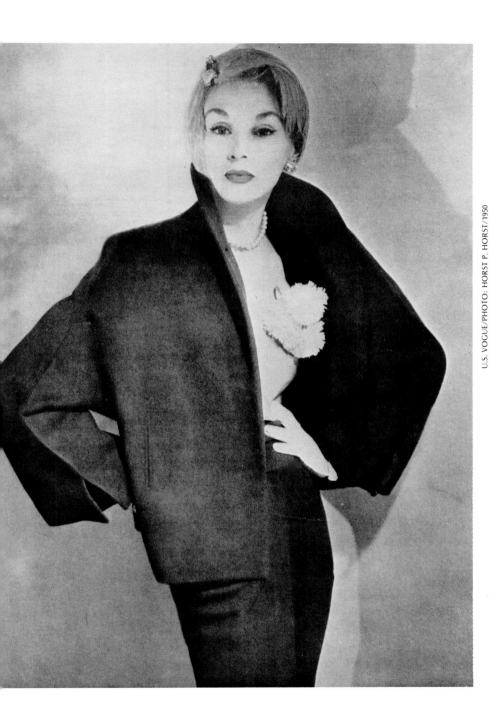

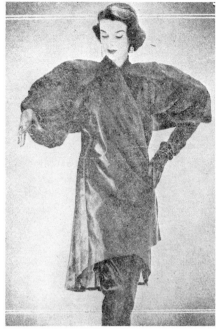

U.S. VOGUE/PHOTO: HORST P. HORST/1950

PHOTOGRAPHER UNKNOWN/1950

sections of fine starched grey lawn." The gown was presented to a far wider audience when James borrowed it back to include in the Modess advertising campaign, when Maxime de la Falaise modeled it on the steps of the Paris Opera House before Cecil Beaton's camera.

The cut and placement of James's sleeves is always a remarkable feature. In the box jacket of the dinner suit (left; cat. no. 317), with its resemblance to a Japanese kimono, the sleeves are not inset, but are part of the body pattern pieces, front and back. The seaming of the sleeves is highlighted with a spine of welting. The ball wrap designed for the Ohrbach's line (above; cat. no. 400) features elaborately conceived pneumatic flange sleeves, which arc and taper from a pleated line below the V-pointed back yoke and from a rolled front line. A subtle and elegant lining of lavender satin and black velvet contrasts with the rich deep brown of the exterior satin, once again demonstrating James's outstanding sense for color and texture. Proportion, color, and surfaces are united to create a garment lining every bit as spectacular as the casting of the exterior.

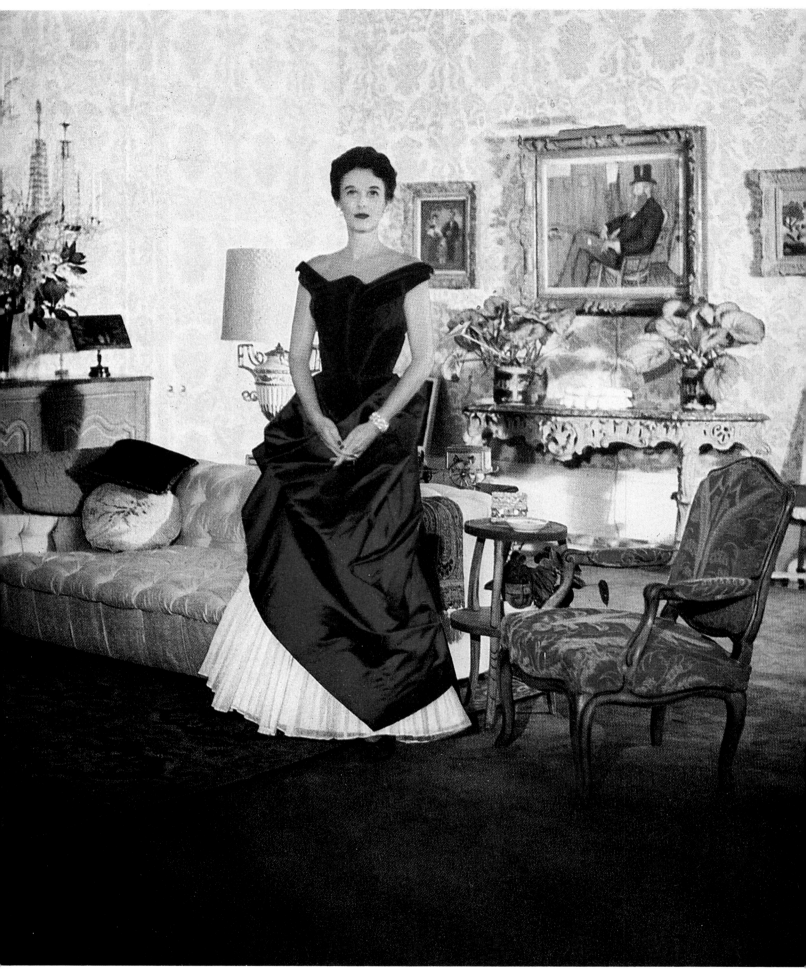

Posed in her
Manhasset, Long
Island home, "Kiluna
Farm," Barbara
(Babe) Paley is
photographed in a
well-known Charles
James dress (facing
page; cat. no. 83): "a
play of textures, a
polonaise of red velvet
and satin in the same
deep ruby red with
different lights, and a
pleated underskirt,
unexpectedly rough
and starchy of white
cotton." Eight of
James's most
prominent clients
acquired this dress, all
in the same fabrics.
They were called on to
participate in a March
of Dimes benefit
finale, all wearing this
gown, escorted by
eight gentlemen in
formal attire, bearing
bouquets of roses
matching the color of
the dresses. For many
years the inclusion of
Charles James
garments was the
highlight of March of
Dimes fundraisers.

In establishing this
spectacular gown
(right; cat. no. 93),
James sheathed the
torso and blew out a
full, knee-line skirt
flounce. As seen by a
contemporary fashion
writer, it was: "A cut
above, a cut divine,
dressmaking of such
complexity and
brilliancy and beauty
that it commands the
praise and the price —
that we accord to
works of art. The Black
Tulip: a satin stem and
a faille overskirt
shaped like a tulip, up
curved in the back
and built on an
elaborate substructure
of bones and
buckram." James
would later play down
his use of boning in
formal garment
construction, and,
indeed, his later
versions of this
garment were
reworked so that the
weight of the flounce
was supported by the
torso.

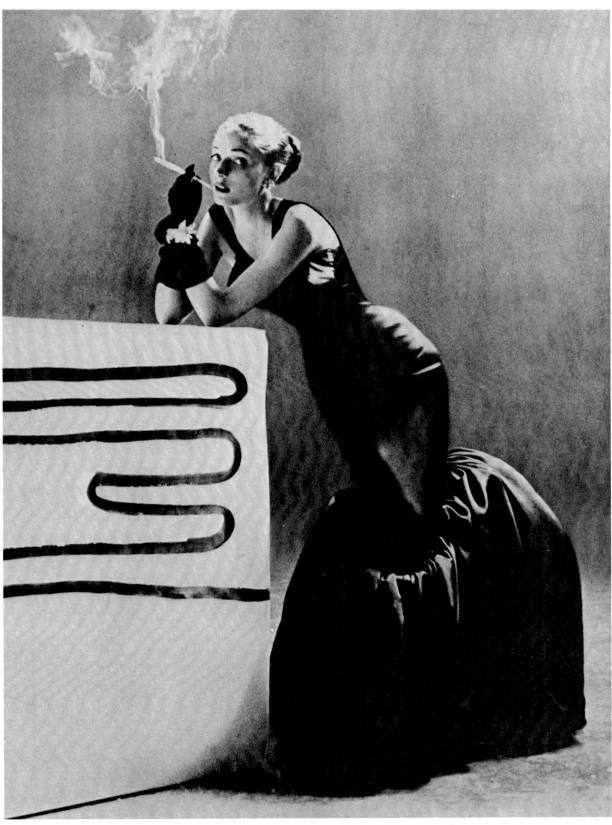

U.S. HARPER'S BAZAAR/PHOTO: RICHARD AVEDON/1950

There are many stories about James and flowers — he seems to have had a great fondness for them — but the fragility of flowers is hardly ever carried over into James's designs. On the contrary, his pieces are sturdy, ever-blooming specimens. In 1950, James was commissioned by *Flair* magazine to design a gown for a special springtime "Rose" issue (below; cat. no. 94). Photographed in James's "Design Studio," the "Rose" dress is a "brilliant abstraction of the rose in that every artful inch contributes a dynamic grace to the female figure. The rib-tight bodice of blush-rose satin unfurls about the shoulders in an effect of rose petals. The skirt of tea rose faille, narrow as a stem from the front, pulls back into one exuberant sculpture of folds."

At this time James had a fascination with shoulders and he devised a series of framing necklines that were cut,

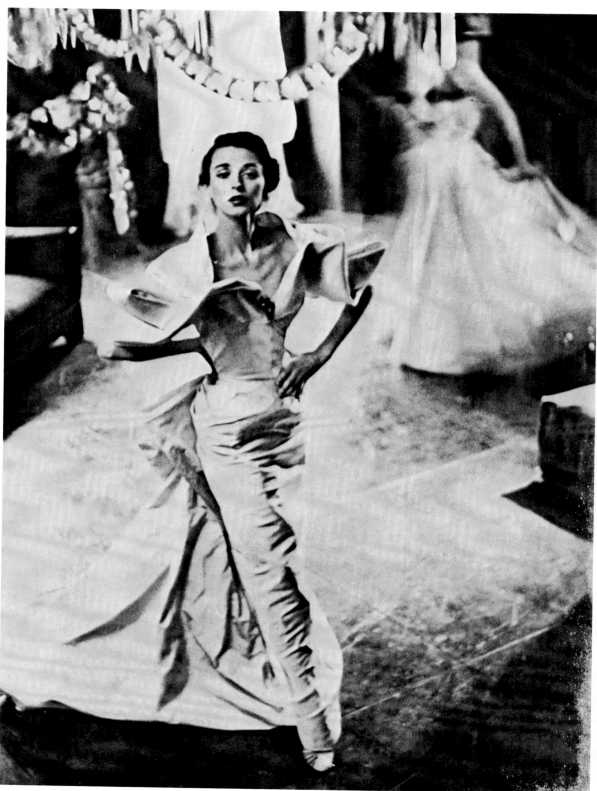

FLAIR/PHOTO: LOUIS FAURER/1950

52

draped, and wired in a variety of asymmetrical modes. Going back to his spirally wrapped garments of nearly two decades earlier, he constructed "a ruby red silk faille dress for dinner. Designed asymmetrically, cut 'around' the figure, a beautifully subtle dress that looks like a different dress from every angle" (below; cat. no. 167).

Mrs. Cornelius Vanderbilt Whitney, here sketched by the fashion artist

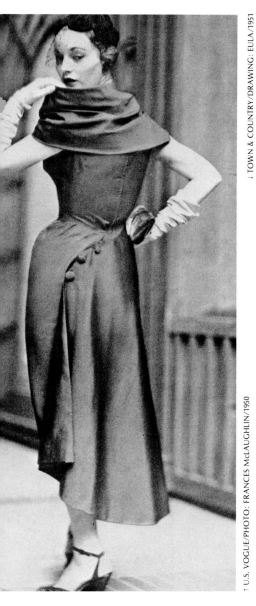

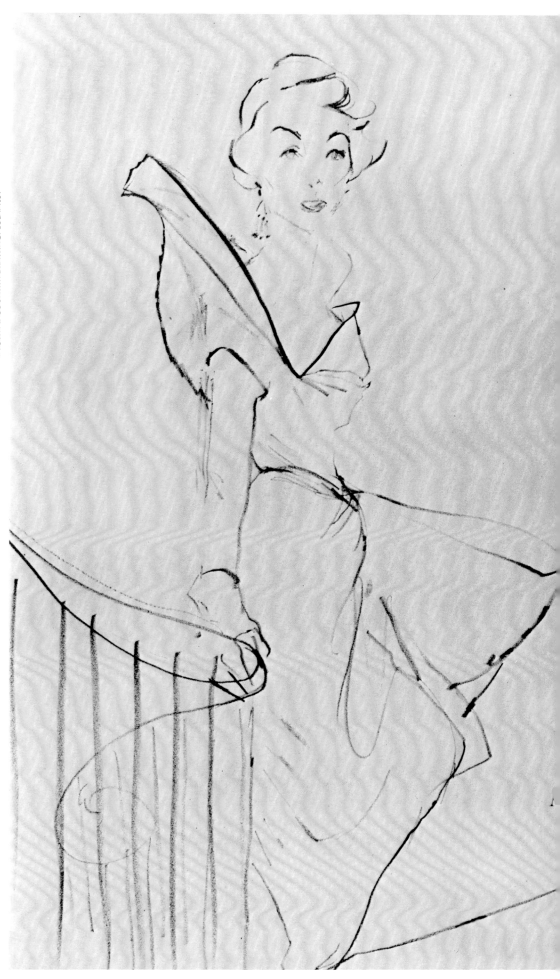

Eula, is shown wearing her latest James evening gown, which displays part of his continuing absorption with obliquely cut necklines and foliate forms (right; cat. no. 100). The original caption observes that James, a fashion law unto himself, had used his genius 'in the subtle contrasts of color and fabric, walnut-brown silk faille for the leaf-like bodice, laurel green for the shining satin skirt, spirally wrapped into a stiffened wing" of this ball gown.

COLLECTION: THE BROOKLYN MUSEUM/DRAWING: CHARLES JAMES

U.S. HARPER'S BAZAAR/PHOTO: RICHARD AVEDON/1951

In 1951 James designed for Mrs. Whitney a deep, folded-over shawl-collared circular cape, to be fabricated in Catoir silk. His sketch of this design conveys a form less enveloping than the finished garment (left; cat. no. 404); he has added a tenuous sleeve to the left side. Fabrics with body — satins or heavily sized nets — were surface and facing treatments, and the arc line of the garment is only broken by the insertion of a small neckline band.

James worked at perfecting an arc sleeve. Around 1951 it made an appearance in a short jacket of artillery drill (above; cat. no. 407), as a suit jacket in satin or taffeta (facing page; cat. no. 322), and in a knee-length town coat of Melton cloth (cat. no. 405). The fabrics, all of substance, hold the shape of the sleeves, which were very loosely based on those of the Louis Philippe era. Editorial comment on this cut noted that James "is about as disinterested in a suit's special cut as an engineer is in a bridge" and that "the suit has a skirt 3½ yards around and a pair of sleeves that give a deep, wide rounded look to the whole bodice." Evidently, for James the compass was a key working tool at this moment.

54

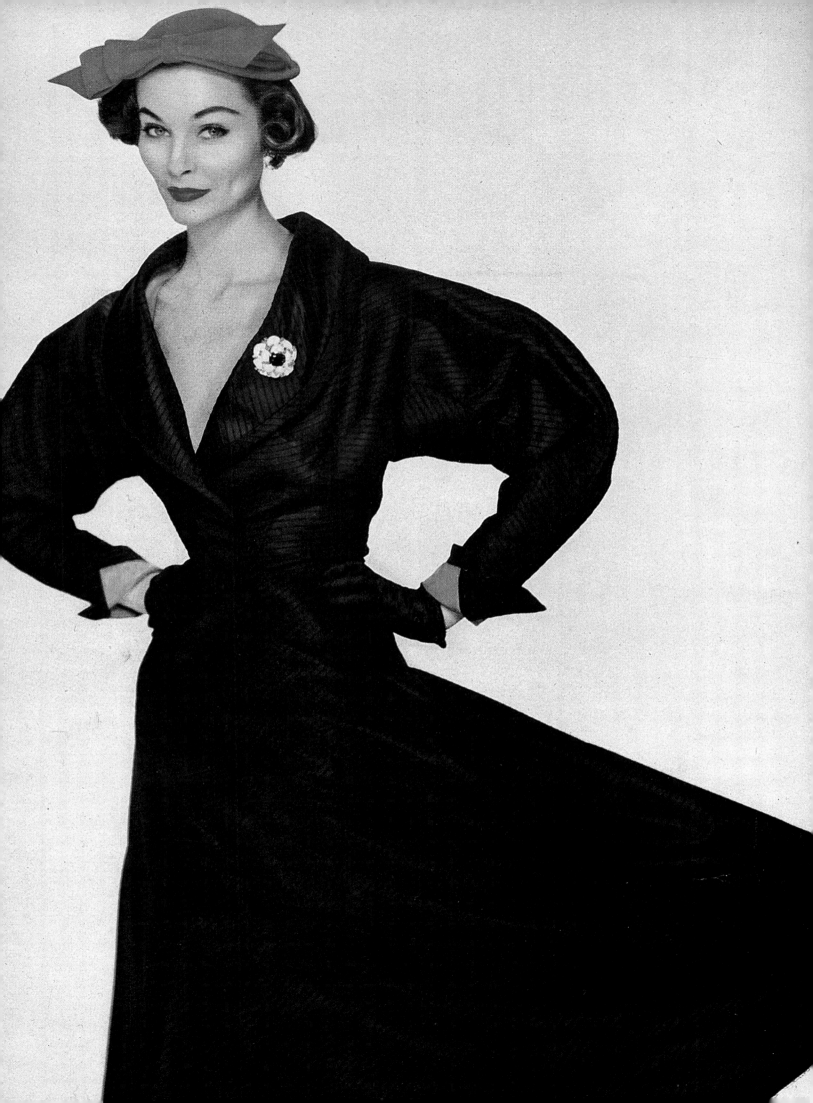

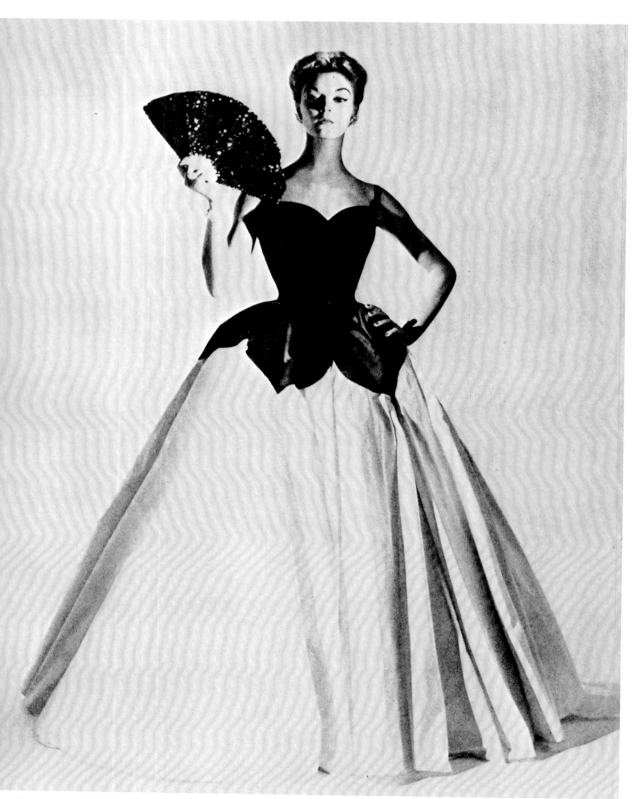

In 1949, James designed the "Petal" dress for Millicent Rogers, but publicity did not come until 1951, when it was shown as part of his "black-and-white" evening collection (left; cat. no. 85). "The bodice is a long, curving stem of black velvet above petals of black satin, above 25 yards of blowing, billowing white taffeta." Taking the petal peplum in 1956, mirror-imaging it, and boning the points, James created an exquisite shoulder wrap — a sensuous, serpentine sculptural form, usually fabricated in velvet with a satin facing (cat. no. 455). In 1958, he revived the gown for a proposed line of mass-produced Junior dresses with ballerina-length skirts.

The trim, trumpet-silhouette ball dress of ivory white Alençon lace from Charles Whelan was part of the first James collection for Samuel Winston (facing page, left; cat. no. 105). The flared hemline, with its seductive backward dip and new length, gave the dress a new name — "Tango." *Vogue* noted that "the bodice (and there is no greater master than James at building bodices)," lined with yellow taffeta, has a deep inset of black taffeta high under the bustline; the decolletage becomes a matter of points of lace, like large handkerchiefs, standing away from the bosom.

In 1949, Jennifer Jones appeared at the Venice Film Festival in the "Bustle" ball gown designed for her by James (facing page, right; cat. no. 91). One of the most frequently executed James designs, it was made in full length, mid-calf, and with dipping hemline. The structured skirt is composed of multilayered nylon and/or silk tulle, with a hemline circumference of six yards. Chiffon veils a satin bodice and dips in front, as a draped apron. The garment's real publicity came in 1954–55, when it became the center of litigation in the Samuel Winston lawsuit.

U.S. VOGUE/PHOTO: HORST P. HORST/1951

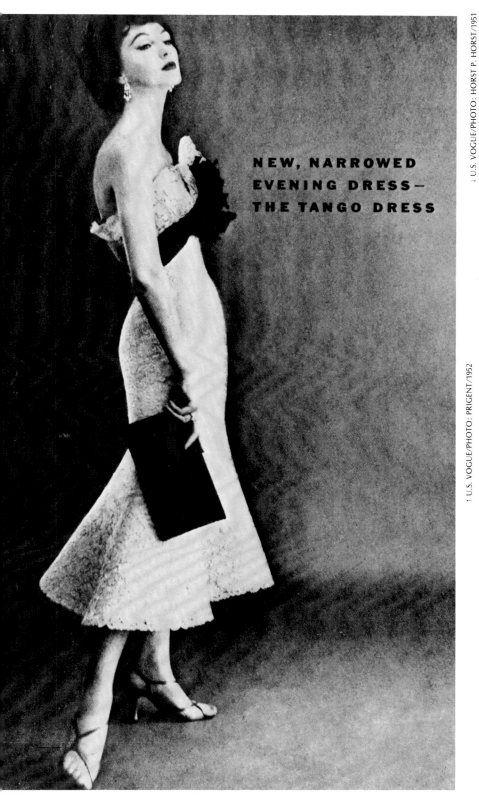

↑ U.S. VOGUE/PHOTO: PRIGENT/1952

**NEW, NARROWED
EVENING DRESS—
THE TANGO DRESS**

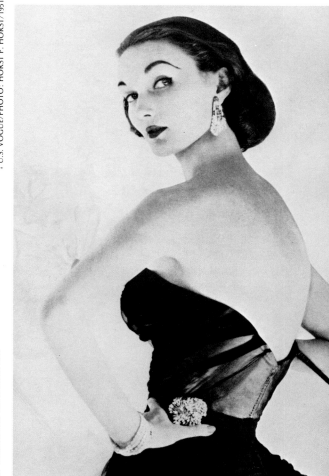

↑ U.S. VOGUE/PHOTO: HORST P. HORST/1951

TOWN & COUNTRY/PHOTO: DESMOND RUSSELL/1953

The collection James designed for Samuel Winston in 1953 featured an "Empire"-waisted day dress the designer dubbed "Egyptian." Here, Mrs. Augustin Jay Powers, Jr., models the dissected cut sheath in Rodier wool tweed, with a dramatically winged neckline and inset "Empire" belt of velvet (left; cat. no. 187). This slender and very geometric garment conforms to the styles James developed from his association with his future wife, Nancy Lee Gregory, and bears out his claim that she was one of the major designing influences of his career. The quartering and separation of the torso reflect the mathematical precision that James would apply to his creations over the remainder of his career.

Perhaps James's final phase began, as had his career, with millinery. His next-to-last fashion journal cover is of "one of spring's most exciting hats," of grey felt sectioned with beige satin binding (right; cat. no. 553). This helmet-like head-covering reflects a purification of line from his own earlier pieces; and both this hat and the "Empire" dress herald in their linear cut the styles more frequently associated with André Courrèges, the French couturier whose designs were the hallmark of the 1960s. Courrèges was hailed as "The Designer of the Space Age"; clearly, James's designs foreshadow the Space Age.

U.S. VOGUE/PHOTO: PRIGENT/1952 →

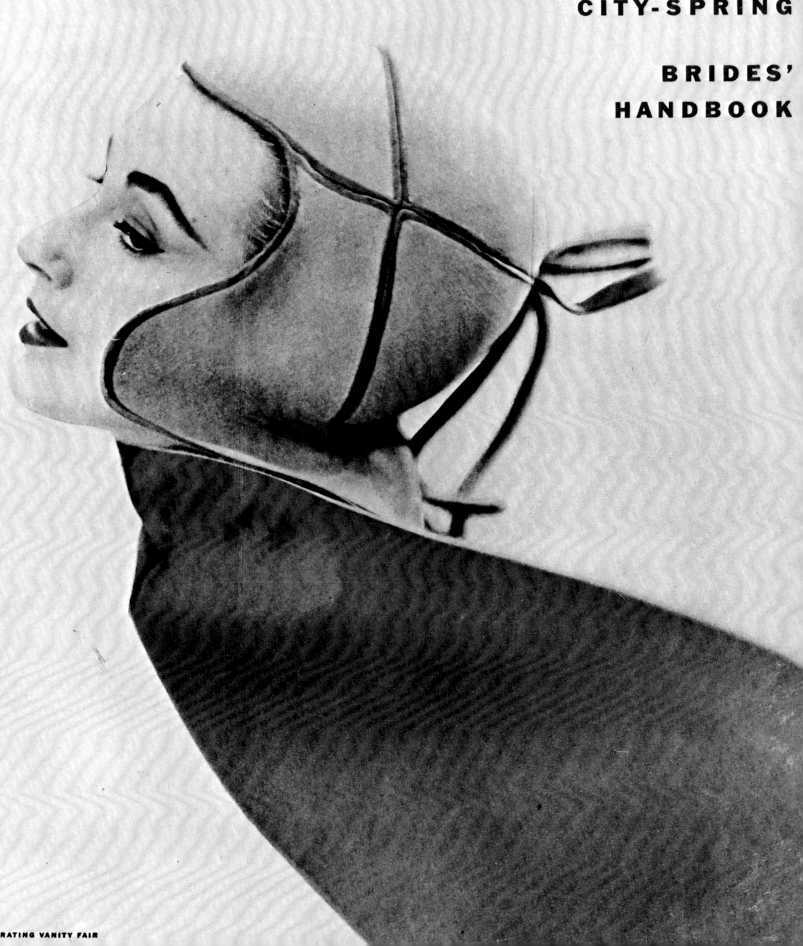

VOGUE

KEY DRESSES FOR
CITY-SPRING

BRIDES'
HANDBOOK

ORATING VANITY FAIR

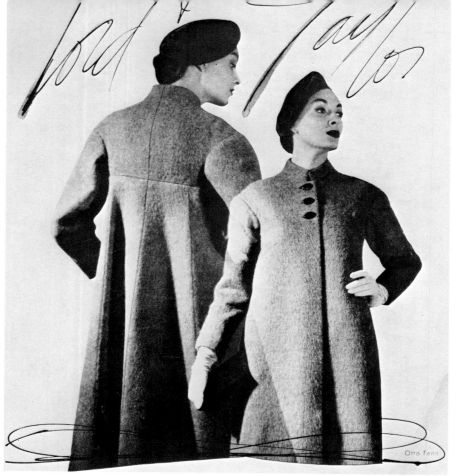

↑ U.S. VOGUE/PHOTO: GENE FENN/1954 ↓ U.S. VOGUE/PHOTO: ERWIN BLUMENFELD/1953

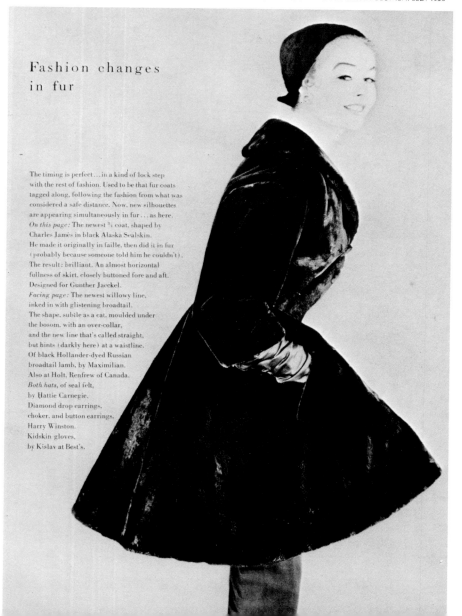

Fashion changes in fur

The timing is perfect...in a kind of lock step
with the rest of fashion. Used to be that fur coats
tagged along, following the fashion from what was
considered a safe distance. Now, new silhouettes
are appearing simultaneously in fur...as here.
On this page: The newest ¾ coat, shaped by
Charles James in black Alaska Sealskin.
He made it originally in faille, then did it in fur
(probably because someone told him he couldn't).
The result: brilliant. An almost horizontal
fullness of skirt, closely buttoned fore and aft.
Designed for Gunther Jaeckel.
Facing page: The newest willowy line,
inked in with glistening broadtail.
The shape, subtile as a cat, moulded under
the bosom, with an over-collar,
and the new line that's called straight,
but hints (darkly here) at a waistline.
Of black Hollander-dyed Russian
broadtail lamb, by Maximilian.
Also at Holt, Renfrew of Canada.
Both hats, of seal felt,
by Hattie Carnegie.
Diamond drop earrings,
choker, and button earrings,
Harry Winston.
Kidskin gloves,
by Kislav at Best's.

Perhaps to private clients, the ultimate was a James design for evening wear, but his greatest contribution to the market certainly was to be found in the coats he presented at the time of his association with William S. Popper. James's accomplished lines practically guaranteed a look of femininity — the lines above the shoulder blade in back and above the breastbone in front. James felt that these lines remained a constant measurement throughout a woman's life and always remained beautiful. The coat at top left (cat. no. 423), with its sharp lines, was advertised as James's "shape-of-the-future coat." Like most of his designs for Popper, the coat was sold through Lord & Taylor, whose windows of James coats still provoke special memories in those who once gazed at them in awe and admiration.

The "Gothic" coat (facing page; cat. no. 421), pyramid or cone shaped, with narrow shoulders accentuated by a satin band, takes the vertical lines of the previous coat (cat. no. 423) and cuts them off with arcs. Internal stiffening projects the marquetry of panels in a sweep to back and side.

The three-quarter-length coat in black Alaska sealskin is fitted through the waist and has wide, barrel-shaped, two-thirds-length sleeves, detailed with notched-out cuff (bottom left; cat. no. 415). Another of the garments made for his wife-to-be, this coat was executed by the established furrier Gunther Jaeckel, whom James once threatened with an open jar of moths.

Two editions of a Chesterfield coat are seen on the following pages. Presented initially in 1952 as part of Popper's collection, the early version of the coat is single breasted, with three waistline buttons in descending scale (page 63; cat. no. 409). To balance the cascading back fullness, James placed deep diagonal hipline pockets, which jut out over a structure of haircloth padding. Mrs. Cornelius Vanderbilt Whitney is seen modeling her coat in cranberry-red Angelo fur fabric.

Two years later, the coat, this time manufactured by Dressmaker Casuals (an ill-fated firm James helped to bring down by too close an association), appeared on the cover of *Vogue* (page 62; cat. no. 418). It was executed in fabrics selected by James for their color and texture; tiger-color herringbone tweed, woven in France by Montagnac, with trim of black silk velvet.

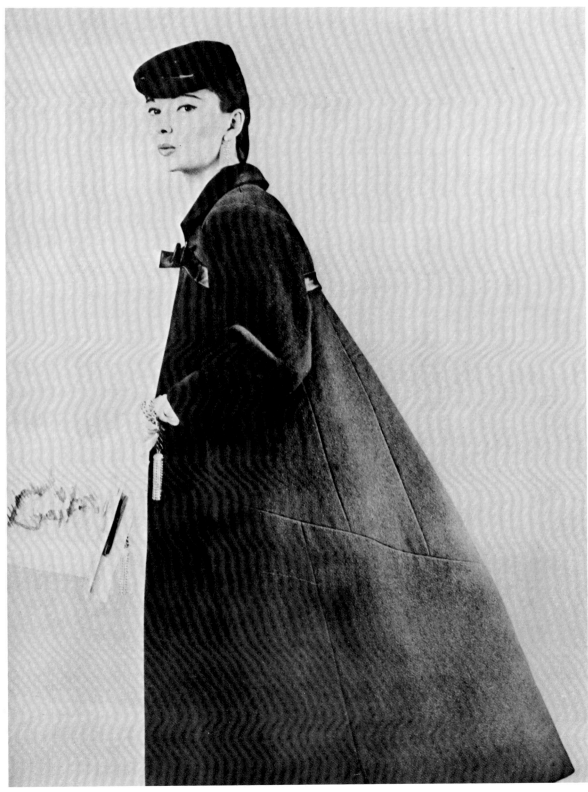

U.S. HARPER'S BAZAAR/PHOTO: LOUISE DAHL-WOLFE/1954

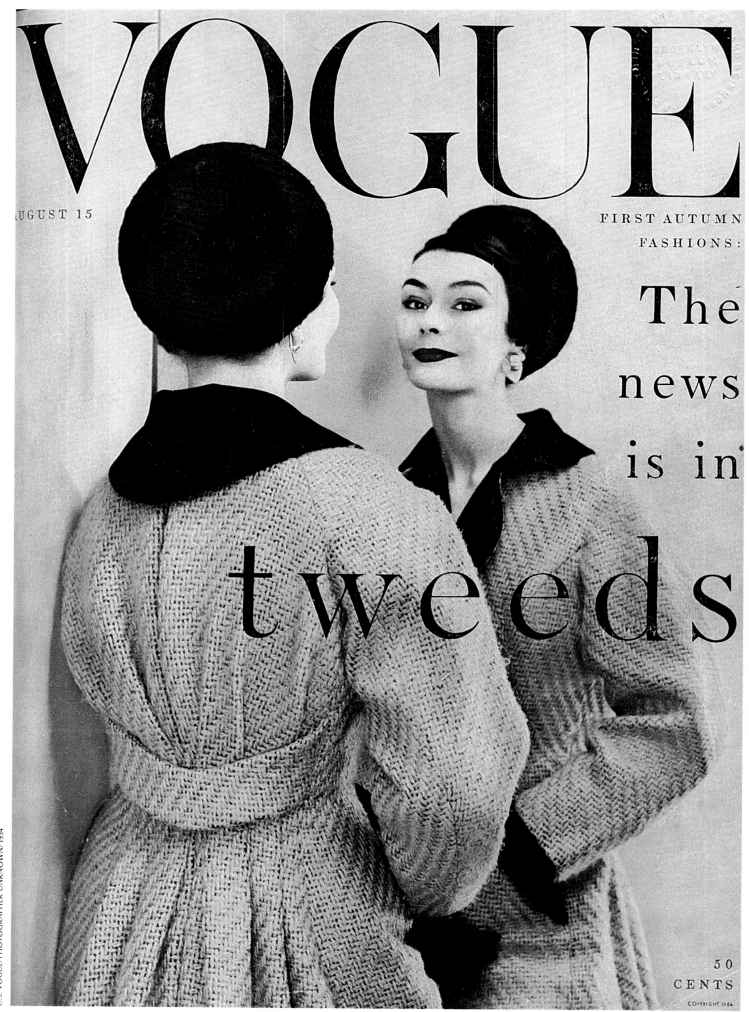

VOGUE

AUGUST 15

FIRST AUTUMN
FASHIONS:

The
news
is in
tweeds

50
CENTS
COPYRIGHT 1954

TOWN & COUNTRY/PHOTO: EMERICK BRONSON/1952

Three long-time friends were associated with John Taras's 1946 ballet *Camille,* presented at the Metropolitan Opera House, New York: Cecil Beaton as costume designer, Alicia Markova and Anton Dolin as leading dancers. James noted that his concept for a tiered cape of tulle was an attempt to aid Beaton in a complicated undertaking (it is not known to what extent his design was reflected in the finished costumes). Later, James made a less-theatrical circular tiered cape in tulle for a private client (cat. no. 404).

The show-stopping gown of James's career, in his own estimation as well as that of the press, is the "Abstract" or "Clover Leaf" ball gown commissioned by Mrs. William Randolph Hearst, Jr., to wear to the Eisenhower Inaugural Ball in 1953 (right; cat. no. 114). Mrs. Hearst proceeded to make the gown a part of the international scene, appearing at Queen Elizabeth II's Coronation Ball in London and a similar function at the Palace of Versailles.

James related: "I had intended it to be the last and final statement and it was composed of several parts previously developed as separate designs." The serpentine hemline formation appears to be the result of James's mulling over the outline of his 1948 clover-leaf shaped beret (cat. no. 548).

While the foundation structure rigidly controls the contours of the gown, it undulates softly, reiterating the pliability of the cloth. In the sense of modern sculpture, this gown

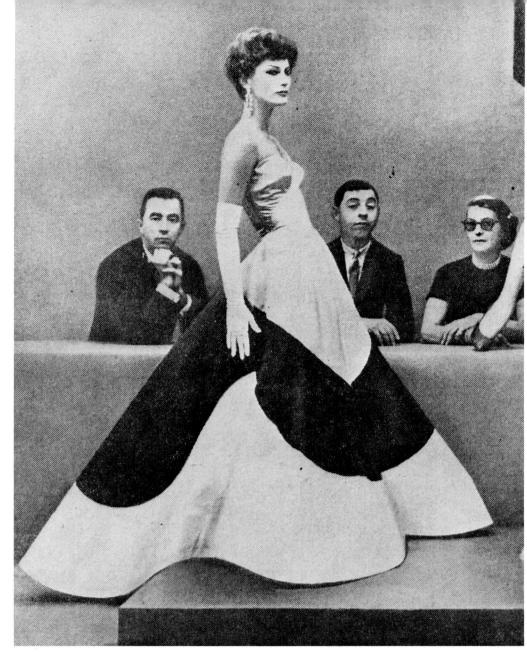

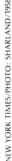

NEW YORK TIMES/PHOTO: SHARLAND/1958

eloquently puts forth all of James's sensitivity to line and color: he has engineered a work of art in fabric. In the press photograph James poses with three other American designers whose foresight kept their creations in fashion far longer than a single season: James Galanos, Pauline Trigère, and Norman Norell (not pictured).

James applied his fascination with curves to his design of furniture. A sofa, reminiscent of Salvador Dali's "Mae West lips" sofa, was designed in 1952, and James included it in the decor of his East 57th Street salon (left; cat. no. 577). The spiral gown before the sofa has side-to-back projecting hemline lobes (cat. no. 121). While a full length and firm structure mark its design as of the 1950s, its cut places it back thirty years, to the time when James first contemplated spirally wrapping the torso.

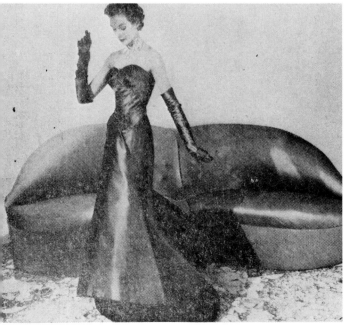

NEW YORK HERALD TRIBUNE/PHOTOGRAPHER UNKNOWN/1954

COLLECTION: THE BROOKLYN MUSEUM/DRAWING: CHARLES JAMES/1946

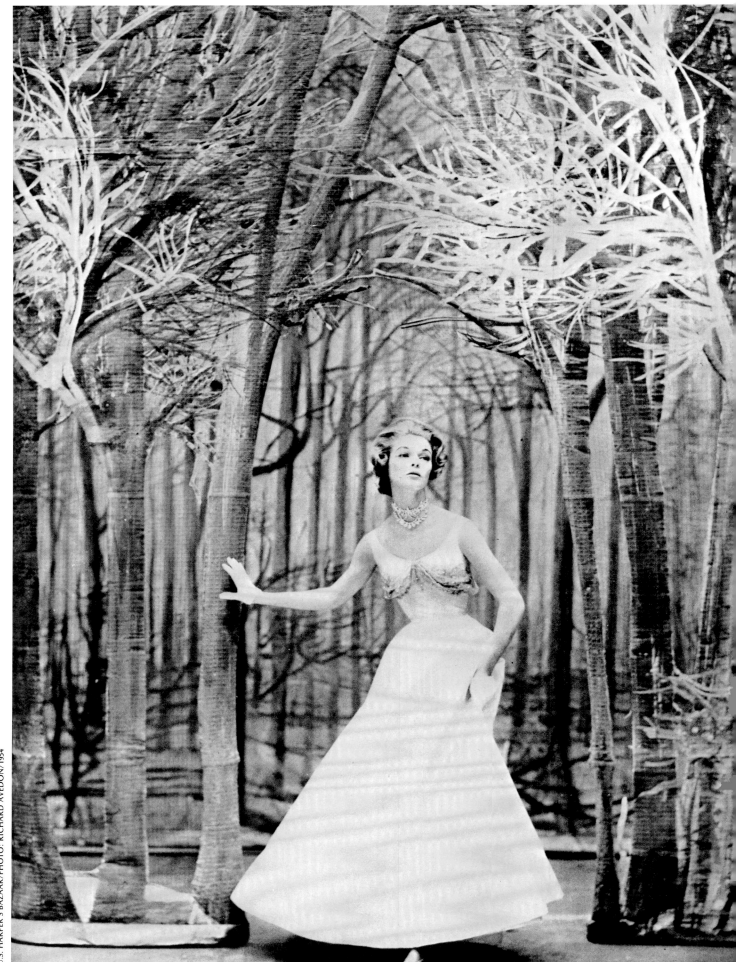

Even though the challenge of readapting and incorporating a cut or line became an obsession with James, he welcomed the possibilities of new synthetic fabrics for his couture clothes.

Chosing a Celanese acetate sharkskin, the white fabric of so many summer sports clothes, he turned out a slipper-length evening gown bedecked with clustered swags of gilt thread, little pearls, and glittering stars (facing page; cat. no. 120). Except when judiciously employing plaids, James seems to make a much stronger

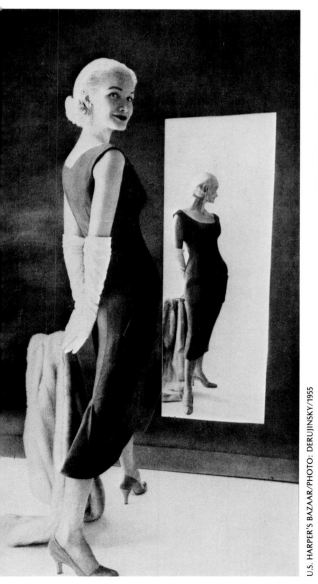

U.S. HARPER'S BAZAAR/PHOTO: DERUJINSKY/1955

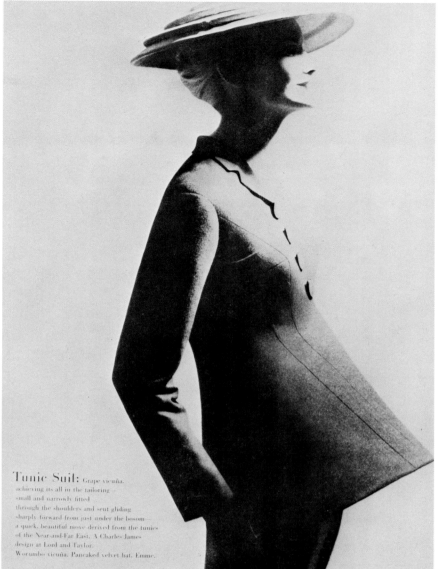

Tunic Suit: Grape vicuña. achieving its all in the tailoring small and narrowly fitted through the shoulders and sent gliding sharply forward from just under the bosom a quick, beautiful move derived from the tunics of the Near-and-Far East. A Charles James design at Lord and Taylor. Worumbo vicuña. Pancaked velvet hat. Emme.

U.S. HARPER'S BAZAAR/PHOTO: LILLIAN BASSMAN/1955

statement when sticking strictly to unpatterned cloths, letting his line and cut speak. The necklace is also a James design (cat. no. 585).

The "Tunic" or "Pagoda" suit represented to James his best attempt at tailoring a suit, and his name for it reflects his sources: Near and Far Eastern tunics (above; cat. no. 336). The near–V-point construction at the jacket hemline evolved from a line of models in which tapering lines were a key ingredient.

At the very moment James was in court pleading the necessity for apparel designers to recognize authorship and establish a strong signature, the compromises attending his attempted tie-ups with mass production were diluting his own special contributions. The princess-line cocktail dress demonstrates one of James's solutions when he chose the allure of money over matter (left; cat. no. 204): the dress exhibits none of the imagination or bravura associated with his thesis gowns; rather, it is merely one of the crowd.

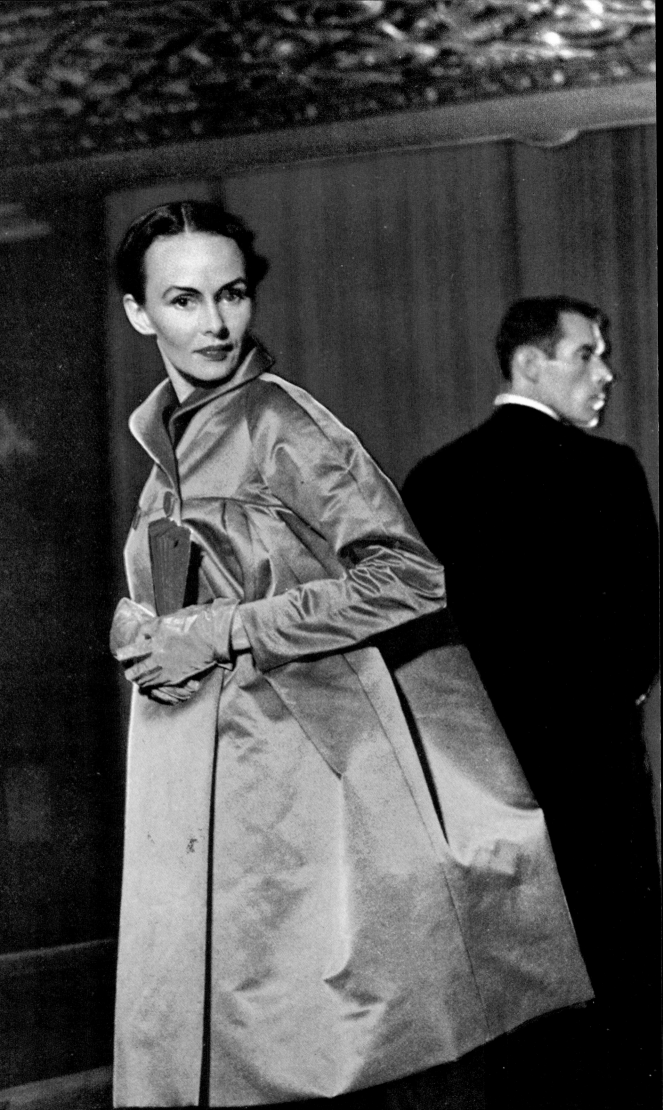

Never afraid of flaunting himself, James embarked on a series of advertisements that featured his garments made up in the advertiser's product. He even enticed Mrs. William Randolph Hearst, Jr., to model a peacock-blue Celanese acetate slipper-satin theater coat (facing page; cat. no. 417). Later, a Du Pont advertisement pictured James's "Butterfly" ball gown, with its draped sheath torso framed by striations of satin and two back-side cascading wings of pools of tulle (below; cat. no. 122). The subtle yet effervescent multi-layering of nylon net or tulle set the wings ashimmer when in motion. For the American Rayon Institute James produced three outfits, including the "Gothic" sheath, in rayon and acetate crepe, which James felt was a design that inspired many adaptations on Seventh Avenue, and the dinner suit of tapestried rayon brocade with a full-length skirt, the pattern for which had been worked out nearly a quarter of a century before, when James had been living in London (right; cat. nos. 210, 351).

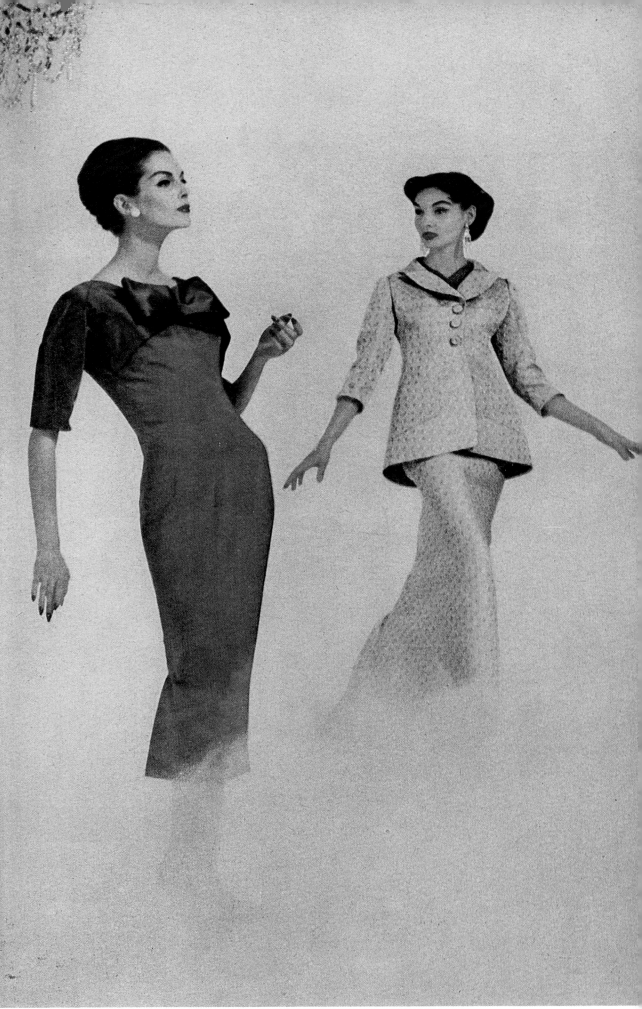

Shortly after the birth of Charles James, Jr., his father undertook the creation of a line of infants' and toddlers' wear (below, left; cat. no. 492). Marketed by Alexis, these special designs lost none of the linear precision associated with their designer.

As has frequently happened in fashion history, garments originally intended for the nursery were scaled up to adult proportions. Such was the case with the infant's opera cape, which had been inspired by a nineteenth-century *manteau de visite,* or short cape worn over full skirts (cat. no. 476). James's notations on his sketch for an adult version indicate he saw the garment as either single or double breasted, with or without collar, and either five-eighths or seven-eighths, but never full length (facing page; cat. no. 458).

Toward the end of his active career James produced a trousered dinner ensemble, with a front fall closure traceable to the slops of sailors. In keeping with prevailing modes, he tapered the legs, but referred to the Navy's bell-bottom trousers with a box-pleated kick at the ankles (below, right; cat. no. 274).

LADIES HOME JOURNAL/PHOTOGRAPHER UNKNOWN/1956

TOWN & COUNTRY/PHOTO: LUIS LEMUS/1956

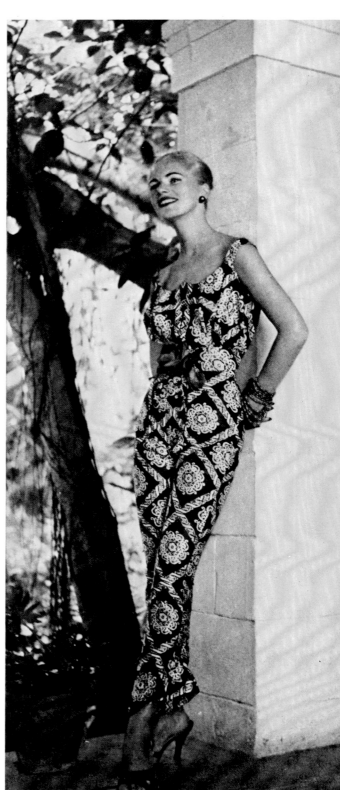

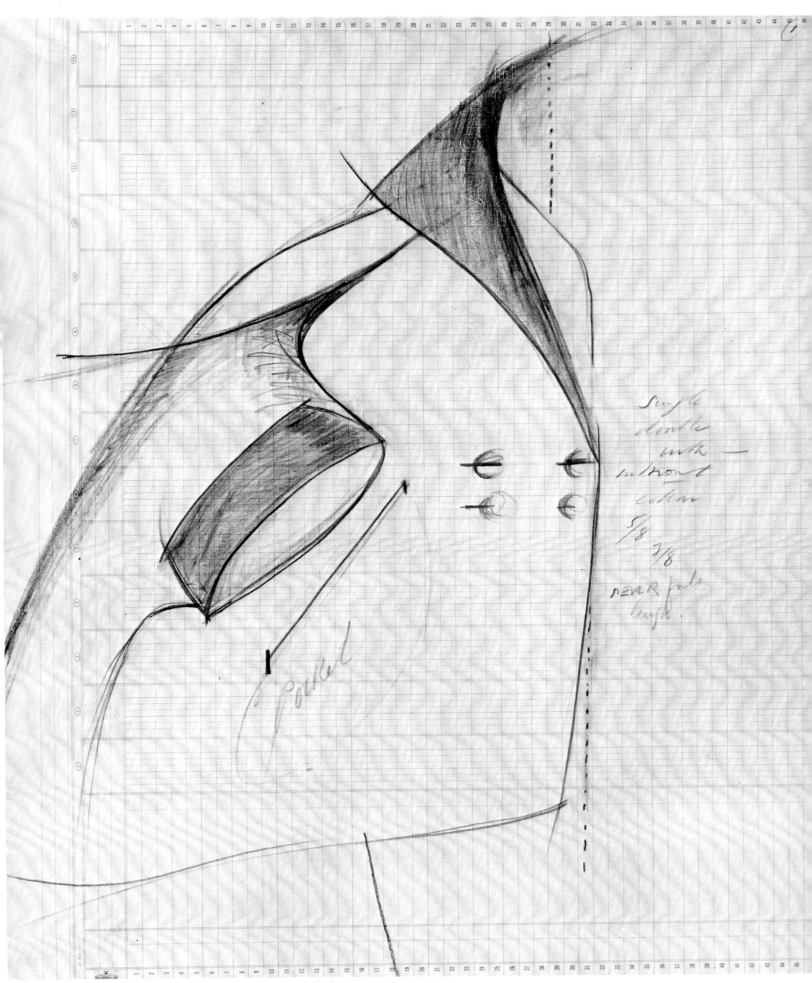

single
double
with —
inbront
cotton
5/8
7/8
NEVR pale
lengh.

Pocket

COLLECTION: THE BROOKLYN MUSEUM/DRAWING: CHARLES JAMES/1956

During the late 1950s, much of James's life revolved around litigation and depression. Standing beside him throughout it all was Mrs. Hearst. In 1955, he created an "Empire"-waisted ball gown with a very bouffant polonaise (facing page; cat. no. 126). An early concept, sketched below, includes a swirl of fabric terminating in an oversize midcalf bow. In the interpretation, the bow was lost, and the finished product for Mrs. Hearst, in midnight blue velvet and worn to the March of Dimes Ball in January of the year of its creation, is the same as the rose-red model pictured, an advertisement of the American Rayon Institute. James called it the "Balloon" dress, and, ever in search

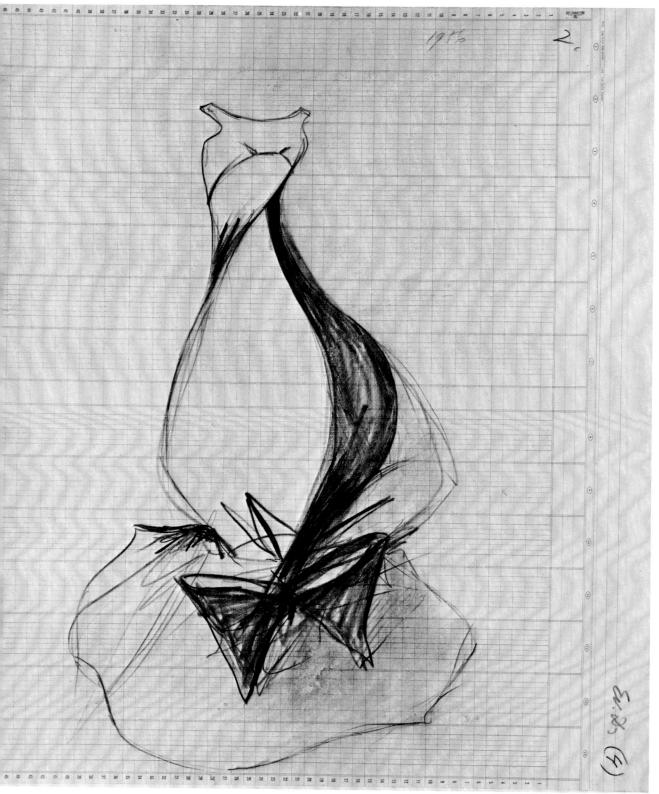

COLLECTION: THE BROOKLYN MUSEUM/DRAWING: CHARLES JAMES/1956

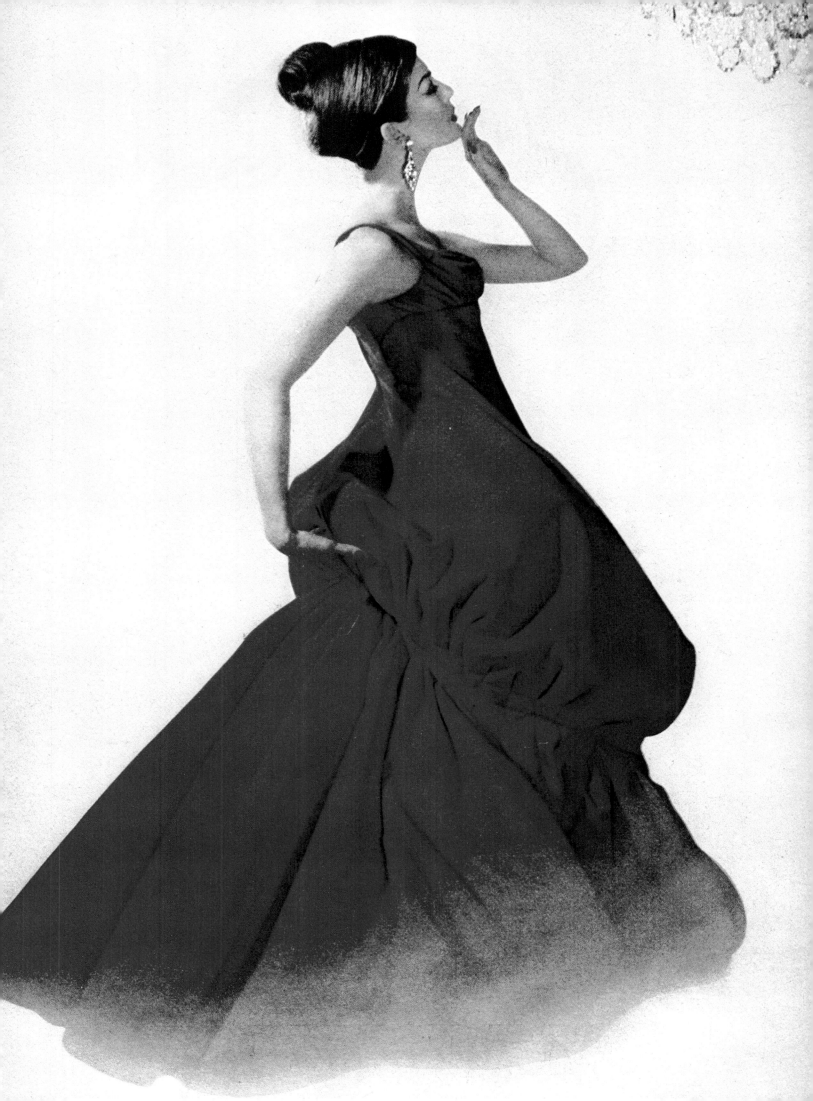

of publicity, he took the rose-red gown and an evening coat of the same design he had worked out in black velvet to Diana Vreeland's office at *Harper's Bazaar* in June, 1956.

The coat opens from neck to floor, with sleeves, cut-in-one with the bodice, arc shaped and with a flared cuff. The pouch-like pouffed polonaise could easily be converted into a maternity outfit, which James produced for a promotion for the Mennen Company. Their 1957 campaign was launched using a scarlet-red, sleeved "Balloon" gown in the magazine press (left) and on the jacket cover for a record album, "Ladies-in-Waiting."

By the end of the 1950s, James found himself out in the cold of the fashion design world. Doors had been closed forever; credit was not to be had; family life was played out hand to mouth. Reworking a garment, heretofore a challenge, now became an obsession. James's anger is graphically conveyed by such terse linear statements as the one for a 1959 coat (facing page; cat. no. 464). Structured almost as if the designer had conceived it being executed in sheet metal, the coat has a most telling feature — a tortoise-shell back.

For several years in the early 1960s, James totally avoided participation in the world of apparel design. Yet he could not retreat forever — it simply was not in his makeup. So for a few understanding and sympathetic clients who could bear with his brilliance, James returned to take up the challenge of defining form in fabric. Much of his work was merely the resuscitation of earlier models. But he broke new ground with designs for bifurcated and upper-torso garments. Whatever problem he posed himself, his solution was modulated on universal rules of beauty, proportion, and all those other indescribable features that make one stop short, pause, and exclaim with awe that something must be the creation of genius.

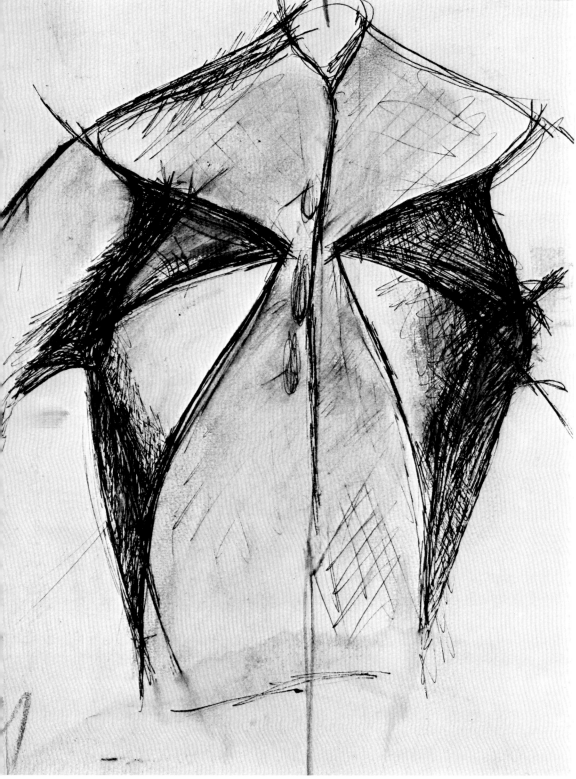

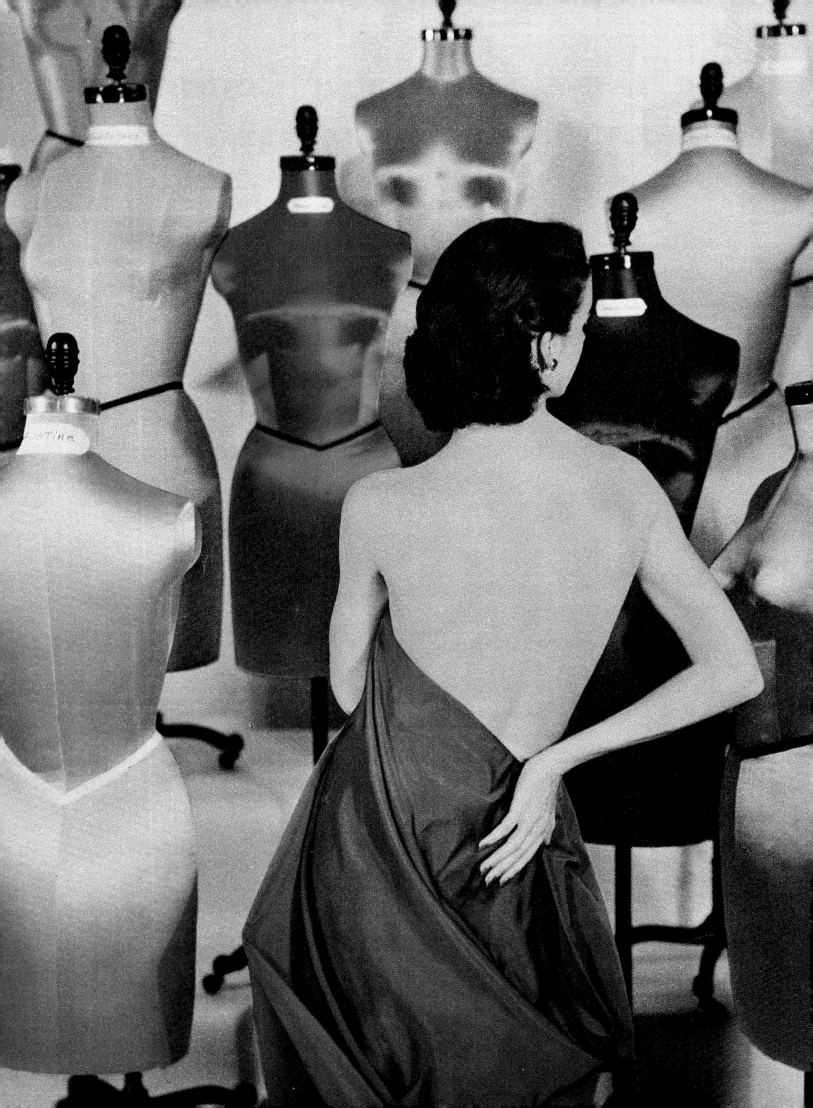

CHARLES JAMES
Elizabeth Ann Coleman

The Background

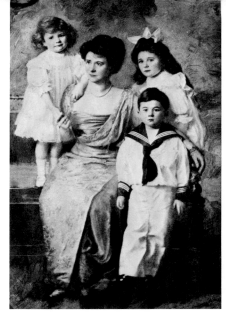

Tinted family photograph with (left to right) younger sister Margaret, Mother Louise, Charles aged about six, and older sister Frances.

COLLECTION: FRANCES JAMES KLIN/CIRCA 1912

Rebellion, raffishness, and rigidity bedevilled the life of Charles James. His existence was a chaos; his motives contradictory. He scorned yet courted the rich, as he scorned yet courted Seventh Avenue. Impeccable in craftsmanship and taste, an elitist who spared no expense or energy in the realization of an ideal, James yet harbored a craving for razzle-dazzle publicity and ever-wider exposure. He seemed convinced, although proven wrong time after time, that he was always on the verge of making a fortune. Spending hours, days, and weeks on a single garment, he still believed that money could be his overnight. James's efforts to achieve success in the exclusive world of haute couture and in mass marketing simultaneously failed completely in a financial sense, yet his ideas about "packaging himself" were years ahead of his time, and later designers would apply them with stratospheric financial returns. Although he lacked the managerial skills to organize his business practices for his ultimate benefit, it was often his own personality that tripped him up: through some self-destructive impulse, or perhaps sheer nastiness, or perhaps again through contempt for those he bargained with, he continually sabotaged sound agreements by his non-performance and misrepresentation.

If a victim of the "system" in the last analysis — degraded and virtually destitute — he was a victim on a very high level, one who exacted his own pound of flesh again and again on the way down. James manipulated people mercilessly for his own ends or to gain what he thought he deserved, believing that he deserved a good deal. But one thing never in dispute was his devotion to his craft and art.

Charles James was a child of both the old and the new worlds, and his family expected him to conform to the demands of two very different civilizations: that of the energetic, boisterous, and nouveau-riche Chicago, his mother's home town, and the more self-contained society of Edwardian England. His father's family came from Cornwall. James grew up on both sides of the Atlantic, and whether residing in the United Kingdom or the United States, he was raised in comfort. Throughout his life, although he repeatedly alienated those who might help him financially, he never lost his taste for luxuries, or his sense that he was entitled to them.

Facing page: In 1950, James unveiled newly proportioned dressmaker dummies, which he called "Jennies" after his client Jennifer Jones. They represented his concept of the American figure, which he analyzed as narrower and longer-waisted than conventional forms.

James was descended on his maternal side from settlers in Baltimore, Maryland, and the Schoharie Valley, New York, who later moved to St. Louis, Missouri, where his grandmother, Fanny Frothingham Enders, and his great-aunt, Margaret (Tanté) E. Enders, were born.[1]

In 1863, a new Canadian emigrant, Charles Wilson Brega, arrived in Chicago, rapidly making a name for himself by becoming a successful and wealthy businessman. He chose a very proper address on South Michigan Avenue — No. 2816 — for erecting a fashionable Romanesque-style residence, and there he brought his bride, Fanny Enders. In 1874, a daughter, Louise Enders Brega, was born.

James's paternal grandfather, Colonel Walter Haweis James, is described as "very small, pugnacious, charming and eccentric." The second son in a Cornish landowning family, he started a military training school in the 1880s, where one of his pupils was Winston Churchill. James's father, Ralph Ernest Haweis James, son of the colonel and his wife, Mabel Caunter, attended Eton and became an instructor at the Royal Military College, Sandhurst. According to the family, a shipboard romance blossomed, as Ralph, accompanying a military unit on its way from China to the coronation of Edward VII, met and courted Miss Brega, who was on a leg of a world cruise. Wedded life began for them in Chicago, following a large and fashionable ceremony in the fall of 1903.[2] By 1904, the couple was living in Surrey, where their son, Charles Wilson Brega James,

1 Both sisters were to contribute greatly to James's financial security, and Tanté Enders was a source of emotional strength to him, as well.
2 The bride, as befitted her social standing, was married in an elegant lace-trimmed gown imported by the trousseau department of Chicago's Marshall Field & Co., from Worth, the great French house of couture.

COLLECTION: JANE SHEARMAN/CIRCA 1914

Photographed in London, Charles is holding an umbrella-shaped form identified by his older sister as his "first invention."

was born at home, Agincourt House, Camberley, Surrey, July 18, 1906.[3]

Provided with a traditional upper-class education, young Charles was sent to New Beacon School, Sevenoaks, England, between 1914 and 1918, and in 1919, for a few months, to the Hopkins School, Lake Placid, New York, when the Jameses returned briefly to the States at the time of the death of his grandmother Fanny. Florence Lowden Miller, a life-long friend of the family, remembers meeting Charles at this time and describes the 13-year-old as an "obnoxious little boy." Then came three influential terms at Harrow. Here James fell into a milieu he understood, and several life-long or passing friendships were established, including those with Cecil Beaton, Evelyn Waugh, and Francis Rose.

Until her death in 1919, his widowed American grandmother had lived with the family in the red brick Dutch seventeenth-century-style house they had taken in Egerton Gardens, London (to which they returned after her burial in America). She contributed substantially to maintain the family's life style, and her estate provided support for James's parents, which was particularly needed when investments made by Charles's father in Chicago went bad.[4]

James was expelled from Harrow as the result of a "sexual escapade."[5] His parents now placed him at the University of Bordeaux in a pre-university curriculum stressing music — his tastes encompassed both Debussy and the jazz he had heard on trips back to Chicago's South Side — in the hopes it would prepare him for Oxford. His continuing rebellious acts in Europe then led them to seek the assistance of a friend in securing enrollment at Yale, but nothing came of it.

Through family intervention, at the age of 18 he was given a job with his father's employer, the utilities magnate Samuel Insull in Chicago, where his parents had moved permanently.[6] Young James was assigned to the architectural design department,

where oil stations were designed. (In later years, he would describe himself as both an architect and an engineer.)[7] Employment there was followed by a very brief stint with the *Chicago Herald Examiner.*

At the age of 19, James left his past completely behind him — including any possibility of a career in music — by establishing himself, in a seemingly audacious manner, as one able to fashion fabrics into wearable forms. Heretofore, he had treated only two-dimensional yard goods, creating surface decoration. Now he took on the challenge of creating the most sculptural of all apparel, millinery. There is no evidence of how and where James first came by his decision or training in this demanding profession. But using the name of a French schooltime friend, the irrepressible young man opened his first shop, Charles Boucheron, at 1209 North State Street, Chicago.[8]

By this time, Charles's antics had so alienated his parents, particularly his father, that his very name was not to be spoken, and his mother and sisters were conspicuous non-patrons at his shop. Nevertheless, his clients were often friends of his mother, as well as members of Chicago society and the theater world, and Florence Miller recalls that his hats were bought not because of their "striking and amazing design," but because friends wished to support Charles. They must also have been awed by having the young milliner fashion hats right on their heads. Eventually, both the hats and James himself proved so outrageous that his name was removed from the "debutante list," relieving him of the duty of escorting budding socialites.[9] Applying a little arm twisting, he was able to raise $2,500 from members of the Pirie family, enabling him to open a tiny millinery shop — his third — in 1928.

Thus, even at this very early stage in his career, when he was barely 22, a pattern had been set. James's working years were to be characterized by a series of brief stops, to which he brought some trap-

3 The family, including daughters Frances and Margaret, spent the better part of the next decade in England.

4 In London there were five servants, and family life could be energetic and unnerving, as Evelyn Waugh recorded in his diaries in late September, 1924 (*The Twenties Diary, 1924–1928*): "On Friday I took tea *en famille* with Charles James and found him restless, his sisters noisy, and his father's butler in pince-nez."

5 He was already showing an artistic bent, for just at that time some of his paintings were on exhibition at the school, a musical composition of his was played at school chapel, and, at his own expense, he had published a book of poetry illustrated with his own woodcuts.

6 The senior James is reputed to have put all of his modest capital into the Insull Company, Commonwealth Edison, which went bankrupt during the Depression. He had been made vice-president of State Line Generating in 1928; the business was later reorganized, and James became president of the Chicago District Power and Light (later, Generating) Company in 1949.

7 The position came after Charles had been employed both unsatisfactorily and temporarily as Mr. Insull's assistant, a glorified office clerk. It is reported that he sat directly outside Mr. Insull's office, so hating work that he did everything he could to be fired. He went about creating then-modish batik panels and scarves (that were modeled by the office girls), and when the dyes became more than a little messy, Insull decided his new assistant would have to be located elsewhere.

8 Meanwhile, his sister Frances, a bit of a rebel herself, danced in London in Frederick Ashton's first ballet (1926), one whose title and subject, *A Tragedy of Fashion, or The Scarlet Scissors,* would have more bearing on James's family's life than could immediately be perceived!

9 Given his self-admitted homosexual leanings and his hunger for publicity, James may well have felt his new situation an advantage, not a disgrace.

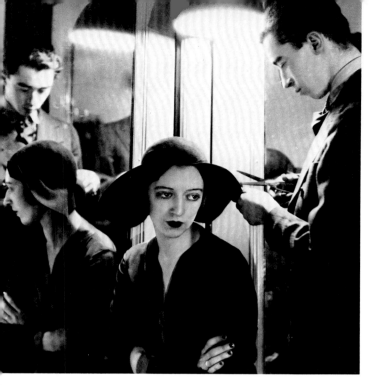

The young James, working as a milliner under the name Boucheron, shapes a felt hat on Marianne Van Rensselaer before Cecil Beaton's camera.

ings of a stable existence and always the tools of his trade. He would make hotels his home, find a source for borrowing money, and then quickly move on, usually hounded by creditors and often having offended those best in a position to help or patronize him.

In 1928, he must have wearied of Chicago, and with a financial advance from another family friend, Fowler McCormick, he left in a second-hand Pierce-Arrow roadster — the rumble seat packed high with hats. After a pause in fashionable Southampton,

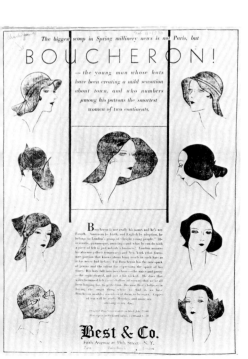

Best & Co., placed a three-quarter-page advertisement in the New York Times on February 16, 1930, for millinery fashioned by "Boucheron," one of the earliest commercial documents associated with James.

Long Island, he arrived in New York City, where he opened a shop over a garage in the Murray Hill district. There he installed two showrooms, one a dark cobalt blue, in which to display light-colored garments, and the other a dead white, for exhibiting dark clothes. He continued to sell hats under the name Boucheron, particularly through Mary Lewis at Best & Co. She took a chance on the young unknown, and remained a strong supporter. By 1933–34, Best's was carrying a number of his designs, and Mary Lewis later sponsored his entry into the United States. In 1928 Charles branched out into designing dresses, catering to private clients. One of the earliest was Gertrude Lawrence.

The stint in New York City was typically brief, and following a Transatlantic crossing in the summer of 1929, James established himself in London and had his first showing. There, according to a contemporary account, he had decided to launch himself as a "sartorial structural architect" to fabric houses and others. The same year, on October 18, his sister Frances was married to the photographer Gordon Anthony Stannus (brother of Ninette de Valois, founder of the Sadler's Wells Ballet); Charles was asked to dress the bride and her attendants (cat. no. 465).[10]

Three years later Margaret followed her sister down the aisle and Charles again created the attendants' garments, while Margaret wore the heirloom rosepoint-lace Worth gown in which her mother had been wed.[11]

The year 1930 found a fashionable Mayfair address — 1 Bruton Street — attached to the name E. Haweis James, as Charles was then styling himself.[12] (Much of London, including the press, knew him as "Charlie" at the time.) But he went bankrupt almost immediately, celebrating his failure in business with a lavish party. The hats he was able to salvage from the London bailiffs were shipped off to Mary Lewis, who had them placed in Best & Co.'s windows, and to Fortnum & Mason, which had opened a shop in New York City in 1931.

Charles traveled between Paris and London during the greater part of the 'thirties. Sometime before 1933 he went to Paris to educate himself in line, fabric, and construction, and by early 1933 he was back in London.[13] At this time, he was evolving his

10 Following the breakup of the brief marriage, Frances opened her own shop in London — called "Frances" — where, to the great annoyance of her brother, she too created millinery.
11 Both sisters were married in London and have spent much of their lives in England; Margaret now lives in Scotland and Frances in Canada.
12 This location was one of the choicest in London for haute couture, and James's neighbors included Norman Hartnell.
13 Virginia Woolf wrote on February 2, 1933, to Vita Sackville-West (The Letters of Virginia Woolf, vol. 5): "And I dined with Mary [Hutchinson] and she told me about Charlie James the man milliner who was dropped by Heaven into her hands This Charlie does in Ryder Street. Her new dress is like that cold dish at Fortnum's all white with black dice or like Christabel's [McClaren] or like anything that's symmetrical, diabolical and geometrically perfect. So geometrical is Charlie James that if a stitch is crooked, Vita, the whole dress is torn to shreds, which Mary bears without wincing."

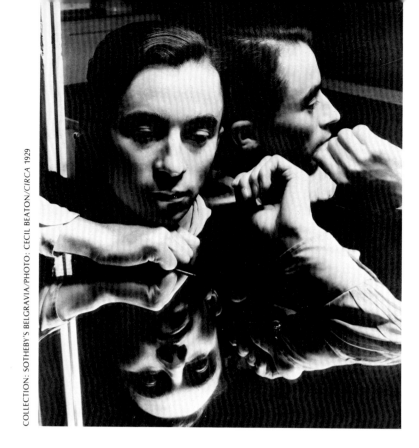

COLLECTION: SOTHEBY'S BELGRAVIA/PHOTO: CECIL BEATON/CIRCA 1929

Cecil Beaton's photograph of his young friend and schoolmate captures the thoughtful image of James reflected in a piano top, London.

Selection from an advertisement for Roberts Frocks, designed by James in 1933–34. Captioned by the designer "Lake Forest Cottons," these modish summer cotton day dresses are not generally associated with James, but a stage in the evolution of the lyre-cut bodice can be observed on the model on the right.

PHILADELPHIA INQUIRER/1934

wrap-around culottes and redesigning his "Taxi" dress of 1929–30 to exploit the new colored plastic fasteners manufactured by Lightning Fasteners (Birmingham) Ltd. (cat. no. 132).[14] The popularity of this sleek, very contemporary dress spread to the United States, where in 1933–34 it was manufactured by Abood Knit Mills and merchandised by Best's, Marshall Field's, and other quality stores. Best's had become his major outlet, selling his dresses, coats, hats, and belts in several price categories.

In 1933, James increased his visibility by selling about 200 models, some for copying, mainly to American buyers, including Taylor Importing Co., Casino Frocks, Roberts Dresses, and Marshall Field. He was in Paris at the time and outraged the Parisian couture industry by his act: how could an upstart Anglo-American milliner-turned-couturier — and a couturier working out of London, at that — be worthy of this coveted title, when he was stooping so low as to sell models for copying *and* to do business with Americans? Decades later, of course, the entire French industry would see the advantages of which James was most certainly already aware: money and increased exposure (even though his name might not be on the label).[15]

By June, 1933, James had secured a second address on Bruton Street. Living in, rather than above, the shop, he had taken first floor rooms in an eighteenth-century house, including the splendid double drawing rooms. Here he installed tufted blue satin wall coverings (see photograph, p. 14) and hung a full-length nude portrait above one of the fireplaces. Here, too, swathed in tulle, he received guests, and

went to his sick bed wearing a fur coat, claiming he was too poor for pajamas. He had by now established himself among the knowing as a milliner with some attractive and daring ideas about dress design.[16]

Sailing in the fall of 1933 for the United States, James stopped first in New York for a November showing of his own town and country collection of cotton summer dresses at Alfred Dunhill and Fortnum & Mason. Following this, the winter doldrums of early January, 1934, were brightened for Chicago's socially prominent with an "invitation only" showing of his designs in the Wedgwood Room of Marshall Field & Co. They came to see their insouciant young friend, whose hats were thought clever but whose dresses were another thing. James wrote of the event, "With a small loan from Mary Slaughter Field and three calls between 8 and 8:30, Mother engineered . . . the biggest success I really ever had." This good lady would assist him again and again. The occasion was tarnished when Charles became

14 With Elsa Schiaparelli, James is credited with first utilizing zippers in both a decorative and functional manner.
15 A column in the *Philadelphia Inquirer*, June 3, 1934, indicates the renown Charles had thus gained with the headline: "Fashions by this spectacular designer available for the first time at budget prices." The article goes on to introduce him as "the designer who sat up all night to finish a beret for the ex-Queen of Spain, who told Irene Castle that her nose was very nice but that she would look better in a simpler hat, and proceeded to design the cloche that took Chicago by storm. Margot Asquith declares that his clothes have the best grammar in England — meaning that they are structurally sound." One of his clients from the Paris sale, Casino Frocks, was still proudly advertising four years later (1937) that some of their models continued to bear Jamesean hallmarks.
16 His new address, which was to solidify his position as a couturier, also widened his social and artistic horizons. To his Thursday afternoon salons came both clients and friends: Cecil Beaton, Harold Nicolson, Lady Ottoline Morrell, Mrs. St. John Hutchinson, the Honorable Mrs. Byran Guinness, who had introduced him to the artist Pavel Tchelitchew, ex-Queen Ena of Spain (née Victoria Eugenia of Battenberg), Alicia Markova, Virginia Woolf, Nancy Cunard, and the Honorable Stephen Tennant.

Drawing to a dressmaker should be a shorthand method
of noting down ideas which are born of an intimate familiarity with the
implements of his trade.

It is better to develop a group
of models from one fresh idea, than
to make one model from
a group of old ones.

(The general public prefers old ones)

Two pages of pencil sketches by James include only one identifiable name — that of Miss Barnes, his London vendeuse — but several snippets of philosophy, notably: "make the grain do the work" and "forget all you know & learn something every day."

embroiled in a feud with a local socialite dress-maker/shopkeeper named Marjorie Letts, after she had alleged in the *Chicago American* that he had not made the models himself.

Later in 1934, James established a salon and work-shop at the exclusive Hotel Lancaster, Paris, where his friend Jean Cocteau also lived. There, he worked on attracting a chic Continental clientele whose passion was elegant couture attire, while at the same time continuing to sell his designs to buyers.[17] Mostly, the international peregrinations of this period seem to be lost in the thicket of his moves; however, a sketchbook of beachwear survives from his visit to Capri in 1935, and by spring of 1937, he was living and working in London's Dorchester Hotel.

James's first Paris showing, held in 1937, included a selection of wraps made from old silk grosgrain millinery ribbons produced by Colcombet of St. Etienne (cat. nos. 368–371). These outer garments took the fancy of the French fashion world,[18] and on viewing them, the aged Paul Poiret, widely thought to be one of the great innovators of dress design in the twentieth century, was inspired to tell James, "I pass you my crown, wear it well."[19] In the next three years James designed fabrics for Colcombet; he also established a competition at the Paris branch of Parsons School of Design for the best adaptation of Cocteau's motifs for printed silks (cat. no. 47).

Running as much from creditors in London as the war in Europe, the self-styled "artist/designer," brown haired and 5'7" (as his passport had it), departed Paris on August 22, 1939, to return, via

A cluttered working environment was established by James early in his career. He was described as one who "designs with a length of fabric and a pair of shears. . . . He literally builds the frock and draws the design after it is finished." In one of this series of photographs, a sculptural human form is propped up in a semi-prone position on the bed.

17 He also continued to live beyond his means. Once, when unable to pay his hotel bill, he placed his Vuitton trunks with the baggage of a departing guest. Taking his Alsatian, Zampa, out for a walk, he coolly collected his belongings outside the hotel and moved on, probably to the equally exclusive Hotel Plaza-Athénée, where he took a suite with a small roof garden on the top floor.
18 They were also bought by Harrods of London and by Lord & Taylor, Bonwit Teller, Milgrim, Jay Thorpe, and Bergdorf Goodman in New York.
19 Poiret's crown of glory was to turn to one of thorns for James as well. The old Frenchman, who had reached the pinnacle of his profession, a position achieved by a select few in any undertaking, was now forgotten and poverty stricken. James's life would end in similar obscurity.

London, to New York in October; his entry into the United States was sponsored by Best's Mary Lewis. In 1940, he formalized his business as Charles James, Inc., with facilities at 63 East 57th Street. He now began to fabricate softly styled sportswear; for the next few years, his designs were executed chiefly for long-standing custom clients. On February 8, 1942, James secured permanent residence in the United States.[20]

About this time, Charles James and Mrs. Thomas Jenkins Lewis, known to the world as Elizabeth Arden, became professionally involved. They had enjoyed a flourishing friendship for more than ten years, having met in 1929 when introduced by a mutual friend, Elisabeth (Bessie) Marberry. Arden found James multi-faceted, and she considered him an ideal escort — amusing, talented, and very social and well connected. She had even worn a James design for her first portrait by Augustus John. For her second marriage, to Prince Michael Evanloff, about 1942, James executed a trousseau, including the dress in which Arden was married at her spa, Maine Chance. Arden's marriage was brief, but her honeymoon with James was just beginning.

In 1943, she selected James as the exclusive designer of custom-made clothes at the Arden Salon, 691 Fifth Avenue. James was given the second floor — the Fashion Floor — and, carried away as he often was, James not only planned the collection, but designed the showroom (see photograph, p. 31) and, using his mother's capital, built fitting, cutting, and sewing rooms (see illustration, p. 6), although this was far more than Arden suggested or paid for. The opening of the Fashion Floor was celebrated with a Red Cross Benefit at the Ritz Carlton Hotel in 1944, where twenty-five James garments were paraded, including softly draped crepe and silk dresses, negligees, and velvet and satin afternoon dresses. Several of the designs originally had been created in the late 'twenties and 'thirties but proved still to be "high fashion" in the 'forties; as James wryly observed, it took *Vogue* over eleven years to pick them up (cat. no. 5).

But press coverage was disappointing and Charles's mother provided the reason in writing about another showing — one in Chicago — for which she had tried to drum up interest: "I have done everything possible . . . and have given many personal family details which would make your grandfather's hair stand on end, as well as your Aunt's [Great Aunt Enders], in order to help you. The difficulty is as follows: Elizabeth Arden's name cannot be mentioned in the social columns because she is 'trade' and anything said about her must appear in the fashion articles."[21]

In the fall of 1944 James's mother died, the one person he had managed never to alienate. While she regarded his antics with horror, acquiesced to his banishment from the family, and indeed recognized as clearly as anyone the extent to which Charles's difficulties were of his own making, her love seems never to have wavered. Her efforts to secure press coverage for the Chicago show had been undertaken from her hospital bed only days before her death. It was James's unfulfilled wish that she "come to New York and share in the first prosperity I have truly had" — the opening of the Arden Fashion Floor.

Charles adored his mother, and her death on October 26 removed the only person capable of effecting a reconciliation between father and son. Charles later wrote: "Since Mother died, Daddy has become very strange, and sits alone in his apartment dressed in Chinese robes. . . . Frances is on the blacklist for once having joined the ballet and always enjoyed herself. Margaret is a farmer. Mother was the heart of our family and when she died it sort of fell apart." The elder James apparently had withheld from Charles the information of his mother's final illness and had deliberately neglected to pass on to his dying wife correspondence from their son.

James and Arden parted ways professionally in 1945 over a series of minor disputes. For one thing, Arden did not like James's drapery selection for the showroom; then, he had chosen an exquisite and costly ruby glass urn to decorate the salon windows, which he lit from behind, causing the Arden Salon to be nicknamed the "red light" house. And finally, there was his charge that she had stolen one of his designs, a skating skirt, without giving him proper credit. Although his association with the Arden Salon lasted only two years, it provided him with the platform for catapulting himself into the "front line" — the cream of fashion society. He and Arden remained friends, and when his son was born, she was named godmother.

With some inherited money and liberal loans from Mrs. William H. Moore, a friend of his mother's, in 1945 James opened his own small custom salon at 699 Madison Avenue. Its memorable features were bold black waxed floors and a large wall window hung with a transparent drapery, separating showroom and workroom, so that clients could glimpse the ins and outs of the execution of their garments (see photographs, pp. 30, 45). In James's "Design Atelier," he employed, at full union wages, Japanese workers recently released from U.S. internment camps. He later claimed that this was the only workroom that was ever profitable. Always energetic (and often over-reaching himself, as he had in designing the Arden fitting rooms), he established a program

20 He remained a British citizen until the day of his death, but settling in the United Kingdom for any length of time would never be possible, due to the financial chaos left in his departing wake.

21 James was not invited by Arden to appear at the Chicago opening, a benefit for St. Luke's. The press covered the socialites, not his clothes.

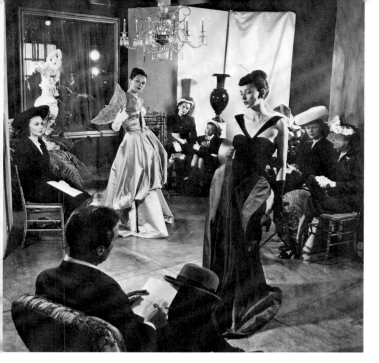

A distinguishing feature of the salon at 699 Madison Avenue was the framed window covered by a transparent curtain, which permitted a view into the workroom. At this 1947 showing, James sits with his back to the camera (but is reflected in the glass). Fashion columnist "Austine" sits to his left. *Below:* James's "Design Atelier" included both Japanese and American apprentices and workers. To impress upon the staff the seriousness of their endeavors, a large workroom sign demanded: "If you have to make a mistake, make a new one."

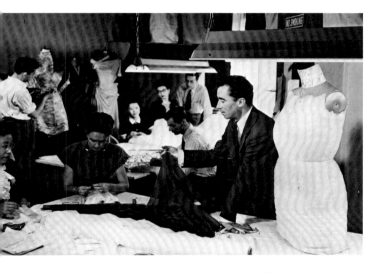

James is shown (below) researching in The Brooklyn Museum with his assistant Kate Peil, who ran the workrooms at 699 and 716 Madison Avenue. She has been described as a dressmaker who was strong and methodical; through her admiration for James she was able to keep the business going long beyond the time it should have folded. In the background hang two early nineteenth-century garments from the Museum's collection and a "ribbon" dressing gown by James (cat. no. 227).

for teaching apprentices, including, in 1947, twelve young men studying under the G.I. Bill.

At this active time in his career — the late 'forties and early 'fifties — James became well known across the nation through his sales of original dresses to better department stores and specialty shops. He undoubtedly realized, however, that the publicity might be fleeting, and one of his long-standing priorities was to establish lasting recognition for what he had done. To this end, desiring that his "inventory of invention" be accorded broad public acknowledgment, he devised systems for donations of his garments to museums. As early as 1944, he had been introduced to the research facilities of The Brooklyn Museum by Michelle Murphy, Design Laboratory Director, and had become enthusiastic about her thesis that "true artists do not turn to museums for ideas to redevelop, but to find out what they have in themselves by comparing it with the past." Perhaps hoping to extend their association, he arranged a third-party donation of two of his designs. Thus, at the early age of 37 he was in the position of seeing his works viewed as art, and for the rest of his life he was obsessed with being preserved as well as being observed.[22]

His schemes for giving reveal a lively — and sometimes devious — imagination at work, for James was not interested only in art. At least one of his proposals was examined by the Internal Revenue Service. James had the client (unidentified, although quite possibly Millicent Rogers), who was in a high tax bracket, pay double the price for the initial dress and donate it. Then, in James's words, "the replacement dress she was given was never paid for, and, as in the case of French haute couture, [it was] paid for by myself as a form of public relations, . . . *not* direct advertising. The IRS tried to upset this, . . . [but] it was agreed that I did have the right to give her a wardrobe [It] did reflect brilliantly on me and made clear the value of HER inspiration, by which finally a large hunk of the dress industry benefitted." Mrs. Rogers, James's premiere American client, was involved in the major museum donation of his work, which James himself engineered. His plan called for her to build up a study collection of his creations for her, to be placed in The Brooklyn Museum, encompassing patterns, muslins, and completed garments, as well as documentation of the structural evolution.[23]

James returned triumphantly to Europe in 1947. Bringing a selection of day and evening creations to London, he was honored with a showing at Hardy Amies's salon and praised by his host and colleague. Following this event, in Paris, he was fêted at a

22 A description of his work as characterized by "pure Olympian beauty" also obsessed him.
23 Its presentation to the Museum in January 1949 was preceded by a lavish exhibition of the promised donation entitled "Decade of Design" — James's first one-man museum show.

"Decade of Design," an exhibition at The Brooklyn Museum, 1948, displayed garments made and/or designed for Millicent Rogers during the preceding ten years. A special bust of Mrs. Rogers (middle right) was sculpted for the occasion by Lillian Greneker.

midnight extravaganza by candlelight at the Hotel Plaza-Athénée, to the accompaniment of harp and champagne. Invitations had been sent out by his old friends Christian Bérard and Comte Étienne de Beaumont, and prominent French couturiers, including Fath, Dior, Carpentier, and Schiaparelli, went to the unprecedented lengths of lending their best mannequins for the showing. The milliner Paulette provided the necessary headgear. Millicent Rogers noted a year later that "the show excited much favorable comment, inasmuch as his work was not derived in any way from other market sources, but represented as much his own conception of fashion as the fashions demanded by his clients." The most favorable comment is attributed to the couturier most closely identified with fashion in 1947, Christian Dior, father of the "New Look." He is credited with saying that James inspired the "New Look," a point reiterated by the columnist "Austine" at the time of the opening of the exhibition "Decade of Design." Buoyed by his reception, and with his usual enthusiasm, James toyed with opening another Paris workroom.

By 1948, James considered himself probably the highest priced dressmaker in the world, and in 1949 he claimed revenue of $125,000. In something over two decades, he had risen from an obscure, tenacious, eccentric, but highly inventive milliner to become one of the outstanding couturiers of his day. Through a process of evolution, he created the designs that elevated him from a position of eminence to one of pre-eminence; the qualities the designs of the next few years would project, and the intelligence from which they derived, were the culmination of all that had come before. As early as 1933, this milliner/dressmaker was quoted: "Cut in dressmaking is like grammar in language. A good design should be like a well-made sentence, and it should only express one idea at a time. The difference in designs is fundamentally a difference of structure." In a lifetime, except for a period of about four years in the early 1960s when he gave up designing garments, he developed approximately two hundred thesis designs, with many permutations, which bore out his observation that "there are not many original shapes or silhouettes — only a million variations."

To James, fashion in clothes was "what is rare, correctly proportioned, and though utterly discreet, libidinous." He further asserted that the birth of any movement in taste occurs among those who have a love of it and do not essentially seek to profit from its exploitation. According to James, fashion was created by a partnership between cultivated women with a love of experimentation and the dressmakers who invented for them — the outgrowth of melding personalities.[24] Resoundingly he proclaimed, "I am not a designer; designers are hired help that only copy what's in the wind. They don't create fashion. Only a couturier does this, with his client as inspiration." Francis Rose, a friend of long standing, succinctly captured the James creative drive: "This great artist, Charley James, who chose silks and furs instead of stone or paint as his media, built sculptures and created paintings around the living flesh."

James worked like an engineer, planning and outlining in precise dimensions, often over wired, padded, structured forms he built himself, the shape his silhouette was to take, always relating the extremes of fantasy to functional design. Although he never boasted any formal design training, his ability and exceptional eye led him to enhance the figure by line and cut. To the artist in Charles James the recognition that "all my seams have meaning — they emphasize something about the body" was more important than following the whims of fashion. He concluded that the major element when contemplating the development of a design was the human form, and solutions involved the necessity of giving this form "variation of physical appeal; in other words, all garments should be cut and constructed so as to make up for and correct deficiencie of the human figure in relation to the projected fashion." (He frequently made the client's "dummy," or dressmaker's form, as he wished her to be rather than as she was.) He bravely and remarkably correctly calculated ten-to-fifteen-year lives for his designs, and many have had greater longevity. To

24 Yet he could also note that in 1953 he had predicted blue jeans would become the only "art form" of apparel.
25 To this end, James had little concern for detail in his sketches, which he himself styled wooden and without movement, especially his early attempts. His emphasis was on seam construction, and he used drawing as a means for expressing the design he could not afford to execute, in a style that was angry, impatient, and suggesting protest. James was always struggling with or for something.

most designers and clients alike, the functioning life span of a fashionable garment is a mere season — a flash, a momentary streak. In 1973 James said, "My work has never been out of date. It is only a matter of time until it becomes a new look again."

As someone who devised and constructed garments, he was guarded about, yet flattered by being called an architect — "they immediately think of steel girders." Yet he was an architect of the structure of fashion and always believed that the sense of proportion given to a design and the relationship between gnomonic measurements and variables were infinitely more important than what is called so lightly "the design." James observed that "unlike many of my generation, I see nothing ugly in any fashion when it is properly developed and given the proportion which is necessary to relate the average woman's figure to a shell (carapace) in which she must be able to move, and move in the manner of a particular period."[26]

James knew and comprehended intellectually perhaps better than any of his colleagues all the fine and refining points that produced a quality couture garment.[27] He believed couture work could be achieved with a master pattern (or "sloper"), the basic module from which many developments, adaptations, and variations could be derived. The teacher in James further explained that "an endless diversity of designs is possible from the combination and permutation of its parts; design is built from listed parts that have been successful in other garments. There should be slopers for every shape, silhouette, or type of garment, and its component sections: sleeve, skirt, bodice, or armhole. A knowledge of how to combine master patterns is essential in the translation of a sketch to a finished garment. The master pattern might be compared to the basic chassis in the automotive industry, from which many cars are bred. A true engineer fuses in his imagination the choice of master block with the knowledge of how the garment is affected by posture, the movement of its wearer, by the grain of the fabric and the ultimate placement of seams, in order to create a new product beyond the area of experiment."[28]

James relished the displacement of a dart to achieve a more perfect bodily fit, noting "the attenuated character of line rather than body is typical of James's concept of fashion; in only rare cases does James conceive of fashion as calling for immaturity of curves of fashionable thinness." His sketches delineate arcs in reverse curves which relate most specifically to the female rather than the

Arcs in reverse curves — a major design element underlying James's work.

male body. He emphasized some aspects of the body at the expense of others, and he also used erotic symbols, features which can be traced throughout his work. He liked to point out his use of drapery to enhance curves and his application of the "Z-cut" at the waistline to give it form.[29]

Consistent with a life-long dedication to perfection — "my designs are not luxuries, they represent fashion research" — in which vocational talent, an inquisitive mind, and skills were involved, James reputedly spent three years and $20,000 just to perfect a straight sleeve (cat. no. 300). The result was a one-inch longer sleeve that permitted the wearer to move without dislocating the waistline, bunching the collar, or splitting a gusset. He went on to make an exhaustive analysis of bodices over fifty and one hundred years of age (many in the collection of The Brooklyn Museum) to determine by comparative measures both what had remained constant and what had changed.

26 While he claimed his designs were built around movement and that he addressed movement more than form, there is contradictory evidence from his clients. Marietta Tree praises the interior "civil engineering" of his ball gowns, which were the most comfortable dresses she ever wore, and Sunny Bradfield comments that you did not realize you were wearing clothes because even a garment that was heavy as lead was balanced, and when worn felt more like a swathing of cloud or gauze. However, Mrs. St. John Hutchinson observed that James was "sometimes so entranced by the shape he was 'sculpting' over one's own shape that when the dress arrived . . . it was impossible to get into it. It existed on its own, and much time was then spent (to one's exasperation) in discerning the proper relationship between [the] shapes."
27 What he failed at times to come to grips with was the practical side — the discipline that couture dressmaking requires to produce an item on time, or to finish it at all.
28 James had a remarkable command of words; his personal letters and the byline articles he wrote — often for the satisfaction of seeing his name in the press — betray the upbringing of a well-read, cultivated person. (Formal speaking, however, apparently did not come easily, and his speeches were usually brief). He loved reiterating his theories about his approach to garment design, and as a teacher, he was inspiring, although often only a few could comprehend the complexities of his thoughts; after all, he was far from a "textbook" example himself. But by studying his written words as well as his linear concepts, the ideas which form his creations become clearer.
 His brilliant and ever-fertile mind continued to experiment with his theories about interchangeable elements. He explained that "all designs break down into component parts, enabling creative genius to assemble those parts in exciting new ways." His explorations led so far as a collaboration with Herbert T. Cobey of Galion, Ohio, vice-president of the Perfection Steel Body Company and Cobey Corporation, manufacturers of farm equipment and hydraulic and road machinery. James and Cobey both recognized the practicality of a more durable substance than paper for the sloper and together came up with the idea of manufacturing the slopers in aluminum. The press praised the venture — "industry is linking hands with the visionary artist" — but, contrary to published reports, the project was not completely realized.
 In an application of the thesis to mass-production apparel, in 1962 James contracted with the discount house E. J. Korvette to design an off-the-rack line to coincide with the opening of their new Fifth Avenue store. James provided five designs — for a coat, a suit, and three dresses — none of which was a finished garment, but consisted of coded parts to be put together in garment machine shops. At least twenty garments could be created from the kaleidoscope of pattern pieces provided by James. The prototype coat, ironically, was conceived in 1956 as a uniform for 100,000 supermarket checkout personnel (cat. no. 214; never manufactured); later, in a remarkable demonstration of James's theories, it surfaced as a high-fashion custom coat for Mrs. Jackson Pollock, for whom James designed a wardrobe (cat. no. 464).
29 Alfred Barr, late Director of the Museum of Modern Art, New York, likened the effects of James's cutting to the best and simplest of fifteenth-century armor.

James himself ranked his creations, and few today would challenge his first choice. This was the black and white thesis or "Abstract" ball gown, also called by James the "Four-Leaf Clover" ball gown, created in 1953 (cat. no. 114). Structured over several layers, its impressive bulk floats from the hips, allowing the wearer to glide across the room. In the course of time, James had become more structurally oriented in his design and execution of garments, even feeling that his "engineering" techniques were worthy of study by engineering students. To provide an impressive illustration of this thesis, a structural analysis of his "Abstract" ball gown has been prepared by an architectural and engineering draftsman (see pp. 88–89). His interpretation delineates the extraordinary and complex construction underlying what on the surface appears to be a slick, undulating sculptural form. The genius of Charles James is evident in all aspects of the creation of the "Abstract" ball gown: his sublime sense of color — cream satin, flat black silk velvet and off-white faille, all products of the finest French textile mills; his ability to structure a garment so that nearly fifteen pounds of flexible sculpture rests lightly on the armature of the human body; his preoccupation with the perfection of line in relation to the lines of the body.

Next on the list is a bow dress. It is unclear whether this is the pretty silk and organdy confection, with design elements of the 1870s and 1880s, made for the Countess of Rosse and Mme. Lopez-Willshaw in the late 1930s (cat. no. 44) or a dress owned by Mrs. Robert Horne Charles, which she described as a "streamered bouffant gown."

Third is the gown he created especially for Mme. Lopez-Willshaw of gilt military braid (cat. no. 96). The complexity of execution comes from successfully uniting stiffened lawn, which gives, and rigid metallic braid, in a parade of alternating fabric fingers. The "Pagoda Suit," marked fourth, was created in 1954 (cat. no. 336). Here, James's mastery of the demanding art of tailoring creates the excellence of cut and proportion. James's several lists of his favorites always included a place for his fifth choice, but he never filled it.[30]

By the late 'forties, James's position in the fashion world was assured, and for several years he continued to flourish. But within the bloom of activities,

the seeds of destruction had already been sown. It was James's idea that anyone claiming to have an influence over fashion could not be a designer alone but must assume the responsibilities of management. So at the height of his popularity, in 1949, attempting to create an apparatus for the more widespread merchandising of his name and his designs (both for couture clients and for mass production), James embarked on a series of business ventures that could have been exciting and profitable, but which turned out to be disastrous. James's failures were due to his lack of management ability, his disdain for financial responsibility, the conflicting drives that pushed him toward quantity manufacture as the only way to make real money, and his personal standards, which did not permit him anything less than "custom" perfection even in areas of mass production, his indulgence in whims of the moment, and, finally, his evident relish in engaging in double-dealing maneuvers. As if all this were not enough, James's unrivaled greatness as a designer was not championed even by his colleagues because of his bad-mouthing of their efforts. The real success Charles James always felt was his due would forever elude him.

From New York, James pointed his finger with envy toward the management behind the French couture industry. Working from a country and city where prominence in fashion was measured by money and mass production rather than taste and experiment, he longed to be among those who on a professional level would understand what he wished to achieve. Acknowledging that a custom salon rarely made money, he refused to sell his creations wholesale and campaigned to sell his original models — designed for his private clientele without consideration for the techniques of quantity production — to leading department stores, in the French manner. It was his hope that they and the garment and textile industries in the United States — and the world — would, through their buying, subsidize American couture on the level achieved in France, so that designers might exist without commercializing their work. Between 1945 and 1947 James sold forty-five original models, at model price, across the country. James believed that it was not the function of the manufacturers to both design and to mass produce items, but that they should, rather, search out, purchase, and adapt models from couturiers. For him, the couturier was the author, the manufacturer the publisher. He wrote, "My name is one of the top ones in this country and the only name known in Europe just because I am NOT a manufacturer."

However, James's initial idea that buyers should be free to develop those of his ideas they thought promising, even though it left him without control over the final product, inspired ambiguous feelings,

30 In 1948, the *New York Journal* observed that James had been acclaimed an "inventor in fashion. His work is particularly noted for its three-dimensional qualities, clarity, and prophetic sense of trends." James's estimation of his most important silhouette shapes — by which he felt the entire clothing industry had benefitted — was communicated to Jessica Daves of *Vogue:* (1) "Gothic" sheath, "which presaged what would take place after the sack" (cat. no. 210); (2) balloon skirts (?cat. no. 375); (3) chrysalis or "Cocoon" coats (cat. nos. 395, 399); (4) "spirally constructed clothes, which assisted in launching zippers" (cat. no. 132); (5) grosgrain evening coats, "which reinstated numerous derelict looms in France" (cat. nos. 368–371); (6) polonaise draped sheaths (cat. no. 1); (7) low-pocketed bluebell-shaped coats (?cat. no. 409); (8) straight-backed Chesterfield coats (?cat. no. 411).

and he became bitter over its implications as time went on. As he said, "An artist has little in this life to count an asset other than the property vested in identification of his name with his work." In view of this, he made a habit of covering his workshop walls with records of changes in standard designs that had been derived from his own. While the changes may have been infinitesimal, they nevertheless created a total change in proportion, and therefore, in his "signature." As he confided, "I fought the proposed Anti-Piracy Bill on the theory that a good deal of piracy helps establish a signature." But he was also quoted as saying, "I am the most copied person in the world. In the old days when they copied me and said so, I was flattered. Today when they copy me, I feel extremely deprived of revenue. My clothes are on different schedules going into eternity."

In 1949, financed primarily with family money plus a contribution from Mrs. William H. Moore, James brought into being Charles James Services, Inc., established with the exclusive rights to promote and control the use of the name "Charles James" in commercial fields of design.[31] This business enterprise — a precursor of today's world-wide "designer label" industry — left James, however, with ownership of his name solely in the area of custom dressmaking. There was no problem in the theory, since Charles James Services *was* Charles James, but as he took the Services and subsequent companies deeper and deeper into debt, defaulted on taxes, negotiated (and renegotiated) loans, failed to deliver on contract, and in the end, with fatal results, merged (and merged again) the finances of CJ Services with company after company, ownership of his name became an unresolvable question. What had begun as a commercial asset of high potential was to become an unredeemable element in the tangled web of James's business complications.

In the first of several reorganization efforts, Charles James Proprietorship, an agency for the custom business, came into being in 1952. This and other new companies were created ostensibly for the purpose of increasing marketing effectiveness in a wide range of apparel and accessories and/or to meet a new challenge as perceived by James, but the real reasons were to raise more money and to ease the liabilities of growing creditor pressure by diverting funds. Perhaps, also, James believed that "turning over a new leaf" would restore financial equilibrium. However, his devious methods of operation put this last goal forever out of reach.

Operating side by side with CJ Services, the Proprietorship, according to James's formulation, paid the expenses of the Services — including rent on three premises, one of which was James's residence — with the intent of invoicing the Services for expenses attributable to that agency. (There is no evidence that this was done.) Meanwhile, working through both CJ Services and CJ Proprietorship, in disregard for their separate functions, James was simultaneously creating designs for his private clients and selling those same designs — and earlier ones — to better department stores (such as Lord & Taylor), with a license for the stores to manufacture and sell the garments under their label, without his name (perhaps so that his custom clients would not be unpleasantly surprised to discover "their" dresses could also be purchased in a department store). Within a year, in an extravagant expenditure of money before the fact, CJ Services began to train production personnel into supervisory/training teams versed in James's manufacturing requirements, for rental to licensed manufacturers of James designs should the occasion demand it. In 1954, CJ Services took new space — two floors at 12 East 57th Street — and expanded its activities to include wholesale manufacturing of garments to be sold through retail stores.

In the same year, a limited partnership, formed to manufacture garments for private clients, was established. This was Charles James Associates, financed by Nancy Lee Gregory, the de Menils, and Josephine Abercrombie Robinson, in exchange for common stock in CJ Services, Inc. CJ Proprietorship was dropped from the books, and finances for CJ Services and CJ Associates were merged, an action that would later work against James in his efforts to settle tax claims and to sell CJ Services at a net operating loss. James's total business receipts from April, 1954, to March, 1955, were $112,693, while expenditures ran to $310,266. Outside the business, money was also disappearing at an alarming rate. In the most expensive of his lawsuits — the Winston affair — although James was awarded a decision of $22,018.48 (receiving $19,018.48, an amount immediately attached by the Federal Government for back taxes), he claimed costs of $300,000.[32]

Even the couture business, which in the popular mind is associated with a great deal of money, was for James more a matter of glamour than profit. In 1949, his custom suits sold for about $800, yet James estimated he spent between $1,000 and $3,000 in experiment and research on each garment. Around this time, he calculated that it would require at least $500,000 a year to support a couture business in the proper style. In 1950, at the time of his "Winnie" award,[33] *Life* characterized the recipient as "a

32 In another lawsuit with even less result, James brought a breach-of-contract action against Bruno Belt Company for non-payment, whereupon that company was dissolved and its parent company declared bankruptcy.
33 The "Winnie" was an award devised by Coty, Inc., the international perfume and cosmetic company, in 1942, to call attention to the originality, scope, and power of American fashion and bring it into equal prominence with European fashion. The bronze statuette (designed by Malvina Hoffman) was preferred in recognition of James's "great mystery of color and artistry of draping." Charles celebrated with a lavish party at the St. Regis Hotel, where he decorated the draped red tablecloths with rambling roses. Bonnie Cashin also was honored with a "Winnie" that year.

31 Later, James's wife-to-be, Nancy Lee Gregory, would also put money into CJ Services.

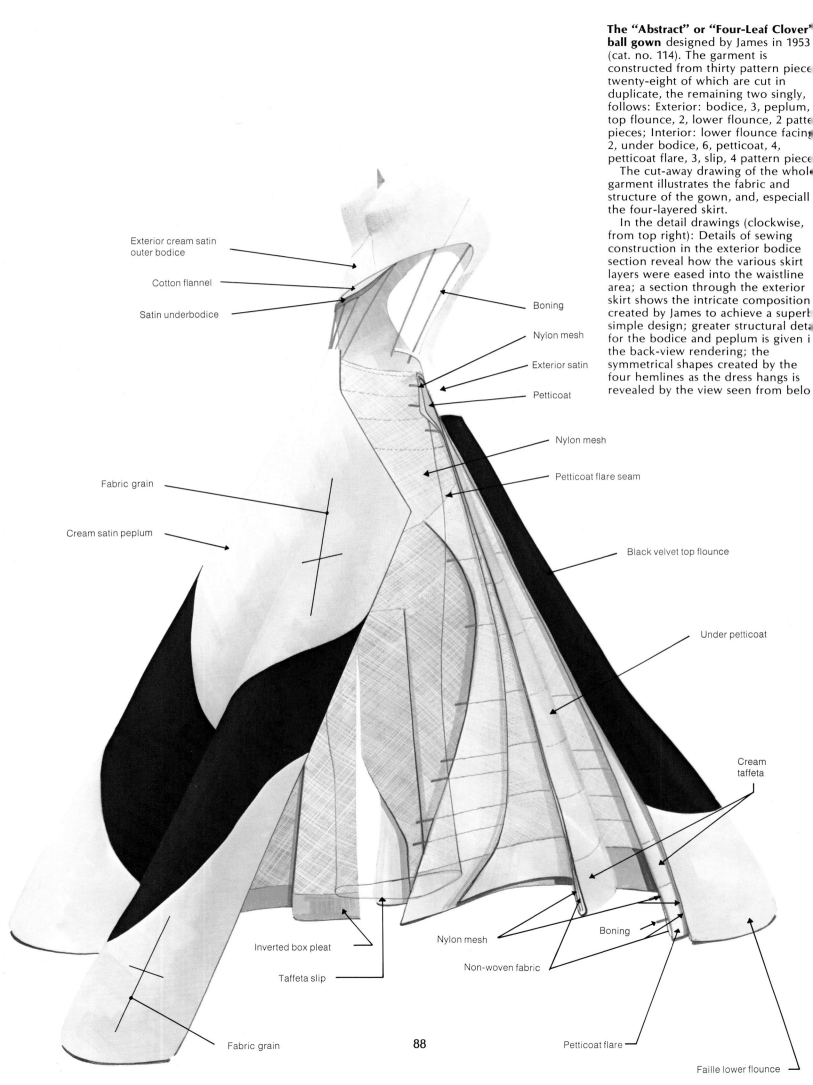

The "Abstract" or "Four-Leaf Clover" ball gown designed by James in 1953 (cat. no. 114). The garment is constructed from thirty pattern piece[s] twenty-eight of which are cut in duplicate, the remaining two singly, [as] follows: Exterior: bodice, 3, peplum, [1,] top flounce, 2, lower flounce, 2 patte[rn] pieces; Interior: lower flounce facing [2,] under bodice, 6, petticoat, 4, petticoat flare, 3, slip, 4 pattern piece[s].

The cut-away drawing of the whol[e] garment illustrates the fabric and structure of the gown, and, especiall[y] the four-layered skirt.

In the detail drawings (clockwise, from top right): Details of sewing construction in the exterior bodice section reveal how the various skirt layers were eased into the waistline area; a section through the exterior skirt shows the intricate composition created by James to achieve a superb[ly] simple design; greater structural deta[il] for the bodice and peplum is given i[n] the back-view rendering; the symmetrical shapes created by the four hemlines as the dress hangs is revealed by the view seen from belo[w].

Exterior cream satin outer bodice

Cotton flannel

Satin underbodice

Boning

Nylon mesh

Exterior satin

Petticoat

Fabric grain

Cream satin peplum

Nylon mesh

Petticoat flare seam

Black velvet top flounce

Under petticoat

Cream taffeta

Inverted box pleat

Nylon mesh

Boning

Taffeta slip

Non-woven fabric

Fabric grain

Petticoat flare

Faille lower flounce

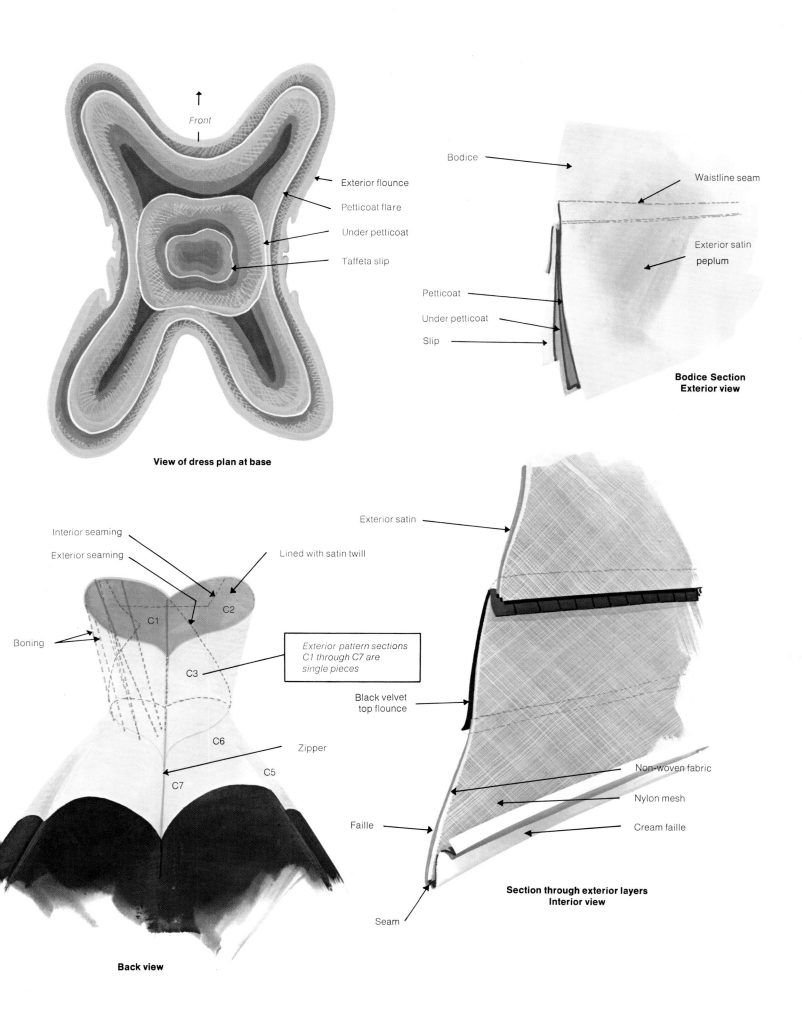

Front

Exterior flounce

Petticoat flare

Under petticoat

Taffeta slip

View of dress plan at base

Bodice

Waistline seam

Exterior satin
peplum

Petticoat

Under petticoat

Slip

**Bodice Section
Exterior view**

Interior seaming

Exterior seaming

Lined with satin twill

C1

C2

*Exterior pattern sections
C1 through C7 are
single pieces*

C3

Boning

C6

Zipper

C5

C7

Back view

Exterior satin

Black velvet
top flounce

Non-woven fabric

Nylon mesh

Faille

Cream faille

Seam

**Section through exterior layers
Interior view**

Drawings by Bill Wilkinson, 1982

designer's designer — so exclusive that he is customarily broke. Even at $700–$1,500 a dress he loses money, since he sells only about one hundred a year to devoted clients. His losses are mostly made up by friends, who consider him a genius, not a business man." James's couture output in 1954 was approximately 36 garments, priced to allow him a profit margin of $500 apiece. And four years later, when he designed just five custom garments, his profit margin was still the same for each.[34]

In 1955, in recognition of his financial quagmire, James met with Arturo Peralta-Ramos, son of Millicent Rogers, on August 2, to discuss "the possibilities of . . . making a study of the Charles James companies. The object of this study would be to devise a system whereby the various phases of the organization could be put on a profitable basis." From the study came a recommendation that "the Charles James 'legend' . . . must be aggressively and methodically turned to profit by means of Charles James Manufacturers and its off-shoots, and Charles James Services in particular." Thus came into being another corporation, Charles James Manufacturers, Co., which took up the role previously played by CJ Services (now almost strangled by its financial/tax liabilities) and was responsible for the manufacture and marketing of James's products. Between 1955 and 1957, loans totalling some $180,000 were made to keep CJ Services afloat and to fund CJ Manufacturers.[35]

In July of 1957, U.S. Treasury Department agents seized the offices and contents at 12 East 57th Street for non-payment of withholding taxes ($75,000 against CJ Services, $5,000 against the custom business). James now proposed yet another reorganization of CJ Services, Inc., including its ultimate absorption into the "Charles James Foundation for the Development of Creative Fashion Design." "The idea is the outgrowth of years of disaster and learning"; it would not be "a school but a participation in performance," like a theater workshop, with the aims of teaching, publishing a textbook, offering apprenticeships and industrial services, and donating designs to schools and museums. To fund the Foundation, James proposed to sell CJ Services at a net operating loss to a large manufacturer who could use the tax deduction and who would then donate rights to the name "Charles James" to the Foundation for a further deduction. However, he was hamstrung when even professional accountants found it impossible to separate the accounts of CJ Services

from those of CJ Associates. So he sought private funding in the form of scholarship money, but received only small amounts, plus the donation of workroom space from the Ray Vogue School of Design in Chicago. Nevertheless, the Charles James Foundation was chartered as a not-for-profit corporation on March 5, 1958, by the State of Illinois.[36] Without major funding or income-producing activities, however, it was abandoned within the year. CJ Services and CJ Associates were now dormant, never to be active again.

In 1958, New York City marshals seized another James property, the office and contents at 716 Madison Avenue, to satisfy judgments against James obtained by his creditors. At this point, even his long-suffering assistant Kate Peil gave up. Doggedly, James made yet one more effort to establish a business platform for his activities. With the backing of a select group of former clients — Mary Ellen Hecht, Jane Doggett, Muriel Bultman Francis, Marit Guinness Aschan, and Gloria Case — and with Herbert T. Cobey of Galion, Ohio, he founded Non-Plagia, Inc. in the spring of 1959. The arrangement was that, in return for stock, James would create and fit no fewer than seven garments for each of the backers. At the same time the garments were to be owned by the corporation, as part of an original design collection that could be modeled for business promotion. However, the primary backer, Mary Ellen Hecht, withdrew her support after a relatively brief association, and James's final business scheme fell through. It would be several years before he truly admitted defeat, retired to the decidedly non-fancy Chelsea Hotel, and even gave up designing for a period. But with the collapse of Non-Plagia, which is actually no more than a footnote in James's recorded business machinations, James's life as a putative business entrepreneur was at an end.

To unravel his "tangled web" and as a guide to the byzantine, quixotic, and often fragmented nature of James's business life, a chart of his fateful endeavors appears on pages 92–95, along with his other documented business activities and business-related events. The chart signals the first appearance of the Charles James companies; it cannot, however, record their termination, since no James company is known to have ever been formally dissolved. By including as well the known contract activities to which he was a part, his major legal imbroglios, important showings of his work, and the accolades bestowed on him by those both in and out of the fashion industry, the chart indicates the highlights as

34 Frequently, he undertook the fittings wearing black loafers and a robe of white toweling. His gowns left the salon in brown boxes until his messenger protested that their neighbor, Mainbocher, was using elegant boxes of white. Forthwith, James revised his wrapping.

35 When in financial trouble James would turn to his favorite relative, his Great Aunt (Tanté) Margaret Enders. This energetic and worldly-wise woman was persuaded to support the sundry business endeavors with family monies, often indirectly by making arrangements with Charles's assistant Kate Peil, a dressmaker characterized as strong and methodical, knowing as much or more than James about cut and construction.

36 The founding board members were Mr. and Mrs. Charles James, Douglas Flood, Phyllis W. Healy, Fritz Bultman, Jr., Aurora Elroy Thurston, and James's personal publicist, Felice Maier. With Halston (a James student who went on to greater glories) and Ruth Chandler, James had looked for premises in New York, including the Jay Thorpe Building, but had been unable to find any.

well as the low points in the very unorthodox business career of this master couturier. A glance at the numerous addresses maintained by Charles James, both residential and professional, gives a graphic impression of his extravagant lifestyle, even in the face of mounting financial liabilities, and the desperation to which he was reduced — epitomized by his movements in 1958 — when creditors began to tighten the noose.

Through the thicks and thins of business debacles, James the creative artist remained conspicuously alive. In 1949, he spent a month in a sculptor's studio working in clay on forms from which his newly proportioned papier-mâché workroom mannequins would be made. The form was full length, extending below the knees at the back into a prominence not unsimilar to the prow of an icebreaker, with a silhouette described as "Egyptian." By 1951, the forms had been manufactured and marketed by Cavanaugh Form Co.; James christened them "Jennies," after his client Jennifer Jones (see photograph, p. 76). They were hailed because James did not "create a size twelve dress but a shape twelve," in line with his belief that a dress form "does not connect with 'designing' but with the sculpture of design."

During the early 1950s, James was operating in high gear. In 1952 the collections of two major companies were made up of his designs exclusively. Both were presented during a single week in June. Samuel Winston showed street, afternoon, and evening dresses, jackets, skirts, and bodices. The twenty James designs on display at William S. Popper included suits and soft tweed topcoats in three-quarter and street lengths (cat. nos. 409–413). The coats created by James at this time set design standards for a whole generation.

The following year Neiman Marcus, citing his "distinguished service to an industry," recognized James with an award for his "Empire" or unbroken-line dress (cat. no. 187). For day, the bustline had been raised to nine inches from the shoulder, for evening to eight inches, and the waist was indented only from the side, with the back cut straight.[37] At this time James was designing couture wear for Lord & Taylor as well as for Neiman Marcus, and he was also under contract to Samuel Winston.[38]

During the 1950s James experimented with his principle of the "floating line." Maintaining that the waist was not a fixed place and, therefore, that it did not have to be encircled in a single plane, he created two belt collections for the Bruno Belt Company, exercising to the full his flair for precision, panache, and unpredictability. To avoid what he termed the "hoop on a barrel" look, he personally supervised all the patterns. The belts, of molded curves, retained their shape whether they were wrapped around anyone or not (cat. nos. 562–569). James then turned around and applied the same principle to another part of the body. For Albert Weiss, manufacturers of costume jewelry, he created festooned necklaces shaped to the neck, along with other sculpted rhinestone pieces — 20 designs in all (cat. nos. 582–585).[39]

Charles James Services expanded to include wholesale manufacturing in 1954. His first collection, completed the following year, featured the introduction of the "Mellon" look, as James named it. This new silhouette for coats, suits, and dresses was based on a narrow back, high, broad armholes, and a broad, loose-fitting front (cat. no. 417). The cut related realistically to the female figure; James confirmed that the model coats could be worn by women of standard sizes twelve through sixteen, observing that "women don't get fat all over, usually just in front, and this shape allows for variation."[40]

The year 1954 was a tumultuous one. James's association with Samuel Winston exploded when Winston sued James for breach of contract (nonperformance) and James counter-sued on the grounds that Winston had been involved in a conspiracy to deprive him of proper credit for his work. The trial, held in the New York State Supreme Court chambers of Judge Irving L. Levey, dragged on for fourteen months, and, although James was the winner in the end, financially the trial was another disaster for him. In awarding James the decision, Judge Levey reprimanded him for uncalled-for antics as well as for the inordinate number of witnesses whose "contributions, although interesting, at times were of little aid in determining the issues." In

37 Fashion commentator Eugenia Sheppard wrote, "Many of James's changes come from man tailoring, but he turns them into a completely feminine look. The straight backline of his dresses is like men's suit jackets. The width of his armholes and the shape of his sleeves — some of them pressed flat like trousers — are borrowed from his [own] wardrobe."
38 Ominously however, in the second year of the Winston contract the designs were created as much by James's couture personnel as by James himself. Perhaps he was growing bored with the arrangement, as he would with so many others. Many of James's later legal problems came from his continuing history of under-production and non-performance.
39 One of the few other non-apparel-producing contractors of CJ Services was Brierleigh, Ltd. makers of fine furniture; they undertook to market a two-piece sofa of James's design. While James claimed that "the sofa is not 'moderne' or any form of Cubism," its similarity to his friend Salvador Dali's settee of 1936, in the shape of Mae West's lips, cannot be ignored (cat. no. 577). The piece was heralded as unconventional and a reflection of the designer's sensitivity to shape and form. He said, "I wanted to avoid the birds-on-a-perch look of people sitting on a conventional sofa. The curves are the indentations that would occur if you sat on wet cement." The two units are placed so that they turn slightly toward each other, enhancing the illusion that the curves emerge from the air. Characteristically, James supervised all production steps, and production numbers were consequently much smaller than projected.
40 Acknowledging that only the very youthful could be dressed for their figures, James said, "a designer should dress the personality." He felt that the perfect woman had the silhouette of a girl of eighteen but was nearly forty years of age. He also said that "all my designs represented a vicarious love affair with women whose beauty I took a delight in enhancing." Elsewhere, he wrote: "Involvements with women I've always avoided, in order to work for them to my last effort and dollar. My fame has been dearly bought." James was concerned about how his garments appeared in public, and to this end he advised on accessories and even modeled his own creations, leaving his client with a statement about what she could and could not do in the garment. According to Anne, Countess of Rosse, he once, over luncheon at the Ritz, became outraged at a client because one of his garments was not being worn or projected according to his expectation. He could be unmercifully critical, even of those he needed to impress.

Chart of the recorded business life of Charles James

The first appearance of a James company is marked by the use of
bold type; subsequent appearances indicate continuing activity.
No James company is known to have been formally dissolved.
□ Details in italics are from extant labels.

Key to address(es):
[R] Residence
[SA] Salon
[SH] Shop
[ST] Studio
[W] Workshop(s)

CHARLES JAMES COMPANIES	RECORDED BUSINESS ACTIVITY	ADDRESS(ES)

1926 Boucheron, Inc. Company incorporated (with James
as president) after brief period trading as "Charles Boucheron" • Millinery; working with Mme. de Launay, friend
and milliner.

CHICAGO:
[R] 1204 North State Street
[SH] 1209 North State Street
[SH] 101 East Oak Street

1928 Boucheron, Inc. New millinery shop opened with
$2,500 raised from the Pirie family • Working with Mme. de Launay • Departs Chicago by car with money
advanced by family friend, Fowler McCormick • In New York, designing garments and millinery; opens two
showrooms over garage • Continued to sell hats, particularly through Mary Lewis at Best & Co., under trade name
"Boucheron."
□ "Mme de Launay" — handwritten inside felt hat (late 1920s).

CHICAGO:
[R] 1204 North State Street
[R] Hotel Ambassador
[SH] 116 East Oak Street
SOUTHAMPTON, Long Island.
NEW YORK:
[SH] Murray Hill district.

1929 Makes Transatlantic crossing in early summer.

LONDON.

1930 Continuing to design hats as well as
garments • Listed in the London telephone directory as "C. Haweis James."

LONDON:
[R+SA] 1 Bruton Street

1931 Bankruptcy; hats salvaged from
London bailiffs are shipped to New York where they are sold at Best & Co. and the new Fortnum & Mason store.

LONDON.

1932
□ "Boucheron of London" — typed on tape (early 1930s).

LONDON:
[R+W] ?6 South Molton Street

Note In the 1930s James is constantly shuttling between London and Paris. It has not been possible to establish the
date of his first visit to Paris except that it was sometime prior to 1933, nor are there sufficient known records from
which to compile a complete itinerary during this period. However, the following documented movements and events
give an indication of the pattern of James's activities. Almost all his business ventures were initially funded and
maintained by loans from family and friends with whom James negotiated (and renegotiated) repayment in various
forms in order to postpone the day of reckoning.

1933 Designs garments for H. J. Nicolls
& Co., Ltd., London; Viyella of Nottingham (4 models for sale through Harrods) • James's "Taxi" street dress
(designed, London 1929 — now redesigned with zipper) marketed in UK by Cable Co., featured in Lightning Zipp
Fasteners, Ltd., advertisements, and marketed in USA by Abood Knit Mills and merchandised by Best & Co., Marshall
Field & Co., and other quality stores • Best & Co., now selling a wide range of James's designs • Creative
activities broaden to include patented dress clasps, belts, sportswear, and (especially for the American market) linen
accessories • Visits to Paris result in sales of about 200 models, some for copying, mostly to American buyers,
including Taylor Importing Co., Casino Frocks, Marshall Field & Co., and Roberts Dresses • In November, James is
in New York for a showing of his town and country collection (marketed under James's name by Roberts Dresses) at
Alfred Dunhill and Fortnum and Mason.
□ "James/15 Bruton St./London. W" — woven, purple on red (1933).

LONDON:
[R+W] Ryder Street
[R+SA] 15 Bruton Street

NEW YORK.

1934 Invitation-only presentation of cout-
ure collection in the Wedgwood Room of Marshall Field & Co., Chicago, engineered by James's mother and with the
aid of a loan from Mary Slaughter Field • Designs tweed suit for Linker & Herbert, modeled by Vera Maxwell, and
soft woolen skirts for Trollman & Masket Manufacturers.
 Listed in London telephone directory
as "Charles B. H. James" • First known commissions to design stage costumes • Established Paris base
• Continues selling designs to the trade.

CHICAGO.
NEW YORK.
LONDON:
[R+SA] 15 Bruton Street
PARIS:
[R+SA+W] Hotel Lancaster
[R+SA+W] ?Hotel Plaza-Athénée

1935 Listed in London telephone directory as "C. B. H. James." • Visits Capri.
□ "model by/Charles James" — incised gilt metal-covered disc (London, mid-1930s).

LONDON:
[R+SA] 15 Bruton Street

1936 Charles James (London) Ltd.
□ "Charles James/15 Bruton St. W1." — woven, white on black (London, 1936).

LONDON:
[R+SA] 15 Bruton Street

1937 Charles James (London) Ltd. James's first Paris showing includes
outer garments fabricated (in 1936) from a stock of old silk grosgrain 18-inch-wide ribbons used in the millinery trade;
these designs are purchased by Harrods (London), and Lord & Taylor, Bonwit Teller, Sally Milgrim, Jay Thorpe, and
Bergdorf Goodman, Inc. (New York) • James designs fabrics (1937–39) for Colcombet of St. Etienne, producers of
the original stock of millinery ribbons.

LONDON:
[R+W] Dorchester Hotel
PARIS.

1939 James leaves Paris (August 22), via
London, for New York (October) • USA entry sponsored by Mary Lewis of Best & Co.

1940–42 Charles James, Inc. Begins to design and manufacture softly styled sportswear, chiefly creating designs for long-standing custom clients, and often selling these and earlier couture work to manufacturers (Smith Pollack & Robbins, Zuckerman & Kraus) and to major stores.

NEW YORK:
[SA+W] 63 East 57 Street

1943 Selected by Elizabeth Arden to be the exclusive designer (1943–45) of custom-made clothes at the Arden Salon; given the entire second floor where he designed the collection and the showroom and, using his mother's capital, built fitting, cutting, and sewing rooms.

NEW YORK:
[SA+W] 691 Fifth Avenue

1944 Opening of the Arden Salon celebrated with a Red Cross Benefit at the Ritz-Carlton Hotel; includes parade of 25 James creations • James's Arden collection shown in Chicago at a benefit for St. Luke's without press photo-coverage of the garments, and without the designer present.

NEW YORK:
[SA+W] 691 Fifth Avenue
 [R+ST] Hotel Delmonico

1945 Small, second-floor walk-up, custom salon made possible with liberal loans from Mrs. William H. Moore plus a small inheritance received by James • Sells model to Chen Yu for use in advertisement for cosmetics.
☐ *"Ch. James/45" or "Charles James/45" — handwritten on cream, white, or black-and-white ribbon (circa 1944, and later couture garments).*

NEW YORK:
 [R+ST] Hotel Delmonico
[SA+W] 699 Madison Avenue

1946

NEW YORK:
 [R+ST] Hotel Delmonico
[SA+W] 699 Madison Avenue

1947 Departs New York (June 20) on the *Mauritania*, bringing with him a selection of his day and evening creations • Visits London and stays in Paris at the Hotel Lancaster. Fêted in both capitals: London, with a showing at Hardy Amies's salon at 14 Savile Row; Paris, with a showing at a midnight extravaganza at the Hotel Plaza-Athénée • Considers opening a Paris workroom • Thought to have returned to New York onboard the *Veendam* • Designs coat for Philip Mangone.

NEW YORK:
 [R+ST] Hotel Delmonico
[SA+W] 699 Madison Avenue

1948 Supplies 5 evening dresses for inclusion in a series of "Modess" advertisements (Personal Products, 1948–50) • "Decade of Design" exhibition of James's garments held at The Brooklyn Museum (November-December); the clothes exhibited were all from the collection of Millicent Rogers and were donated to the Museum after the exhibition closed (January 1949).
☐ *"Charles James/699 Madison Avenue/New York" — printed gold and black on white paper (1948 and later).*

NEW YORK:
 [R+ST] Hotel Delmonico
[SA+W] 699 Madison Avenue

1949 Charles James Services, Inc., established with the *exclusive* right to control and promote the use of the name "Charles James" in commercial design fields other than James's own custom business; financed primarily with family money plus contributions by Mrs. William H. Moore and, later, James's wife-to-be, Nancy Lee Gregory • James claimed revenue of $125,000 for the year; custom suits currently sold for approximately $800 each • Creates (in clay) forms from which his papier-mâché workroom mannequins are made — later to be manufactured and marketed by Cavanaugh Form Co. (*circa* 1951) • Travels to France and Italy, returning to America in December.

NEW YORK:
 [R+ST] Hotel Delmonico
[SA+W] 699 Madison Avenue

1950 Charles James Services, Inc. Year's income from diverse sources includes: Personal Products (Modess) $7,000; McCalls $3,000; Ohrbach's $20,000; for decorating the de Menil house $3,000 • James calculates $500,000 a year needed to support a couture business • Receives a "Winnie" — a Coty American Fashion Critics Award — for "great mystery of color and artistry of draping."

NEW YORK:
 [R+ST] Hotel Delmonico
[SA+W] 699 Madison Avenue

1951 Charles James Services, Inc. Income includes $2,000 from Cavanaugh Form Co.

NEW YORK:
[SA+W] 699 Madison Avenue

1952 Charles James Proprietorship and
 Charles James Services, Inc., concurrent, with latter renting space at 716 Madison Avenue and Sherry Netherland Hotel; CJ Proprietorship, the agency for the custom business, paying expenses of CJ Services with the intent of invoicing CJ Services for expenses attributable to that company • James simultaneously (i) creating designs for private clients *and* selling these and earlier "original designs" to stores with license to manufacture under the store's label (no evidence that James was identified on the store label) and (ii), making *both* these kinds of sale through CJ Proprietorship *and* CJ Services • CJ Services contracts: Samuel Winston, for 30 designs per annum with a guarantee to James of $15,000 a year (street, afternoon, and evening dresses, jackets, separate skirts and bodices shown at Winston's 530 Seventh Avenue showroom in June, with wholesale prices beginning at $39, but emphasis at $89 level); William S. Popper, for 20 designs (Lord & Taylor purchased 10 of these designs for $2,000 for the store's Spring 1953 collection from Popper's June showing at 521 West 39 Street of James's suits and soft tweed top-coats in three-quarter and street lengths) • Year's income includes: Samuel Winston $15,000; William S. Popper $10,000; Cavanaugh Form Co. $2,000; furniture design $2,000.
☐ *"Samuel Winston/by Charles James — woven, black on white (1952–54).*

NEW YORK:
[SA+W] 699 Madison Avenue
 [R+W] Sherry Netherland Hotel
 [W] 716 Madison Avenue

1953 Charles James Services, Inc.
 Charles James Proprietorship. By this year James has agreed to complete 12 designs each for Lord & Taylor and Neiman Marcus for an average of $1,250 per garment • James's "Empire" or unbroken-line dress leads to a citation for "Distinguished Service to an Industry" from Neiman Marcus • Samuel Winston reports 60% increase in sales after one year of association with James (designs created as much by James's couture personnel as by James) • CJ Services begin training production personnel into supervisory/ training teams, versed in James's manufacturing requirements, to be rented out to licensed manufacturers of James's designs • CJ Services contracts: Bruno Belt Co. (subsidiary of Vogue Belts), resulting in 2 collections employing James's "floating line" principle and made from patterns personally supervised by him, first collection exclusive to Lord & Taylor at $9.95–$18.95 retail, second sold at Saks Fifth Avenue, R. H. Macy's, and other stores; Gunther Jaeckel

NEW YORK:
 [R+W] Sherry Netherland Hotel
 [W] 716 Madison Avenue

The first appearance of a James company is marked by the use of bold type; subsequent appearances indicate continuing activity. No James company is known to have been formally dissolved.

□ Details in italics are from extant labels.

Key to address(es):
[R] Residence
[SA] Salon
[SH] Shop
[ST] Studio
[W] Workshop(s)

CHARLES JAMES COMPANIES	RECORDED BUSINESS ACTIVITY	ADDRESS(ES)

1953 *continued*

for fur coats ● James contracts with, and produces for Lane Bryant, 4 maternity garments to be featured in a color film (1954) promoting the store (Lane Bryant did not contemplate merchandising the garments); Samuel Winston requests license to copy the garments as general clothes (not maternity) but receives no response from James who is busy offering to withdraw 2 of the 4 garments from Lane Bryant if Lord & Taylor will merchandise them; film is completed with the 4 original garments, and later one is merchandised by Lane Bryant ● CJ Services and CJ Proprietorship record equal billing for the year.

1954 Charles James Associates Ltd., formed to manufacture garments for private clients; financed by Nancy Lee Gregory, the de Menils, and Josephine Abercrombie Robinson, who were to receive in exchange common stock in Charles James Services, Inc. CJ Proprietorship dropped from the books and finances for CJ Services and CJ Associates merged — an action later to work against James's efforts to settle tax claims, and to sell CJ Services at a net operating loss ● CJ Services contracts: Brierleigh Ltd., makers of fine furniture, to market James's two-piece sofa; Albert Weiss, manufacturers of costume jewelry, for 20 original designs including James's "floating line" principle in festooned, sculpted rhinestone necklaces, shaped to the neck, bracelets, etc. (Weiss paid James promptly but did not renew the contract); Celanese Corporation, for the concept and design of a two-page advertisement featuring James's coat in their fabric; Custom Craft Manufacturing, for 4 skirt designs in tweed and wool ● CJ Services move into 2 floors of 12 East 57 Street and serve as independent manufacturing wholesale business for garments to be sold through retail outlets ● Second year of Winston contract ends (July) with James having produced only 12 of 30 required designs; Winston sues for breach of contract and recovery of $61,341.52; James brings action against Winston, his wife Mildred, and their chief designer Roxanne Kaminstein, who had been retained by Winston specifically to develop with James a group of dresses at Winston prices and with Winston label (James, who was not identified on the label, was to receive royalties from sales — not a design fee); James sought damages of $500,000 for conspiracy to supplant his name with that of Roxanne on adaptations and reproductions, claiming the action was not technically a piracy suit but a test of whether or not the same laws applied in the fashion market as governed the correct labeling of commercial products sold nationwide in other markets; James earned a decision of $22,018.48, receiving as a settlement $19,018.48 (which amount was immediately attached by the Federal Government for back taxes); James claimed the costs of the action were $300,000. In his decision, the judge noted that Roxanne's "overnight metamorphosis from a recent housewife . . . to publicized dress designer, taxes one's credulity" and expressed his surprise that "in this tremendous field, ranking conservatively among the first five American industries, such unregulated and primitive conditions obtain that unreserved pilfering is tolerated and openly permitted." ● Bruno Belt Co., contract ends when James claims unauthorized line was developed by the parent company, Vogue Belts, and brings breach of contract suit against Bruno Belt Co., for non-payment; Vogue Belts dissolves Bruno and itself goes into bankruptcy ● CJ Services contract with Dressmaker Casuals, Inc. (a company originally suggested by Samuel Winston, and formed by Robert Winter-Berger and Robert Lang) to manufacture and market James casual suits and coats with a James label; workroom for Dressmaker Casuals is set up at 12 East 57 Street, with James overseeing all stages of manufacture from color-dyeing to his precise specifications, to having his personal assistant, Roland Nemec, involved in the operation; first collection of suits and coats also included dresses (although they had not been part of the original plan) and, although delayed, the collection was highly acclaimed; relationship ends when James obtains an injunction against further use of his name until monies owed to him are received ● James receives second Coty American Fashion Critics Award, a special citation for "giving new life to an industry through his sculpturesque ready-to-wear coats designed for Dressmaker Casuals" ● James continues to dress a private clientele, averaging only 3 garments in 4 weeks, each garment priced to produce a profit of $500.

□ "Design By/Charles James/for/Bruno Models" — gilt-stamped on leather (1954).

□ "Dressmaker/Casuals, Inc./with/Charles/James/Imported Fabric" — woven, black and gold on white (1954).

(Address for 1954): NEW YORK: [R+W] Sherry Netherland Hotel [W] 716 Madison Avenue [SA+W] 12 East 57 Street

1955 Charles James Services, Inc., first collection presented (June).

Charles James Manufacturers, Co., established as a result of a study of James's companies by James and Arturo Peralta-Ramos (son of Millicent Rogers); the new company was to take up the role previously that of CJ Services (now almost strangled by its financial/tax liabilities), and to manufacture and market James's products; between 1955 and 1957 loans totalling $180,000 were made to keep CJ Services afloat and to fund CJ Manufacturers ● James's business receipts April 1954–March 1955 total $112,963 against expenditures of $310,266.

□ "an original design/by/Charles James" — woven, pink and black on white (1955, for Charles James Manufacturers).

(Address for 1955): NEW YORK: [R+W] Sherry Netherland Hotel [W] 716 Madison Avenue [SA+W] 12 East 57 Street

1956 Charles James Services, Inc.

Charles James Manufacturers, Co. CJ Services contracts: Design of a uniform for 100,000 supermarket checkout personnel presented by James at the Supermarket Institute Convention in Cleveland (this design is not manufactured, but later evolves into a coat for Mrs. Jackson Pollock, and the prototype coat for the 1962 E. J. Korvette off-the-rack line); Albrecht Furs & Sons, licensee and custom-maker of Borgana coats in Dynel synthetic-fur cloth, for coats styled by James; Alexis Corporation of Atlanta and Gainesville (a subsidiary of Warren Featherbone Co.), five-year agreement to create a line of children's wear (from birth to 18 months), James to produce 75 designs at $50 each from which Alexis would select 50 for James to supply factory patterns. Fabrics are to be chosen by James who is to receive a royalty of three-quarters of one percent of gross sales in return for the exclusive use of James's name by Alexis in their market (labels to state either "Designed by Charles James" or "Shaped by Charles James"). Red-flocked papier-mâché child torso forms created by James for the Alexis launch party at 12 East 57 Street.

(Address for 1956): NEW YORK: [W] 716 Madison Avenue [SA+W] 12 East 57 Street [R+W] Sherry Netherland Hotel [R] 30 Beekman Place [R] 830 Park Avenue [R] 340 East 74 Street

1956 *continued*

By the end of the year 31 department stores and speciality shops were merchandising Alexis Infants' Wear (in 1957 James claims to have provided more than 90 designs and has extended the age range to 3 years) • From this year on CJ Services produces contracts with stage performers for single garments which James often arrived at from adapting designs originally created by him for his couture clientele.

☐ *"handi-panti*/by alexis/*reg." and "designed/by/Charles/James" — two woven labels, blue on white (1956–57).*

1957 Charles James Services, Inc.

Charles James Manufacturers, Co. James's gowns shown at a lavish din-
ner hosted by the Diamond Industry • In July, Treasury Department agents seize the offices and contents at 12 East 57 Street for non-payment of withholding taxes ($75,000 against CJ Services, $5,000 against the custom business) • CJ Services move operations to 716 Madison Avenue • Inaugural presentation of Borgana coats able to be staged at 12 East 57 Street salon in September following a temporary agreement with the IRS.

☐ *"Charles James/Albrecht Furs" — machine-stitched on lining (1957–58).*

NEW YORK:
 [W] 716 Madison Avenue
[SA+W] 12 East 57 Street
 [R+W] Sulgrave Hotel
CHICAGO:
 [R] Ambassador Hotel

1958 Charles James Services, Inc., subject of an attempted reorganization as part of a plan for its eventual absorption into the

Charles James Foundation, Inc., proposed by James and chartered in Illinois as a not-for-profit organization (March) with James, Mrs. Charles James, Douglas Flood, Phyllis W. Healy, Fritz Bultman, Jr., Aurora Elroy Thurston, and Felice Maier as founding board members; James proposes to sell CJ Services at a net operating loss to a large manufacturer who would, in turn, donate the rights to the use of the name "Charles James" to the Foundation for a further tax deduction; inability to separate professionally the accounts of CJ Services from those of CJ Associates prohibits sale • CJ Foundation first aborted project is "Floodlight," a series of fashion shows; James turns to seeking private funding for the Foundation in the form of scholarship money but receives only small sums plus the pledge of space in the Ray Vogue School of Design, Chicago; without major funding CJ Foundation abandoned within the year • CJ Services contract with Albrecht & Sons canceled (March) due to too high styling and insufficient sales (CJ Services's last foray into mass production) • CJ Services and CJ Associates now dormant, never to be active again • Dansant, a manufacturer of teenage, junior, prom, and party dresses (at 1385 Broadway), propose to James an 18-month contract for a prom dress plus 10 adaptations from that design for other dresses, for a fee of $5,000 (to be paid to the CJ Foundation) with the use of the James name; James attempts to involve singer Joni James so that a label could be "The Joni James Prom Dress/created for Joni by Charles James"; finally, label was negotiated to read "Shaped by Charles James"; no known result to this proposed contract • Offices and contents at 716 Madison Avenue seized by New York City marshals to satisfy judgments against James obtained by his creditors • In the fall, James participates in a University of Chicago Service League show, where 60 of his ball gowns designed over a 20-year period are presented, with Mrs. Charles James as one of the models • James contracts through the Foundation to design a single gown for Eileen Farrell for a production of "Medea"; fee set at $300 of a total project budget of $725 (plus an extra allowance if elaborate embroidery was demanded); in one month James has escalated the costs to $1,160 for a finished wardrobe comprising a blood-red dress with gold-lined cape, 2 floor-length veils (one with a beaded edge), and a corset • Company called Ranone makes agreement with James for the purchase, reproduction, and adaptation of 5 coats and suits, to be identified as "from a design by Charles James" (no record of the fulfillment of this project) • Men's Production Guild bestows honorary membership on James • Custom couture garments for the year approximately only 5, each of which takes 3–4 weeks to produce, still with only a $500 profit margin for James.

NEW YORK:
[W] 716 Madison Avenue
CHICAGO:
[R] Ambassador East Hotel
[R] Lake Shore Club
[R] Lake Shore Drive Hotel
NEW YORK:
[R] Sulgrave Hotel
[R] Westbury Hotel
[R] Gotham Hotel
[R] Beekman Towers Hotel
[R] Plaza Hotel
[R] Barbizon-Plaza Hotel
[R] Manhattan Hotel
 *(registered as Chester
 Johnson of 700 North
 Michigan Avenue, Chicago)*
NEW ORLEANS:
[R] Roosevelt Hotel
KANSAS CITY:
[R] Hotel Muehlebach
NEW YORK:
[R] Hotel Alrae
[R] Hotel Gladstone
CHICAGO:
[R] Allerton Hotel
[R] East Oak Hotel

1959 **Non-Plagia, Inc.,** founded by James with backing by former clients Mary Ellen Hecht, Gloria Case, Jane Doggett, Muriel Bultman Francis, Marit Guinness Aschan, and Herbert T. Cobey of the Perfection Steel Body, Corp., for whom, in return for stock in the company, James will create and fit not less than 7 garments each. Together they will form part of an original-design collection owned by the corporation, which will present the models for business promotion; concept falls through when the primary backer, Mary Ellen Hecht withdraws her support • James's 1958 plans (intended for the CJ Foundation) to create 25 original designs for the Chicago International Fair & Exposition, and to participate in the opening celebrations for the St. Lawrence Seaway, do not materialize.

CHICAGO:
[R] Lake Shore Drive Hotel
NEW YORK:
[R] Hotel Gladstone

1960

NEW YORK STATE:
[R] Scarsdale

1961

NEW YORK:
[R] 70 Park Avenue

1962 E. J. Korvette announce that James is
to design an off-the-rack line which will retail at $50 to $200 and be labeled "From a Charles James Design"; Korvette acquire 5 designs (coat, suit, and 3 dresses), none of which are complete garments but coded parts to be put together in the machine shops of 7 budget-conscious factories to create at least 20 garments; prototype coat is an evolution of the supermarket uniform designed in 1956 • James receives industry citation from Woolens and Worsteds of America, Inc.

1964–78 Very few private clients • Designs
speculative line of jewelry which he fails to sell to Corocraft Jewelry (1963) • In 1969, 85 James designs spanning 1929–63 are shown as part of a multimedia presentation at a benefit for — at James's insistence — the engineering rather than the design students at Pratt Institute (held at the Electric Circus, and supported by Halston and Mrs. Henry Kaiser) • Briefly hired by Halston as a technical consultant (1970) • Awarded the first Fine Arts Guggenheim Fellowship ever to be given to a fashion designer (1975); in the same year James is the subject of a one-man exhibition at the Everson Museum of Art, Syracuse, New York.

NEW YORK:
[R+ST] Chelsea Hotel

1980

☐ *"A Charles James Design 1976/Executed by Homer Layne 1980" — handwritten on white tape (posthumous).*

another legal action, James obtained an injunction against a firm called Dressmaker Casuals, Inc., prohibiting them from the further use of his name until they paid him monies owed. Here, too, the outcome was hardly a complete victory, for Dressmaker Casuals, which went out of business, had been formed to manufacture and market casual coats and suits with a James label, and his highly acclaimed sculpturesque ready-to-wear coats for the firm won for James a second Coty award (cat. no. 418).[41] This special citation was bestowed on "a man of intellectual fury, artistic despair, and incisive opinions, who is angry at mediocrity and despairing that American couture will never reach the inventive individuality or document of taste he was convinced he and it merited."[42] Said James, "Artists do not all come out of the same mold, as some businessmen think. And they are not, as convention would have it, capricious, wasteful, vague, and irresponsible." Nevertheless, between 1954 and 1958, James was embroiled in a succession of lawsuits, resulting from his obdurate refusal to honor contracts, his double dealings, his delays in supplying promised designs, and his outbursts of temper, all forming a history of business ineptitude, irascibility, and unreliability that would forever destroy his credit among those in a position to advance him.

On July 8, 1954, a major change in his personal life was marked by a ceremony in St. Bartholomew's Church, Park Avenue, New York.

Charles W. B. James, to the surprise of many, wed. The bride, Nancy Lee Gregory, stirred her husband's creative imagination as well as providing considerable monetary support. According to James, a major revision of his work was initiated by his marriage, his bride having a Cranach-Modigliani-like posture and silhouette, one in which pinched chestline contrasts with the forward thrust of ample pelvis and hips, allowing a perfect plumb line to be dropped from the mid-shoulder point of the back. Earlier garments, worked out for Millicent Rogers and others, stressed waistline and broader chest. In evolving new silhouettes, James worked with bound muslin stuffed with odds and ends — newspapers, fabrics, absorbent cotton — layer by layer building up a sculptural form which he then encompassed with whalebone. The newlyweds resided through 1956 at the exclusive Sherry-Netherland Hotel (where James had lived since 1952), at Fifth Avenue and 59th Street, just a few steps away from salon and workroom. In less than three years there were two offspring, Charles Haweis James and Louise Brega James.[43] The birth of red-headed Louise was not a happy occasion, however, since her mother, already under the care of Dr. Max Jacobson (who would earn a shady reputation as "Dr. Feelgood"), suffered a severe and lengthy postpartum depression, aggravated by the complex litigious situation in which the family found itself. Indeed, Charles himself, by early 1957, was under Dr. Jacobson's care, "to prevent a complete nervous breakdown."

Perhaps inspired by fatherhood, and at the initiation of Ellen Engel of the Christian Dior office in New York, James contracted with the Alexis

41 James himself, however, was more than a little responsible for the collapse of the company, which rented workroom space in his building at 12 East 57th Street. There James oversaw all aspects of manufacture, applying "custom" standards to a mass-production enterprise, thereby guaranteeing that the undertaking would lose money. One of James's major problems was always his inability to resolve the conflict between the limitless perfection of couture work as he saw it and the limitations inherent in quantity manufacture.

Total — often excessive — involvement in any undertaking was part and parcel of James's commitment. In 1950, for the West Coast launching of a line he had designed for Ohrbach's, he directed the decoration of the grand ballroom where the opening was to take place. According to reports, however, the climactic finale of the show was not provided by a garment but by James's last-minute and unauthorized floral arrangement, a mountain of orchids floating in a water-filled grand piano. The beauty and bravado of the moment were soon called to the attention of the senior Mr. Ohrbach when, the next morning, he was presented with a bill not for the rental of the piano but for its purchase.

42 In 1959 James threatened the return of this "Coty" because Pauline Trigère was awarded one for a coat which James claimed was based on his cut.

43 Young Charles was christened at New York's Cathedral of St. John the Divine, with Elizabeth Arden as godmother and Gypsy Rose Lee in attendance.

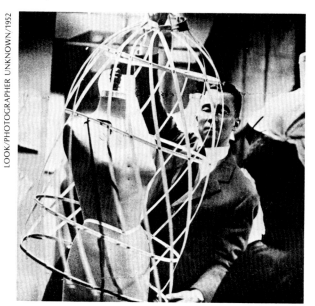

Left: James, suspending a whalebone skirt structure over one of his dressmaker's forms, contemplates his theories on women's shapes.

Right: Nancy and Charles James, with one of their King Charles spaniels, photographed in the fourth-floor showroom at 12 East 57th Street. Also visible are the James sofa (cat. no. 577) and the window hangings he devised of white Pellon. The walls were covered with a flocked lingerie pink, and the floor was of cork. Chairs were covered in yellow satin. The workroom was on another floor.

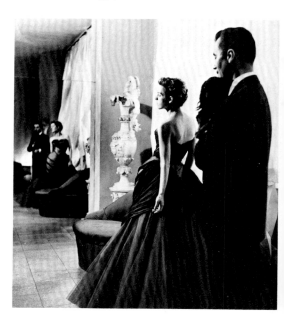

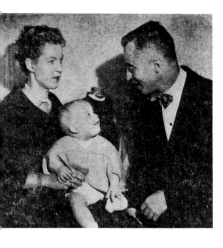

The caption to this 1956 press photograph read: "Mr. and Mrs. Charles James and Charles, Jr., who issued the invitations to see his father's new collection of infants' clothes for Alexis. Charles, Jr., is modeling a miniature opera cape of blue flannel designed by his father."

Quick pencil sketches executed by James on yellow paper around 1956, an attempt by James to document some of his designs and the clients for whom they were made.

COLLECTION: THE BROOKLYN MUSEUM/CIRCA 1956

Corporation of Atlanta and Gainesville to create a line of infants' wear (birth to eighteen months), later extending the age range to three years. James had hoped to introduce the line at Chicago's Carson, Pirie, Scott, as a "homecoming," but instead, invitations on behalf of Charles James, Jr., announced a launch party at 12 East 57th Street in early October, 1956. White capped, aproned "nurses" carried the clothes into the showroom. For the event, the very young host was attired in the line's pale-blue wool flannel miniature opera cape, based on a mid-nineteenth-century *manteau de visite* (cat. no. 476), and his parents attended in matching suit jackets that flared like minarets, his mother's tunic suit in a deep purple, his father's a rough wool tweed. James created special child torso forms for the modeling of the clothes. Princess Grace of Monaco included eighteen garments in her daughter Caroline's layette.

For the Alexis project, James estimated that a design developed from a drawing would take six to eight weeks and that the various stages of production would require an equal amount of time before the stock could be given to salesmen. Grading (sizing of the patterns) was only done after the line was shown and an indication of buying interest on models had been tabulated.[44] Aside from his usual distinctive handling of line, James introduced improved structural features: sleeves set in elliptical armholes to allow greater forward arm movement and contoured shoulder straps. No doubt these practical innovations had been worked out on the resident relative. Commentators hailed the collection's simplicity, but the lack of fluff and frills had to be corrected for the market. James may have devoted as much or more energy and time to this contract than any other, working on it from 1955 until well into 1957, perhaps a reflection of his fondness for children.[45] However, the contract was

for five years, and it seems probable that, in typically Jamesean fashion, he did not complete it.

In early September, 1957, through a temporary agreement with the IRS, which had seized his property at 12 East 57th Street during the summer, James's line of Borgana (Dynel fur cloth) coats for Albrecht & Sons of St. Paul was unveiled on the premises of his former showroom. James renamed the cloth "plush" and declared, "Borgana is synthetic NOTHING, but one of the more beautiful fabric inventions of the last decade . . . warm, crushproof, indefeatable plush." Sales of the coats were, however, disappointing, and the contract was canceled on March 7, 1958.

This setback marked the beginning of an even more drastic deterioration in the fortunes of Charles James. Over the years to come, there would be stabs at rejoining the business world with paper and product proposals, but nothing of real substance would evolve. Longed-for success and security were to be evermore elusive. In the custom field, it seemed fewer women had money, the forebearance to work with a difficult personality, or the assurance to be challenging and provocative by wearing James

44 Confusingly, James now began to renumber his models and to repeat numbers.
45 Reviewing the tortuous movements of the life of Charles James, children, flowers and dogs, seem to have been the chief lasting claimants of his affection.

clothes. Life for Charles James began to go very sour: lawsuits and subpoenas were a daily threat, and monetary resources had by and large dried up. James was a frantic and frenetic man. His marriage was jeopardized. Recognizing the pressure, Dr. Jacobson commented that Charles must be given credit for the tremendous effort he made to keep both his marriage and business intact. James himself wrote, "Our marriage has been successful as marriages go. Happier far than most, . . . Nancy and I have retained what others so often lose, complete faith in each other. I do not know if I did right to marry and ruin Nancy, but the advice to save was in our case not the solution. The necessity of success and achievement came first. . . . You must never forget that Nancy for me is an absolute star, and she has given me life through becoming the mother of my children."

Nancy James had made substantial loans to finance the various businesses her husband had devised, and in all of them she lost large amounts of her principal.[46] It was her money that financed the legal actions involving Bruno Belt, Samuel Winston, and Dressmaker Casuals. When the money ran out, the family did not stop running but ran faster than ever, moving frantically from address to address (mostly hotels), beginning in 1956 and reaching a velocity of desperate proportions in 1958, when Charles even registered under an assumed name. There is no entry for any Jamesean activity in the New York City telephone directories for 1958–59. After his 57th Street location was gone, James moved his business activities briefly to the Sulgrave Hotel in New York but by the end of the year had taken up residence at the Ambassador East in Chicago. Proximity to his father, who had been uncharacteristically sympathetic at the time of the IRS seizure, only revived the habitual acrimony. The elder James wrote of "the appalling mess . . . into which your folly and immeasurable conceit have brought you and your unfortunate family. You are totally unrepentant, show no intention, wish, or inclination to live within your income, and you brazenly assert that your PRESTIGE demands that you live on a scale utterly beyond any reasonable prospect of any income you may earn." Earlier, his father had removed access for Charles to additional funds when he had sold his son's share of the jewelry inherited from his mother — who had intended it for Charles's bride — believing that because of Charles's homosexual tendencies he would never marry. In 1958, Charles asked his father for an amount nearly equal to the value of the jewelry. The request was immediately rejected. With this sum, Charles had intended to move his family into Chicago's luxurious Glass House (an apartment building by Mies van der Rohe),

where he hoped to establish the family's first home, at "home" (Chicago), stating that Chicago had wider horizons and more vision than New York. Friends there would mean position, appreciation, warmth, music, pictures, travel. Living in the Glass House, a dream never realized, Charles had planned to give surface and substance to the walls and ceiling of the studio by decorating them with a client's favorite shade of scarlet-red felt. Another small room he envisioned completely lined with navy Borgana, "together with nylon carpets, pellon curtains, a very old Steinway, and some personal magic." His goal was to have the results of his decorating ideas published, for payment, in the magazine Living.[47]

Staying at the Allerton Hotel, James prepared for participation in the University of Chicago Service League Show at the Shoreland Hotel. With Nancy as one of the models, sixty ball gowns designed over a twenty-year period were paraded. Mrs. Cornelius Vanderbilt Whitney sent her entire wardrobe, along with a maid to care for the garments. But mostly in Chicago, and increasingly in general, James was like a grounded ship, washed ashore and unable to participate in the commerce of his profession. While continuing to live far beyond his means, the few business agreements he became involved with reflected the vain hope that, while the income might not be great, the publicity derived would effect a whole business career reversal. In 1960, he lived for a while in Scarsdale — hardly the center of any segment of the fashion industry; then, in 1961, he returned to Manhattan without his family. They separated, as James explained, "not because we wanted to but because there just isn't any money."

By 1964, he took up final and permanent residence, again in a hotel, this time one with a character to match his own. The historic but crumbling Chelsea Hotel, on run-down West 23rd Street, was the home of such noted artists as Virgil Thomson, but also the scene of sordid drug-related crimes and other unsavory events. James established a cluttered studio there, but gave up designing clothes for several years. He lived in the hotel until his death in 1978.

Over the years, even when he was busiest avoiding creditors and plotting business maneuvers, James had toyed with the idea of writing a book. In 1956 he began discussions with Harper & Row for publication of an autobiography, in hopes of documenting his "habit to bite off more than I have the

46 When New York City marshals seized the workroom at 716 Madison Avenue, the fact was kept secret from her.

47 While busy planning this palatial home, the near-destitute James was embarking on a grandiose scheme for the formation of his own foundation. It was at this time that his financial fantasy and fiscal reality were furthest apart. Although living from hand to mouth, he maintained memberships in two of Chicago's most elite clubs, Casino and Arts.

Charles confided his ambiguous, yet highly emotional feelings about money to his life-long friend, Florence Lowden Miller: "I have never been sure about wealth, in that money never seems to have the same value day by day, and sometimes having a loose five-dollar bill allows one some tremendous intellectual luxury, while at other times having quite a lot of loose cash makes me feel poor because I can't buy something very rare."

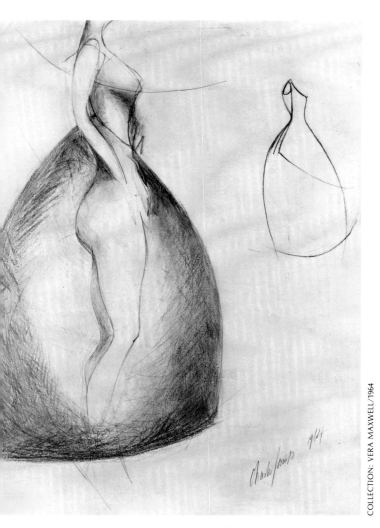

Pencil sketch, illuminating relation of body to garment. Signed: "Charles James/1964."

COLLECTION: VERA MAXWELL/1964

ustification to hope to chew, . . . but have nevertheless chewed, not without success." (He had already written an obituary for his friend Millicent Rogers and would later write one for Christian Dior, whose working habits he had earlier described as "establishing a trademark of design in a brief time by presenting an angelic character while at heart being a fighter who had the skill to remain discreetly out of sight while directing his battles.") The Harper's project did not materialize, but in 1958 his proposal for the same or a similar book, one "not to be purely a fashion history, but a record of experience written by one who chose fashion as a creative medium rather than as an opportunity to stitch up and peddle frocks," was under discussion with Ivan Obolensky. James felt that "before one knows it, one is a monument and [has] had the privilege of being a lighthouse for others," perhaps one of the reasons he felt encouraged to tell his story. There was no tangible result from these talks, however. Nor did his idea for compiling a textbook bear fruit. In 1958 James confided to the literary agent, James Oliver Brown that the CJ Foundation, one of the stated aims of which was to publish a textbook,

"will give me time to work, as I will have to make fewer clothes for the ruinous rich." But he did not find that time. Many years later, in connection with his Guggenheim Fellowship in 1975, James received $15,000 for the compilation of a book on his techniques; this, too, remained unwritten.[48]

James was somewhat more productive on the lecture circuit, but here as well the number of his ideas far outran his ability to realize them. In the summer of 1958, James discussed with the dean of the School of Design, Washington University, the possibility of additional courses relating to fashion design. He entitled his proposal the "INJECTOR COURSE, . . . permitting the faculty to inject certain knowledge, . . . without disturbing the present curriculum." Out of discussions with the dean and a prominent manufacturer came a lecture before a fashion group in St. Louis, "The Creation of Fashion," presented in October. James drew attention to both his past and his future: "I have seen where my grandparents lived in 1873, and coming to St. Louis except for funerals is an experience. My final return will be to Bellefontaine, . . . where I will probably be buried with twenty relatives and fourteen press albums." Charles James knew there was no present — "it is gone before you can pin it down" — but he found it hard to separate himself from the past.

With Thomas Folds, then chairman of the art department, Northwestern University, he discussed a basic course in fashion design at Chicago's Art Institute. After a single presentation, however, he was asked to dissociate himself from the Institute, having run afoul of a staff member. James continued to have in mind a movement in which "American fashion could and should create first-edition influence on world taste," and he was counting on his Foundation to train students for entry into the fashion profession. Among those who sought a Jamesean tutorial were Halston, Ray Diffen, Patricia Zipprodt, Arnold Isaacs (Scaasi), Tarquin Ebker, Tod Draz, and George Halle.[49]

From his retreat in Scarsdale, James initiated plans for seminars relating to the "Calculus of Fashion," a course to deal with the scientific aspects of design and with techniques in which artisans should be trained to enable them to translate the ideas of artists into mass-produced clothes.[50] James saw it as an extension of the work started with Brooklyn's

48 At the time of the Guggenheim award, Robert Motherwell remarked that the James drawings "were more powerful and more to the point than any of the work submitted by so-called artists — that is, painters and sculptors."
49 Halston — R. Halston Frowick — a native of Indiana, who was to play quite a role in the life of Charles James, had also begun a designer's life as a milliner in Chicago, before being asked to create for Bergdorf Goodman in New York. Having collaborated with James on several ideas, notably regarding the CJ Foundation, Halston, fabulously successful and finding his former mentor down and out, hired him in 1970 as a technical consultant to help engineer the mechanics of fashions. Elsa Peretti, the jewelry designer, modeled for a showing in this brief joint venture.
50 The course was to be given at The Brooklyn Museum, Philadelphia College of Art, University of Washington, Pratt Institute, and the Rhode Island School of Design, but James delivered only a few lectures.

late Design Laboratory Director, Michelle Murphy, and proposed a book with the same title.

James continued to lecture throughout his last years. He appeared at Hartford's Wadsworth Atheneum in 1964, and in 1968 embarked on a project entitled "Metamorphology," which he delivered as a lecture in 1974. In December, 1969, with the support of Halston and Mrs. Henry Kaiser, "because he has always been one of my heroes," a splashy benefit was produced at the Electric Circus, in which eighty-five James designs created between 1929 and 1963 were shown as part of a multimedia program, with sketches of the garments by Antonio Lopez. The show, at forty dollars per ticket, was to benefit, at James's special request, not the apparel-design students but the engineering students at Pratt Institute. Many of the pieces were scheduled thereafter to be lent to the Art Students League, with a final repository in the Smithsonian Institution.

In addition to career eclipse, James suffered physical decline in his last years. His erratic working hours, dependence on drugs (many first given to him by his wife's doctor, Max Jacobson), and poor eating habits were exacerbated by diabetes and kidney disease. An interviewer described him as a wizened monkey. He was frail — "his hand is as muscular as a sculptor's." But still he fought on, achieving a one-man show at the Everson Museum of Art, Syracuse, New York, entitled "A Total Life Involvement." When asked why there was no catalogue for the exhibition, the museum's director is said to have responded, "James ate his way through it." Money to support him came in small but continuous amounts from understanding friends, a few scattered lectures, and the sale in 1976 of his 1938 quilted jacket to the Victoria and Albert Museum, London. But the vast public acclaim he had always sought eluded him to the end.

James died of bronchial pneumonia on September 23, 1978. His companion and protégé Homer Layne was to be his chief beneficiary, but because of a series of voiding irregularities in his self-drawn will, New York State would not accept it for probate. It was directed that the estate go to his children, who in turn transferred it to their mother, who had paid the funeral expenses from her home in Kansas. Mrs. James and her children, wanting to observe the intent of the will, then turned the estate back to Layne. Thus, at the end, this man, "famed for keeping his promises — and going broke," kept his promise.

Enhancing the figure by line and cut rather than a slavish following of fashion whims — this approach to the art of dress had made him famous. The genius of Charles James had been his brilliant comprehension that "art steps in where nature fails."

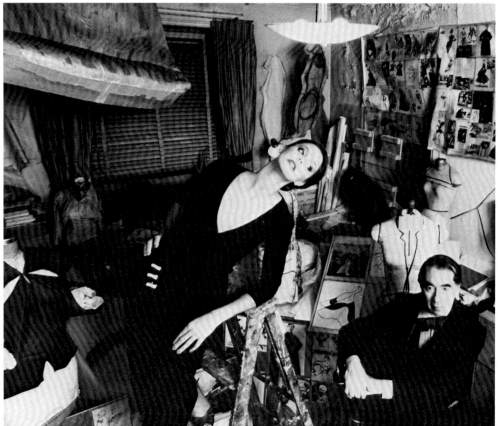

James with the model Marcella Klep, who wears his "Taxi" dress (cat. no. 132). Posed in his Chelsea Hotel studio three weeks before his death, the designer is surrounded by his "inventory of invention."

PHOTO: ART KANE/1978

CHARLES JAMES

Bill Cunningham

The Man

The magic spell cast by Charles James's work came into my life on opening night of the Metropolitan Opera in 1948. As in a dream, there appeared on the grand staircase three women gowned and jeweled in ceremonial magnificence, like exotic birds from an enchanted forest. Wearing a white satin and black velvet gown that suggested a swan, Mrs. Cornelius Vanderbilt Whitney stood out, diamonds and emeralds filling in her strapless neckline, a glittering flowered tiara of diamonds and platinum encircling her hair.

The second woman, in a cascade of Tiepolo-blue satin accentuated with navy-blue velvet bodice, her shoulders clouded in yards of blue tulle, was opera singer Risë Stevens.

The patrician posture of the third woman resembled a Boldini portrait from the Belle Epoque. Her gown was a deep garnet-red satin, the bodice molded from velvet, the skirt asymmetrical folds of satin with a fan of starched white pleats bursting from the side. She was the actress Gypsy Rose Lee.

I had collided with a fashion world envisioned and perfected by a master dressmaker of the century, Charles James. My young eyes were far less intrigued by the opera entrance of the dowager, Mrs. Cornelius Vanderbilt, with her signature headache band of gold lamé and a white fox skin draped over her shoulder. Or by the Weegee image of the august Mrs. George Washington Kavanaugh, dripping in diamonds, white ermine, and purple orchids — looking just as the photographer had so brilliantly captured her entrance five years earlier. It was the James women in their new-shaped gowns that remained the burning memory.

In 1954, a friend introduced me to her roommate, who was working as a Charles James model in the designer's salon at 12 East 57th Street. She described in detail scenes I would hear of again and again for the next twenty-eight years — everything from James's dizzying heights of creativity to his feisty personality, not above locking the workers in the shop overnight so they would finish the clothes by morning.

Like many New Yorkers with an interest in style and society, I found my fantasies set afire whenever the work of James appeared. His masterpiece gowns of the early 'fifties were the anticipated climax of all the big fashion shows. The Fifth Avenue windows at Lord & Taylor were filled with his unforgettably shaped coats and suits. My aunt said she would be buried in her James dress, she loved it so much. Meanwhile, the gossip columns were filled with spicy intrigues of James's legal entanglements and feuds.

During this time, James was at the cutting edge of the avant garde. He was a personage, lionized by the intellectuals and the serious art world while spurned by Seventh Avenue, which he fearlessly attacked for its promiscuous piracy of his work. He dressed all the famous names in America. When he gave a show in Chicago, the cream of that city's society, which ordinarily shunned publicity, attended en masse, in homage to his creative artistry and to his Chicago forebears.

He was a link to many of the celebrated figures of the Belle Epoque, with the wit to remember what he had experienced as a youth in London during the late Edwardian period and in Paris between the world wars. He lived to retell these stories as the American spaceship was landing on the moon. He had dressed Proust's Maria, Duchess of Gramont, and Diaghilev's prima ballerina Karsavina. He knew Mrs. Potter Palmer of Chicago and Mrs. Jack Gardner of Boston in their sunset years.

I finally met James in the spring of 1962. He was then working in a room off the studio of the well-known Broadway costume designer Ray Diffen, who had given James shelter in one of his transitional periods. James needed an audience, and he loved to associate with young open minds. He sparkled with groups of students, disciples, and other listeners, and he also enjoyed inquiring reporters, who probed into his past and reactivated his memory, bringing forth stories of his great-aunt and her contemporaries and a never-ending fascination with real and imagined relatives who he said were related to many of our Founding Fathers. He spoke of their great houses in Chicago, Newport, and New York, taking pride in their backgrounds in society and commerce and never tiring of elaborating and changing the stories to enliven them for those who had heard them before.

Virginia Pope, the *New York Times* dean of fashion writers, wrote her first and last *Times* fashion

PHOTO: BILL CUNNINGHAM/1974

An intense conversationalist, James is seen with long-time friend and fashion columnist Virginia Pope over tea, February 1974. Miss Pope is quoted: "He acquired his knowledge of fashion architecture through his continued study of the human form."

article on James. Miss Pope, an old Chicago friend of James's family stretching back well before the turn of the century, entertained Charles's entourage of friends at monthly teas. A regal woman whose ancestors were signers of the Declaration of Independence, she resembled Queen Mary, with her stylized white hair and toque hat at a rakish angle. She often chided Charlie for spending so much time on the past. "I want to know about people of today," she would say.

James's habit was to call friends late at night and initiate long conversations. If you had the time and were interested, it was marvelously entertaining and instructive. Unfortunately, the press and business people, beseiged with these calls, soon refused to accept them, because it was impossible to stop him once he had started. Undoubtedly, they were also afraid of being drawn into one of his incredible orchestrated schemes. I remember once he was detained overnight in a Baltimore jail for

nonpayment of a hotel bill. After frantic calls, he reached a Seventh Avenue friend who often helped with the food, provided the bill was under $100.00. As Charles pleaded for the bail money, she retorted, "You have always wanted to write a book — now is the time. Many of the best people, like Oscar Wilde and others, did their best writing in jail." This left James fuming. The next morning influential Washington clients came to his rescue.

James had no sense of humor about himself or his work, yet he told wonderfully funny stories on others. Many friends recall a stormy visit to the furriers where he was correcting one of his patterns for a fur coat. After several failures to understand the cut on the part of the furriers, James walked into their storeroom waving a jar. "Either you construct the way I want or I'll open this jar of moths." Another time he was being evicted from a Fifth Avenue hotel suite. He sent his assistant Tarquin Ebker out to "Barbara Hutton's boutique" (the five-and-dime) to purchase as many thermometers as he could with their last $50.00. Tarquin returned to the hotel and the two nailed the dozen or more thermometers to the walls. He then made an appointment with the management to pay his back rent of four months if the manager would come to the room at 3:00 P.M., then called the Board of Health and told them he could not work because his apartment had no heat, that he was confined to his bed, and that the hotel was threatening to evict him at 3:00 P.M. Could they have someone there at that time? James threw open all the windows so the mid-winter cold could penetrate the room and send the thermometers plummeting. He took to his bed and awaited the arrival of the Board of Health and management. The City inspectors arrived first and on reading the thermometers threatened the hotel with health violations. The management dropped its eviction, allowing James time to "regain his health" and pay his debt in thirty days.

One of the most productive friendships of his entire career was his meeting and collaboration with the young illustrator Antonio Lopez, who introduced himself to James at a restaurant in 1964. Charles liked him and realized that through him he had found an opportunity to acquire a record in drawing of the masterpieces of his great years. The

A 1974 nocturnal drawing session in the Chelsea Hotel studio with Antonio, documenting a late 1959 coat modeled by client Mrs. Fritz (Frederick) Bultman, Jr.

drawings were eventually to be given, through complicated tax-shelter arrangements, to museums that already housed collections of his clothes. A major project, often pursued with great intensity over a period of ten years, resulted from this meeting. Work was frequently carried on throughout illuminating nights, with Charles explaining the shapes, directing the model's posture, and introducing Antonio to an elegance far beyond the commercial work he had known on Seventh Avenue. These "seminars" were held with students and friends and James's most loyal disciple Homer Layne, a Tennessee farm boy who became Charles's faithful worker and saw him through to the end. Homer was a godsend, overseeing studio gatherings that stretched into the early morning hours — a time James felt the most profound work was accomplished. Occasionally, a distinguished client would arrive for a nocturnal fitting while Antonio

sketched, the reporters took notes, the photographers snapped — and Charles held a discussion on the fine points of couture, the follies of the rich, and "the plagiarists of Seventh Avenue."

Antonio's eyes seemed to eat up the sculptured shapes with which Charles presented him. You could almost see the stimulation he took in through his eyes and transferred out through his long fingers with a flow of beautiful line on the white paper. This was the mystical process of great talent in communication before our very eyes.

Charles was extraordinarily helpful to photographers who would listen, teaching them what to look for in the design and the best way to photograph the point of interest in the most flattering shadows and light. As might be expected, he had a sharp temper for photographers who used the artist's designs to embellish their pictures rather than feature the clothes.

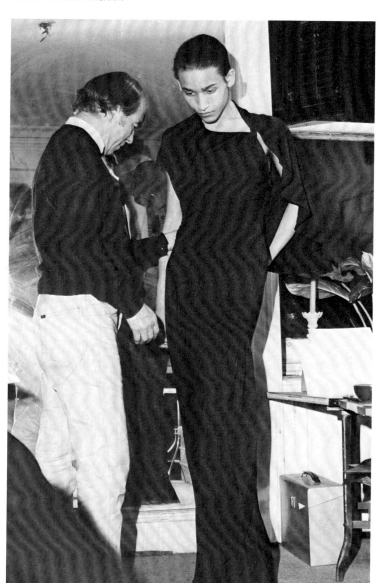

Preparing for gallery installation at the Everson Museum, Syracuse, New York, 1975.

James adjusts a black crepe gown, first executed in 1929, on Juan Hernandez. The youth, plucked from 23rd Street, possessed the perfect body for the design.

I remember vividly at 2:00 A.M. during one of the drawing sessions Charles became exasperated by the female model's hips and buttocks, which bulged and distorted the line of a slender black 1929 gown. Antonio quietly left the studio on the pretext of going for coffee. He returned from 23rd Street with a handsome, straw-thin young man whose body fit perfectly into the sinuous gown — and the drawing session went on at an inspired pace.

James often fitted and showed the clothes on his own body when a model was not available or if he was displeased with the model's posture. The point was to demonstrate the intricacy of cut and shape on a human form, whoever fitted.

Charles was generous to his students. When they were invited to big parties, he often lent them garments from his collection so they could experience firsthand the wearing of his shapes and fit. Unfortunately, the clothes often returned damaged from wild disco parties, yet Charles was never able to refuse when he thought the request was sincere. And, of course, there was always the

possibility of press coverage and the re-igniting of his career.

Once Antonio and his model were allowed to wear the celebrated 1937 white satin quilted jacket. James was thrilled when Antonio returned the jacket with a series of photographs. He had put the coat over the bare-chested, muscle-sculptured body of a soccer player astride a shiny Harley Davidson motorcycle. James's feminine opera jacket placed in the saddle of the giant machine had the fantasy effect of a space-age warrior.

James himself was unconventional in his style of dress. When he received the Neiman-Marcus Award in 1953, he did not wear the prescribed black pants but a black tie with blue jeans — in honor of Texas — a uniform Andy Warhol was to make popular twenty years later.

The studio group changed weekly, and as word spread, young designers clamored to be included. They came with their cameras, their tape recorders, their eyes, and their memories, as Charles held his informal seminars and Antonio continued to draw. This last decade of James's life was a dramatic change from the rich glamour of his early years. He said, "The great private parties ended at the outbreak of World War II. After the war, society purchased tickets to benefit events, where they were selling either a product or themselves." Yet in their own way the later years were just as rewarding to a master setting his life's work in order. At times there was tension, when the disco life blossomed and Antonio and his friends became involved in all-night dancing. Charles couldn't understand this kind of behavior in the face of his urgent mission to complete the drawings of his work. He felt his days slipping away and the determination and energy to battle becoming more difficult to summon, but he persevered, and the work was not only finished, it was displayed in a 1975 museum retrospective of over 1,000 drawings, sculpture, shapes for jewelry, and forms for the solution of his design problems.

As the fiery temperament of James and his eccentric-artist personality fade in memory, his art emerges as a tour de force transcending the immediate moment into a world of infinity. The poet laureate of American fashion, he did not design — he shaped and sculptured twentieth-century forms of the dressmaker's craft into the first wearable soft sculptures.

James was an artist, sculptor, and architect. His designs exhibit a furious energy. The rigor of his concepts was Apollonian in its control, and he challenged every cliché of the dressmaker's craft with a raw, gritty mastery of shape, a precision of cut, a dignity of line, and a crescendo of unexpected color. The results are an anthology of the epoch, from a talent that comes once or twice in a century. America can be a very punishing place for a man who creates his own beat, and James's stellar achievements resulted in his reputation as the "lone eagle."

The reigning monarchs of Paris couture — Poiret, Chanel, Schiaparelli, Dior and Balenciaga — recognized and praised his fluency in sculpting unique shapes and in the displacement of the dart and seaming. They were fascinated by his theory that the thin wall of air between the wearer's body and the cloth was the real problem in endowing the wearer with a shape that was not her own.

Charles James's output spanned more than half a century, beginning at his 1926 millinery shop in Chicago and ending with the last dress in August, 1978. His clientele was not only celebrated, but a necessary collaboration. The client-couture relationship was the life-blood of fashion. No problem could be resolved or nothing invented without the client, according to James, who claimed to have chosen the clientele he dressed. They were not only women of great affluence, but possessed a particular elegance and posture. The dialogue between couturier and client is what solved the special problems, and the results were the foundation of the twice-yearly collections shown to buyers and manufacturers who purchased the triumphs of this couturier-client marriage for mass copying and adapting. Seventh Avenue manufacturers seeking licensee agreements or direct collaboration with James in the adapting of his designs were often unprepared for his fierce and uncompromising use of his name. James was totally aware of the enormous dollar value of the designer's name. In the early 'fifties he said, "My name is my

capital." It was twenty years later that Pierre Cardin showed everyone just how valuable a designer's signature was to the multi-million dollar licensee business that was to make today's designers very rich men indeed. Paul Poiret, in the early decades of this century, was the first to establish the value of the designer's name to other products.

With the decline of fashion — and, indeed, of women — as "decorative," the giant industry slowly shifted gears to the needs of working women. While Seventh Avenue developed expertise in technical areas to produce quickly and efficiently, designers became a secondary force. Logic tells us dressmakers cannot fight the age. How perfectly the battlefield was set for the arrival of Charles James. With his uncompromising, perfectionist attitude he entered into a fifty-year war, and it was the stuff of a Wagnerian grand opera.

Possibly James was born in the wrong century. His genius would have been in harmony with the tightly corseted Victorians. Instead he fought a heroic battle to reshape and fit in a century that was in search of comfort rather than the constraints of the nineteenth century. To Americans born after World War I, the gospel of fashion was freedom and ease.

James's grandiose theory of imposing the desired shape over the woman's natural body made him a visionary Don Quixote, walking alone. There were no shortcuts permitted in his self-styled apocalyptic mission. He succeeded in producing truly original innovations that owed nothing to anyone else and were without historical revivals. "I nailed into the heads of my students that there is no going back; study the past to know why, not what — and from the why, dream and do. There is no shortcut to creation. There may also be no profit, but the search for the idea, found after a long, exhausting struggle, stands on its own merit," James said.

Where other designers sought financial rewards, glamour and social status from their fashion contribution, James worked alone in the solitary workroom he cherished above all else. He was found of saying, "It took twenty years to train and assemble workrooms that could execute to perfection my ideas." Much of his time was spent in retraining workers from outdated and sloppy

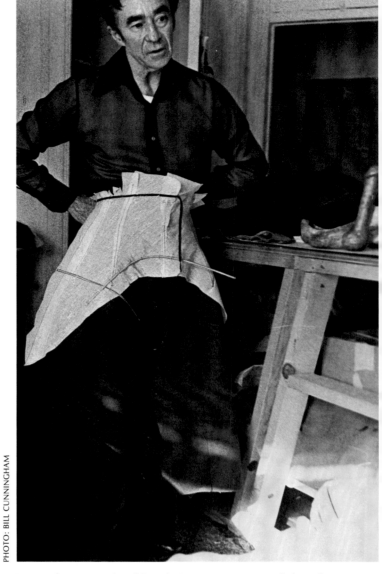

James demonstrating his solution to a structured skirt shape. Viewed from the reverse side, note can be made of preliminary reed-boning, tape markings, and dart and seam placing.

Calipers in hand, James elucidates on a garment built over a constructed form.

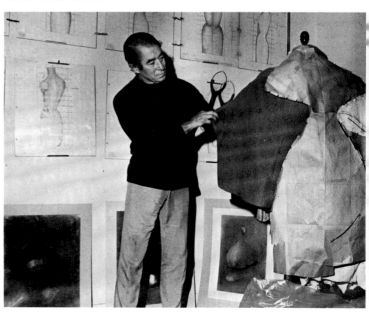

dressmaking habits. In 1945 James tore down the wall separating his workroom from his salon and replaced it with a near-floor-to-ceiling glass wall, so clients and visitors could see the art of the craftsman in full flower. He spent enormous sums of money to teach his workers the technique to construct his new shapes.

What a glorious view into the heart of a great couture house! Muslins were squared off like architect's graph paper slipcovering dress dummies. Others were padded out like blocks of marble, waiting for James to stretch contrasting colored tapes with mathematical precision in the displacing of seams and in the search for new points of tension. James sometimes disregarded the natural way the bias fell; he forced the many different grains into his shape, in contrast to Madeleine Vionnet, who was totally disciplined about the bias and conformed to the rules.

Suspended from his studio ceiling were sculptured shapes in stiff pattern-making paper — a cocoon coat, a bodice, a half-view of S-curved gowns, a sleeve from a suit of medieval armor, a collection of wooden plumber's pipe molds, a huge black molded workman's rubber glove holding a spray of purple orchids — these were the forms that set him on fire.

James was forever studying and taking patterns of armor, with its exacting cut, and relating it to a cloth coat. The soaring arch sleeve is a James signature that might suggest the open wing of a great bird. His feeling for shape also sprang from his early years in millinery, where felt hats are molded, dissected in sections, and then reassembled, with the seams providing a third dimension of line and contrasting color bindings.

While the great couture houses work their patterns flat or draped, James cut and molded his fabrics into sweeping forms. His use of the diagonal grain rather than the vertical or horizontal more commonly used by the dressmakers was one of the mysteries involved in his achievement of the desired shape.

All of James's muslins were marked by apprentices in six-inch grids, just like the graph paper used by the turn-of-the-century immigrant tailors for reproducing and sizing. James often layered four or five different pieces of graphed muslin on top of

each other, each at a different grain, tracing a pattern through and thereby giving himself five different grain sections to experiment with before he decided which shaped best to the body and his design.

By the end of his career, he was obsessed by architectural design. A client reported, "There were so many pieces in the garment that the cut became a jigsaw puzzle." And he forgot about the client waiting for the dress. He just ripped and tore it apart, rebuilding and fitting, never satisfied with his work.

At the peak of his fame in 1949, James spent a month at a sculptor's studio working on clay forms that resulted in a revolutionary new dress dummy which anticipated a whole new posture. This was based on the measurements of his patron, Standard Oil heiress Millicent Rogers, and a long study of 150 years of costume to see what body measurements had not changed in that period of time. He incorporated into his new dress form the measurements that never changed, such as a lower back waistline for long-waisted clients. He felt that you could always raise the waistline, but you couldn't lower the shape that was built into the mannequins. He also changed the waistline from one parallel to the floor to one that dipped in front and back, along the contour of the bones. He shortened the measurement from the nape of the neck across the top of the shoulder to the front underarm pivot point to 10½ inches. (Existing mannequins were 11½ to 12½ inches.) This measurement was later adapted by the U.S. Department of Standards, whose measurements made up the old mannequins that James disagreed with. James's version was a skeletonized form, whereas the existing form represented a dress on a body. James theorized that it was more advantageous to pad out each dummy to the customer's measurement. He also indented the underarm to follow the natural mold of the rib cage. The standard form was a straight line, which left an excess of fabric under the armhole. With his mannequins, the posture plumb line from shoulder-back to the floor would miss the prominent part of the buttocks by two inches. In existing dummies, the plumb line hit the buttocks. He initiated the posture

change to that of a convex stomach line and a pulled-in derrière.

James is especially remembered for his extraordinary ballgowns, although they only represented a five-year period in his long working life. At the apotheosis of his career, he reshaped Mrs. William Randolph Hearst, Jr., making her body something it wasn't. He lifted her breasts, pushed her hips and abdomen forward, dropped her back waistline, and achieved a posture like the breast of a swan for his black-and-white strapless gown. The dress weighed nearly 15 pounds, yet the enormous skirt moved with the grace of a feather, balanced perfectly on the separately constructed bodice and the undulating waistline that distributed the weight over the hipbone. Over the gown she wore a short jacket completely covered with five dozen fresh white gardenias, attached five hours before the gala and then stored in the refrigerator of her Washington hotel, awaiting her triumphal entrance into the White House inaugural gala for President Eisenhower.

The sculptural thesis culminated in his later years in drawings and models for an unproduced line of jewelry. These sculptured forms are fascinating, since they are the basis for the shapes of his clothes, and the method by which he arrived at his forms is quite as interesting as the clothes themselves.

While Seventh Avenue regarded fashion as a team effort, Charles James demanded to be recognized as singular — the one who conceives and builds entirely by himself without commercial interference in the construction of the original model. Without this single-mindedness, the costume collection at The Brooklyn Museum would not have been the recipient of the duplicates of original muslin and paper patterns of everything his star client, Millicent Rogers, had ordered. It is due to her regard for James as a collectible artist of museum quality as well as his own enthusiasm for the preservation of his work that the largest holding of his designs is in the possession of The Brooklyn Museum.

James spent much of his time arranging for museums here and in Europe to establish sizeable collections of his work and complete documentation of it, in the form of hundreds of drawings offering

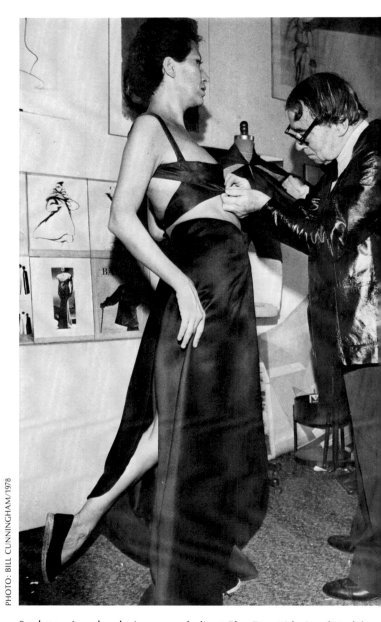

PHOTO: BILL CUNNINGHAM/1978

Sculptor, jewelry designer, and client Elsa Peretti being fitted for a "Figure 8" skirt and bodice. James died two weeks after this picture was taken.

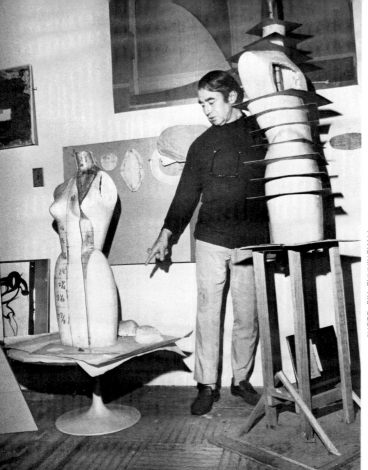

James explaining his analysis of the human torso using his well-publicized dissected plaster model.

Bodice devised by James based on an early nineteenth-century prototype.

an extraordinary insight into his architectural and sculptural vision of fashion and his working methods.

While most of Seventh Avenue recognized his genius, many thought of James as "the most wasted talent in our history — we couldn't harness it." Indeed it was this rambunctious, challenging spirit that was able to look past the accepted and create a totally new way of constructing fashion. We should be thankful for the tenacity of his rebellion against the commonplace and his search for the truth that produced the end product that is the subject of this book. James often said: "A great dressmaker does not seek acceptance; he challenges popularity by the force of his conviction and renders popular in the end what the public hates at first sight."

James approached his shaping of fashion with a terrifying intensity. His knowledge of anatomy, psychology, economics, technology and aesthetics was awesome. At times he exhibited sheer ruthlessness with his workers and clients in his quest for perfection.

While the mainstream of fashion changed to flat, folding, geometric clothes and stretch fabrics for fitted garments, James never relented in his principles of structured fit through shaping and permissible bondage. His knowledge and use of corseting the body to achieve a desired posture was a lifelong study. Starting with the corset, he

achieved shapes with chiffon one could never get through draping. He was fascinated by nineteenth-century corseting, especially on finishing-school girls, "whose corsets were altered and taken in every two weeks." Dior in his 1947 New Look made corsets of net fitted to the woman's body. Dior repeated the customer's figure, whereas Charles James gave the client his perfected figure.

James was fascinated by the tension between fabric, cut, and the discipline of style — setting masses against masses. He recalled dealing with the large size of an opera singer: "We tied two dress forms together and built one over it." Kate Smith, known for her singing of "God Bless America," said: "You couldn't wear Charles James if you were my size." James replied, "Yes, but I never heard of a big Cadillac not being painted pale blue." James believed he had the power to invest problem figures with the magic of his imposed shape — indeed, that he was the Frank Lloyd Wright of fashion.

He had a fantastic arsenal of craftsmanship and a genius for using all of his techniques in the execution of his manifesto, exploding the baroque curve into a modern vocabulary and thus creating an intellectual signature in shape, cut, and fit.

In 1956, James expanded the baby cape he made for his son's christening into a full-structured form for grown women. In 1965, he created a flexible sculpture model later executed in foam rubber and

metal templates. Through the center a flexible rod bends the figure to show the effect a change of posture will have on the fit of a dress and its points of stress. After studying the bodices of a gown long associated with the Empress Josephine, James made a no-cup bra cut on the bias with only a drawstring on top. When pulled closed, it raised the bust without the help of wire and cups.

Those who worked with James (his customers, magazine editors, and fabric salesmen) all spoke glowingly of his vivid individual sense of color. Rarely did he use prints, preferring solid colors in unexpected combinations to heighten the dramatic shape and cut. Best known was his use of tobacco brown as an accent with black, or the combination of black, navy, and brown; at other times, teal blue and olive green, or a dusty rose mixed with

burgundy, fuchsia or magenta; a deep, deep red accentuated with copper; mulberry and cranberry accentuated with delicate seashell pink; aquamarine in both flat and shiny fabrics in the same gown; and a wonderful bright vermilion — the color of his favorite flower, the anthurium. In other gowns, he mixed the pinks, mauves, and purples of the hybrid orchid.

At a time when coats were all lined in black, navy or brown, James's coats opened to a splash of colored taffeta: a smoky, silver-grey wool opened to a garnet-red lining, a taxicab yellow evening coat opened to a Tiepolo-blue lining. Experts in the fabric world said he knew more about materials than anyone in America. Said one expert, "James spoke to the cloth."

During the late 'sixties and early 'seventies, James's work tables were covered with muslins and patterns in an experiment for the cut of trousers. He had even gone so far as to sculpt the penis to determine its cause and effect in the design of trousers. In 1972, the waist of his trousers was given an unusual shape: a diagonal waistline was high in back and dipped to a low point in front, which allowed the same trouser to fit three different waist sizes. At a time when Seventh Avenue was becoming rich by copying the classic blue jean and embroidering a designer's name on the back, James was still searching for new shapes.

During his last years, Charles continually nailed into our heads his theories and credos and as much history of his family background as we could remember, and the time spent with him continued to carry us on a high plateau, where the effect of an evening with him was the absolute — a dream not unlike opium. The return to everyday life was difficult. We felt he needed something, but all we could offer was our thanks.

If Charles James were alive today, he would be challenging the present and looking into the future. He sought to find dressmaking truth in the experimental couture workroom, expanding new frontiers that would be picked up by mass production and establish the artist's recognizable signature. James stood quite alone. His work must be classed as pure special creation in an adverse environment. He was rarified air.

Juan Ramos, Antonio's associate, models black velvet trousers designed in 1972. Cut for either men or women, the point of interest is the diagonal waistline, high in back and sloping to front, a feature which allows a 25-inch to 29-inch waist to wear the same size.

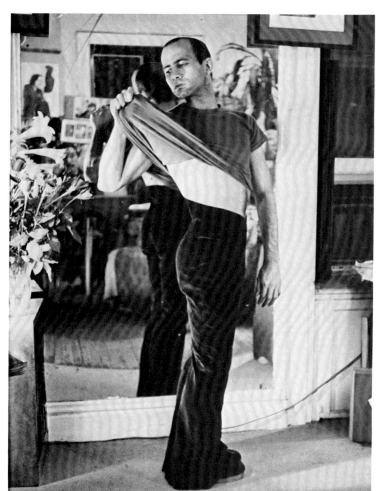

PHOTO: BILL CUNNINGHAM

CHARLES JAMES

The Couturier

I

Anne, Countess of Rosse

provides this memory of Charles James during his London years (1930s). Sister of the celebrated scenic and costume designer Oliver Messel and mother of Lord Snowdon, Lady Rosse's perspective on fashion reflects a history of association with art as well as with society.

⁄⁄Charlie James was one of the greatest masters of 'le plus grande Couture.' Whimsical and impetuous, he was a true genius of line and originality and a perfectionist. Everything he designed was a masterpiece of style and elegance. He laced daring originality with an unfailing flair of the best possible taste for the occasion for which the dresses had to be worn.

But — the wearer if she wanted to enjoy his creations had sometimes to be sacrificed for the designs! To begin with, there could be a mystery as to how to get into the clothes when they arrived! Or which was the front or the back, which he might have altered at the last moment! With some, walking might be difficult — or sitting down tricky! But an appreciative wearer would gladly cooperate.

Looking back, therefore, it was small wonder that his clientele in England didn't expand into the Mrs. Everywoman's World — who'd be in search of that little useful dress for all occasions.

And yet, I still have, amongst my treasured collection (made for my honeymoon in 1935) simple (yet not really simple!) cotton dresses for the tropics and Far East — stout thick wear for mid-winter in China and Russia — unique designs for desert wear and also dresses for embassy dinners. But the zenith of delight to me was the designs for 'en grande tenue' — challenging and exquisite.

Charlie's childhood or his home life were never known to me nor do I remember where I first met him — I think it must have been through Baroness D'Erlanger — that great patron of all young artists.

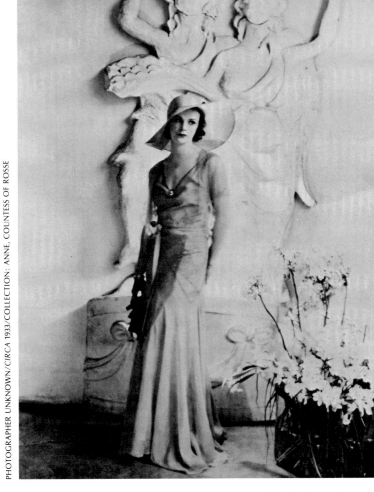

Anne, Countess of Rosse, in an Ascot ensemble designed for her about 1933 (cat. nos. 9 and 540).

He seemed to blow into the London orbit in the early 1930s and he must have been very young then. My most vivid memories are of the time he had a grand salon in Bruton Street, luxuriant with gilt furniture and crystal chandeliers. How it was ever financed I cannot imagine! But a faithful friend, Miss Barnes, wielded what discipline there existed — she was so kind, efficient and calm. I remember her tenderly.

So far from the platform of today — when one rushes into a mass production store that accommodates every lady with replicas of great houses — to suit the tall and the short, the fat and the thin, the young and the old. Charlie's creations then were specialties for special people — all masterpieces.

His most treasured client, I think, was Millicent Rogers, the great American beauty who wore his clothes with such grace.

In London, so little did he seem to care about the niceties of encouraging a wide and wealthy clientele, or indeed good business at all, that he could be downright difficult with some of his much-needed customers — that was his honesty. I remember — with misery, embarrassment, yet amusement as my thoughts go back — a very rich and charming American London hostess whom I

took to see him; though he looked up, there was silence as we came in. 'Charlie, I've brought my friend Mrs. X., who so admires your beautiful clothes,' I ventured. 'What do you want?' he asked her bluntly. 'Oh well, I'd like to see what you've got,' the dear fat middle-aged lady replied. 'Well, I couldn't possibly make anything for a frump like you. Why, you can't even walk properly!' Oh the despair of helping bring lucrative customers! But there were no ill feelings at all — we all just laughed.

So — in London, big and prolific business could never have been for Charlie, yet all yearned for his exquisite clothes. With that eccentric genius he was never prepared to yield or flatter.

Yet, *I* remember him as appealingly tender and generous; however impetuous he could be, he was never out for money — cheques could be lost or torn up, even in hard times. His values were of true art, and art alone.

Understandably there came a day when the bailiffs came into Bruton Street and his beautiful collection was quickly thrown into taxis at six in the morning, for me to find piled up on the floors of my little dining room as I was preparing a luncheon party! Such was his generosity that he wanted to give me the lot in the end.

The last time I heard that familiar voice was from New York to Ireland, '*Anne, have you still got* that black velvet evening coat I made you? I want it at once — for an exhibition — someone will come and collect it.' Of course I had, and treasured it as I did all that he ever made me, and treasured too the golden memories that they recalled. //

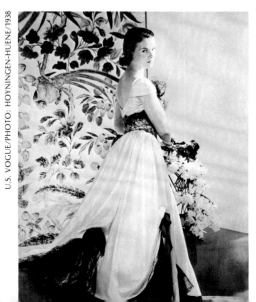

Lady Rosse in layered gown designed in 1938 for a ball in New York (cat. no. 45).

Austine Hearst

(Mrs. William Randolph Hearst, Jr.) was a New York client and patron of Charles James after his years at the Elizabeth Arden Salon (post-1945). As the former fashion columnist "Austine," and a perennial member of the "Best Dressed" list, she is in a unique position to write of James's contribution.

// Best designer America has produced, vituperative enemy, selfish egoist, charismatic salesman, evocative storyteller, Renaissance man — you'll hear widely different characterizations of Charles James from those who remember him: his clients, his competitors, his workers.

In truth, all of those attributes . . . and many more . . . describe this complex genius.

In preparing to write a few words for this posthumous honor to Charlie, I have unravelled skeins of tangled memories. Though aware of my presumption in attempting to present a picture of my friend, who is now a legend, I cannot think of a task, difficult though it is, in which I could be more happily engaged.

After much reflection, it seems to me his greatest of many mistakes was to have wished to make a fortune in a business which in the United States could barely provide a living. Today, in 1982, designers can make money — selling perfume, granting licenses, tying up with retail outlets, giving their stamp of approval to candy boxes and auto seat covers. But creating made-to-order costumes and fitting them for individual women rarely generates much of a profit.

Certainly, not enough money to satisfy Charlie. Madame Grès has written that her private clients have lost her many millions each year. In that case, Charlie didn't lose so much.

To be honest, he was extra-extravagant. He lived in hotels, ordered room service, and never compromised on workmanship or material. He was always in hock and in need, and damaged his health, I'm sure, with late hours and the stress of fighting and swimming upstream. He could never understand that he could not somehow find a way to be rewarded for his talent. And he blamed the fashion establishment.

He turned, in desperation, really, to the study of mass-market clothes — to Seventh Avenue. He

decided it would be easy to translate his knowledge, his designs, and patterns into making clothes on Seventh Avenue.

He did not realize that the field was vastly different from the world of couture — not better or worse, but totally different.

He broke his heart and his health wanting to become important, a financial success in the mass-market production of clothes. He believed he could manage the ins and outs of pattern sizing, distribution, vast workroom cutting and sewing, labor negotiations, advertising — everything. He wasn't trained or temperamentally suited for Seventh Avenue any more than Michelangelo would have been to fashion photography. Perhaps his indomitable Chicago forebears, of whom he was very proud, cursed him with Midwest American tenacity. Like a fighting, spunky terrier he hung on, bloody but unbowed; he battled and won lawsuits, wrote letters, made phone calls, and suffered fury and frustration.

He might as well have tried to stuff a polecat in a paper bag.

What happened to him could have destroyed Christian Dior or Balenciaga or any other creative talent without the discipline and restraint of business management.

Any couturier creating clothes for private customers must find an accommodating, rich partner to make a marriage, so to speak. Those who have succeeded as designers in the United States seem invariably to have been those capable of deft adaptation to our society and the business world of their times, those accepting and guided by business advisors.

If Charles James had found a business manager whom he trusted, perhaps he could have reaped his deserved golden harvest. But even that Man For All Seasons, Thomas Jefferson, died in debt, unable to balance his books in spite of his many talents, and history has overlooked *his* trespasses.

Among numerous other ventures, Charlie decorated houses and designed dress forms, hats, shoes, scarves — even furniture. A Texan family owns and treasures his avant-garde sofa, shaped in the form of a pair of soft, sensuous lips.

Still, most of his mass market attempts miscarried.

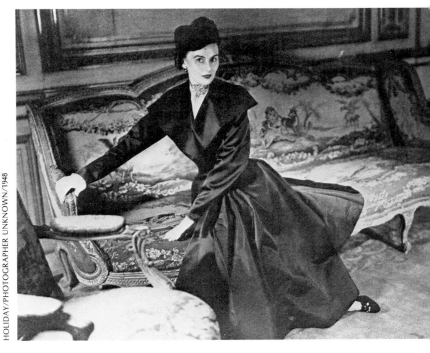

Mrs. William Randolph Hearst, Jr., in satin trousseau coat photographed at French & Co., New York (cat. no. 384).

Though he miraculously never lost faith in his own ability, nor his significant contribution to the art of design, he should never have aspired to cater to the working person. He should have stuck to the high-level connoisseur who understood his clothes, which have meaning far beyond the visual.

While he could sketch beautifully, in making clothes he usually draped live models with fabric. With an artist's eye and considerable ingenuity, he combined colors, searching for odd dye lots. His off-beat mixtures, like his style in naming colors, have become commonplace today. Orange was always "pumpkin"; pink was "bull-tongue"; beige was "biscuit." Combinations of lilac and henna, aquamarine and peridot, were innovative when he first put them together.

In his workrooms he was critical and unmercifully hard on his workers, but harder on himself. By training his personnel like the late celebrated restauranteur Henri Soulé, who generated a whole series of restaurants, James influenced many designers — Halston, Adolfo, Scaasi to mention a few of the most successful — some of whom also worked and trained in his workroom.

Like two others of today's best designers in America, Galanos and Scaasi, Charles James's taste and training were formed by working in Paris. Son of an English father and a Chicago heiress, Charles was educated in England, spoke fluent French, read continuously, and collected books on various subjects. I recall hours of discussion with him about the arts, history, and politics, and I still have the inscribed copy of Willa Cather's *A Lost Lady* that he gave me.

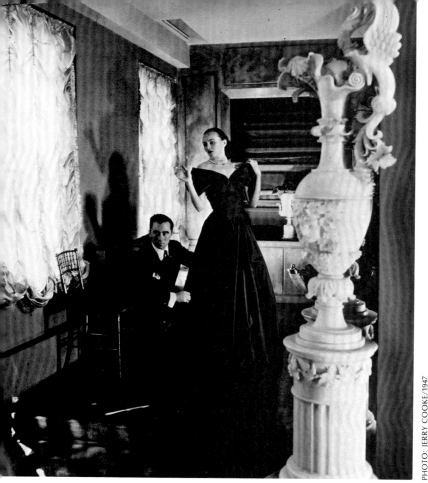

A favorite client and friend, Austine Hearst is photographed in James's salon wearing his "Rose" dress of deep wine satin and bittersweet faille (cat. no. 94).

Mirrored reflection of Mrs. Hearst in evening dress (cat. no. 30) and Charles James at the designer's salon before a cabinet of fabrics ranging in color from deep royal purples, bright blues, and grey blues to greens and brownish golds.

Austine Hearst modeling a two-piece evening ensemble of faille and satin (cat. nos. 241 and 246).

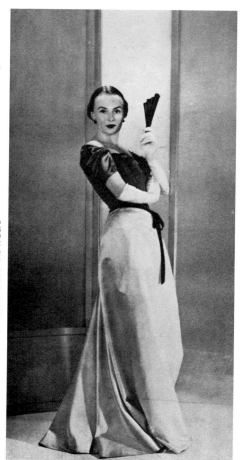

In conversations he could skillfully combine, in exquisite detail, the social scientist's analytical insight with the historian's perspective. Vivid, caustic, loquacious, humorous, and entertaining, he selected words with scholarly precision — he was fascinated with them.

His brain was an enchanted loom, weaving ideas and shifting harmonies and patterns.

Perhaps his stormy personal life contributed to his devilish disagreements, his belief that the fashion world was full of vanity, greed, and broken promises.

A man of pugnacity and passion, he was quite satisfied to create disturbances. But what frustration to feel that fashion editors of newspapers and magazines did not give him space or help, did not recognize his talent. Instead they devoted write-ups and pages to mass-market designers who copied his creations.

And the fashion editors are still doing it. Still buttering their bread because the stores that sell the clothes advertise in their publications. The publications have to pay their light bills, salaries, and their stockholders.

Of course, it is unfair, of course it is unwise, carried to extremes.

Charles James should be a moral lesson, a warning to many of us, to fashion editors, to museum and

costume curators, to the whole fashion industry. We must ask ourselves how what happened to Charles James can be prevented from happening over and over again. We're not justified with pious avowals — "he was difficult, contentious, unreliable."

So have been geniuses in other times. It's our job to nurture and appreciate them.

Leonardo da Vinci was commissioned and paid to do a portrait of a client's wife. The customer never got the picture. Da Vinci kept insisting he had not finished it, and took it to France when he went to work for Francis the First. The *Mona Lisa* hangs in the Louvre today, never delivered to the rightful owner.

So we must forgive geniuses their transgressions. Remember them only by the beauty and inspiration they give us, their legacy to us.

Influential, responsible leaders at the peak of the fashion pyramid, store owners, editors, commentators — even customers — must dedicate themselves to searching for and developing America's designing talent. It will pay off. Maybe not next season but always in the long run.

But I must refrain from waxing philosophical about artists. Should they starve in a garret or turn commercial? Forget Charles James's disappointing life, his tragic, debt-ridden, embittered end in the Chelsea Hotel. I choose to remember above all the best and the brightest. Better to think of Napoleon robed resplendently for his coronation as Emperor than in pain and despair at St. Helena.

I will always remember the *magic* of wearing one of Charles James's ravishing, romantic ballgowns, remember being transformed by him like Cinderella into a radiant princess.

Everyone turns when I sweep into the room, the gentlemen in admiration, the ladies in envy.

I'm *the* sensation of the evening, a triumphant opera star, showered with bouquets and a standing ovation, a prima ballerina bringing down the house.

I'm a star!

Whether they've worn his clothes or not, Charles James's admirers thank the Brooklyn Museum for this homage, if long overdue, to a great American designer.

Look at the clothes. His work speaks for him. //

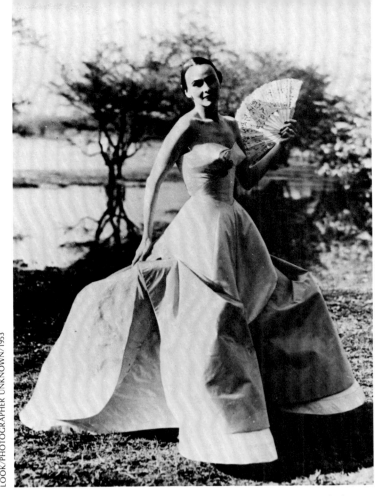

LOOK/PHOTOGRAPHER UNKNOWN/1953

Complementing the beauty of Washington, D.C.,'s famed cherry blossoms, Mrs. Hearst poses in a variant model of the "Abstract" ballgown in white taffeta with pink satin flounce (cat. no. 114).

Named to the "Best Dressed" list in 1956 — as well as in several other years — Mrs. Hearst is seen in a gown of tulle and satin that is, quite literally, "staggering": not only is it a marvel of construction but the wearer can barely move in it (cat. no. 122).

NEW YORK DAILY MIRROR/PHOTOGRAPHER UNKNOWN/1957

CHARLES JAMES

Elizabeth Ann Coleman

The Work

The entries are organized by groups as follows:

The entries have been numbered in order to provide a reference tool for future research of James's designs.

Notes on the entries:

1 A ● indicates that the garment is in the exhibition.

2 The garment type (preceded, where applicable, by James's name for the garment in quotation marks) is followed by the date of the initial design [James's style number, where known, is in brackets]. Except where otherwise stated, all garments were designed in New York.

3 The garment's construction is described from the neckline down. A □ indicates no construction is available because it has not been possible to trace the garment.

4 *Additional versions:* **Date** followed by fabrics used (client, where known in parentheses). The term "offered by" refers to merchandising of the garment by a store or company on a custom basis.

5 *Patterns:* Except where otherwise noted, all patterns are in the collection of The Brooklyn Museum. In addition to paper patterns, James often made muslin patterns. He sometimes assembled a muslin pattern to create a half muslin model of the garment, and he occasionally made full muslin models. Where applicable, the pattern or model is followed by The Brooklyn Museum accession number.

6 The collection is given in italics; additional collections are in brackets, abbreviated as follows:

ASL — Art Students League, New York
CAM — Cincinnati Art Museum, Ohio
CEDC — Centre d' Enseignement et de Documentation du Costume, Paris, France
CHS — Chicago Historical Society, Illinois
CJA — Charles James Archives
FIT — Fashion Institute of Technology, New York
GG — The Goldstein Gallery, University of Minnesota, St. Paul
LAGMA — Los Angeles County Museum of Art, California
MCNY — Museum of the City of New York, New York
MHS — Missouri Historical Society, St. Louis
MMA — The Metropolitan Museum of Art, New York
NMAH — National Museum of American History, Smithsonian Institution, Washington, D.C.
PAM — Phoenix Art Museum, Arizona
RISD — Museum of Art, Rhode Island School of Design, Providence
ROM — Royal Ontario Museum, Toronto, Canada
TBM — The Brooklyn Museum, New York
TRP — Art Gallery and Museums, The Royal Pavilion, Brighton, England
V&A — Victoria and Albert Museum, London, England
WA — Wadsworth Atheneum, Hartford, Connecticut

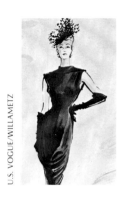

U.S. VOGUE/WILLAMETZ

Evening Dresses

1 EVENING DRESS, 1928

Draped neckline; sleeveless; double-pointed waistline; polonaise draped skirt front. Early versions ankle length with train; later versions knee length. Initial fabrics and client unknown.

Additional versions: **1933** fabrics unknown (Mrs. Arthur Bissell). **1944** fabrics unknown (offered by Elizabeth Arden).

References: U.S. Vogue, July 1944, p. 56.

2 "SCARF" EVENING DRESS, ?1929

Diagonal neckline sweeping into hip-length, semi-circular cape; bias-cut body forming spiral wraparound skirt; ankle length. Designed initially for Lady Leucha Warner (fabrics unknown).

Additional versions: **1932** fabrics unknown (Gertrude Lawrence). **?1932** fabrics unknown (Mrs. Oliver Burr Jennings). **1939** client-supplied white Chinese silk dyed green (Mrs. George P. Raymond). **?1946** black silk crepe Mongol created by Coudurier, Fructus et Descher of Pari (Mrs. Edmond G. Bradfield).

Patterns: muslin V&A T.20.1980

References: Metropolis, 1975, pp. 4–5.

Mrs. George P. Raymond
[CJA]

3 EVENING DRESS, 1931 ●

Diagonal neckline front and back; strapped, short draped panel on right side; floor length. Designed initially for Lady Leucha Warner (fabrics unknown).

Additional versions: **1933** fabrics unknown (marketed by Taylor Importing Co.). **1934** dark sapphire bouclé crepe (Mrs. Walter S. Carr). **?1934** fabrics unknown (merchandised by Marshall Field & Co. and by Best & Co.).

Chicago Historical Society, Gift of Mrs. Walter S. Carr 1960.435

4 DINNER DRESS, 1932

Narrow top with crossover straps concealing petals; short skirt. Designed initially in black crepe de chine with white chiffon for Frances James (worn with James-designed petal hat). □

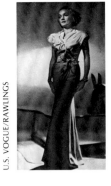

5 **DINNER SHEATH, ?1932** London

One-piece; ties with self-material bows on diagonal from shoulder to hip; open to hemline; asymmetrical bias cut; draped neckline. Designed initially for Lady Leucha Warner (fabrics unknown).

Additional versions: **1944** grey silk satin (offered by Elizabeth Arden). **1944** fabrics unknown (Marlene Dietrich).
References: U.S. *Vogue,* Oct. 1, 1944, p. 126.

6 **EVENING DRESS, 1933** London ●

Crossover halter and off-shoulder straps cut in one with fitted bodice; bias-cut, ankle-length skirt. Initial fabrics and client unknown.

Additional versions: **1933** white pebble crepe, labeled "Charles James/15 Bruton Street W.1" (Mrs. St. John Hutchinson).
Charles James Archives

7 **EVENING DRESS, ?1933** London

Overlapping diagonal bodice with short sleeves, raised waist; bias cut with two waistline bows; three eyelets at back waist; ankle-length skirt. Initial fabrics and client unknown.

Additional versions: **1933** black satin figured with stripes (Mrs. St. John Hutchinson).
Art Students League

8 **EVENING DRESS, 1933** London

High-necked trapezoidal yoke with epaulettes; blouson bodice with elbow-length cap sleeves; hipline yoke; long, slightly flared skirt. Initial fabrics and client unknown.

Additional versions: **1933** black velvet on chalk white heavy chiffon.
References: U.K. *Harper's Bazar,* Sept. 1933, p. 28.

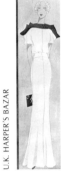

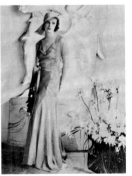
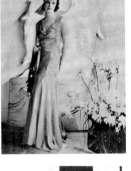

9 **LATE-AFTERNOON** or **ASCOT DRESS, 1933** London

V-neckline; short handkerchief-drape sleeves; pieced trapezoidal-form torso; long flared skirt with slight train. Designed initially for Anne, Countess of Rosse (pastel silk crepe organza).

10 **EVENING DRESS, 1933** London
(see also cat. no. 359)

Long evening gown with classical drapery of side folds brought up to shoulderline with neckline scarf; high bodice in front, low in back. Designed initially in pearl grey georgette for an unknown client.

References: U.K. *Harper's Bazar,* June 1933, p. 13.

11 **EVENING DRESS, 1933** London

Long sheath gown; scoop neck; sleeveless; stitched bands of bias-cut braided fabric. Initial fabrics and client unknown.

Additional versions: **1934** white crepe (Mrs. Arthur Bissell; offered by Marshall Field & Co.). **?1934** fabrics unknown (Hermione Bradley, Mrs. Oliver Burr Jennings). **1940** fabrics unknown (Gypsy Rose Lee).
References: *Chicago American,* Jan. 8, 1934.

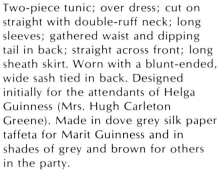

12 **BRIDESMAID DRESS, 1934** London

Two-piece tunic; over dress; cut on straight with double-ruff neck; long sleeves; gathered waist and dipping tail in back; straight across front; long sheath skirt. Worn with a blunt-ended, wide sash tied in back. Designed initially for the attendants of Helga Guinness (Mrs. Hugh Carleton Greene). Made in dove grey silk paper taffeta for Marit Guinness and in shades of grey and brown for others in the party.

Marit Guinness Aschan

13 **WEDDING GUEST DRESS, 1934** London

Designed initially in green silk shot with flame-like colors for Mrs. H. S. H. Guinness. □

14 **WEDDING DRESS, 1934** London

High neck dipping in back; long, curved, inset sleeves with trapezoidal-shaped cuffs; V bodice line to waist; bodice cut on straight; skirt on bias in one piece with join down center back; front knee-high, dipping hemline flounce trailing off into a bifurcated, arced train ending in points; back hemline draped up into seam of flounce. Designed initially in ecru crepe-backed satin charmeuse for Barbara Beaton (Mrs. Alec Hambro).

References: Cecil Beaton, *The Wandering Years* (London: Weidenfeld & Nicolson, 1961), p. 26.
Victoria and Albert Museum, Gift of Alec Hambro
T.271.1974

15 **EVENING DRESS, 1934** London

Deep V-neck with draped bustline on either side of inverted V; bias-cut skirt in one with bodice; crossover arced straps in back. Initial fabrics and client unknown.

Additional versions: **1934** yellow-green gold-faced silk satin (Mrs. Alec Hambro).
References: *International Herald Tribune,* Dec. 4/5, 1971.
Victoria and Albert Museum, Gift of Alec Hambro
T.272.1974

16 **EVENING DRESS, ?1934** London

Diagonal teardrop-shaped neckline; spirally wound torso with side drapery from waist to train. Initial fabrics and client unknown.

Additional versions: **1934** black velvet (June Hart).
References: U.K. *Harper's Bazar,* Nov. 1934, pp. 26–27.

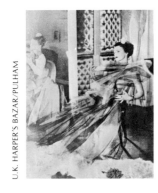

17 EVENING DRESS, 1934 London

Strapless bodice; full layered skirt. Initial fabrics and client unknown.

Additional versions: **1934** pink and black silk tulle (Anne, Countess of Rosse).
References: U.K. *Harper's Bazar*, Nov. 1934, p. 56.

18 EVENING GOWN, 1934 Paris ●

Square neck; short, draped sleeves; fitted torso with front pendant plastron to which full hemline flounce is attached; tent-shaped back gore. Initial fabrics and client unknown.

Additional versions: **1937** pale peach satin (Mrs. Esmond O'Brien).
References: The Brooklyn Museum sketches 57.218.11a.
Fashion Institute of Technology, Gift of Mrs. John Hammond 1977.89.2

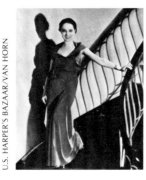

19 EVENING DRESS, 1934 London

Trapezoidal neck; foldover sleeves; bias draped with faced tie at right hip. Initial fabrics and client unknown.

Additional versions: **1934** slate crepe (offered by Best & Co.).
References: U.S. *Harper's Bazaar*, April 1934, p. 114.

20 EVENING DRESS, ?1935 London

Bias cut; tabard over bodice in front; dips to waist in back; one-piece skirt. Initial fabrics and client unknown.

Additional versions: **?1935** pale ice-blue silk satin (Mrs. Osbert Lancaster).
Victoria and Albert Museum, Gift of Miss Honey Harris T273.1974

21 EVENING DRESS, ?1935 London
(see cat. illustration 363)

Loosely draped, spirally wrapped bodice; diagonally tucked hipline yoke; floor-length sheath slit in front. Initial fabrics and client unknown.

Additional versions: **1935** faille.
References: U.K. *Harper's Bazar*, Aug. 1935, pp. 16–17.

22 EVENING DRESS, ?1935 London

Ribbon tie at neck. Initial fabrics and client unknown. □

Additional versions: **1935** white organdy with scarlet ribbon, white satin slip (Diana Guinness, Marit Guinness).

23 EVENING DRESS, 1935 London

Scoop neck; high, heart-shaped bustline accented with ruffle; sheath torso with apron construction. Initial fabrics and client unknown.

Additional versions: **1935** black satin and chiffon (Mrs. St. John Hutchinson).
Charles James Archives

24 EVENING DRESS, ?1936 London

Front and back V-neck; double-twisted knot at bustline pulling in fullness; full flared skirt. Initial fabrics and client unknown.

Additional versions: **1936** grey-green charmeuse (Mrs. H. S. H. Guinness).
Marit Guinness Aschan

25 EVENING DRESS, 1936 London

Scoop neck; sleeveless; bias cut with irregularly twisted cord around three-quarters of waist; side twist at mid-thigh; slight train. Initial fabrics and client unknown.

Additional versions: **1936** black novelty weave silk satin-faced crepe woven with cellophane (Mrs. H. S. H. Guinness).
Marit Guinness Aschan

26 DINNER DRESS, 1936 London

Slashed halter neckline; short sleeves; front crossed over hip; harem-like drape. Initial fabrics and client unknown.

Additional versions: **?1936** black velvet (Mrs. Oliver Burr Jennings); fabrics unknown (Gypsy Rose Lee).
Charles James Archives

27 EVENING DRESS, 1936 Paris

Scoop neck with flounce over wide shoulders; sleeveless; bias-cut fitted bodice coming to point at center back; draped skirt. Initial fabrics and client unknown.

Additional versions: **1936** flesh-colored silk satin with black cellophane cloth trim (Mrs. St. John Hutchinson).
Charles James Archives

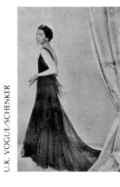

28 EVENING GOWN, 1936 ?London

Series of geometric shapes; unfitted bodice; diagonal flounce hemline to back waist, over back bustle and train. Initial fabrics and client unknown.

Additional versions: **?1936** black rayon georgette.
References: U.K. *Vogue*, May 13, 1936, p. 63.

29 EVENING GOWN AND STOLE, 1936 London

Shoestring shoulder straps; central cornucopia front folds; laced back; flared skirt with three two-thirds arc flounce inserts. Designed initially in pink silk satin ribbon, mustard satin and pale blue paper silk taffeta for Anne, Countess of Rosse. Evolved into skirt of "Abstract" dress (see cat. no. 114).

Anne, Countess of Rosse

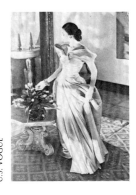

30 EVENING DRESS, 1936 London [CJ 135] ●

Off the shoulder with full cap sleeves and standaway rolled neckline in front. Various skirts. Initial fabrics and client unknown.

Additional versions: **1939** black velvet and brown satin (Mrs. George S. Mahana). **1946** scarlet red bodice (Mrs. William Randolph Hearst, Jr.); black velvet and brown satin (Gypsy Rose Lee); ruby silk satin bodice, tobacco faille skirt (Millicent Rogers). **1948** ice-blue satin (Mrs. Mario Pansa). **?1948** scarlet red satin (Mrs. William Randolph Hearst, Jr.); grey satin bodice, gun metal silk taffeta skirt (Mrs. Howard Linn); fabrics unknown (Toni Frissell Bacon, Mrs. Joseph E. Davies @ $925, Muriel Francis, Jennifer Jones, Princess Stanislas Radziwill). **1949** black velvet and brown satin (Gypsy Rose Lee). **1950** blush rose satin and tea rose faille (Mrs. William S. Paley). **?1951** fabrics unknown (offered by The Dayton Co., The Simpson Co., and Neiman Marcus).

Patterns: paper 49.233.76; muslin 49.233.50; half muslin model 49.233.38

References: U.S. *Harper's Bazaar*, June 1948, p. 26; U.S. *Vogue*, June 1948, pp. 32, 113; *Flair*, May 1950, p. 47; *American Fabrics and Fashion*, Fall 1973, p. 18; *Collier's*, Sept. 1947, p. 101.

The Brooklyn Museum, Gift of Paul and Arturo Peralta-Ramos 54.141.92
[CHS]

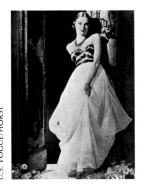

31 EVENING DRESS, 1936 Paris ●

Strapped, heart-shaped bodice; harem-draped, layered skirt. Initial fabrics and client unknown.

Additional versions: **1937** Colcombet silk ribbon bodice in emerald, pink, and royal purple, white silk mousseline skirt (Marit Guinness Aschan, imported by Russeks). **1945** Indian pearl grey sari silk with woven foil gold and silver leaves, draped asymmetrical halter neckline (Mrs. Harrison Williams).

References: U.S. *Vogue*, June 15, 1937, p. 64.

The Brooklyn Museum, Gift of Mrs. Harrison Williams 48.199.1

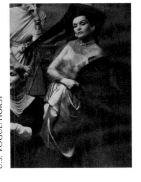

32 EVENING DRESS, 1936 Paris [CJ 112] ●

Draped hipline skirt; various bodice and sleeve treatments; draping placement and fullness varies. Initial fabrics and client unknown.

Additional versions: **1944** dark brown organza over pale grey organdy, labeled "Ch. James." **1945** lavender silk satin with black satin bow, labeled "Charles James/45" (Toni Frissell Bacon); pale lavender silk satin with chartreuse silk taffeta draped belt, labeled "Charles James/45" (Millicent Rogers); mauve changeable silk faille and eggplant silk satin with matching faille jacket lined with gold silk satin, labeled "Charles James/45" (Mrs. Harrison Williams). **1947** toast-brown silk satin.

Patterns: paper 49.233.73; muslin 49.233.47; half muslin model 49.233.33

References: U.S. *Vogue*, May 1, 1947, pp. 130–131, 176; The Brooklyn Museum sketches 57.218.16b.

The Brooklyn Museum, Gift of Mrs. Harrison Williams 48.199.2
[MMA]

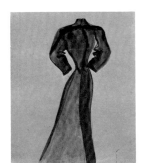

33 EVENING OUTFIT, 1936 Paris

Fitted bodice with inset sleeves; points at waistline; gored skirt. Initial fabrics and client unknown.

Additional versions: **1936** red millinery grosgrain (Elizabeth Arden). **1937** fabrics unknown (offered by Bonwit Teller, Hattie Carnegie, and Sally Milgrim).

References: The Brooklyn Museum sketches 57.218.11a.

34 EVENING DRESS, ?1937 London

Double shoestring halter straps; looped-in Y-stay at center back; fan-folded bodice front and back; sheath skirt with slight train. Initial fabrics and client unknown.

Additional versions: **1937** black silk satin (Philippa Barnes).
Victoria and Albert Museum, Gift of Miss Hawthorne Barnes T288.1978

35 EVENING DRESS, ?1937 ?London

Scoop neck with tab over bustline; fabric fingers down flared skirt. Initial fabrics and client unknown. ☐

Additional versions: **1937** fabrics unknown (offered by Russeks).

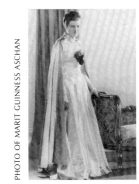

36 RIBBON BALL GOWN, 1937 Paris [CJ 173] ●

Strapped or strapless boned bodice; skirt of tapered ribbon gores forming two overlapping panels with pointed hemline. Later versions with divided attached skirt and even hemline. Developed from a design for a cape (see cat. no. 374). Initial fabrics and client unknown.

Additional versions: **1937** white taffeta ribbon bodice, skirt of robin's egg blue, white, and pink taffeta ribbons (Marit Guinness Aschan); ice-cream colors, made from ribbons (Mrs. Arturo Lopez-Willshaw). **1946** bodice of honey satin skirt of satin pastels (Mrs. Ernest Beaton). **?1946** fabrics unknown (Mrs. Sidney Kent Legaré, Mrs. Sidney Legendre). **1947** white satin bodice, blue satin and faille, grey and aqua taffeta, gold satin, custom-dyed (Millicent Rogers). **?1947** black silk jersey, skirt of maroon, white, bright blue faille, pale pink charmeuse, pale blue satin, gold cannelle silk, black silk jersey (Mrs. Joseph Love); fabrics unknown (offered by Dayton Co.). **1951** black velvet bodice, skirt of aqua faille, chocolate satin, pale blue charmeuse, eggshell faille, brown satin, gold cannelle silk @ $850 (Mrs. Robert Horne Charles); grey satin bodice, skirt of pale green, yellow, blue, grey @ $600 (Mrs. Douglas Fairbanks, Jr.); fabrics unknown (Mrs. Billy Rose).

References: U.S. *Vogue*, March 15, 1947, p. 179; June 1948, p. 113; *Collier's*, Sept. 1947, p. 101.

The Brooklyn Museum, Gift of Millicent Rogers 49.233.14
[CEDC, MMA, NMAH, Marit Guinness Aschan]

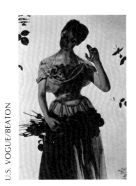

37 "CORSELETTE" or "L'SYLPHIDE" EVENING DRESS, 1937 Paris ●

Draped neckline revealing flowers; twisted shoulder straps; girdle-of-the-graces-shape, stitched, back-lacing boned corselette over matching waistline-inset; layered full skirt either plain or with kneeline darts. Corselette based on 1860s prototype. Initial fabrics and client unknown.

Additional versions: **1937** white organza over white taffeta, white satin, pink cord (Anne, Countess of Rosse); saffron and flesh organza, crepe-faced slipper satin, pale yellow-gold silk satin bodice and corselette, rose cord, salmon and pale tangerine roses (Marit Guinness Aschan); white organza over cream charmeuse, pink satin, pink cord, shaded pink roses, labeled "Made in France" (Esme O'Brien); mauve organza with flowers (offered by Best & Co.); white satin with flowers (offered by Hattie Carnegie).

References: U.K. *Harper's Bazar*, May 1937, pp. 106–107; U.S. *Vogue*, June 1, 1937, p. 49.

Fashion Institute of Technology, Gift of Mrs. John Hammond 1977.89.3
[Anne, Countess of Rosse; Marit Guinness Aschan]

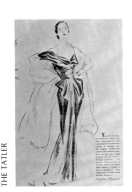

38 EVENING DRESS, 1937 London

Wide shoulders; teardrop-shaped neckline supported by narrow shoulder straps; fitted bodice with centrally pointed waistline above triangular, draped skirt point; hipline drapery, sheath skirt; bias cut. Initial fabrics and client unknown.

Additonal versions: **?1937** novelty moire and petersham ribbon (Bradley Salon).

References: The *Tatler*, Sept. 29, ?1937, p. XXIII.

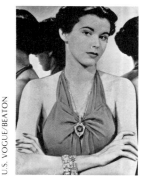

39 EVENING DRESS, 1937 London ●

Halter neckline formed from divided, wedge-shaped drape of front panel pulled through open knot of body-encircling bustline drape. Initial fabrics and client unknown.

Additional versions: **1938** fuchsia silk crepe, labeled "James/15 Bruton St./London W." (Marit Guinness Aschan).
References: U.S. Vogue, Nov. 1, 1937, p. 75.
Marit Guinness Aschan

40 DRESS, 1937 Paris

With train. Initial fabrics and client unknown. □

Additonal versions: **1937** flowered orange Colcombet silk (Marit Guinness Aschan).

41 EVENING DRESS, 1937 London

Short cyclamen-shaped sleeves. Initial fabrics and client unknown. □

Additional versions: **1937** pink satin with mauve sleeve lining (Marit Guinness Aschan).

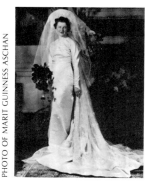

42 WEDDING DRESS AND SLIP, 1937 London

Princess line; V-neckline above double points; draped sham cummerbund; wide "Watteau" folded back, falling into four-foot wide pointed train; long arc sleeves cut in one with dress and ending in point over hand. Designed initially in pinkish pearl Lyon silk satin, tulle, and crepe-faced silk satin for Marit Guinness (Aschan). Labeled "James/ 15 Bruton St./London W."

Marit Guinness Aschan

43 EVENING DRESS, 1937 London

Asymmetrical front neckline; crossover-strap back V-neckline; back bustle crescent shaped and off to side, supported with crin, partial drape in front across sheath skirt, fitted with hemline flare and kick-out at front hemline. Initial fabrics and client unknown.

Additional versions: **?1937** black faille (Anne, Countess of Rosse).
Anne, Countess of Rosse

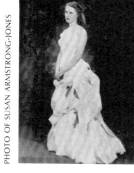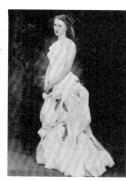

44 BALL GOWN, 1938 Paris ●

Crossover shoestring straps; fitted, draped bodice; bouilloné skirt tied up randomly with streamer bows; hemline flounce. Initial fabrics and client unknown.

Additional versions: **1938** pale blue cotton organdy, colored satin ribbons (Mme. Arturo Lopez-Willshaw); pink silk faille, pink organza, ribbons in dark apple green gold, emerald, two shades of blue, three shades of pink, white, and ice blue, labeled "James/15 Bruton St./London W." (Anne, Countess of Rosse).
References: The Brooklyn Museum sketches 57.218.16a.
Anne, Countess of Rosse

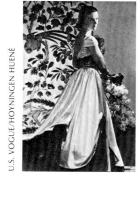

45 EVENING DRESS, 1938 London

Sweetheart-shaped neckline; twisted shoulder straps; overlaid, flared lace bodice; dropped waist; tri-looped skirt with three tucks gathered into bowed trim, worn over wired, layered underskirt. Designed initially in cream white silk satin, black chantilly lace, and velvet bows for Anne, Countess of Rosse.

References: U.S. Vogue, May 15, 1938, p. 62.
Anne, Countess of Rosse

46 "STARFISH" EVENING DRESS, 1938 Paris

Strapless bodice of three lozenge shapes; long, full skirt with hemline structure of elevated star form. Initial fabrics and client unknown.

Additional versions: **1938** black.
Charles James Archives

47 DINNER DRESS, 1938 Paris

Stitched, draped bertha; shallow V-neckline with front cut in one with sleeves; lined and interwoven with lozenge-shaped void; double-pyramid waistline seam; sheath skirt of four panels. Initial fabrics and client unknown.

Additional versions: **1939** printed green silk crepe with draped mask motif designed and signed by Jean Cocteau, labeled "James/15 Bruton St./London W."
Victoria and Albert Museum, Gift of Charles James T274.1974

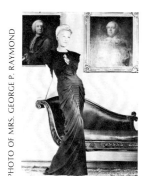

48 "LA SIRÈNE" EVENING DRESS, 1938 Paris [CJ 100] ●

Horizontally tucked bodice; skirt shirred in back and on either side of funnel-shaped front panel; bias-cut hemline flounce. Various neckline and sleeve treatments. Designed initially in crepe for Mrs. Oliver Burr Jennings.

Additional versions: **1938** fabrics unknown (Comtesse Elie de Ganay). **1939** fabrics unknown (Gypsy Rose Lee). **1940** scarlet red silk and wool crepe with matching silk crepe lining (Doris Duke). **1941** navy crepe with matching satin-backed crepe lining @ $315 (Mrs. William Hunt). **?1941** black crepe (Mrs. George P. Raymond). **1944** black (offered by Elizabeth Arden). **1951** fabrics unknown @ $825 (Mrs. Vernon Taylor). **1955** white silk crepe (merchandised by Lord & Taylor).
References: U.S. Vogue, Dec. 1944, p. 55; sculpture by Nicolesco Dorobantzau in the collection of Mrs. George P. Raymond, New York; The Brooklyn Museum sketches 57.218.2.
Fashion Institute of Technology, Gift of Doris Duke 71.265 [CHS, CJA, Mrs. George P. Raymond]

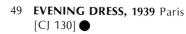

49 EVENING DRESS, 1939 Paris [CJ 130] ●

Strapped or strapless draped-front gown with front raised pouff. Designed initially in 1939 and completed in 1947 in pearl grey silk satin (labeled "Ch. James/47") for Millicent Rogers.

Additional versions: **1947** cerulean silk satin; fabrics unknown (Mrs. Robert Sarnoff, Mrs. Louis Soles; offered by D. H. Holmes, Dayton Co., and Simpson Co.). **1949** silver-grey silk satin with black velvet bodice. **?1950** pink silk satin.
Patterns: paper 49.233.74; muslin 49.233.48 half muslin model 49.233.39
References: U.S. Harper's Bazaar, April 1947, p. 181; U.S. Vogue, June 1948, p. 113; Holiday, Jan. 1949, p. 121; Chicago Daily Tribune, Nov. 18, 1958; Collier's, Sept. 1947, pp. 100–101; The Brooklyn Museum sketches.
The Brooklyn Museum, Gift of Paul and Arturo Peralta-Ramos 54.141.93 [CJA, NMAH]

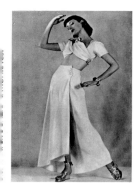

50 DINNER SUIT WITH FIGURE-8 SKIRT, 1939

Culotte passing between legs and wrapping over front and back; one-piece pattern; cut on bias; draped crossover bodice. Designed initially for Diana Vreeland and the Fashion Group Show (fabrics unknown).

Additional versions: **1940** ice white celbrook by Celanese with three gold fasteners. **1941** white rayon rip cord, three gold fasteners (offered by B. Altman & Co., Burdines, and Carson, Pirie, Scott, & Co.). **?1942** fabrics unknown (Doris Duke, Gypsy Rose Lee; offered by Lord & Taylor).
Patterns: muslin model V&A T21.1980
References: Current Biography, July 1956, p. 36; *U.S. Harper's Bazaar,* Jan. 1940, p. 52; Jan. 1941, p. 81.
Victoria and Albert Museum, Gift of Homer Layne T21.1980

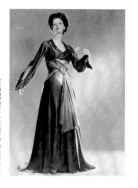

51 DINNER DRESS, ?1939 ●

Slashed-seam shawl collar; long, draped, slashed, and faced sleeves knotted at wrist; Empire crossover bodice with wide lacing tie; hipline shaped yoke; semi-circular skirt. Initial fabrics and client unknown.

Additional versions: **1941** peacock crepe-backed silk satin, Prussian blue crepe and magenta chiffon (Mrs. George P. Raymond). **?1942** fabrics unknown (Gypsy Rose Lee).
The Brooklyn Museum, Gift of Mrs. George P. Raymond 81.5

52 DINNER DRESS, 1941

Shawl neckline; long arc sleeves; seamed at waist; figure-8 skirt. Initial fabrics and client unknown. □

Additional versions: **1941** grey-brown satin.
Charles James Archives

53 EVENING DRESS, 1942

Fitted one-piece dress with sham bolero front; Y-back bodice; contrasting inserts over bust; draped point in front; harem drape at hipline. Designed initially for Gypsy Rose Lee (fabrics unknown).

References: The Brooklyn Museum sketches 57.218.16.

54 EVENING DRESS, 1944 ●

Asymmetrical bias cut; halter-like neckline with left side insert stiffened to form standing tab; back bodice with ovoid opening above hipline yoke; flared skirt with side vent with rounded edges. Designed initially for Elizabeth Arden (fabrics unknown).

Additional versions: **1944** black silk satin and black silk jersey, labeled "Charles James" (Mrs. William Woodward, Jr.). **1947** black rayon satin and black rayon jersey (American Bemberg Co.).
References: The Soho Weekly News, Sept. 28, 1978, p. 33.
The Metropolitan Museum of Art, Gift of Mrs. William Woodward, Jr. 64.74.1
[CJA]

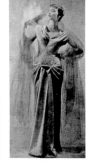

55 EVENING DRESS, 1944 ●

Fitted sheath; shoulderline folded drapery; center-front hipline drapery. Initial fabrics and client unknown.

Additional versions: **1945** old rose crepe-backed silk satin (Millicent Rogers). **1947** silvery pink satin (offered by Dayton Co. and by Julius Garfinckel). **1950** silver grey.
References: U.S. Vogue, April 15, 1947, p. 122; *U.S. Harper's Bazaar,* April 1950, p. 178.
The Brooklyn Museum, Gift of Paul and Arturo Peralta-Ramos 54.141.86

56 EVENING DRESS, 1944

Heart-shaped neckline; short sleeves; shaped bustline; fitted torso; thighline drapery from center front; triangular bustline inserts. Designed initially for Elizabeth Arden (fabrics unknown).

Additional versions: **1944** navy satin, flesh net.
Charles James Archives

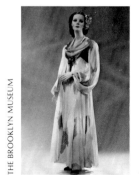

57 EVENING DRESS, 1944

Shoestring straps; draped bustline; inset lozenge waistband; stiffened pannier-like, draped hipline; slit hemline flare. Initial fabrics and client unknown.

Additional versions: **1944** pink satin; black satin, black jersey.
References: U.S. Vogue, Dec. 1944, p. 52.
Fashion Institute of Technology 76.2.3

58 EVENING DRESS, 1944 ●

Sweetheart front neck; wide crossover straps in back; back waistline yoke; skirt draped to one side. Initial fabrics and client unknown.

Additional versions: **1944** fabrics unknown (Duchess de Gramont). **1945** red-orange taffeta, orange georgette over cream white taffeta, labeled "Ch. James" (Millicent Rogers).
The Brooklyn Museum, Gift of Millicent Rogers 51.33

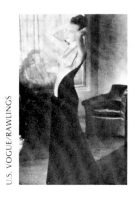

59 EVENING DRESS, 1944 [CJ 101] ●

Cowl neck; bishop sleeves; fitted inset bodice; ankle-length circular skirt. Designed initially in imported organdy woven with lilac spray motif, cream silk satin, and maroon crepe for Millicent Rogers.

Additional versions: **1948** fabrics unknown (Jennifer Jones).
The Brooklyn Museum, Gift of Millicent Rogers 49.233.11

60 EVENING DRESS, 1945

Sheath; narrow shoulder straps cut in one with deep front yoke reaching hipline. Designed initially in black velvet and Benedictine satin for ·Mrs. William Randolph Hearst, Jr.

References: U.S. Vogue, Dec. 1, 1945, p. 134; *American Fabrics and Fashions,* Fall 1973, p. 19.

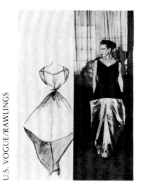

61 "PARACHUTE" DINNER DRESS, 1945 ●

Draped V-neck; cutout back with bow closure at shoulder blades; fitted bodice with deep hipline yoke; tulip-shaped skirt with panniered effect. Initial fabrics and client unknown.

Additional versions: **1945** dark yellow-blue changeable chiffon, moss green taffeta, ombre alligator-patterned striped upholstery fabric, labeled "Ch. James/45" (Mrs. William Rand); black velvet and biscuit satin (Mrs. William Woodward, Jr.). **?1945** fabrics unknown (Mrs. William Randolph Hearst, Jr.).
References: U.S. Vogue, Dec. 1, 1945, p. 135.
The Metropolitan Museum of Art, Gift of Mrs. William Rand 1975.145.1

62 DINNER DRESS, ?1946

V-neck with slight sweetheart drapery; wide sawtooth line under bust; fitted bodice with dip at back waist; flower-bud-shaped sleeves with side cut out; fitted bias-cut skirt back with front picked up to form stitched-down panniers; attached slip. Initial fabrics and client unknown.

Additional versions: **1946** off-white, pink organza with woven pink, blue, and gold stripes, white satin slip, labeled "Ch. James/46" (Mrs. Joseph Mellen).
Art Students League

63 EVENING DRESS, ?1946

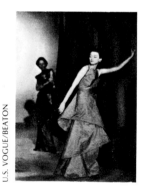

Spirally constructed and flaring concentrically; fitted bodice with neckline in the shape of a huge folded leaf. Initial fabrics and client unknown.

Additional versions: **1946** fuchsia millinery taffeta (Dayton Co.).
References: U.S. Vogue, July 1946, p. 70.

64 EVENING DRESS, ?1946
(see cat. illustration 63)

Broad shoulders; sheath-shaped skirt slashed to reveal underlayer. Initial fabrics and client unknown.

Additional versions: **1946** lead-colored faille, gunmetal satin.
References: U.S. Vogue, July 1946, p. 70.

65 EVENING DRESS, ?1946

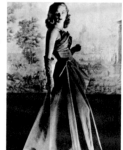

Bustline folded to points attached to thin straps; fitted bodice; hipline drapery; flared skirt. Initial fabrics and client unknown.

Additional versions: **1946** cobalt faille (Dayton Co.).
References: U.S. Harper's Bazaar, Oct. 1946, p. 267.

66 EVENING DRESS, 1946

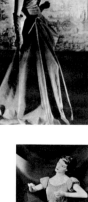

Short full sleeves; scoop neckline; hipline yoke; full shirred skirt. Designed initially in mauve jersey with a narrow, gold leather tie belt for Millicent Rogers (at client's suggestion).
The Brooklyn Museum, Gift of Millicent Rogers 49.233.1

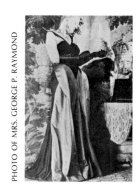

67 EVENING DRESS, 1946 [CJ 132] ●

Strapped V-neck; fitted bodice; winged side panels; fluid, draped back. Designed initially with a bodice of black silk velvet and a skirt of tobacco silk faille, garnet silk satin, and black wool-backed silk crepe for Millicent Rogers.

Additional versions: **1946** same fabrics as initial design (Mrs. George P. Raymond). **?1947** fabrics unknown (Princess Bon Compagne, Mrs. Sidney Kent Legarè, Mrs. Warren Pershing; offered by Dayton Co.). **1948** fabrics unknown (Mrs. Jack Heinz, II).
Patterns: paper 49.233.75; muslin 49.233.49; half muslin model 49.233.30
References: Collier's, Sept. 1947, p. 100.
The Brooklyn Museum, Gift of Millicent Rogers 49.233.4 [WA]

68 EVENING DRESS, 1946 [CJ 148] ●

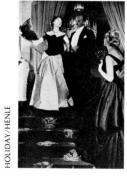

Strapped fitted bodice; long skirt gathered up into four padded hipline pouffs. Initial fabrics and client unknown.

Additional versions: **1947** fabrics unknown (offered by D. H. Holmes). **1948** ice-blue silk satin, part of trousseau (Mrs. Walter Jeffords); sea-green Benedictine silk satin from Ben Mann; laurel green silk satin and silk faille from Ben Mann; fabrics unknown (offered by Carson, Pirie, Scott & Co., Julius Garfinckel, and Simpson Co.). **1951** cream white satin @ $850, labeled "Charles James/51" (Cynthia Cunningham); satin @ $875 (Mrs. Richard Reynolds).
Patterns: paper 49.233.78; muslin 49.233.52; half muslin model 49.233.40
References: U.S. Vogue, June 1948, p. 113; Nov. 1, 1948, p. 107; U.S. Harper's Bazaar, Nov. 1948, p. 119; Dec. 1948, p. 104.
The Brooklyn Museum, Gift of Mr. & Mrs. Robert Coulson 64.109.1

69 EVENING DRESS, 1947

Halter bodice on cartridge-pleated skirt attached to pointed hipline yoke. Initial fabrics and client unknown. □
Additional versions: **?1947** turquoise and black satin.

70 EVENING DRESS, 1947 ●

Straight-cut halter bodice with entwined crossover straps in back; narrow back waistline yoke; deep center-front box pleat with side folds off slim front going into bustled back, pulled up into a tab over the waistline. Initial fabrics and client unknown.

Additional versions: **1947** black silk satin and black velvet, labeled "Ch. James/47" (Mrs. William Woodward, Jr.). **?1947** silver lavender lamé, labeled "Ch. James" (offered by Carson, Pirie, Scott & Co.). **?1948** black silk satin and velvet (Mrs. William Randolph Hearst, Jr., Millicent Rogers).
References: Holiday, Jan. 1949, p. 121.
The Brooklyn Museum, Gift of Millicent Rogers 49.233.18 [MMA]

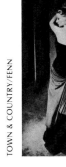

71 "BUSTLE" EVENING DRESS, 1947 [CJ 145] ●

Strapless, draped-back bodice; symmetrical polonaise-draped overskirt hanging low on back with rosette knot tournure. Designed initially with a bodice of black silk velvet and a stiff slipper satin skirt draped with tobacco brown jersey for Millicent Rogers.

Additional versions: **1947** celedon green silk satin-faced taffeta bodice, grey ribbed taffeta overskirt, cinnamon brown silk satin underskirt — fabrics originally ordered by King Leopold of Belgium from the New York City interior decorator Rose Cummings as furnishing fabrics for the royal palace at Laeken; order cancelled after death of Queen Astrid (Mrs. George P. Raymond). **?1947** black silk velvet bodice, black silk taffeta and crepe skirt draped with brown birdseye-faced silk @ $650 (Mrs. Robert Horne Charles). **1948** black silk velvet bodice, black satin skirt with black taffeta underskirt and brown silk faille overskirt, labeled "Charles James/48" (Mrs. Gilbert Miller). **?1948** fabrics unknown (Margaret Case, Mrs. Jean de Menil, Mrs. William S. Paley; offered by D. H. Holmes, Carson, Pirie, Scott & Co., and Julius Garfinckel). **?1949** black velvet and purple satin (Mrs. Leland Hayward). **?1950** fabrics unknown (Mrs. Rudolph A. Bernatschke).
Patterns: paper 49.233.77; muslin 49.233.51; half muslin model 49.233.37
References: The American Weekly, March 22, 1953, p. 12; *Town & Country,* July 1948, p. 38; Oct. 1949, p. 71.
The Brooklyn Museum, Gift of Millicent Rogers 49.233.37
[NMAH, WA]

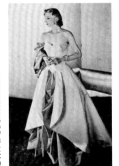

72 EVENING DRESS, 1947 [CJ 151] ●

Draped, strapless bustline; fitted bodice; arched overskirt with turned back revers; draped underskirt. Designed initially for Millicent Rogers (fabrics unknown).

Additional versions: **1948** pale pink silk faille with saffron silk taffeta, labeled "Charles James/48" (Millicent Rogers); flesh silk faille with deep peach peau de soie, white taffeta underskirt, labeled "Charles James/48" (Millicent Rogers). **?1948** grey mauve silk satin with mustard-gold taffeta (Mrs. Joseph Love); brocaded lamé (offered by Carson, Pirie, Scott & Co.); fabrics unknown (Mrs. Henry Fonda, Mrs. William Randolph Hearst, Jr.; offered by Julius Garfinckel). **?1949** fabrics unknown (Jennifer Jones).
Patterns: paper 49.233.79; muslin 49.233.53; half muslin model 49.233.32
References: Town & Country, July 1948, p. 39; *Coronet,* Dec. 1948, p. 78; *American Weekly,* March 22, 1953, p. 12.
The Brooklyn Museum, Gift of Paul and Arturo Peralta-Ramos 54.141.94
[CJA, WA]

73 EVENING DRESS, ?1948

Sweetheart-shaped neckline with shoulder strap and fitted, V-pointed waistline; full overskirt with arced hemline and central draped panel. Initial fabrics and client unknown.

Additional versions: **1948** apricot silk faille, eggplant satin over black velvet (The Fashion House).
References: U.S. Vogue, March 1, 1948, p. 215.

74 EVENING DRESS, ?1948

Jacket — V-neck; clutch closure; waist length with cutaway tail; long sleeves with pointed, flared cuffs. Gown — trimmed bodice; flared skirt. Initial fabrics and client unknown.

Additional versions: **?1948** white wool trimmed with green velvet (Alice Topp-Lee).
Missouri Historical Society, Gift of Alice Topp-Lee

75 EVENING GOWN, ?1948 [CJ 165]

Initial fabrics and client unknown. □

Additional versions: **1951** fabrics unknown @ $600 (Mrs. Douglas Fairbanks, Jr.).

76 EVENING DRESS, ?1948 [CJ 170]

Initial fabrics and client unknown. □

Additional versions: **1951** fabrics unknown, CJ 170A @ $850 (Mrs. S. Bronfman).

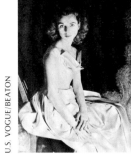

77 EVENING DRESS, 1948

Winged V-neckline; shoulder straps; fitted bodice; draped skirt. Designed initially in pale blue satin for Mrs. Richard T. Wharton.

Additional versions: **1948** black silk velvet, silver grey satin.
References: U.S. Vogue, July 1948, p. 48; *Holiday,* Jan. 1949, p. 121.

78 EVENING DRESS, ?1948

Ribbon bows with long streamers spreading over skirt. Initial fabrics and client unknown. □

Additional versions: **?1948** red velvet, white organza, red velvet-faced satin ribbon (Mrs. Robert Horne Charles).

79 EVENING GOWN, ?1948

Diagonally draped single shoulder with folded bow at side waistline; back drapery to full skirt. Initial fabrics and client unknown.

Additional versions: **1948** water lily shades, green taffeta, pale yellow-green satin (D. H. Holmes); white satin and faille from Ben Mann (The Fashion House).
References: U.S. Harper's Bazaar, March 1948, p. 178; *U.S. Vogue,* June 1948, p. 113.

80 WEDDING GOWN, 1948 ●

V-neck; short over-sleeves; draped bustline; fitted torso; lobed waistline; draped hipline panels extending to draped and puffed back bustle; shallow train. Designed initially in cream silk satin, white tulle, lilac chiffon, and white taffeta with silk lace appliques for Austine McDonnell Cassini (Mrs. William Randolph Hearst, Jr.).

Mrs. William Randolph Hearst, Jr.

81 EVENING and WEDDING DRESS, 1949 ●

Sweetheart neckline; twisted shoulder straps; draped bustline; V-pointed waistline; bustle-back overskirt; full underskirt of contrasting material. Initial fabrics and client unknown.

Additional versions: **1949** lavender and lime green (Mrs. Edmond G. Bradfield); pale shell-pink silk satin and ivory taffeta with train (Jane Lee), periwinkle blue satin and aquamarine taffeta (Mrs. Ronald Tree); lavender satin and ice-blue taffeta (Personal Products).
References: U.S. Harper's Bazaar, June 1949, p. 114; *U.S. Vogue,* Nov. 1, 1954, pp. 112–115.
The Metropolitan Museum of Art, Gift of Marietta Tree 65.36.1
[Jane Love Lee]

82 BALL GOWN, 1949 [CJ 174]

Initial fabrics and client unknown. □

Additional versions: **1951** fabrics unknown @ $925 (Mrs. Joseph E. Davies, Mrs. William S. Paley); fabrics unknown, CJ 174D @ $750 (Grace Parker Pickering); fabrics unknown, CJ 174C jacket @ $475 (Mrs. Vernon Taylor).

83 CONCERT or BALL GOWN, 1949 [CJ 175] ●

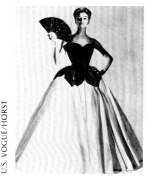

U.S. VOGUE/RAWLINGS

Strapped, draped, and fitted bodice; asymmetrical polonaise drape; pleated underskirt. Designed initially with a bodice of ruby silk velvet, an overskirt of garnet Catoir silk satin, and an underskirt of white organdy for Mrs. William S. Paley.

Additional versions: **1949** same fabrics as initial design (Mrs. William Randolph Hearst, Jr., Eleanor Lambert, Millicent Rogers, Gloria Swanson). **1951** same fabrics as initial design (Baroness W. Langer von Langendorff, Lily Pons, Jennifer Jones). **?1951** same fabrics as initial design (Mrs. H. Coffina, Mrs. Douglas Fairbanks, Jr.).

Patterns: paper 53.170

References: U.S. Vogue, Nov. 1, 1950, pp. 114–115; Jessica Davis, ed., *The World in Vogue* (New York: Viking Press, 1963), p. 300.

The Brooklyn Museum, Gift of Paul and Arturo Peralta-Ramos 54.141.91
[MMA, RISD, Mrs. Douglas Fairbanks, Jr.]

84 "LEAF" DRESS, 1949 [CJ 177]

Initial fabrics and client unknown. □

Additional versions: **1951** fabrics unknown @ $775 (Mrs. Cornelius Vanderbilt Whitney).

85 "PETAL BALL" GOWN, 1949 [CJ 180] ●

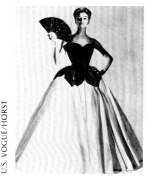

U.S. VOGUE/HORST

Short sleeved or strapless; heart-shaped neckline; fitted bodice; petal-shaped hip yoke attached to a full skirt over organdy and nylon horsehair underskirts. Designed initially for Millicent Rogers (fabrics unknown).

Additional versions: **1951** light green taffeta, overlaid peplum, mid-calf-length skirt (Mrs. Robert Coulson); fabrics unknown @ $825 (Mrs. Robert Guggenheim); black velvet, black satin, white taffeta @ $625, labeled "C James/51" (Mrs. Byron Harvey, Jr.); fabrics unknown @ $700 (Lisa Kirk); fabrics unknown @ $975 (Millicent Rogers); fabrics unknown @ $850 (Mrs. Cornelius Vanderbilt Whitney); fabrics unknown (Mrs. Fred Lowell, Mrs. Walter Savory); black silk velvet, black silk satin, white silk taffeta (offered by Lord & Taylor). **?1951** fabrics unknown (Mrs. Sterling Morton, Mrs. William S. Paley). **1952** yellow-green silk velvet, ivory silk taffeta (Mrs. Ronald Tree). **?1953** pale satin, organdy. **1957** pearl grey satin, blue grey velvet and taffeta (Joni James); yellow satin, gold faille, CJ 181A (Joni James).

References: U.S. Vogue, Nov. 1, 1951, p. 89; Oct. 15, 1954, p. 79; The Brooklyn Museum sketches 57.218.15.

Chicago Historical Society, Gift of Mrs. Byron Harvey, Jr. 1960.26
[TBM, MMA]

86 LATE-AFTERNOON DRESS, 1949 [CJ 182]

Initial fabrics and client unknown. □

Additional versions: **1951** fabrics unknown @ $625 (Mrs. James T. Cunningham).

87 DINNER DRESS, 1949 [CJ 183]

Initial fabrics and client unknown. □

Additional versions: **1951** fabrics unknown @ $700 (Lisa Kirk); fabrics unknown @ $675 (Martha Roundtree); satin @ $775 (Mrs. Cornelius Vanderbilt Whitney); fabrics unknown @ $750 and $775 (offered by Lord & Taylor).

88 BALL GOWN, 1949 [CJ 184]

Initial fabrics and client unknown. □

Additional versions: **1951** fabrics unknown @ $625 (Mrs. William Randolph Hearst, Jr.).

89 EVENING DRESS, 1949 [CJ 185]

Initial fabrics and client unknown. □

Additional versions: **1951** fabrics unknown @ $700 (Lisa Kirk).

90 EVENING GOWN, 1949 [CJ 186]

Initial fabrics and client unknown. □

Additional versions: **1951** fabrics unknown @ $775 (Martha Roundtree).

91 BUSTLE or "SWAN" BALL GOWN, 1949 [CJ 187] ●

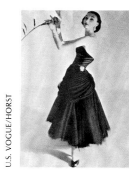

U.S. VOGUE/HORST

Strapped or strapless fitted bodice; draped apron polonaise; divided skirt in back; full-length, mid-calf, or dipping hemline. Designed initially in black chiffon and tulle for Jennifer Jones.

Additional versions: **1949** chestnut-brown chiffon, white satin, and brown, yellow, salmon, purple, and chartreuse tulle, labeled "C. James/51" (Mrs. Corson Ellis); off-white satin, black tulle with fringe, and black, black-brown, chestnut, mocha, and beige tulle (Mrs. William Randolph Hearst, Jr.); black chiffon, black taffeta, black tulle over brown tulle shaded from dark brown to beige (Eleanor Lambert); chestnut-brown tulle (Alice Topp-Lee); fabrics unknown @ $825 (Mrs. Ivan Obolensky); black chiffon, white satin, tulle, short skirt (offered by Lord & Taylor). **1951** black chiffon, black taffeta, layered black tulle (Mrs. Lester Hano). **?1951** black chiffon, white satin, multi-colored tulle @ $925 (Elizabeth Fairall). **1953** black chiffon, pale-pink satin, and black, rose, pink, and oyster-white tulle, labeled "An Original Design/by Charles James" (Mrs. Rodman A. de Heeren). **1954** brown chiffon, white satin, and chestnut-brown, yellow, salmon, purple, and chartreuse tulle (Mrs. Charles James); brown chiffon, white satin, multi-colored tulle (Alice Topp-Lee); brown chiffon, white satin, and brown, orange, peach, fuchsia, gold, and ocher tulle, labeled "Charles James/54" (Mrs. Cornelius Vanderbilt Whitney); yellow-grey chiffon over white satin, white tulle, labeled "Charles James/54" (Mrs. Cornelius Vanderbilt Whitney). **1955** grey-blue chiffon, pink satin, and oyster-white, pale grey-blue, orchid, medium-blue tulle, labeled "Charles James/55" (Mrs. Joseph Love); fabrics unknown (marketed by Samuel Winston and sold as designed by Roxanne). **1956** white chiffon, satin, and tulle (Mrs. Charles James); deep-peach chiffon, white satin, colored tulle (Mme. Arturo Lopez-Willshaw). **1957** white (marketed by Charles James Associates); brown, CJ 187G (marketed by Charles James Associates); brown, CJ 187 (marketed by Charles James Associates); brown, CJ 187M (marketed by Charles James Associates). **?1958** fabrics unknown (Mrs. Byron Harvey, Jr., Patrice Munsel, Mrs. Ronald Tree; merchandised by Lord & Taylor).

References: U.S. Vogue, Nov. 15, 1951, pp. 86–87.
The Brooklyn Museum, Gift of Mr. Rodman A. de Heeren 61.42.16

[CEDC, CHS, LACM, MHS, MMA, WA]

92 EVENING DRESS, 1949 [CJ 188]

Initial fabrics and client unknown. □

Additional versions: **1951** fabrics unknown @ $850 (Mrs. Vernon Taylor).

93 "TULIP" BALL GOWN, 1949

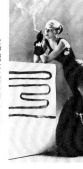

U.S. HARPER'S BAZAAR/AVEDON

Strapless, bow-shaped bustline; unstructured, fitted torso; gathered, structured, elliptical hemline flounce flaring from kneeline; some dipping in back. Initial fabrics and client unknown.

Additional versions: **1949** black satin, black faille. **?1950** black satin, black gros de Londres (Mrs. Sidney Kent Legaré). **1953** black velvet, off-white faille, labeled "Charles James/53/Townshop/de Pinna/Fifth Ave. N.Y." (offered by de Pinna). **?1953** navy satin, navy faille, labeled "Julius Garfinckel Co./Washington D.C." (offered by Julius Garfinckel). **?1972** black satin, black faille, V shoulder straps (Elizabeth S. de Cuevas).

References: U.S. Harper's Bazaar, July 1949, p. 50.
Homer Layne
[MMA, Elizabeth S. de Cuevas]

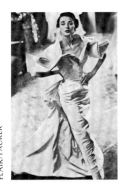

94 "ROSE" DRESS, 1950

Petal-clustered sleeves; stand away V-neck; fitted bodice; sheath skirt with full petal-shaped bustle. Designed initially in blush rose satin and tea rose faille for *Flair* magazine.

Additional versions: **1950** deep-wine satin, bittersweet faille, skirt draped to side and flared at hemline (Mrs. William Randolph Hearst, Jr.).

References: Flair, May 1950, p. 47; *Look*, Jan. 2, 1951, p. 52; The Brooklyn Museum sketches 57.218.

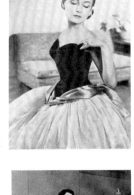

95 EVENING DRESS, 1950

Strapless fitted bodice extending over hips; crushed sash tied in back; full layered skirt. Initial fabrics and client unknown.

Additional versions: **1950** deep-ruby Martin velvet, orange satin, white organdy.

References: U.S. Harper's Bazaar, July 1950, p. 56.

96 BALL GOWN, 1950

Shawl collar; elbow-length sleeves; fitted bodice ending in hipline peplum constructed of yards of braid which separate 68 panels of full skirt; diagonal bustline sash with large bow. Designed initially in gold-ribbed military braid, starched grey lawn, and grey satin for Mme. Arturo Lopez-Willshaw.

References: Town & Country, April 1950, pp. 40–43; *U.S. Vogue*, Nov. 1, 1950, inside back cover.

97 BALL GOWN, 1951

V-neckline; sleeveless fitted bodice composed of fabric strips ending in large bows at hipline, with streamers ending at kneeline. Initial fabrics and client unknown.

Additional versions: **1951** blue, green, and gold taffeta and satin (Mrs. William Randolph Hearst, Jr.).

Museum of Art, Rhode Island School of Design, Gift of Mrs. William Randolph Hearst, Jr. 57.084.2

98 DEBUTANTE DRESS, 1951

Sweetheart neckline; cap sleeves gathered at shoulderline with two rows of stitching; fitted bodice with V-pointed waist; attached full skirt. Designed initially in pearl-grey silk taffeta for James's niece, Jane Smith.

Jane Smith Shearman

99 EVENING DRESS, 1951

Wide shoulder straps; draped bustline; fitted, pointed bodice with central puffed plastron; full hipline-draped skirt. Initial fabrics and client unknown.

Additional versions: **1951** pearl-grey chiffon over pale-blue silk satin, white taffeta slip (Mrs. Sidney K. Legaré, Alice Topp-Lee).

Homer Layne

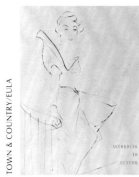

ACCORDING TO CUSTOM

100 EVENING GOWN, ?1951 ●

Pointed waist; fitted bodice with diagonally draped left-shoulder piece; skirt draped front and back from arc side darts and unpressed pleats. Initial fabrics and client unknown.

Additional versions: **1951** walnut-brown taffeta, laurel-green satin (Mrs. Cornelius Vanderbilt Whitney).

References: Town & Country, Oct. 1, 1951, pp. 122–123.

The Metropolitan Museum of Art, Gift of Eleanor S.W. McCollum 1975.246.7a-b

101 EVENING DRESS, ?1952

Strapless with shirred bustline; draped, heart-shaped bodice with dipping waistline point and diamond form flanking bustline; A-line, mid-calf-length skirt with flaring hem. Initial fabrics and client unknown.

Additional versions: **1952** turquoise taffeta, black velvet (marketed by Samuel Winston).

References: Sales catalogue, Christie's East, May 10, 1979, lot #73.

102 SHORT TUNIC EVENING DRESS, 1952

Wide V-neckline with wide, pointed revers; short sleeves; pointed waist; draped circular skirt with uneven hemline; draped sheath wraparound underskirt. Initial fabrics and client unknown.

Additional versions: **1952** tobacco-brown taffeta (Mrs. Rudolph A. Bernatschke).

The Brooklyn Museum, Gift of Mrs. Rudolph A. Bernatschke 55.194.17a&b

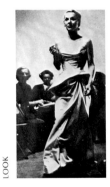

103 EVENING DRESS, 1952 ●

Strapless, asymmetrically draped, fitted bodice; flaring, asymmetrical peplum above left side drape in front; symmetrical back puffs above kneeline hemline flare. Initial fabrics and client unknown.

Additional versions: **1952** white silk satin (Mrs. Cornelius Vanderbilt Whitney); eggshell-white satin, labeled "Samuel Winston/by Charles James" (marketed by Samuel Winston). **?1952** white satin (Fabricant).

References: Look, Sept. 1952, p. 93.

The Metropolitan Museum of Art, Gift of Eleanor S. W. McCollum 1975.246.8
[FIT]

104 EVENING ENSEMBLE, ?1952

Jacket — shawl collar; fitted torso with shallow hipline peplum. Evening sheath — shoestring straps; heart-shaped bustline; fitted torso with flaring skirt. Strapless sheath — calf length; flared skirt; dipping hemline faced with red. Initial fabrics and client unknown.

Additional versions: **?1952** navy peau de soie, red silk (Alice Topp-Lee).

Missouri Historical Society, Gift of Alice Topp-Lee

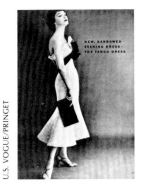

U.S. VOGUE/PRINGET

105 "TANGO" EVENING DRESS, 1952

Narrow, strapless, princess-line sheath with standaway handkerchief points; diagonal underbust band; calf-length, trumpet-flared skirt with backward dip. Designed initially for Lisa Kirk (fabrics unknown).

Additional versions: **1952** white Alençon lace, black faille, yellow taffeta (merchandised by Lord & Taylor, Hutzler Brothers, and I. Magnin); ivory lace from Charles Whelan, black taffeta (marketed by Samuel Winston).

References: U.S. Vogue, Sept. 1, 1952, p. 178.

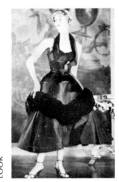

LOOK

106 "POUFF" EVENING DRESS, 1952 [CJ 199] ●

Draped, strapless, or petal halter fitted bodice; deep hipline-yoke, shirred undulating band; structured, side-pleated, flared skirt. Designed initially in midnight-blue duchess satin, black velvet, and black gros de Londres for Samuel Winston's 1952 fall collection.

Additional versions: **1952** same fabrics as initial design (Mrs. Jean de Menil, Mrs. Byron Harvey, Jr.); rose satin, black velvet, grey taffeta (Mrs. Cornelius Vanderbilt Whitney); fabrics unknown (Mrs. William Randolph Hearst, Jr.; offered by Lord & Taylor).

References: Look, Sept. 1952, p. 92.

The Brooklyn Museum, Gift of Mrs. Jean de Menil 53.73.1 [CHS, MCNY]

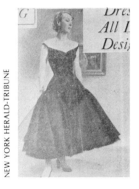

NEW YORK HERALD-TRIBUNE

107 "INFANTA" or "WILLIAMSBURG" SILHOUETTE EVENING DRESS, 1952

Strapped sweetheart neckline; fitted, encrusted torso with deep, rounded hip yoke; full layered skirt; flattened front and back, wide at sides. Designed initially for and marketed by Samuel Winston (fabrics unknown).

Additional versions: **1952** jet bugle beads, black, rust, yellow, green, beige, and brown silk tulle, labeled "Bramson" (Mrs. Julius Epstein).

References: New York Herald-Tribune, June 20, 1952; Look, Sept. 1952, pp. 91–93.

Chicago Historical Society, Gift of Mrs. Julius Epstein 1968.229

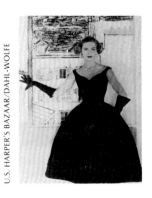

U.S. HARPER'S BAZAAR/DAHL-WOLFE

108 "INFANTA" or "WILLIAMSBURG" SILHOUETTE EVENING DRESS, 1952

Strapped sweetheart neckline; fitted bodice; mid-calf-length skirt; flattened front and back, wide at sides with ogival front hemline panel. Designed initially for and marketed by Samuel Winston (fabrics unknown).

Additional versions: **1952** black velvet, satin, and jet @ $495 (merchandised by Lord & Taylor, I. Magnin, and Pasternak).

References: U.S. Harper's Bazaar, Sept., 1952, p. 187; Look, Sept. 1952, pp. 91–93; The Brooklyn Museum sketches 57.218.8aa.

109 SHORT FORMAL EVENING DRESS, 1953

Long fitted torso; full skirt. Initial fabrics and client unknown. □

Additional versions: **1953** grey satin and faille (Neiman Marcus).

References: Dallas Morning News, Sept. 8, 1953, p. 2.

110 SHORT FORMAL EVENING DRESS, 1953

Wide neckline; covered shoulders; long torso; full skirt. Initial fabrics and client unknown. □

Additional versions: **1953** poison-green wool (offered by Neiman Marcus).

References: Dallas Morning News, Sept. 8, 1953, p. 2.

111 EVENING DRESS, 1953

Full-length fitted gown. Initial fabrics and client unknown. □

Additional versions: **1953** black sequins (offered by Neiman Marcus).

References: Dallas Morning News, Sept. 8, 1953, p. 2.

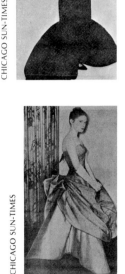

CHICAGO SUN-TIMES

112 "LAMPSHADE" EVENING GOWN, 1953 [CJ 1101] ●

Strapless; fitted torso; structured, figure-8-shaped kneeline flounce. Initial fabrics and client unknown.

Additional versions: **?1954** black velvet, black satin, CJ 1101(I) (Mrs. Charles James); fabrics unknown (Lisa Kirk); black velvet, black satin, white velvet, white satin (Marni Nixon). **1957** black velvet, black satin (Charles James Associates).

The Brooklyn Museum

113 BALL GOWN, 1953 [CJ 1103] ●

Crossover, fitted, strapless bodice; draped polonaise apron with back bow over cloverleaf underskirt. Designed initially in pink satin and Gallagher's cerise taffeta @ $925 for Neiman Marcus.

Additional versions: **1953** fabrics unknown (merchandised by Henry Harris, Garland's, Julius Garfinckel, Lord & Taylor, Neiman Marcus, Wanamaker's; marketed by Samuel Winston).

Fashion Institute of Technology

CHICAGO SUN-TIMES

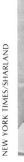

NEW YORK TIMES/SHARLAND

114 "FOUR-LEAF CLOVER" or "ABSTRACT" BALL GOWN, 1953 [CJ 1104] ●

Strapless, fitted bodice; structured, four-lobed skirt. Designed initially for Mrs. William Randolph Hearst, Jr. (fabrics unknown).

Additional versions: **1953** white duchess satin, black velours de Lyon, ivory faille, labeled "Charles James/53" (@ $925 to Miss Elizabeth Fairall; @ unknown price to Mrs. Cornelius Vanderbilt Whitney); fabrics unknown (Mrs. Byron Harvey, Jr., Lisa Kirk); gathered pink satin flounce over white taffeta (Mrs. William Randolph Hearst, Jr.). **1957** fabrics unknown (Charles James Associates).

Patterns: paper 53.169c; muslin 53.169b; half muslin model 53.169a

References: Look, June 30, 1953, p. 97; The Brooklyn Museum Annual Report, 1953–54, p. 29; New York Times, May 20, 1958, p. 37; New York, Oct. 16, 1978, p. 84; The Brooklyn Museum sketches 57.218.12b; NMAH sketch.

The Brooklyn Museum, Gift of Mrs. Cornelius Vanderbilt Whitney 53.169.1 [MMA, V&A]

115 EVENING GOWN, 1953 [CJ 1105]

Scoop neck; high bustline; fitted, trapezoidal-shaped, dropped-waist body; draped back; hipline fullness; front arced vent; slight train in back. Designed initially in pale lemon-faced silk satin for Mrs. William Randolph Hearst, Jr.

The Brooklyn Museum

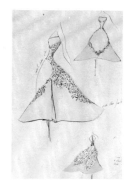

116 BALL GOWN, 1953 [CJ 1106]

Strapless, symmetrically cut bodice with revers at back. Initial fabrics and client unknown.

Additional versions: **1953** pearl-pink satin, white faille, re-embroidered black lace overlay, ginger shantung (Josephine Abercrombie).

Patterns: paper and muslin 53.265

References: Harnsburg News, July 24, 1957; The Brooklyn Museum sketches 57.218.12a–c.

The Brooklyn Museum, Gift of Josephine Abercrombie 53.265

117 BALL GOWN, 1953

Strapless, fitted bodice cut in one with slightly flared torso; serpentine, kneeline puffed flounce over structured, lace-covered hemline. Initial fabrics and client unknown.

Additional versions: **1953** yellow changeable silk, gold and white silk taffeta, pale-pink silk satin, black machine lace (Mrs. Cornelius Vanderbilt Whitney).

The Metropolitan Museum of Art, Gift of Eleanor S.W. McCollum 1975.246.11

118 BALL GOWN, 1953 ●

Strapless, fitted, pleated bustline bodice; front, knee-length, lobed apron panel outlined by wide flounce box-pleated at center front and attached to back yoke in form of folded, pointed tabs; structured cloverleaf underskirt. Initial fabrics and client unknown.

Additional versions: **1953** pale grey-blue double faced with white silk satin and rose silk faille, labeled "Charles James/53" (Mrs. Robert Guggenheim).

National Museum of American History, Gift of Rebecca Pollard Logan 1979.00068.1

119 WEDDING DRESS, 1954

Scoop neck; semi-fitted bodice; gored, draped-up skirt open on side; mid-calf length. Designed initially for Nancy Lee Gregory (Mrs. Charles James). Fabrics unknown.

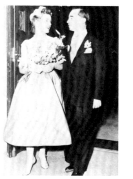

120 EVENING DRESS, 1954

Strapped, draped Empire bodice; gored, fitted panel; torso cut at waist; flared skirt; slipper length. Designed initially in white Celanese acetate sharkskin encrusted with gilt thread, pearls, and glass stars @ $1,250 for an unknown client.

Additional versions: **1954** ivory white faille encrusted with gold, silver, and pearl beads (Muriel Bultman Francis, Gypsy Rose Lee).

References: U.S. *Harper's Bazaar,* April 1954, pp. 154–155.

The Brooklyn Museum, Gift of Muriel Francis 67.215.5 [CJA]

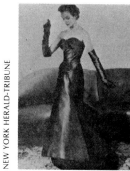

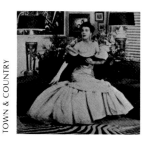

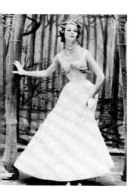

121 EVENING GOWN, 1954 [CJ 1109] ●

Spirally built tubular body with structured back-projecting hemline. Designed initially for Lisa Kirk (fabrics unknown).

Additional versions: **1954** emerald-green satin (Mrs. Jean de Menil).

Patterns: muslin 55.12.2

References: New York *Herald-Tribune,* Sept. 13, 1954, p. 12.

The Brooklyn Museum, Gift of Mrs. Jean de Menil 55.15.1

122 "BUTTERFLY" BALL GOWN, 1954 ●

Strapless, fitted sheath with horizontally draped front; structured side wings; back-bustle skirt in two three-part segments; 25 yards of tulle, weighing 18 pounds, suspended from waist. Designed initially in white silk chiffon, white silk satin, and daffodil, orange, gold, and topaz tulle @ $1,250 for Mrs. William Randolph Hearst, Jr.

Additional versions: **1954** toast chiffon, white satin, pale maize to cyclamen tulle (Mrs. Charles James). **1955** sunshine chiffon, yellow satin, saffron faille, nylon tulle in "bird of paradise" colors (DuPont Co.); fabrics unknown @ $1,000 (offered by Lord & Taylor, I. Magnin, and Simpson Co.); white silk chiffon and deep-yellow, pale-green, pale-blue tulle, labeled "An Original Design by Charles James" (Mrs. M. J. Boylen); smoke chiffon, white satin, pale-grey satin and mauve, dark grey-brown, lavender, and celery nylon tulle, labeled "An Original Design by Charles James" (Mrs. Cornelius Vanderbilt Whitney); tea rose silk chiffon, pale-yellow satin (Mrs. Cornelius Vanderbilt Whitney).

References: Chicago *American,* March 5, 1955, p. 15; Dallas Wall Street Journal, June 29, 1955; U.S. *Harper's Bazaar,* Sept. 1955, p. 11; U.S. *Vogue,* Sept. 1, 1955, p. 84; American Fabrics, Winter 1955–56, p. 18; U.S. *Vogue,* March 1, 1956, p. 184; New York Daily Mirror, Jan. 3, 1957; Chicago Daily Tribune, Nov. 18, 1958.

The Brooklyn Museum, Gift of Mrs. Jean de Menil 57.109.1 [CHS, ROM]

123 "TREE" DRESS, 1955 [CJ 1129] ●

Strapped or strapless shirred torso extending to hipline, draped up into back bodice, down into skirt, and forming front pendant polonaise over back fullness-gathered skirt. Initial fabrics and client unknown.

Additional versions: **1955** hot-pink silk taffeta, red, pink, and white tulle (Mrs. Douglas Fairbanks, Jr.); pink silk taffeta (Jane Frohman, Mrs. Vladimir Ivanovitch, Lisa Kirk, Gypsy Rose Lee); grey-blue silk taffeta (Mrs. Ronald Tree); rose-pink silk taffeta, shocking-pink, medium-pink, pale-pink, and white silk tulle (Mrs. Cornelius Vanderbilt Whitney); pink silk taffeta, flame, fuchsia, and cerise tulle @ $1,250, gloves to match @ $35 (Mrs. Cornelius Vanderbilt Whitney); white taffeta, rose, light-green and white tulle, labeled "An Original Design by Charles James" (Mrs. Cornelius Vanderbilt Whitney); fabrics unknown @ $1,000 and $925 (offered by Lord & Taylor). **1957** pale-pink silk taffeta, lilac satin, romany beauty orchid, crimson-red, bright-pink, white, silk tulle (Mrs. William Cameron); black taffeta (marketed by Charles James Associates). **1958** rose silk taffeta @ $1,200 (Joni James); fuchsia silk taffeta, purple, gold, pink, and white tulle.

References: New York *Times,* Oct. 2, 1955, p. 13; Town & Country, April 1957, p. 77; Gypsy Rose Lee, *Gypsy* (New York: Harper & Brothers, 1957), p. 307.

The Brooklyn Museum, Gift of Mrs. Douglas Fairbanks, Jr. 81.25.3 [FIT, MMA, V&A, Josephine T. Feles]

124 WEDDING DRESS, 1955

Fitted through waistline; draped side panels; folded under the skirt at hemline. Initial fabrics and client unknown.

Additional versions: **1955** textured radium-blue taffeta.

References: Chicago *American,* March 5, 1955, p. 15.

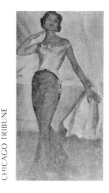

125 "DIAMOND" DRESS, 1955 ●

Strapped scoop neck; fitted bodice; arced up in front and down to kneeline point in back; inset, hourglass-shaped, center-back panel; fitted torso extending into cloverleaf-shaped fishtail skirt train. Initial fabrics and client unknown.

Additional versions: **1957** white satin, mushroom gros de Londres, black velvet (Marguerite Piazza, Mrs. Jean de Menil).

Patterns: paper 59.71

The Brooklyn Museum, Gift of Mr. and Mrs. Jean de Menil 59.39

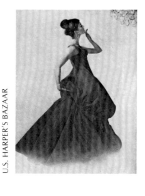

126 "BALLOON" BALL GOWN, 1955 ●

Square neckline; narrow shoulder bands; high empire bustline; fitted, panelled torso falling into full puffed front apron; full skirt. Also made as coat. Initial fabrics and client unknown.

Additional versions: **1956** rose rayon velvet by Crompton-Richman (American Rayon Institute); royal-blue silk velvet — fabrics supplied by client who purchased them from Saks Fifth Avenue @ $1,200 (Mrs. William Randolph Hearst, Jr.); red velvet, long arced-sleeve maternity version (The Mennen Company); fabrics unknown (offered by Nan Duskin, Bramson's, and Charles James); black faille, long arced-sleeve, at-home version (Mrs. Edmond G. Bradfield).

References: U.S. Harper's Bazaar, Sept. 1956, p. 37; Life, Jan. 21, 1957, p. 32.

Rhode Island School of Design, Gift of Mrs. William Randolph Hearst, Jr. 57.192

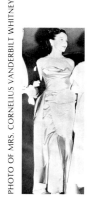

127 BALL GOWN, ?1957 ●

Draped, fitted, strapless bodice; asymmetrically draped, fitted, pendant-shaped front torso with deep gathered flounce. Initial fabrics and client unknown.

Additional versions: **1957** pale-aqua changeable silk taffeta, pale-aqua silk satin (Mrs. Cornelius Vanderbilt Whitney).

Museum of the City of New York, Gift of Eleanor S. W. McCollom 75.153.3

128 "INFANTA" EVENING DRESS, 1957 [CJ 1133]

Scoop neckline; princess-like torso; thigh-high hemline flounce; box pleated front and back; bowed division-line band. Initial fabrics and client unknown.

Additional versions: **1957** rep, CJ 1133A (Mrs. Edmond G. Bradfield); pale-pink satin, deep hot-pink faille, wine velvet (Mrs. Douglas Fairbanks Jr.); black faille, CJ 1133A (Felice Maier); flesh silk satin, taupe faille, black velvet, with matching bias-cut taupe stole @ $643.75 (Mrs. Morehead Patterson).

References: The Brooklyn Museum sketches 57.218.8j.

The Brooklyn Museum, Gift of Mrs. Morehead Patterson 72.22.1a&b

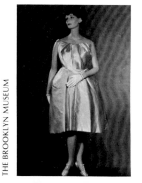

129 SHORT WEDDING DRESS, 1960

Fullness of loose bodice folded into scoop neckline; dipping elliptical waistline; back crossover V-line with one arced revers; front hipline elliptical yoke; knee-length skirt. Designed initially in cream silk satin for Mrs. Dylan Thomas.

The Brooklyn Museum, Gift of Vera Maxwell 67.165

130 SHORT EVENING DRESS, 1961

V-neck; four symmetrical, radiating, unpressed petal pleats; loosely draped bodice with dipping elliptical waist; back crossover V-line with one arced revers; front hipline elliptical yoke; knee-length skirt. Designed initially in cream silk for Mrs. Jackson Pollock.

Metropolitan Museum of Art, Gift of Lee Krasner Pollock 1975.52.3

131 EVENING DRESS, 1974

Strapped, high Empire waist; fitted torso with inset bust-to-kneeline hourglass panel; trumpet-flared, knee-high flounce. Initial fabrics and client unknown.

Additional versions: **1974** orange and white silk satin (Elizabeth S. de Cuevas).

Elizabeth S. de Cuevas

Dresses

132 "SPIRAL WRAP" or "TAXI" STREET DRESS, 1929–30 London

Bias cut wrapping body one-and-a-half times; first closing with clasps, later with zipper. Initial fabrics and client unknown.

Additional versions: **1929–30** black wool, three bakelite clasps (client unknown). **1931** fabrics unknown (Lady Leucha Warner). **1932** black with three white clasps (Mrs. St. John Hutchinson); white with three black clasps (client unknown). **1933** novelty weave linen, metal zipper (Anne, Countess de Rosse); fabrics unknown with colored plastic zip fasteners (Lightning Zipp). **1933–34** fabrics unknown (manufactured by Abood Knit Mills for Best & Co. in two sizes with zipper; merchandised by Marshall Field & Co., Tiche, Goettinger, and City of Paris). **1934** light-weight beige wool with zipper (Marshall Field & Co.). **?1934** fabrics unknown (Mrs. Henry Holt). **?1939** fabrics unknown (Gypsy Rose Lee). **?1977** fabrics unknown (Elsa Perretti).

References: U.K. Vogue, June 14, 1933, p. 97; Chicago American, Jan. 8, 1934.

Anne, Countess of Rosse

[CJA]

133 MOTHER OF BRIDE DRESS, 1929 ?London

Initial fabrics and client unknown. □

Additional versions: **?1929** charmeuse (Louise B. James).

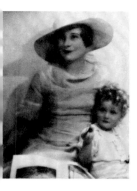

134 BRIDESMAID DRESS, 1932
London

Draped cowl neck; elbow-length sleeves with turned back cuffs; semi-fitted torso; flaring, layered skirt. Designed initially for Frances James (fabrics unknown).

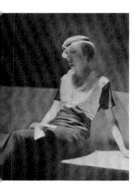

135 DAY DRESS, ?1932 London

Shawl collar; sham waistcoat front bodice ending in long sash ties at back; cap sleeves; sheath skirt. Initial fabrics and client unknown.

Additional versions: **1933** navy-blue and white Viyella, silk crepe (offered by Harrods).
References: U.K. *Vogue,* March 22, 1933, p. 88.

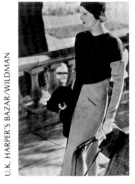

136 DAY DRESS, ?1932 London

Jewel neck; fitted V-waist bodice; a long tapered sleeve of contrasting fabric jutting out in unstitched pleats below short cap sleeve; contrasting panels in sheath skirt. Initial fabrics and client unknown.

Additional versions: **1933** brown and pale-grey Viyella Thirty-six bouclé.
References: U.K. *Harper's Bazar,* Aug. 1933, p. 27.

137 DRESS, 1933 London

Two scarves tie at neckline; no closure. Initial fabrics and client unknown. □

Additional versions: **?1934** black satin crepe (client unknown).
References: Richmond *News-Leader,* March 19, 1976, p. 10.

138 AFTERNOON DRESS, 1933
?London

Designed initially as an evening dress for Mrs. Oliver Burr Jennings (fabrics unknown). □

Additional versions: **1944** fabrics unknown (offered by Elizabeth Arden). **?1944** fabrics unknown (Millicent Rogers).

139 DAY DRESS, ?1934 London

Initial fabrics and client unknown. □

Additional versions: **1934** patterned organdy (Helga Guinness).

140 COCKTAIL DRESS, 1934 London

High wraparound or overlaid halter neckline in butterfly conformation; overlapped short sleeves ending at point on shoulder; diagonal zipper; street-length skirt. Initial fabrics and client unknown.

Additional versions: **1934** black satin (Anne, Countess of Rosse). **?1972** black satin (Elizabeth S. de Cuevas).
Anne, Countess of Rosse
[Elizabeth S. De Cuevas]

141 LATE-AFTERNOON DRESS, ?1935
London

Oval opening in front under crossover stand collar; long sleeves; plain in front with bib arced insert in back; tailored bodice with double-pointed waistband wrapping around to back; symmetrically-cut bias street-length skirt. Initial fabrics and client unknown.

Additional versions: **?1936** glove cotton velvet, black hammered satin (Mrs. St. John Hutchinson).
Art Students League

142 "MOONLIGHT" DINNER DRESS, ?1936 London

Asymmetrical draped neckline ending in pendant; trapezoidal cap sleeves; draped attached cape concealing diagonally slashed draped back; back hip yoke; fan flare at center-front hemline; wraparound draped belt. Initial fabrics and client unknown.

Additional versions: **1936** cream silk shot with gold (Mrs. H. S. H. Guinness).
Marit Guinness Aschan

143 DAY DRESS, ?1936 London

Jewel neck; cap sleeves; semi-fitted torso with four buttons, two at bustline and two at waistline; street-length sheath skirt. Initial fabrics and client unknown.

Additional versions: **?1937** crisp linen or duck, large novelty buttons.
References: The Brooklyn Museum sketches 57.218.1.

144 AFTERNOON DRESS, ?1936
London

Initial fabrics and client unknown. □

Additional versions: **1937** red silk bodice patterned with black needles and thread, black skirt, jacket woven with pink, red, and black (Marit Guinness Aschan).

145 DINNER DRESS, ?1940

Arced, slashed neckline yoke with tie; full bell, elbow-length sleeves; scalloped waistline with arced hipline yoke flanking central apron-like panel; flared street-length skirt. Initial fabrics and client unknown.

Additional versions: **?1940** grey-brown double-faced silk satin, grey-blue organdy (Mrs. George P. Raymond).
Mrs. George P. Raymond

146 MORNING DRESS, 1943 [CJ 211]

Shallow V-neck; long wedge-shaped sleeves with slit diagonal cuffs; front panel shirred at neck and hanging loose from knee down.

Additional versions: **1943** heavy white sharkskin, mustard silk crepe, maroon velvet ribbon, labeled "Ch. James/43" (Millicent Rogers).
Patterns: paper 49.233.81; muslin 49.233.55; half muslin model 49.233.26
The Brooklyn Museum, Gift of Millicent Rogers 49.233.29

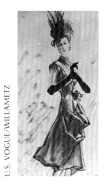

147 DAY DRESS, 1944

Stand collar; loose sleeve caps; fitted torso; draped polonaise skirt with uneven hemline. Initial fabrics and client unknown.

Additional versions: **1944** crisp fabric (offered by Elizabeth Arden). **?1944** navy-blue ribbed silk, strapless version (Mrs. Joseph Love).
References: U.S. Vogue, July 1944, p. 58.

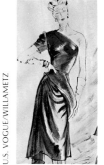

148 DINNER DRESS, 1944

Bare left shoulder; cap sleeve on right; tailored torso; draped hip loop that ends below hemline of sheath skirt and can be pulled over shoulder or wrapped around back. Initial fabrics and client unknown.

Additional versions: **1944** inky-blue satin (offered by Elizabeth Arden).
References: U.S. Vogue, July 1944, p. 59.

149 DINNER DRESS, 1945

Front-gathered jewel neck; wrist-length, double-tiered sleeves with upper arm draped over into sphere and lower arm radiating leg-o-mutton shape from ten tucks; triangular waistline gussets above triangular hipline yoke gussets; street-length sheath skirt. Initial fabrics and client unknown.

Additional versions: **?1945** black satin (Mrs. George P. Raymond).
References: U.S. Vogue, Dec. 1, 1945, p. 135; The Brooklyn Museum sketches 57.218.15v.
Mrs. George P. Raymond

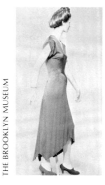

150 AFTERNOON DRESS, 1945
[CJ 200]

V-neck sham slashed halter; short sleeves shirred at shoulder; arced, deep inset waistline band; narrow skirt with small pleated-up back tournure; hemline dipping from center front to points at sides and center back. Designed initially in olive green silk jersey for Millicent Rogers (labeled "Ch. James/45").

Patterns: paper 49.233.80, muslin 49.233.54, half muslin model 49.233.25
The Brooklyn Museum, Gift of Millicent Rogers 49.233.10

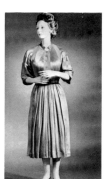

151 AFTERNOON DRESS, 1945
[CJ 215]

Stand collar; elbow-length inset sleeves with deep turned-back cuffs; front button closure; skirt gathered in front, flared in back on either side of T-shaped hipline yoke panel. Designed initially in grey self-striped silk satin crepe for Millicent Rogers.

Additional versions: **?1946** fabrics unknown (Mrs. Charles Bell, Mrs. Harrison Williams).
Patterns: paper 49.233.82; muslin 49.233.56; half muslin model 49.233.31
The Brooklyn Museum, Gift of Millicent Rogers 49.233.8

152 AFTERNOON DRESS, 1946
[CJ 218]

Diagonal V-neck; elbow-length dolman sleeves; trapezoidal-shaped bodice extending into hipline peplum; narrow skirt gathered to side. Initial fabrics and client unknown.

Additional versions: **?1948** printed brown silk (Marit Guinness Aschan).
Patterns: paper 49.233.83; muslin 49.233.57
The Brooklyn Museum, Gift of Millicent Rogers [Marit Guinness Aschan]

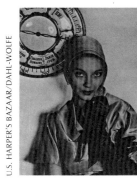

153 RESTAURANT DRESS, 1946
[CJ 220]

Reverse, standaway, heart-shaped neckline; front V-shaped bodice panels continuing to back as yoke; inset gathered sleeves; wedge-shaped hipline yoke on either side of pouffed and shirred center-front waistline, gored skirt; double cone inset at back waistline; tied to bustline. Designed initially in Florentine greige silk taffeta curtain fabric from Rose Cummings for Millicent Rogers (labeled "Ch. James/46").

Additional versions: **1946** silver faille, black satin ribbon (Mrs. Sidney Legendre); grey-brown taffeta, brown ribbon; fabrics unknown (offered by The Dayton Co.). **1948** greige silk and ribbon (Mrs. Marit Guinness Aschan). **?1949** fabrics unknown (Mrs. William Randolph Hearst, Jr. Mrs. Walter Jeffords).
Patterns: paper 49.233.84; muslin 49.233.58; half muslin model 49.233.27
References: U.S. Harper's Bazaar, Nov. 1946, p. 245.
The Brooklyn Museum, Gift of Millicent Rogers 49.233.2 [CJA]

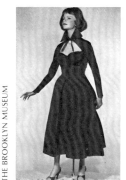

154 "INFANTA" LATE-DAY DRESS, 1946

Pointed stand-out collar with bow at neckline, open above gathered bustline; long tapered sleeves; fitted bodice seams converging at center-front, back, and side points; full gored skirt with cluster of inverted pleats at center-front waistline. Initial fabrics and client unknown.

Additional versions: **1950** dark-grey faille (Muriel Bultman Francis). **?1951** fabrics unknown (Jennifer Jones).
The Brooklyn Museum, Gift of Muriel Bultman Francis 67.215.1

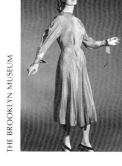

155 AFTERNOON DRESS, 1946
[CJ 221]

Round neck with shallow center-front slit; three-quarter-length full, slit sleeves with wide ties; flared skirt. Designed initially in lilac crepe de chine for Millicent Rogers (labeled "Ch. James/46").

Additional versions: **?1947** fabrics unknown (Mrs. Jean de Menil, Eleanor Patterson; offered by The Fashion House).
Patterns: paper 49.233.85; muslin 49.233.59; half muslin model 49.233.22
The Brooklyn Museum, Gift of Millicent Rogers 49.233.7

156 DRESS, 1946 [CJ 225]

Initial fabrics and client unknown. □

Additional versions: **1951** as blue bodice only @ $191.25 (Martha Roundtree).

157 COCKTAIL DRESS, ?1947

Heart-shaped neckline on elliptical-shaped, draped yoke; full cap sleeves pleated near armscye in back; dropped, curved, three-piece shaped skirt with back flare at kneeline. Initial fabrics and client unknown.

Additional versions: **?1947** dark chocolate-brown silk satin (Mrs. Robert Horne Charles).
National Museum of American History, Gift of Marion O. L. Charles 316343.4

158 SUMMER AFTERNOON DRESS, 1947

Skirt with flared fullness extending into bodice; top-stitched seams. Jacket similar to cat. no. 314. Designed initially in light-blue alpaca rayon blend for Mrs. Edmond G. Bradfield.

159 COCKTAIL DRESS, ?1948 [CJ 232]

Initial fabrics and client unknown. □
Additional versions: **1951** fabrics unknown (June Havoc).

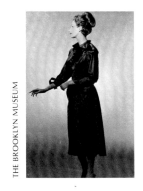

160 LATE-AFTERNOON ENSEMBLE, ?1948

Overblouse with diagonally slit round neck; short sleeves; fitted bodice with side tab slit peplum; narrow sheath wrap-over skirt with three layers in front, one in back. Initial fabrics and client unknown.

Additional versions: **?1948** myrtle-green moiré (Millicent Rogers).
The Brooklyn Museum, Gift of Paul and Arturo Peralta-Ramos 54.141.78

161 COCKTAIL or DINNER DRESS, ?1949 [CJ 258]

Initial fabrics and client unknown. □
Additional versions: **1951** fabrics unknown, CJ 258A @ $425 (Mrs. William Randolph Hearst, Jr.); @ $675 (Lily Pons, Mrs. Cornelius Vanderbilt Whitney).

162 DRAPE DRESS, ?1949 [CJ 260]

Initial fabrics and client unknown. □
Additional versions: **1951** fabrics unknown, CJ 260A @ $125 (Mrs. William Randolph Hearst, Jr.); tan wool @ $575 (Alice Topp-Lee).
The Missouri Historical Society, Gift of Alice Topp-Lee

163 SHIRTWAIST DRESS, ?1949 [CJ 261]

Initial fabrics and client unknown. □
Additional versions: **1951** fabrics unknown, CJ 261A @ $465 (Princess Bon Compagne); faille, CJ 261A @ $625 (Mrs. S. Bronfman); faille, CJ 261A @ $525 (Millicent Rogers); fabrics unknown, CJ 261A @ $625 (Martha Roundtree); fabrics unknown (Mrs. Cornelius Vanderbilt Whitney).

164 AFTERNOON SHIRTWAIST DRESS, ?1949 [CJ 262]

Initial fabrics and client unknown. □
Additional versions: **1951** beige taffeta @ $262.50 (Miss H. Rozen); fabrics unknown @ $425 (Mrs. Jean de Menil); CJ 262A @ $510 (Charles James Inventory).

165 COCKTAIL DRESS, 1949

Wide, pointed stand-away collar; arced neckline yoke with two high arced pockets; three-quarter-length sleeves with wide, arced stand-away cuffs; center-back waistline vertical box pleat; three-quarter-circumference yoke; flared skirt. Designed initially in steel-grey duchess satin for Millicent Rogers.

Additional versions: **1952** grey faille @ $575 (Mrs. Jean de Menil); light-grey faille with contour belt (Muriel Francis).
The Brooklyn Museum, Gift of Paul and Arturo Peralta-Ramos 55.26.50

166 AFTERNOON DRESS, 1949 [CJ 274]

Initial fabrics and client unknown. □
Additional versions: **1951** fabrics unknown (June Havoc); navy faille @ $625 (Martha Roundtree).

167 "SPIRAL" DINNER DRESS, 1949 [CJ 275]

Draped, oblique, off-the-shoulder neckline; spirally cut and draped bodice extending into wraparound skirt with three buttons in an arc on left-back hip. Initial fabrics and client unknown.

Additional versions: **1949** fabrics unknown (Mrs. William S. Paley). **?1949** brown faille (Millicent Rogers). **1950** dark-navy-blue faille (Mrs. Edmond Bradfield); ruby-red faille. **?1950** dark-brown silk faille (Mrs. William Randolph Hearst, Jr.); bright-orange shot with gold faille (Millicent Rogers); fabrics unknown @ $125 purchased for developmental purposes by Ohrbachs). **1951** fabrics unknown (purchased for developmental purposes by Lord & Taylor). **?1951** dark-navy faille (Mrs. Rudolph A. Bernatschke). **1952** poppy-red taffeta (purchased for developmental purposes by Samuel Winston).
Patterns: paper 53.172c; muslin 53.172b; half muslin model 53.172a
References: U.S. Vogue, Nov. 15, 1950, p. 79; Sales catalogue, Christie's East, May 10, 1979, lot #75; Alex Liberman, *Art & Technology of Color Photography* (New York: Simon & Schuster, 1951), p. 142.
The Brooklyn Museum, Gift of Mrs. William Randolph Hearst, Jr. 53.172
[Homer Layne]

168 COCKTAIL DRESS, ?1949

Draped, oblique, off-the-shoulder, wired collar forming one cap sleeve; spiral fitted bodice; narrow skirt from hipline; wedge-shaped yoke; draped, folded, arced floating panel pouffed at back left hip. Variant of cat. no. 167. Initial fabrics and client unknown.

Additional versions: **1952** navy faille (Muriel Francis).
The Brooklyn Museum, Gift of Muriel Francis 66.147.11

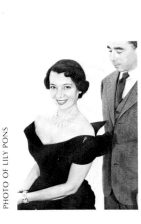

169 DINNER DRESS, ?1949

Off-the-shoulder draped bustline with winged cuff and circular cap sleeves; draped torso; fitted skirt. Initial fabrics and client unknown.

Additional versions: **?1953** fabrics unknown (Lily Pons).

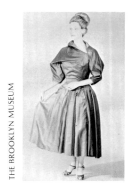

170 AFTERNOON DRESS, 1950

Oblique roll collar; back and front of bodice each cut in one with one elbow-length, melon-shaped sleeve; modified V-point at waist; circular skirt. Initial fabrics and client unknown.

Additional versions: **?1950** Skinner's men's coat lining of wine-and-navy-striped silk taffeta (Millicent Rogers).
The Brooklyn Museum, Gift of Paul and Arturo Peralta-Ramos 54.141.74

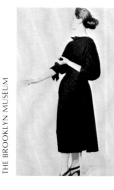

171 DAY DRESS, 1950

Small pointed collar in front; straight neckline in back; three-quarter-length melon sleeves with wedge-shaped French cuffs; fitted bodice; arced in front; sheath skirt wrapped to back with two waistline points above flared, hem-length panel. Designed initially for and merchandised by Ohrbachs (fabrics unknown).

Additional versions: **?1951** black wool jersey (Millicent Rogers).
The Brooklyn Museum, Gift of Paul and Arturo Peralta-Ramos 54.141.67

172 DAY DRESS, 1950

Rectangular neckline with seamed elliptical yoke in back; elbow-length dolman sleeves; double inverted-V, waist-to-neckline construction; street-length skirt with central floating panel and inverted-V side construction. Initial fabrics and client unknown.

Additional versions: **1950** dark dusty-mauve wool face cloth, labeled "Charles James/50" (Gypsy Rose Lee).
Homer Layne

173 DINNER DRESS, 1950

V-neck in front; scooped yoke in back; three-quarter-length dolman sleeves with three unpressed pleats at front shoulderline like epaulettes; three-part, demi-crescent fitted bodice (mid-section extends into sleeve) terminates at center side-seam, hip yoke point; gored flared skirt. Designed initially in black silk faille for Mrs. Edmond G. Bradfield.

Art Students League

174 DAY DRESS AND JACKET, 1951 [CJ 281]

Dress — Jewel neck; short dolman sleeves flanking bustline yoke of triangular and trapezoidal forms; semi-fitted torso with back triangle; front diamond form continuing into gores for street-length skirt.
Jacket — Initial fabrics unknown. Client unknown.

Additional versions: **1951** medium-brown novelty weave wool, labeled "Charles James/51" (Alice Topp-Lee).
Pratt Institute

175 SHIRTWAIST DRESS, 1951 [CJ 286]

Initial fabrics and client unknown. □

Additional versions: **1951** fabrics unknown (June Havoc).

176 DRESS, ?1951 [CJ 287]

Initial fabrics and client unknown. □

Additional versions: **?1951** silk chiffon @ $725 (Mrs. James Cunningham).

177 DRESS, ?1951

Slit stand collar; long dolman sleeves; diagonal draping under bust; stand away hip yoke continuing down front as panel; full skirt. Worn with coat, cat. no. 406. Initial fabrics and client unknown.

Additional versions: **?1951** pumpkin wool (Alice Topp-Lee).
Missouri Historical Society, Gift of Alice Topp-Lee

178 COCKTAIL DRESS, 1952

Front and back neckline and bodice in V-shape; two-thirds-length dolman sleeves gathered on inside elbow; back button closure; waistline seam; full skirt. Designed initially in black taffeta and marketed by Samuel Winston (labeled "Samuel Winston by Charles James").

References: Sales catalogue, Christie's East, May 10, 1979, lot. #78.

179 DRESS, 1952

Boatneck; short sleeves; front slit pockets; self-belt. Designed initially in leaf-green wool mohair and marketed by Samuel Winston (labeled "Samuel Winston by Charles James").

References: Sales catalogue, Christie's East, May 10, 1979, lot #71.

180 DAY DRESS, 1952

V-neck; two-thirds shawl collar; short mushroom sleeves; draped bustline and hipline pockets; fitted bodice; sheath. Designed initially for and marketed by Samuel Winston (fabrics unknown).

Additional versions: **1953** sheer wool @ $155 (merchandised by Lord & Taylor).
References: U.S. Harper's Bazaar, Feb. 1953, p. 13.

181 AFTERNOON DRESS, 1952

Sheath and bolero. Initial fabrics and client unknown. □

Additional versions: **?1932** black taffeta, black wool.
Philadelphia Museum of Art, Gift of Eleanor Pierce

182 DAY DRESS/COCKTAIL SHEATH, 1952 [CJ 2208]

Scoop neck; Empire bustline yoke above pear-shaped sheath trimmed with bows. Initial fabrics and client unknown.

Additional versions: **1954** black antique satin with black velvet ribbon trim. **?1954** black organdy, black wool. **1956** black taffeta, black satin. **?1956** black taffeta, black velvet (Mrs. Rudolph A. Bernatschke). **1962** red wool jersey (merchandised by E. J. Korvette); almond-white silk, black velvet (merchandised by E. J. Korvette); black silk, black velvet (merchandised by E. J. Korvette).
The Brooklyn Museum
[RISD, Homer Layne]

183 DRESS, 1952 [CJ 2211A]

Initial fabrics and client unknown. □

Additional versions: **1957** fabrics unknown (Charles James Associates).

184 DAY DRESS, 1953

V-neck with large bow; horizontal seaming and folds point up long torso line; three-quarter-length sleeves; low panel pockets; shirred bustline. Designed initially for and marketed by Samuel Winston.

Additional versions: **1953** brown wool fleece, taffeta.
References: Dallas *Morning News,* Sept. 8, 1953, p. 1; Sales catalogue, Christie's East, Nov. 28, 1979, lot #37.

185 DRESS, 1953

Plunging neckline with turned back revers cut in one with bodice front; three-quarter-length sleeves; intricately cut skirt, bodice, and midriff; full, gored, street-length skirt. Designed initially in black-and-white checked silk taffeta and marketed by Samuel Winston.

Wadsworth Atheneum, Gift of Mrs. Arthur Stewart 1974.91

186 LATE DAY DRESS, 1953

High brief jacket. Initial fabrics and client unknown. □

Additional versions: **1953** black broadcloth, peacock.
References: Dallas *Morning News,* Sept. 8, 1953, p. 2.

187 "EGYPTIAN" DAY DRESS, 1953

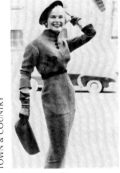

Winged neck; high Empire waistline above inset belt; quadrant sheath skirt. Designed initially in Rodier wool tweed, fireman's-red popcorn jersey, and black velvet, and marketed by Samuel Winston.

Additional versions: **1953** fabrics unknown (offered by Lord & Taylor, Irving, William Penn, and Ben Wolfman).
References: U.S. *Vogue,* Aug. 15, 1953, p. 65; Town & Country, Aug. 1953, p. 81.

188 "EMPRESS JOSEPHINE SWEATSHIRT" COCKTAIL DRESS, 1953

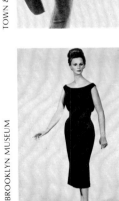

Blouson Empire bodice, sheath skirt. Designed initially for and marketed by Samuel Winston.

Additional versions: **1953** murky-brown and black wool. **?1953** navy-blue satin, black wool broadcloth, labeled "Samuel Winston/by Charles James" (Kay Kerr, Mrs. Albert H. Newman).
References: Dallas *Morning News,* Sept. 8, 1953, p. 2.
The Brooklyn Museum, Gift of Miss Kay Kerr 66.53.7 [CHS]

189 DAY DRESS, 1953

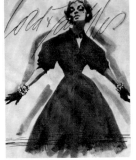

V-neck; full elbow-length dolman sleeves cut in one with V-pointed, arced, semi-fitted bodice; full calf-length skirt. Designed initially for and marketed by Samuel Winston.

Additional versions: **1953** black silk gros de Londres @ $250 (merchandised by Lord & Taylor).
References: U.S. *Harper's Bazaar,* Sept. 1953, p. 13.

190 COCKTAIL DRESS, ?1954

Scoop neck; sleeveless; shirred bustline inserts; semi-fitted bodice front cut in one with back waistband; flared calf-length skirt draped over to left side and caught in front hemline pouff. Initial fabrics and client unknown.

Additional versions: **?1954** pearl-grey diapered silk taffeta.
The Brooklyn Museum

191 SHORT EVENING DRESS, 1954

Notched scooped neckline; sleeveless sheath; fitted torso. Initial fabrics and client unknown.

Additional versions: **1954** fabrics unknown (Mrs. Jean de Menil); brown duvetyne (Mrs. Charles James). **?1955** brown wool duvetyne @ $525 (Gypsy Rose Lee).
References: Wadsworth Atheneum, *The Sculpture of Style* (Hartford, CT: Wadsworth Atheneum); Sketch, Vera Maxwell Collection, New York.

192 COCKTAIL DRESS, 1954 [CJ 2258]

Designed initially in rose Italian silk faille from Kunstreich and marketed by Samuel Winston. □

193 AFTERNOON DRESS, 1954 [CJ 2259]

Bodice with inserted panel. Designed initially in imported broadcloth and beige Staron satin and marketed by Samuel Winston. □

194 AFTERNOON DRESS, 1954 [CJ 2260]

Designed initially in black wool with embroidery from Miss Anea; marketed by Samuel Winston. □

195 COCKTAIL DRESS, 1954 [CJ 2263]

Two-piece. Designed initially in brown faille and marketed by Samuel Winston. □

196 DAY DRESS, 1954 [CJ 2266]

Designed initially in beige Jasco jersey and marketed by Samuel Winston. □

197 COCKTAIL DRESS, 1954 [CJ 2267]

Initial fabrics and client unknown. □

Additional versions: **1954** beige double-faced silk satin, black faille (marketed by Samuel Winston). **1957** fabrics unknown (Charles James Associates).

198 AFTERNOON DRESS, 1954 [CJ 2268]

Front panel. Designed initially in black Rodier wool and black silk faille and marketed by Samuel Winston. □

199 AFTERNOON DRESS, 1954 [CJ 2269]

Draped bust. Designed initially in imported navy broadcloth and marketed by Samuel Winston. □

200 COCKTAIL DRESS, 1954 [CJ 2271]

Full skirt. Designed initially in black silk faille and brown Neyer wool and marketed by Samuel Winston. ☐

201 DINNER DRESS, 1954 [CJ 2272]

Full skirt; bow trim. Designed initially in black silk faille and marketed by Samuel Winston. ☐

202 DRESS, 1954 [CJ 2273]

Full skirted, puffed. Initial fabrics and client unknown. ☐

Additional versions: **1957** fabrics unknown (Charles James Associates).

203 DRESS WITH BOLERO, 1954 [CJ 2277]

Sheath. Initial fabrics and client unknown. ☐

Additional versions: **1957** sheath with button-down bolero, CJ 2277 and CJ 2277A, fabrics unknown (Charles James Associates); black faille with bow bolero, CJ 2277A (Charles James Associates).

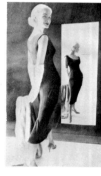
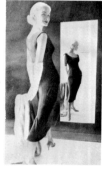

U.S. HARPER'S BAZAAR/DERUJINSKY

204 "PEAR SHAPE" COCKTAIL SHEATH, 1954 [CJ 2278]

Wide curved neck; sleeveless; princess line to raised Empire bustline; two back hemline kick pleats; two diagonally placed hipline patch pockets. Initial fabrics and client unknown.

Additional versions: **1954** brown wool (Mrs. Frederick Bultman, Jr.); wool (Mrs. Charles James). **1955** fabrics unknown @ $235 (offered by Lord & Taylor, I. Magnin, and Neiman Marcus). **?1955** garnet Forstmann wool broadcloth (Mrs. Jean de Menil). **1956** purple-blue wool with short bolero with bow at neckline (Mrs. Rudolf A. Bernatschke). **1957** fabrics unknown (Charles James Associates).
References: U.S. *Harper's Bazaar*, Oct. 1955, p. 191.
The Brooklyn Museum, Gift of Mr. and Mrs. Jean de Menil 60.154
[ASL, CJA, Homer Layne]

205 DAY DRESS, 1954 [CJ 2282]

Sheath with draped bolero. Initial fabrics and client unknown. ☐
Additional versions: **1957** faille (Charles James Associates).

206 DAY DRESS, 1954 [CJ 2285]

Initial fabrics and client unknown. ☐
Additional versions: **1957** black faille, velvet (Charles James Associates).

207 DAY DRESS, ?1954 [CJ 2286]

Initial fabrics and client unknown. ☐

208 "FOURREAU" DRESS, 1955 [CJ 2287]

Collar; shaped chemise; waist demarcation nearly eliminated. Initial fabrics and client unknown.

Additional versions: **1957** red broadcloth (Charles James Associates). **1958** fabrics unknown (Mrs. Max Jacobson).

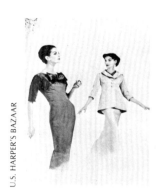

U.S. HARPER'S BAZAAR

209 DRESS, 1955

Boat-shaped neckline; elbow-length sleeves; fitted bodice; self belt; skirt with left-side hip drapery and pocket. Designed intially in grey wool and marketed by Samuel Winston (labeled "Samuel Winston by Charles James").

Chicago Historical Society, Gift of Mrs. Howard Linn 1959.486a&b

210 "GOTHIC" SHEATH, 1955

Scoop neck; high waist with bustline bow; sheath torso. Initial fabrics and client unknown.

Additional versions: **1955** black faille and cashmere, labeled "An Original Design/by/Charles James" (Mrs. Howard Linn); gold rayon and acetate crepe; fabrics unknown (offered by Lord & Taylor, Nan Duskin, and John Wanamaker). **1956** fabrics unknown (offered by Bramson's and by Ruth Maier). **1957** black satin and black wool broadcloth, labeled "An Original Design/by/Charles James" (Mrs. Masten Brown).
References: New York Times, Oct. 2, 1955, p. 13; U.S. *Harper's Bazaar*, Sept. 1956, p. 37.
Chicago Historical Society, Gift of Mrs. Howard Linn 1967.11
[Homer Layne, Mrs. Robert Coulson]

211 DAY DRESS AND BOLERO, 1955

Pear-shaped sheath with arced bolero slit at center back to form two waistline points. Initial fabrics and client unknown.

Additional versions: **1955** rust-brown linen (Mrs. Charles James).
Homer Layne

212 DINNER DRESS, 1955

Initial fabrics and client unknown. ☐
Additional versions: **1955** black cloth with satin collar (Felice Maier).

213 AFTERNOON DRESS, 1955

One piece bib front with bow ties under collar. Initial fabrics and client unknown.

Additional versions: **1955** parchment satin, black French broadcloth.

NEW YORK HERALD-TRIBUNE

214 "SUPERMARKET CHECKER'S" DRESS, 1956

Wide open neckline roll collar; side-buttoning elastic sections above waistline; flared skirt. Designed initially in Celanese raspberry Arnel, bluish pink, saffron, butcher blue, mauve, and ginger for the Supermarket Institute Convention.

Additional versions: **1956** ombre-pink Staron raw silk, narrower collar (Mrs. Edmond G. Bradfield).
References: New York *Herald-Tribune*, May 8, 1956, p. 22.

215 AFTERNOON DRESS, 1957

Initial fabrics and client unknown. ☐
Additional versions: **1957** black cashmere; black Dupioni silk @ $625.

216 MORNING DRESS, ?1957

Open neck; side buttoning; designed to be worn with furs. Initial fabrics and client unknown. ☐
Additional versions: **?1957** beige silk and mohair @ $465.

217 DINNER DRESS, 1962

One piece. Designed initially for and merchandised by E. J. Korvette . □

Additional versions: **?1962** pale-pink and white floral brocade.

218 DINNER DRESS, 1962

Two piece. Designed initially for and merchandised by E. J. Korvette.

Additional versions: **?1962** black with gold metallic and pink raised floral motif.

Loungewear

219 SKIRT, ?1933 London [CJ 301]
(see cat. illustration 210)

Full length; bracketed, trapezoidal front hipline yoke extending to V-points flanking S-curve center-back seam, which flares into fish tail at back hemline. Initial fabrics and client unknown.

Additional versions: **?1940** black silk crepe (Mrs. George Perkins Raymond). **1956** white rayon matelassé, CJ 301A (Mrs. Charles James). **?1956** black rayon matelassé; white rayon matelassé, CJ 301E.
References: U.S. *Harper's Bazaar,* Sept. 1956, p. 37; *New York Times,* Feb. 12, 1962.
The Brooklyn Museum, Gift of Mrs. Jean de Menil 57.151.13

220 CULOTTES/TROUSER SKIRT, ?1934 London [CJ 306]

Full length; full-flared legs; wrap over. Initial fabrics and client unknown.

Additional versions: **1941** white Cellotex sharkskin. **1944** champagne-pink charmeuse (Mrs. Horace Wetmore). **1947** garnet wool broadcloth (Mrs. William Randolph Hearst, Jr.); green wool broadcloth. **1950** charcoal-grey wool flannel (Mrs. William Randolph Hearst, Jr.).
References: U.S. *Harper's Bazaar,* Jan. 1, 1941, p. 81.
The Brooklyn Museum, Gift of Mrs. William Randolph Hearst, Jr. 64.231.3

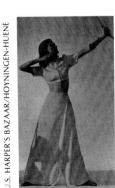

221 PAJAMA/DIVIDED SKIRT, ?1934 London

Divided skirt with widely-cut straight legs; draped to left waist with large bow; hipline yoke. Variant of cat. no. 220. Initial fabrics and client unknown.

Additional versions: **?1954** brown crepe Romaine and silk taffeta, labeled "An Original Design/by/Charles James."
The Brooklyn Museum

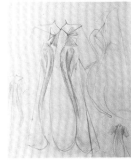

222 DÉSHABILLÉ, ?1937 London

Shallow V-neck with bows at neck; wide shoulder yoke; elbow-length kimono sleeves; flared skirt with front lobe bracketed by swan's neck form. Designed initially in red and black for an unknown client.

References: The Brooklyn Museum sketches 57.218.3.

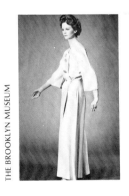

223 PAJAMAS or TROUSER SKIRT, 1940

One leg slimly trousered; other leg wrapped in a skirt-like fold; hooked across dividing line in front. Initial fabrics and client unknown.

Additional versions: **1940** black silk faille (offered by Bergdorf Goodman). **?1940** black satin (Mrs. George P. Raymond).
References: U.S. *Harper's Bazaar,* Dec. 1940, p. 81.
Mrs. George P. Raymond

224 HOSTESS PAJAMAS, ?1940

Two piece; square neck; inset bib; lyre yoke extending into modified sailor collar in back; long full sleeves; full trouser skirt. Initial fabrics and client unknown.

Additional versions: **?1940** greenish-yellow silk organza, lime-green satin (Mrs. George P. Raymond).
Mrs. George P. Raymond

225 LOUNGING PAJAMAS, ?1944

One-piece asymmetrical neckline and bodice closure; two-thirds length flared sleeves; culotte trousers with one narrow leg and one wide leg wrapped over in front. Initial fabrics and client unknown.

Additional versions: **?1944** white sharkskin, gilt metal buttons.
The Brooklyn Museum, Gift of Charles James 47.164

226 DÉSHABILLÉ, 1943 [CJ 300]

Jewel neck; back yoke; inset three-quarter length sleeves; full length; some versions have front closure and long neckline tie. Designed initially in gold silk voile with metallic threads for Millicent Rogers.

Additional versions: **?1943** burgundy, royal-blue and white wool plaid, teal-blue taffeta, royal-blue wool (Millicent Rogers); burgundy wool, crimson silk faille, tangerine silk crepe, shocking-pink charmeuse (Millicent Rogers); chinese-orange silk damask (Millicent Rogers); medium-blue silk faille, pale-pink satin (Millicent Rogers); slate-blue wool, light-brown taffeta, dusty-rose ribbed silk (Millicent Rogers). **1944** surah striped satin (offered by Elizabeth Arden). **1945** sky-blue and white woven silk stripe, orange faille, orange silk crepe, labeled "Charles James/45" (Millicent Rogers); black satin and royal-purple surah ribbon stripe silk, dark chocolate-brown silk crepe, black silk satin ribbon, labeled "Charles James/45" (Millicent Rogers); apple-green, wine and white wool plaid, shocking-pink silk crepe, apple-green wool, dusty-rose satin, labeled "Charles James/45" (Millicent Rogers). **?1945** fabrics unknown (Elizabeth Arden, Mrs. Walter Baker, Mrs. Harrison Williams). **1946** pale-pink and bright-yellow ribbed silk, tangerine taffeta, pale-pink charmeuse, orange taffeta, labeled "Charles James/46" (Millicent Rogers); olive-green, forest-green, and brown iridescent striped silk taffeta, lime-green silk taffeta, orange silk crepe, labeled "Charles James/46" (Millicent Rogers).
Patterns: paper 49.233.86; muslin 49.233.60; half muslin model 49.233.29
References: U.S. *Vogue,* Dec. 15, 1944, p. 52–53.
The Brooklyn Museum, Gift of Millicent Rogers 49.233.5 [RISD]

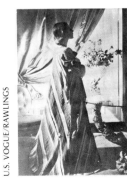

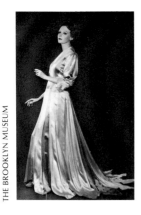

227 DRESSING GOWN or ROBE, 1944

Shallow V-neck; princess-line torso; elbow-length melon sleeves gathered in with pointed cuffs; pointed-tip hemline; made from 6½-inch-wide ribbons. Initial fabrics and client unknown.

Additional versions: **1944** satin ribbons in flesh, ecru, lemon, deep gold, peach and pale red-brown (Edalgi Dinsha).

The Brooklyn Museum, Gift of Edalgi Dinsha 44.179

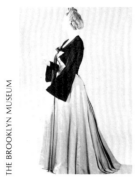

228 HOSTESS GOWN, 1947

Round neckline with arched revers over bust; low bustline ties; long trumpet-flared sleeves; fitted bodice; raised point in front; point at back waistline; full skirt; knife pleated in back. Initial fabrics and client unknown.

Additional versions: **1947** black velvet, burnt-orange silk faille, black silk satin, burnt-orange silk charmeuse, black silk crepe, labeled "Charles James/47" (Millicent Rogers).

The Brooklyn Museum, Gift of Paul and Arturo Peralta-Ramos 54.141.71

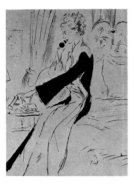

229 HOSTESS GOWN AND UNDERDRESS, 1947

Wrapper — V-yoke extending to hem-length front panel; clutch closure; long flared sleeves; flared skirt. Dress — diamond and triangle bustline; back-knotted narrow shoulder straps; diagonally arced, inset front panel revealed on back right hip; flared hemline with vented scallop at juncture of panels on front left. Initial fabrics and client unknown.

Additional versions: **1947** wrapper — black panne velvet, deep-peach satin, orange-gold taffeta; dress — black charmeuse, black satin, orange-gold crepe (Mrs. Thomas Leiter); black velvet and apricot satin (Mrs. Harrison Williams).

References: U.S. Vogue, Feb. 15, 1948, p. 82; The Brooklyn Museum sketches 58.131.2-3.

National Museum of American History, Gift of Marion O. L. Charles 316343.5

230 BODICE, ?1954 [CJ 3314]

Scoop neck; sleeveless; fan-shaped bust pleats; shaped, bracketed, set-on waistband. Worn with cat. no. 274. Initial fabrics and client unknown.

Additional versions: **1954** champagne satin, CJ 3314B.

The Brooklyn Museum, Gift of Mrs. Jean de Menil 57.151.12b

Skirts
Bodices
Pants

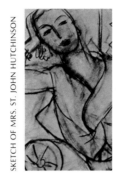

231 BLOUSE, 1934 London

Wraparound with entwined, twisted front. Design initially commissioned by the Swiss organdy interests in New York as a manufactured garment for retail sale at $4.99. Marketed by Best & Co. Initial fabrics unknown.

Additional versions: **1935** fabrics unknown (Mrs. St. John Hutchinson).

References: Esquire, May 1973; Metropolis, 1976, p. 5; sketch of Mrs. St. John Hutchinson by Henri Matisse (collection unknown).

232 BLOUSE, 1934–37 London

Stand-up collar; long sleeves; fitted; prominent, horizontal banding created from counter-directional use of fabric design. Initial fabrics and client unknown.

Additional versions: **1936** plaid fabric (Anne, Countess of Rosse).

References: The Tatler, Jan. 1, 1937.

233 OVER BODICE 1934–37 London

V-neck; draped, turnover shoulder strap; three alternating bustline drapes. Initial fabrics and client unknown.

Additional versions: **?1937** gold silk taffeta (Marit Guinness Aschan).

Marit Guinness Aschan

234 SHORT PANTS, 1938 Paris

Diagonal waist with foldover points; tie closure. Initial fabrics and client unknown.

Homer Layne

235 "FIGURE-8" SKIRT, 1939 London
(see cat. illustration 50)

One-piece; culotte passing between legs and wrapping over front and back. Design suggested to James by Diana Vreeland. Initial fabrics and client unknown.

Additional versions: **1939** fabrics unknown (Doris Duke, Gypsy Rose Lee).

Patterns: muslin model V&A T21.1980

References: U.S. Harper's Bazaar, Jan. 1940, p. 52.

236 BODICE, ?1939 ?London
(see cat. illustration 50)

Draped, crossover bustline; cap sleeves; under-arm clasp closure. Initial fabrics and client unknown.

Additional versions: **1940** icy-white Celbrook.

References: U.S. Harper's Bazaar, Jan. 1940, p. 52.

237 INDIAN DANCER TOP, ?1940
(see cat. illustration 220)

Jewel neck; cap sleeves; front closure ending below bustline. Initial fabrics and client unknown.

Additional versions: **1941** white rayon ripcord; gilt buttons (offered by B. Altman & Co.; Carson, Pirie, Scott & Co.; Burdine's).
References: U.S. *Harper's Bazaar,* Jan. 1941, p. 81.

238 SHORTS, ?1940

Near-kneecap length shorts, with skirt over front. Initial fabrics and client unknown.

Additional versions: **1941** white rayon ripcord (offered by B. Altman & Co.; Carson, Pirie, Scott & Co.; Burdine's).
References: U.S. *Harper's Bazaar,* Jan. 1941, p. 80.

U.S. HARPER'S BAZAAR/HOYNINGEN HUENÉ

239 TOP, ?1943

Jewel neck; inset cap sleeves; yoke to bustline, front and back; fitted bodice with concealed placket front and quadrant front division. Initial fabrics and client unknown.

Additional versions: **1943** steel-grey silk faille.
The Brooklyn Museum, Gift of Horace Wetmore 44.180.2

THE BROOKLYN MUSEUM

240 BLOUSE, ?1944

Single-shoulder cap sleeve cut in one with front bodice; neckline outlined with two entwined ring scarves; fitted torso; side zipper closure. Initial fabrics and client unknown.

Additional versions: **1944** grey faille, lemon-yellow charmeuse.
The Brooklyn Museum, Gift of Horace Wetmore 44.180.3

THE BROOKLYN MUSEUM

241 SKIRT, 1944 [CJ 431]
(see cat. illustration 246)

Shin length; gored with fluted pleats off back V-yoke. Initial fabrics and client unknown.

Additional versions: **1947** royal-purple taffeta — part of suit, cat. no. 246 (Babs Simpson). **?1948** black satin (Millicent Rogers); black taffeta (Millicent Rogers). **1948** cream satin, full length (Mrs. Edmond G. Bradfield); pale-blue satin, full length (Mrs. William Randolph Hearst, Jr.). **?1955** rust-brown taffeta. **1959** black satin (Mrs. Edmond G. Bradfield).
The Brooklyn Museum, Gift of Paul and Arturo Peralta-Ramos 54.141.89

242 BLOUSE, ?1946

Scoop neck with shaped yoke; drawstring at center back; front gathered below yoke and on outer sleeve. Initial fabrics and client unknown.

Additional versions: **1946** wine silk crepe, labeled "Ch. James/46" (Millicent Rogers).
The Brooklyn Museum, Gift of Paul and Arturo Peralta-Ramos 54.141.84

THE BROOKLYN MUSEUM

243 SKIRT, 1947
(see also cat. nos. 305 and 309)

THE BROOKLYN MUSEUM

Street length; slightly-arced, seven-inch hipline yoke slashed on the grain into four panels; gores inset to create circular skirt when spread. Designed initially for Marie, Duchesse de Gramont (fabrics unknown).

Additional versions: **1947** navy silk satin @ $325 (Mrs. Jean de Menil); garnet wool broadcloth (Mrs. William Randolph Hearst, Jr.). **1950** bright olive-green wool broadcloth (Mrs. Edmond G. Bradfield).
The Brooklyn Museum, Gift of Mrs. William Randolph Hearst, Jr. 60.219

244 BLOUSE, 1947

Radiated V-neckline of knife pleats; sleeveless, fitted torso with flared, shallow peplum. Initial fabrics and client unknown.

Additional versions: **1947** royal-purple satin (Babs Simpson).
Fashion Institute of Technology, Gift of Babs Simpson 77.230.1

245 EVENING OVER-BLOUSE, ?1947

Deep V-neckline above pleated fan-shaped bustline; long, fitted sleeves; fitted torso extending into twin-pointed hipline peplum; zippered back closure. Initial fabrics and client unknown.

Additional versions: **1947** burgundy satin (Babs Simpson).
Fashion Institute of Technology, Gift of Babs Simpson 77.230.2

246 DINNER ENSEMBLE, 1948

Over bodice; sweetheart-shaped bustline; mid upper-arm length sleeves; full-length skirt, or skirt as cat. no. 241. Initial fabrics and client unknown.

Additional versions: **1948** bronze silk faille and satin bodice, cream skirt (Mrs. Edmond G. Bradfield); fabrics unknown (Mrs. Jean de Menil); Ben Mann fabrics, myrtle-green faille and satin bodice, pale-blue satin skirt (Mrs. William Randolph Hearst, Jr.); *bodice only,* royal-blue velvet, olive-green, brown, and orange striped silk (Millicent Rogers); *bodice only,* green silk (Millicent Rogers); fabrics unknown (Babs Simpson, offered by Carson, Pirie, Scott & Co., and The Fashion House).
References: U.S. *Harper's Bazaar,* Dec. 1948, p. 105; U.S. *Vogue,* Feb. 1, 1949, p. 210; Portrait of Mrs. Edmond G. Bradfield by David Payne (*collection of the sitter*).
The Brooklyn Museum, Gift of Paul and Arturo Peralta-Ramos 54.141.77

U.S. VOGUE/HORST

247 EVENING SKIRT, 1948

Draped, with back pouff and uneven hemline. Worn with bright-blue silk surah bodice. Designed initially in gold-green satin for Millicent Rogers.

The Brooklyn Museum, Gift of Millicent Rogers 49.233.21

248 SKIRT, 1949

(see also cat. no. 327)

Street length; shaped waistband; deep box pleats at front; flared. Designed initially for Lord & Taylor (fabrics unknown).

Additional versions: **1949** bone and buff checked wool (Mrs. Jean de Menil); olive wool (Millicent Rogers). **1951** brown and black wool tweed (Muriel Bultman Francis). **?1951** fabrics unknown (Mrs. William Randolph Hearst, Jr., Mrs. Ronald Tree). **1952** grey wool.
Patterns: paper 57.151.5b
References: U.S. Vogue, Feb. 1, 1952, p. 7.
The Brooklyn Museum, Gift of Paul and Arturo Peralta-Ramos 55.26.256
[LACMA]

249 BLOUSE, 1949

Asymmetrical neckline; front of bodice extended and draped into a rosette at one shoulder; long sleeves. Initial fabrics and client unknown.

Additional versions: **1949** brown iridescent silk faille (Mrs. Edmond G. Bradfield).

250 BLOUSE, ?1950

Shawl collar. Initial fabrics and client unknown.

Additional versions: **1950** brown satin, tan satin, labeled "C. James/50."
References: Sale catalogue, Christie's East, Feb. 18, 1981, lot #21.

251 OVER-BLOUSE, ?1950

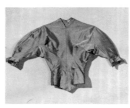

Shallow V-neck; dolman sleeves, draped at elbow and ending in pointed, lily-like cuff line; fitted bodice, peplum pointed in center front, back, and over hips. Initial fabrics and client unknown.

Additional versions: **?1950** beige satin double-faced faille (Muriel Bultman Francis).
The Brooklyn Museum, Gift of Muriel Bultman Francis 66.147.13

252 EVENING BLOUSE, 1950

Asymmetrical neckline; front bodice extended and draped into a rosette at one shoulder. Initial fabrics and client unknown.

Additional versions: **1950** fabrics unknown (Mrs. Edmond G. Bradfield).

253 BLOUSE, 1950

Draped dart, V-neckline; inset, elbow-length, melon-shaped, modified raglan sleeve; fitted torso with large diamond center front panel. Initial fabrics and client unknown.

Additional versions: **?1950** silver-blue satin (Mrs. Edmond G. Bradfield); gold faille, white soutache braid (Mrs. Edmond G. Bradfield).
Art Students League, New York
[Homer Layne]

254 BLOUSE, 1950

Based upon jacket to Dinner Suit cat. no. 322. Designed initially in tie silk for Ohrbach's, and merchandised @ $29.50. ☐

255 BLOUSE, ?1950 [CJ 458]

Initial fabrics and client unknown. ☐

Additional versions: **1951** turquoise @ $265 (Millicent Rogers).

256 TROUSER SKIRT, ?1950 [CJ 459]

Initial fabrics and client unknown. ☐

Additional versions: **1951** fabrics unknown @ $475 (Mrs. William Randolph Hearst, Jr.).

257 GILET or WAISTCOAT, ?1950

Shawl collar; diagonal armholes; fitted torso; two points at waistline; inset bustline pocket. Worn with box jacket of Dinner Suit, cat. no. 317. Initial fabrics and client unknown.

Additional versions: **1951** rust-brown satin, black silk crepe (Mrs. Cornelius Vanderbilt Whitney).
The Metropolitan Museum of Art, Gift of Eleanor Searle Whitney McCollum 1975.246.5c

258 BLOUSE, ?1951

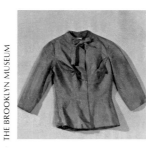

Mandarin collar ending in ties; fold-back revers; two-third length straight sleeves; bustline in seam pockets with arced flaps; concealed front placket closure. Initial fabrics and client unknown.

Additional versions: **?1958** grey taffeta, labeled "An Original Design/by/Charles James."
The Brooklyn Museum

259 BLOUSE, ?1951 [CJ 471]

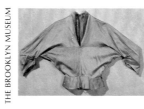

Stand-away V-neck collar; triangular yoke extending to diamond-shape wrist-opening of dolman sleeves cut from waistline and neckline; shallow trapezoidal peplum. Initial fabrics and client unknown.

Additional versions: **1951** red @ $175 (Mme. Eric Boissonas); orange @ $185 (Charles James inventory); red @ $250 (Lily Pons); orange lamé @ $175 (Mrs. George Perkins Raymond); linen CJ 471b dress @ $325 (Millicent Rogers). **?1951** wine-red taffeta (Millicent Rogers); grey figured silk (Millicent Rogers).
References: The Brooklyn Museum sketches 57.218.35l.
The Brooklyn Museum, Gift of Paul and Arturo Peralta-Ramos 54.141.85

260 BLOUSE, ?1951 [CJ 477]

Initial fabrics and client unknown. ☐

Additional versions: **1951** fabrics unknown @ $175 (Princess Bon Compagne).

261 SKIRT, ?1951 [CJ 481]

Initial fabrics and client unknown. ☐

Additional versions: **1951** fabrics unknown @ $175 (Princess Bon Compagne).

262 EVENING SKIRT, ?1951 [CJ 488]

Initial fabrics and client unknown. ☐

Additional versions: **1951** fabrics unknown @ $425 (Princess Bon Compagne).

263 SKIRT, ?1951 [CJ 489]

(see cat. no. 264)

Initial fabrics and client unknown. ☐

Additional versions: **1951** fabrics unknown, with slip @ $225 (Mrs. William Randolph Hearst, Jr.); organdy, with cat. no. 264 @ $725 (Mrs. Richard Reynolds); fabrics unknown, with cat. no. 264 @ $675 (Millicent Rogers).

THE BROOKLYN MUSEUM

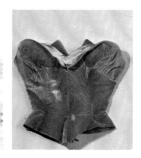

264 EVENING OVER-BODICE
[CJ 490]
(see cat. no. 263)

Strapless; draped inner bust; wired fold-over outer bust and back revers; fitted bodice extending to faced and flared pointed peplum. Initial fabrics and client unknown.

Additional versions: **1951** velvet @ $265 with cat. no. 263 and slip (Mrs. William Randolph Hearst, Jr.); velvet, with cat. no. 263 @ $725 (Mrs. Richard Reynolds); chartreuse velvet, grey satin, turquoise faille, with cat. no. 263 @ $625 (Millicent Rogers).
The Brooklyn Museum, Gift of Paul and Arturo Peralta-Ramos 54.141.80

265 STOLE, 1951 [CJ 494]

Initial fabrics and client unknown. □

Additional versions: **1951** satin @ $275 (Audrée Nethercott); velvet @ $375 (offered by Lord & Taylor); ruby @ $425 (offered by Marshall Field & Co.).

266 SKIRT, 1951 [CJ 495]

Initial fabrics and client unknown. □

Additional versions: **1951** red @ $325 (Mrs. Jean de Menil); **1952** green @ $625 (Millicent Rogers).

267 "ROSE" OUTFIT, 1951

Draped, asymmetric neckline extended into a rosette at one shoulder; sleeveless; fitted bodice with front waistline point; skirt draped over hips and slightly flared. Designed initially as aqua satin blouse; chartreuse satin skirt (client unknown).

Charles James Archives

268 SKIRT, ?1952

Street-length sheath; hip yoke extending to one-third width center front panel. Initial fabrics and client unknown.

The Brooklyn Museum

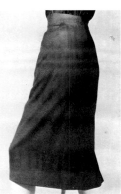

269 "DOROTHY" SKIRT, 1952
[CJ 496]
(see cat. nos. 307, 334, 350 and 353)

Straight; street-length. Named after New York's famous duplicate model. Initial fabrics and client unknown.

Additional versions: **1955** teal-blue wool broadcloth @ $175, labeled "An Original Design/by/Charles James" (Mrs. Jean de Menil). **1956** grey wool flannel. **1959** fabrics unknown @ $50 (Mrs. Herbert T. Cobey); black (Jane Doggett); black brocade @ $50 (Muriel Bultman Francis); red and black Ducharne wool @ $225 (Mary Ellen Hecht).
Patterns: paper 57.151.2b
The Brooklyn Museum, Gift of Mrs. Jean de Menil 57.151.2a&b

270 SKIRT, 1952 [CJ 497d]

Sheath; elliptical waistband; twelve gores; knee-line flare. Initial fabrics and client unknown.

The Brooklyn Museum

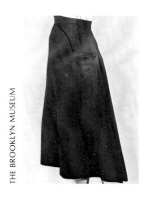

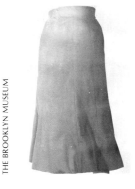

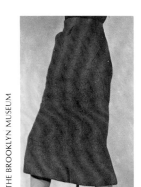

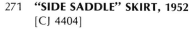

271 "SIDE SADDLE" SKIRT, 1952
[CJ 4404]

Street-length sheath; two curved darts over one hip and curved seam containing pocket over other hip; asymmetrical, hipline V-yoke in back. Initial fabrics and client unknown.

Additional versions: **1955** blue-purple wool broadcloth @ $175, labeled "An Original Design/by/Charles James" (Mrs. Jean de Menil); navy wool broadcloth (Mrs. Hans Zinsser); fabrics unknown (marketed by Samuel Winston). **?1953** charcoal wool (Grete Wootton).
References: Sale catalogue, Sotheby Parke-Bernet, Dec. 4, 1980, lot #164.
The Brooklyn Museum, Gift of Mrs. Jean de Menil 57.151.7a&b

272 "TULIP" or "BUGLE" SKIRT, 1952
[CJ 4418]

High-rise waist; rounded hips with hemline flare; eight shaped, gored panels. Developed in three lengths. Designed initially for, and marketed by Samuel Winston; initial fabrics unknown.

Additional versions: **1955** red wool broadcloth, red faille, labeled "An Original Design/by/Charles James" (Mrs. Jean de Menil).
Patterns: paper 57.151.1b (bell-form over which skirt was shaped 57.151.1c)
The Brooklyn Museum, Gift of Mrs. Jean de Menil 57.151.1a

273 "DIAMOND" SKIRT, 1952
[CJ 4420]
(see cat. no. 334)

Street length; elliptical-point inset over hip, tapered to join spearhead-shape side panels; front and back panels of elongated trapezoidal forms with hemline flare. Designed initially for, and marketed by William S. Popper; initial fabrics unknown.

Additional versions: **1955** pumpkin Rodier wool tweed, faille @ $225, labeled "An Original Design/by/Charles James" (Mrs. Jean de Menil); oxford-grey flannel. **?1952** royal-blue Rodier wool tweed, blue taffeta. **?1953** kelly-green wool tweed (Grete Wootton); pewter tweed; tan tweed. **1955** unknown fabrics (Elizabeth Arden). **1957** green Rodier wool tweed (marketed by Charles James Associates).
Patterns: paper 57.151.3b
The Brooklyn Museum, Gift of Mrs. Jean de Menil 57.151.3a

274 DINNER TROUSERS, 1956
[CJ 4421] ●

Box pleat accenting each trouser leg. Initial fabrics and client unknown.

Additional versions: **1956** black satin — worn with champagne bodice CJ 3314, cat. no. 230 (Mrs. Jean de Menil); black-and-white geometric-print cotton satin by Pacific.
Patterns: paper 57.151.12b&c
References: Town & Country, Jan. 1956, p. 84.
The Brooklyn Museum, Gift of Mrs. Jean de Menil 57.171.12a&d

275 SKIRT, ?1952

Street-length sheath; elliptical waistband; two side front darts; center front seam. Initial fabrics and client unknown.

The Brooklyn Museum

276 SKIRT, ?1952

Street-length sheath; high-rise waistband; side front darts; back kick pleat. Initial fabrics and client unknown.

Additional versions: **1961** greige wool fleece — worn with cat. no. 464 (Mrs. Jackson Pollock).
The Metropolitan Museum of Art, Gift of Lee Krasner 1975.52.4b

277 SKIRT, ?1952

(see also cat. no. 352)

Street-length sheath; raised rounded waistband; two side front darts. Initial fabrics and client unknown.

The Brooklyn Museum, Gift of Mrs. Douglas Fairbanks, Jr. 81.25.2

278 JACKET, 1954

(see cat. no. 351)

Wide stand-away shawl collar with deep arc-pointed revers; V-yoke in back; inset elbow-length bell sleeves; Empire-height waist. Initial fabrics and client unknown.

Additional versions: **1954** black velvet — hip length. **1956** white rayon matelassé, red-brown taffeta — hip length. **?1956** white rayon matelassé, light-brown taffeta — thigh length; white rayon matelassé, light-brown taffeta — hip length.
The Brooklyn Museum
[CJA]

279 ADULT "FRONTIE" PANTS or LIFEGUARD SHORTS, 1956
[CJ 4430A]

Elliptical front cut, folded up and buttoned. Adapted from a design for infants (cat. no. 496) and based upon Western Frontier pants. Initial fabrics and client unknown.

Additional versions: **1956** black cotton corduroy, white plastic buttons.
References: The Brooklyn Museum sketches 57.218.30i.
The Brooklyn Museum

280 BODICE (BRASSIÈRE), 1972

Low-cut bust; shoulder straps cut in one with cupless bust; low-cut diagonal back. Worn with diagonal-waist trousers or culottes. Initial fabrics and client unknown.

Additional versions: **1972** black faille (Elizabeth Strong de Cuevas).
References: American Fabrics and Fashions, Fall 1973, p. 19.
Elizabeth Strong de Cuevas

281 JACKET, ?1972

Stand collar; raglan sleeves with elbow-to-cuff gusset; triangular cross-over front ending in hipline points. Initial fabrics and client unknown.

Additional versions: **?1972** black wool broadcloth. **1977** fabrics unknown (Muriel Bultman Francis).
Muriel Bultman Francis

282 CULOTTES, 1972

High fitted-waist culottes. Initial fabrics and client unknown.

Additional versions: **1972** black satin and faille (Elizabeth Strong de Cuevas).
Elizabeth Strong de Cuevas

283 TROUSERS, 1972

Diagonally-cut waist; zippered fly-closure; trapezoidal cut-in pockets; bell-bottom shaped legs. Initial fabrics and client unknown.

Additional versions: **1972** black (Elizabeth Strong de Cuevas).
Patterns: muslin V&A T23.1980
References: American Fabrics and Fashions, Fall 1973, p. 19.
Elizabeth Strong de Cuevas

284 "BUTTERFLY" EVENING BLOUSON, 1972

Deep V-neck to waist; batwing sleeves caught at shoulder; six radiating unstitched pleats above fitted waistband in back. Initial fabrics and client unknown.

Additional versions: **1972** brown organza (Elizabeth Strong de Cuevas). **?1977** cream-white silk (Elsa Peretti).
Patterns: muslin V&A T22.1980
References: Sketch of Elsa Peretti by Antonio *(collection of the sitter).*
Elizabeth Strong de Cuevas
[Elsa Peretti]

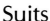

Suits

285 SPRING SUIT, ?1933 London

Jacket — twisted handkerchief tucked through button holes at neck; elbow-length raglan sleeves; loose bodice gathered to belt with jutting peplum. Skirt — street-length sheath. Initial fabrics and client unknown.

Additional versions: **1933** marine-blue face cloth, spotted silk handkerchief @ 12 guineas (offered by H. J. Nicolls & Co., Ltd.; marketed by Linker & Herbert); **?1939** dark-purple bodice, brown flocked parma-violet (Frances James).
References: U.K. Vogue, March 8, 1933, p. 76.

286 WALKING SUIT, 1933 ?London

Coat — modified V-neck with double-breasted, semi-tailored bodice with deeply lobed, folded back, buttoned rever; buttoned waistline closure. Skirt — street-length sheath. Initial fabrics and client unknown.

Additional versions: **1933** oxford-grey wool with cording and black silk frogs (offered by Best & Co.).
References: U.S. Harper's Bazaar, Oct. 1933, p. 136.

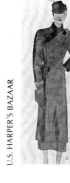

U.K. VOGUE/HORST

U.S. HARPER'S BAZAAR

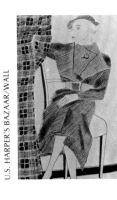

287 SUIT, 1933 London

Jacket — jewel neck with turned back revers from waist up, fanning out over bustline; inset waistband. Skirt — wrapover; street length. Initial fabrics and client unknown.

Additional versions: **1934** green tweed double-faced with beige (offered by Alfred Dunhill of London; marketed by Linker & Herbert).
References: U.S. *Harper's Bazaar,* Jan. 1934, p. 66.

288 SUIT, 1936 London [CJ 503]

Jacket — shawl collar over sham shoulder revers; tailored torso; flared peplum; stitched sham eyes. Skirt — gored; flared; knee length with back diagonal darts. Initial fabrics and client unknown.

Additional versions: **?1943** dark myrtle-green double-faced corded and satin Catoir silk, black double-faced corded and satin silk, cherry-red slipper satin, white taffeta, labeled "Ch. James" (Millicent Rogers); fabrics unknown (Elizabeth Arden, Mrs. Vincent Astor, Gypsy Rose Lee, Mrs. Eric Loder, Mrs. Harrison Williams).
Patterns: paper 49.233.8; muslin 49.233.62; half muslin model 49.233.35
The Brooklyn Museum, Gift of Millicent Rogers 49.233.16a–b

289 JACKET, 1936 Paris

High, pointed, stand-away collar; full petal cap sleeves; fitted bodice with two deep points from front waistline. Initial fabrics and client unknown.

Additional versions: **?1936** purple silk grosgrain; ruby silk grosgrain.
Charles James Archives

290 TWO-PIECE STREET SUIT, 1936 London

Jacket — pointed stand-away collar; dual-button neck closure; long fitted sleeves with slashed cuffs; tailored torso; arced, cut-away, dipping, knee-length hemline; slanted hipline pockets. Skirt — street-length sheath. Initial fabrics and client unknown.

Additional versions: **?1936** black wool broadcloth.
Charles James Archives

291 "SWAN NECK" SUIT, ?1937 London

Jacket — V-neck; long fitted sleeves with applied-fur shoulder epaulettes; rib down sleeves and swan's neck bust to hipline curve; tailored torso. Skirt — street-length sheath. Initial fabrics and client unknown.

Additional versions: **?1937** wool with outline of stone martin.
References: The Brooklyn Museum sketches 57.218.3.

292 DINNER SUIT ENSEMBLE, 1937 London

Jacket — notched collar; arced, top-stitched, tapered yoke; semi-fitted torso; two-button closure; two top-stitched, U-shaped patch pockets with fold-over, slanted end flaps; long sleeves with top-stitched fold-back cuffs. Over-blouse — pentagonal crossover bib-yoke with slanted, stud closure; long sleeves; rounded hipline with side vents. Trousers — based on cat. no. 219. Initial fabrics and client unknown.

Additional versions: **?1940** jacket of pale-pink satin and scarlet-red wool face cloth, trousers of black silk crepe, blouse of scarlet-red silk crepe (Mrs. George Perkins Raymond).
Mrs. George Perkins Raymond

293 SUIT, ?1937 London

Fitted jacket with two eye-buttons at waistline. Initial fabrics and client unknown.□

Additional versions: **1937** navy-blue and lilac paper taffeta (Marit Guinness Aschan).

294 COCKTAIL DRESS AND JACKET, 1938 London

Jacket — waist length; inset yoke terminating in wide, lobed bustline revers; inset three-quarter-length sleeves; three-button closure. Dress — deep arc yoke turned back in front to form reverse-S revers; waistline yoke; flared street-length skirt. Initial fabrics and client unknown.

Additional versions: **?1940** black lattice net over cream charmeuse, champagne wool, black satin (Yeffee Kimball).
Fashion Institute of Technology, Gift of Mrs. Harvey Slatin 74.155.2

295 BOLERO JACKET, 1938 London

Star-shaped neckline; shoulder piece cut on diagonal and extending to side bustline arc; straight sleeves; slightly curved front and dipping back reaching waistline. Initial fabrics and client unknown.

Additional versions: **?1945** navy silk satin, navy silk taffeta (Yeffee Kimball).
Fashion Institute of Technology, Gift of Mrs. Harvey Slatin 74.115.1

296 TWO-PIECE SUIT, 1939

Jacket — shawl collar; inset straight sleeves; front plastron yoke with neckline and waistline button closure; fabrics juxtaposed at shoulderline; tailored torso with hipline peplum. Skirt — street length; flared. Initial fabrics and client unknown.

Additional versions: **?1939** cranberry wool, cranberry faille (Gypsy Rose Lee).
References: Sales catalogue, Plaza Auction Gallery, April 20, 1978, lot #68.
Homer Layne

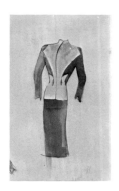

297 DAY SUIT, 1940

Jacket — hip length; fitted; shallow V-neck; inset wide revers extending to hipline peplum and including arced sham pocket form. Skirt — street-length sheath with flounced hipline peplum. Initial fabrics and client unknown.

Additional versions: **1940** fabrics unknown (Duchesse de Gramont). **?1941** black silk-faced satin and wool duvetyne black crepe (Mrs. George Perkins Raymond).
References: The Brooklyn Museum sketches 57.218.28a.
Mrs. George Perkins Raymond

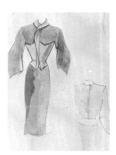

298 SUIT, 1940

Jacket — shawl collar with revers continuing to peplum point; double-V-point yoke ending at bustline; long sleeves full at wrist with rib of secondary fabric; fitted bodice with shallow hipline peplum. Skirt — street-length sheath. Designed initially for Elizabeth Arden (fabrics unknown).
References: The Brooklyn Museum sketches 57.218.28a.

299 SUIT, 1945 [CJ 502]

Jacket — hip length; shawl collar with deep V-neck; inset sleeves; tailored V-torso; deep flared peplum with layered drapery from side front. Skirt — street-length sheath. Designed initially in black silk faille for Mrs. Harrison Williams.

Additional versions: **?1945** black silk faille (Millicent Rogers). **?1947** fabrics unknown (Josephine Abercrombie, Jennifer Jones).
Patterns: paper 49.233.87; muslin 49.233.61; half muslin model 49.233.44
The Brooklyn Museum, Gift of Millicent Rogers 49.233.44

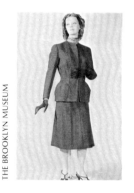

300 SUIT, 1945

Jacket — hip length; fitted, top-stitched, round neck; lyre cut; top-stitched, hipline patch pocket in shape of arced teardrop; waistline button closure. Skirt — street-length sheath. Initial fabrics and client unknown.

Additional versions: **1946** brown and yellow herringbone wool, burgundy slipper satin, labeled "Ch. James/46" (Millicent Rogers). **1947** grey wool.
References: Collier's, Sept. 1947, p. 101.
The Brooklyn Museum, Gift of Paul and Arturo Peralta-Ramos 54.141.66a&b

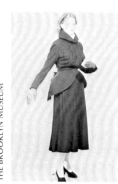

301 "FISH TAIL" SUIT, 1946 [CJ 504]

Jacket — hip length; neckline stand-away revers; double triangular back yoke; draped front plastron from neck to waist; stiffened, dipping arc peplum; slashed in back with triangular points drawn up into looped bustle bow. Skirt — street-length sheath; bracket hip yoke; straight front panel gathered over hips; box-pleated back panel. Initial fabrics and client unknown.

Additional versions: **1947** black wool crepe, violet and black satin (Millicent Rogers). **?1947** black wool crepe, white silk charmeuse, short peplum (Mrs. Rudolph A. Bernatschke). **?1948** fabrics unknown (Gypsy Rose Lee).
Patterns: paper 49.233.89; muslin 49.233.64; half muslin model 49.233.36
The Brooklyn Museum, Gift of Millicent Rogers 49.233.3

302 SUIT JACKET, 1946 [CJ 505]

Jacket — mandarin collar; draped back hip peplum. Skirt — street length; flared; yoke; back cartridge-pleating accent. Initial fabrics and client unknown.

Additional versions: **1946** fabrics unknown (Millicent Rogers).
Patterns: paper 49.233.90; half muslin model 49.233.41
The Brooklyn Museum, Gift of Millicent Rogers 49.233.41

303 AFTERNOON SUIT, ?1946

Jacket — stand collar; rounded stand-away lapels; textured long sleeves; tailored torso; draped hipline peplum pockets terminating at point about three inches from center back. Skirt — trumpet-shaped, street-length sheath; inverted urn-shaped panel in back; high-rise waist. Initial fabrics and client unknown.

Additional versions: **1946** black wool, black novelty waffle-weave silk, black slipper satin, labeled "Ch. James/46" (Toni Frissell Bacon).
The Metropolitan Museum of Art, Gift of Toni Frissell Bacon 1974.81.4

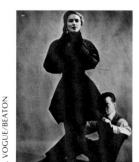

304 SUIT, ?1947 [CJ 507]

Jacket — thigh length; curved sleeves; front envelope peplum. Skirt — street-length wraparound sheath. Initial fabrics and client unknown.

Additional versions: **1948** black faille (offered by Lord & Taylor).
Patterns: paper 49.233.91; muslin 49.233.63; half muslin model 49.233.44
References: U.S. Vogue, March 1, 1948, p. 214.
The Brooklyn Museum, Gift of Millicent Rogers 49.233.43

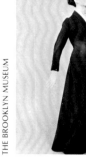

305 THREE-PIECE SUIT, 1947

Jacket — hip length; rounded, notched shawl collar; inset sleeves; tailored torso with five radiating waistline darts; flaring peplum; hook-and-eye closure. Skirt — see cat. no. 243. Culottes — see cat. no. 220. Initial fabrics and client unknown.

Additional versions: **1947** garnet wool broadcloth, pink silk rep and silk satin (Mrs. William Randolph Hearst, Jr.). **?1947** green wool broadcloth, full and straight skirts. **?1948** brown cashmere, jewel neck, slanted breastline patch pockets, pointed cuffs (Alice Topp-Lee).
The Brooklyn Museum, Gift of Mrs. William Randolph Hearst, Jr. 60.219a–c
[MHS]

306 SUIT, 1947

Coat — shawl collar; long sleeves; three-button waistline closure; tailored torso with side-front seams continuing to hipline where they zig over to form pointed inseam pockets and continue to pointed street-length hemline. Skirt — street-length sheath. Initial fabrics and client unknown.

Additional versions: **?1947** mauve wool.
Charles James Archives

307 TRAVEL SUIT, 1947

Jacket — molded stand collar with long, narrow revers folded from center; ribbon necktie through eyelet at neckline; long, narrow, semi-raglan sleeves. Skirt — street-length sheath; high-rise waist; fullness through thighs. First development of the "Dorothy" skirt (see cat. no. 269). Designed initially in brown, cream-striped men's worsted suiting with a brown ribbon necktie for Mrs. Edmond G. Bradfield.

Art Students League, New York

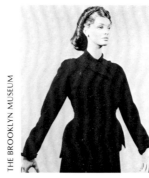

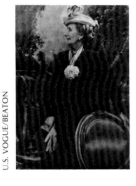

308 SUIT, 1947 [CJ 509]

Jacket — hip length; mandarin or shawl collar; inset sleeves; fitted torso and waist with S-curve construction and structured, arced hipline peplum accented with tapered diagonal welt. Skirt — street length; shaped corselette waistband; flared with two inverted pleats in back. Initial fabrics and client unknown.

Additional versions: **1947** black satin (Mrs. Ernest Beaton); black velvet, royal-purple satin and taffeta (Mrs. Thomas Leiter); black velvet, black satin, royal-purple taffeta, flesh charmeuse, labeled "Charles James/47" (Babs Simpson). **?1947** cherry-red wool, white faille (Millicent Rogers); black velvet, black satin, white patterned Chinese silk (Millicent Rogers); red wool; black velvet. **1948** variant with shaped sleeves, dipping back peplum, and front points not stitched down, in grey wool flannel, burnt-orange satin, grey taffeta, labeled "Charles James/48" (Millicent Rogers). **1950** cranberry wool, changeable purple-brown faille, labeled "Charles James/50."
Patterns: paper 49.233.92; muslin 49.233.65; half muslin model 49.233.42
References: U.S. Vogue, March 15, 1947, p. 170.
The Brooklyn Museum, Gift of Millicent Rogers 51.33.53 [FIT, CJA, Homer Layne]

309 THREE-PIECE DAY SUIT, 1948

Jacket — hip length; tailored; small revers; inset sleeves. Skirt — street-length, circular gored tube (see cat. no. 243). Sheath — street-length sheath with front side seams. Initial fabrics and client unknown.

Additional versions: **1950** bright olive-green wool broadcloth (Mrs. Edmond G. Bradfield). **?1951** fabrics unknown (Mrs. Jean de Menil).

310 THREE-PIECE AFTERNOON OR DINNER SUIT, 1948

Jacket — draped peplum; twin-pointed center-back panel. Skirt — street length; hipline yoke; notched back panel; high-rise waistband. Halter waist; rounded yoke; gathered bustline; fitted waist with wraparound back. Initial fabrics and client unknown.

Additional versions: **?1948** black silk faille, black wool velour, scarab-blue silk faille (Mrs. Edmond G. Bradfield); fabrics unknown (Millicent Rogers).
Art Students League, New York

311 JACKET, ?1948

Stand collar; draped jabot revers; long sleeves with turned-back cuffs; fitted torso; slanted hipline peplum with pocket flaps. Initial fabrics and client unknown.

Additional versions: **?1948** plum wool, brown silk crepe (Millicent Rogers).
The Brooklyn Museum, Gift of Paul and Arturo Peralta-Ramos 54.141.65

312 DAY SUIT, ?1948

Jacket — hip length; tailored; front S-curve neckline with waist-deep, lyre-shaped yoke; raglan sleeves; deep hipline yoke extending into side arcs and including V-shaped pockets; back inverted-V neckline with drapery from shoulders to center back waist, flaring out from gathers to side hips and gathered under center-back hem. Skirt — street-length sheath; side darts; front and back seam. Initial fabrics and client unknown.

Additional versions: **?1949** dark-chocolate wool broadcloth, garnet satin (Muriel Bultman Francis).
The Brooklyn Museum, Gift of Muriel Bultman Francis 66.147.6a&b

313 SUIT, ?1949

Jacket — low stand collar; folded back S-curve revers; notched back yoke; tailored torso with sweeping arc outlined in contrasting piping; three-quarter-length sleeves. Skirt — notched waistline; street length; flared. Initial fabrics and client unknown.

Additional versions: **1949** parma-violet silk faille, white silk crepe, labeled "Charles James/49" (Mrs. H. S. H. Guinness).
References: Guinness family photographs.
Marit Guinness Aschan

314 COMMUTER SUIT, 1949

Jacket — button-and-tie closure at neck; arced and pointed revers; single button at waist; wide peplum. Dress — V-construction neckline and three seams arcing off center front; balloon sleeves with diamond-shaped opening set in all the way to the neckline; street-length skirt. Initial fabrics and client unknown.

Additional versions: **1949** periwinkle-blue alpaca, eggshell-white charmeuse, labeled "Charles James/49" (Mrs. Edmond G. Bradfield).
Art Students League, New York

315 SUIT, 1949

Jacket — hip-length Chesterfield; faced, notched collar; shallow epaulettes on shoulderline above inset sleeves; padded hip peplum. Skirt — street-length sheath. Initial fabrics purchased by Charles James for personal suit.

Additional versions: **?1950** rib-faced grey wool, black velvet.
Homer Layne

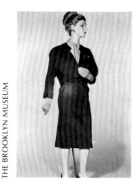

316 DAY SUIT, 1949

Jacket — street length; notched; V neckline with front waistline crossover triangular points; top-stitched welted sleeve seam. Skirt — street-length sheath; elliptical waistband yoke and back yoke extending as panel to hemline. Initial fabrics and client unknown.

Additional versions: **1950** mulberry French wool, plum silk lining, labeled "Charles James/50" (Mrs. Rudolph A. Bernatschke).

The Brooklyn Museum, Gift of Mrs. Rudolph A. Bernatschke 55.194.19

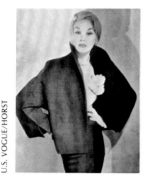

317 DINNER SUIT, 1949 Paris

Jacket (designed 1947) — box; hip length; shawl collar (see also cat. no. 391); double-front clutch closure; dolman sleeves with welted seam. Skirt — street-length, wraparound barrel sheath. Initial fabrics and client unknown.

Additional versions: **1947** ruby wool, black satin. **?1949** black wool face cloth, rust-brown satin, double-cut front (Muriel Bultman Francis). **1950** black wool broadcloth, brown iridescent silk faille (Mrs. Edmond G. Bradfield); ribbed wool lined with fur (Margaret Enders); mulberry wool broadcloth, seal-dyed muskrat (offered by Lord & Taylor). **1951** fur lined @ $775 (Anne Marie de Castro); black wool face cloth, rust-brown satin, waistcoat labeled "Charles James/51" (Mrs. Cornelius Vanderbilt Whitney). **?1951** fabrics unknown (Mrs. Miguel Ferreras).

References: U.S. Vogue, Feb. 15, 1950, p. 66.

The Brooklyn Museum, Gift of Muriel Bultman Francis 66.147.8a–b
[MMA, CJA]

318 COAT AND SUIT ENSEMBLE, ?1949

Coat — V-neck; pointed collar; fitted bodice; waistline pointed-tab closure; street-length skirt. Jacket — stand collar; lyre-cut top-stitched yoke; hipline pockets; slanted peplum, Skirt — street-length sheath. Striped blouse and skirt — semi-fitted bodice; stand collar; tapered raglan sleeves; V hipline inset; circular skirt with hipline flare. Initial fabrics and client unknown.

Additional versions: **1949** coat and jacket in navy Shetland wool with lining, blouse, and skirt in blue-and-sand striped silk, labeled "Charles James/49" (Alice Topp-Lee).

Missouri Historical Society, Gift of Alice Topp-Lee

319 SUIT WITH CAPE COAT, ?1950

Jacket — free-floating back. Skirt — hemline band. Blouse — cut with pentagonal torso section. Initial fabrics and client unknown.

Additional versions: **1950** black cashmere face-cloth, blouse in brown silk with woven dot, labeled "Charles James/50" (Mrs. Edmond G. Bradfield).

Art Students League, New York

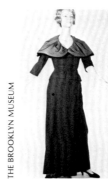

320 DINNER SUIT, ?1950

Over bodice — deep-draped bertha collar; fitted; zippered front. Culottes — wide flared legs (see cat. no. 220). Initial fabrics and client unknown.

Additional versions: **1950** grey faille, charcoal-grey wool flannel (Mrs. William Randolph Hearst, Jr.).

The Brooklyn Museum, Gift of Mrs. William Randolph Hearst, Jr. 64.231.3

321 PEG-TOP SUIT SKIRT, 1950 [CJ 519]

Sheath, top-stitched ribbed side seams, curved out at hipline. Designed initially in black wool broadcloth for Mrs. Cornelius Vanderbilt Whitney.

Additional versions: **1951** black wool broadcloth @ $175 (Mrs. Jean de Menil); grey flannel @ $500 (Mrs. Andrew Fraser); flannel @ $525 (Martha Roundtree).

Patterns: paper 57.151.6a

The Brooklyn Museum, Gift of Mrs. Jean de Menil 57.151.6a
[MMA]

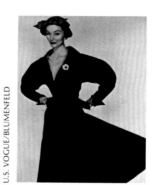

322 DINNER SUIT, 1950 [CJ 520] ●

Jacket — tailored with roll-over edge; V-neck shawl collar; dolman arc sleeves; shaped, flared shallow peplum. Skirt — flared or sheath. Initial fabrics and client unknown.

Additional versions: **1950** dark-brown satin, black velvet, putty faille, full skirt, labeled "Charles James/50" (Muriel Bultman Francis); satin @ $95 (merchandized by Ohrbach's); navy gabardine @ $110 (merchandised by Ohrbach's); brown satin, black velvet, plum taffeta, sheath skirt (merchandised by Ohrbach's). **?1950** beige silk whipcord (Millicent Rogers). **1951** petrol-blue silk rep, olive faille, full skirt, labeled "Charles James/51" (Mrs. Ruldolf A. Bernatschke); silk @ $575 (Princess Bon Compagne); silk @ $500 (Mrs. Byron Harvey, ?Sr.); silk @ $425 (Mrs. Byron Harvey, Jr.); teal-blue silk ottoman, full skirt (Mrs. William Randolph Hearst, Jr.); silk @ $475 (Mrs. William Randolph Hearst, Jr., Gypsy Rose Lee); blue whipcord @ $475 (Millicent Rogers); whipcord @ $525 (Martha Roundtree); dark-blue ribbed silk, turquoise taffeta @ $300 (offered by Lord & Taylor).

References: U.S. Vogue, July 1951, p. 30.

The Brooklyn Museum, Gift of Muriel Bultman Francis 66.147.9
[RISD]

323 SUIT JACKET, ?1951

Waist-length box jacket with shawl collar; sham neckline; single-button closure; sawtooth shoulderline; inset long sleeves. Initial fabrics and client unknown.

Additional versions: **1951** black twill-weave cashmere, labeled "Charles James/51" (Mrs. Cornelius Vanderbilt Whitney).

The Metropolitan Museum of Art, Gift of Eleanor Searle Whitney McCollum 1975.246.3a–b

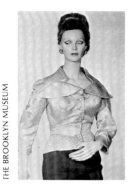

324 EVENING JACKET, ?1951

Three-quarter-circumference stand collar; broad bustline revers over yoke; elbow-length sleeves; tailored torso with shallow flared peplum; V-point to back waistline; deep arc pointed revers. Initial fabrics and client unknown.

Additional versions: **?1951** pink and gold floral silk brocade, coffee faille (Millicent Rogers).
The Brooklyn Museum, Gift of Paul and Arturo Peralta-Ramos 54.141.76

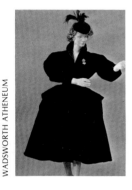

325 THEATRE ENSEMBLE, 1951 ●

Jacket/bodice — V-neck shawl collar with detachable facing; push-up melon sleeves cut in one with bodice; fitted waistline; hook-and-eye closure which also unites bodice to skirt. Skirt — shin length; structured; bifurcated; gored circular hipline; two hipline patch pockets. Worn with hat (cat. no. 551). Designed initially in black velvet, black satin, and light-rust satin @ $850 for Audrée Nethercott.

References: Herbert Callister, *Dress from Three Centuries* (New Haven, CT: Wadworth Atheneum, 1976), pp. 72–73.
Wadsworth Atheneum, Gift of Audrée Nethercott 1970.48

326 SUIT, 1951

Jacket — hip length; tailored; round collar; rectangular front yoke; rounded bustline tab below triangular cut-out; inset sleeves; sham pocketed and shaped hipline peplum. Skirt — street-length sheath; deep back hemline kick box pleat. Initial fabrics and client unknown.

Additional versions: **1951** cranberry cashmere face cloth, tobacco-brown satin, labeled "Charles James/51" (Muriel Bultman Francis). **?1951** cranberry cashmere face cloth, black and burgandy satin (Mrs. Cornelius Vanderbilt Whitney).
The Brooklyn Museum, Gift of Muriel Bultman Francis 66.147.7a–d
[MMA]

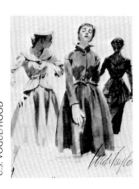

327 "DRESSMAKER" SUIT, 1951 [CJ 516]

Jacket — back collar; standout revers; fitted torso with crossover waistline points from shallow flared peplum; two-button neckline; one-button waistline closure. Skirt — street length; gored; flared; side-front box pleats (see cat. no. 248). Initial fabrics and client unknown.

Additional versions: **1951** brown and black wool tweed, black velvet, black satin, labeled "Charles James/51" (Muriel Bultman Francis); black and brown @ $650 (Charles James inventory); black and brown @ $200 (Charles James inventory); fur-lined jacket @ $625 (Mrs. Vernon Taylor); cloth @ $675 (Mrs. Ronald Tree); black @ $775 (Mrs. Cornelius Vanderbilt Whitney); navy cloth and satin @ $725 (offered by Lord & Taylor); flannel @ $675 (offered by Lord & Taylor); wool @ $650 (offered by Lord & Taylor). **?1951** fabrics unknown (Mrs. William Randolph Hearst, Jr.). **1952** grey wool; fabrics unknown (offered by Lord & Taylor).
References: U.S. *Vogue,* Feb. 1, 1952, p. 7; *Look,* Sept. 1952, p. 93.
The Brooklyn Museum, Gift of Muriel Bultman Francis 67.215.2a–b
[LACM]

328 SUIT, 1951 [CJ 517]

Initial fabrics and client unknown. □

Additional versions: **1951** flannel @ $675 (Mrs. Joseph E. Davies, Mrs. Jean de Menil); brown @ $446.25 (Charles James inventory); flannel @ $200 (Babs Simpson); flannel skirt, CJ 517A @ $225 (Mrs. Vernon Taylor); grey flannel @ $675 (Mrs. Cornelius Vanderbilt Whitney).

329 DAY SUIT, ?1951

Jacket — semi-circular stand collar; pointed revers; arced sleeves; tailored torso; shallow arced peplum with crossover, folded under tabs at center-front waist. Skirt — street-length wraparound sheath. Initial fabrics and client unknown.

Additional versions: **1951** charcoal-grey wool flannel, café-au-lait satin, illegible label (Muriel Bultman Francis). **?1951** navy wool, blue-and-black spotted satin (Mrs. Rudolph A. Bernatschke).
The Brooklyn Museum, Gift of Muriel Bultman Francis 66.147.5a&b
[MMA]

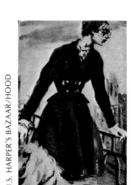

330 DAY SUIT, 1952

Jacket — hip length; notched V-neck collar; round yoke; fitted, double-breasted torso with shallow flared peplum; inset sleeves. Skirt — street length; flared. Designed initially for, and marketed by William S. Popper (fabrics unknown).

Additional versions: **1952** handwoven tweed, velvet @ $235 (merchandised by Lord & Taylor).
References: U.S. *Harper's Bazaar,* Sept. 1952, p. 27.

331 BOLERO JACKET, 1952

V-neck in front with fold-back revers; trapezoidal shape in back above bowed closure; elbow-length, gathered, arced melon sleeves with winged, rolled-back cuffs. Initial fabrics and client unknown.

Additional versions: **1952** bright shocking-pink silk taffeta, black satin ribbon, labeled "Samuel Winston/by Charles James" (marketed by Samuel Winston).
National Museum of American History, Gift of Joseph S. Simms 1977.1166.1

332 BOLERO JACKET, 1952

Diagonal crossover front creating X-collar and revers; long full sleeves with flared cuffs. Initial fabrics and client unknown.

Additional versions: **1952** brown wool.
Homer Layne

333 BOLERO JACKET, 1952

Jewel neck ending in front with extended, lobed tab revers above fluted jabot; slanted cut-away front cut in one with long tapered sleeves. Initial fabrics and client unknown.

Additional versions: **1952** brown silk taffeta, labeled "Samuel Winston/by Charles James" and "Lord & Taylor/Fifth Avenue" (Mrs. Charles James).
The Brooklyn Museum

334 THREE-PIECE SUIT, ?1953

Jacket — hip length; tailored; notched flat collar; inset sleeves; flared, stiffened peplum with pair of arced pocket flaps; four-button torso closure. Skirts — street-length sheath (see cat. no. 350) and calf-length version (see cat. no. 273). Initial fabrics and client unknown.

Additional versions: **1953** oxford-grey wool flannel, labeled "Charles James/53" (Muriel Bultman Francis).
The Brooklyn Museum, Gift of Muriel Bultman Francis 67.215.3a–c

335 SUIT, 1953

Box jacket — waist length; round collar. Skirt — street-length sheath. Designed initially for, and marketed by William S. Popper.

Additional versions: **1953** silk @ $225 (merchandised by Lord & Taylor).
References: U.S. *Vogue,* Feb. 1, 1953, p. 7.

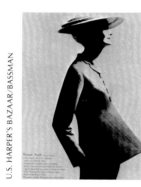

LORD & TAYLOR/HOOD

336 "PAGODA" or "EGYPTIAN" TUNIC SUIT, 1954

Jacket — thigh length; notched collar; deep V-front and back panel construction; long inset sleeves; flared skirt; three-button closure. Skirt — mid-calf length; inverted-V front panel; two back hemline kick pleats. Initial fabrics and client unknown.

Additional versions: **1955** grape wool, purple taffeta, labeled "An Original Design/by/Charles James" (Mrs. Albert H. Newman); grape Worumbo vicuna (offered by Lord & Taylor). **1957** grape vicuna (Charles James Associates). **?1957** Chinese-red silk brocaded with gold in morning-glory motif, gold taffeta, labeled "An Original Design/by/Charles James" (Mrs. Mortimer Solomon); Chinese-red silk brocaded with gold in morning-glory motif, labeled "Lord & Taylor" (offered by Lord & Taylor).
References: U.S. *Harper's Bazaar,* July 1955, p. 65; The Brooklyn Museum sketches 57.218.27h.
The Metropolitan Museum of Art, Gift of Mrs. Mortimer Solomon 1975.301.2a&b
[CHS, PMA]

U.S. HARPER'S BAZAAR/BASSMAN

337 "EGYPTIAN" COAT AND DRESS ENSEMBLE, 1954

Coat — see cat. no. 424. Dress — three-quarter-circumference stand collar; kimono sleeves; high Empire bustline of overlaid triangular tabs; fitted street-length sheath. Initial fabrics and client unknown.

Additional versions: **?1954** Coat — brick-red brushed wool. Dress — brick-red wool (Muriel Bultman Francis).
Muriel Bultman Francis

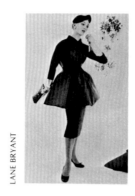

THE BROOKLYN MUSEUM

338 MATERNITY ENSEMBLE, 1954

Jacket — thigh length; roll collar; bustline yoke front and back; gored, flared torso; angled inset pockets; inset sleeves. Skirt — street-length wraparound sheath. Worn with beret (cat. no. 554). Designed initially in magenta wool twill and fuchsia taffeta for Lane Bryant (labeled "Charles James/54").

The Brooklyn Museum, Gift of Lane Bryant 61.104.2a–c

339 MATERNITY OUTFIT, 1954

Two-piece tunic dress — V-neck; diagonal, wrapover, semi-fitted bodice; raised, arced waistband; thigh-length peplum; Skirt — wraparound sheath. Crinoline skirt — nylon mesh supporting peplum. Designed initially in pewter-grey Avisco rayon and acetate for Lane Bryant (merchandised @ $40).

Additional versions: **1954** toast-brown taffeta, labeled "Charles James/54".
References: U.S. *Vogue,* Nov. 1, 1954, p. 144.
The Brooklyn Museum, Gift of Lane Bryant 61.104.1a–b

LANE BRYANT

340 SUIT JACKET, 1954 [CJ 523]

Armhole developed after study by Charles James of the "Empress Josephine" Evening Dress, made in France *circa* 1820 (*The Brooklyn Museum* 53.172.1). Initial fabrics and client unknown. □

341 SUIT SKIRT, 1954 [CJ 545]

Belted waistband. Initial fabrics and client unknown. □

Additional versions: **1957** black (Charles James Associates).

342 "BIRD" SUIT, 1954 [CJ 550]

Initial fabrics and client unknown. □

Additional versions: **1954** fabrics unknown (Mrs. Charles James, Felice Maier). **1957** dark red (Charles James Associates); brown (Charles James Associates).
Patterns: paper (The Brooklyn Museum: not accessioned).

343 SUIT, 1954 [CJ 552]

Initial fabrics and client unknown. □

Additional versions: **1957** black wool broadcloth, satin (Charles James Associates).

344 SUIT, 1954 [CJ 553]

Side button detail. Initial fabrics and client unknown. □

Additional versions: **1957** black broadcloth (Charles James Associates).

345 DAY SUIT, 1954 [CJ 560]

Jacket — hip-length front and back yoke with bow; arced front; flared torso. Skirt — street-length sheath. Initial fabrics and client unknown.

Additional versions: **1954** pink.
References: The Brooklyn Museum sketches 57.218.27c

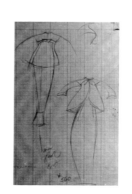

346 JACKETED DRESS, ?1954

Jacket — hip length; notched collar; inset sleeves; arced front; dipping back. Dress — street length; scoop V-neck; semi-fitted short sleeves; sheath skirt.

Additional versions: **?1961** blue-green wool tweed, green taffeta (Mrs. Jackson Pollock).
The Metropolitan Museum of Art, Gift of Lee Krasner 1975.52.5

347 JACKET, ?1954

Peter Pan faced collar; neckline closure; curved, cutaway, dipping, flared, hip-length hemline. Initial fabrics and client unknown.

Additional versions: **?1954** black velvet, garnet wool broadcloth, black taffeta (Muriel Bultman Francis).
The Brooklyn Museum, Gift of Muriel Bultman Francis 66.147.12

348 JACKET, ?1955

Round neck with lobed tab collar; back vent open to just above rib cage reverse-direction pockets in overlapping peplum construction. Initial fabrics and client unknown.

Additional versions: **?1955** double-faced dark-navy Catoir silk satin, navy taffeta (Mrs. John Hays Hammond).
Homer Layne

349 TOWN SUIT, ?1955

Initial fabrics and client unknown. □

Additional versions: **1957** green Rodier wool with green faille waistcoat @ $700.

350 "EGYPTIAN" DINNER SUIT, 1955 [CJ 536]

U.S. VOGUE/COFFIN

Jacket — thigh length; roll collar with narrow pointed revers; inset sleeves; Empire bustline above inverted-Y tailored torso; back V-yoke flared peplum; three-button bustline closure. Skirt — street-length sheath (see cat. nos. 219, 269, 334, and 351). Initial fabrics and client unknown.

Additional versions: **1955** brocade (Gloria Case, Mrs. Charles James); grape Worumbo vicuna with natural ranch mink collar, (offered by Lord & Taylor, Neiman Marcus, I. Magnin, and Saks Fifth Avenue). **1956** brocade @ $300 (American Rayon Institute); black wool broadcloth, red-black changeable silk taffeta, labeled "An Original Design/by/Charles James" @ $675 (Mrs. Jean de Menil); white broadcloth (Mrs. Charles James); white rayon matelassé, cream silk taffeta, floor-length skirt, labeled "An Original Design/by/Charles James" (Mrs. Charles James). **1957** grape wool flannel (Charles James Associates); black wool broadcloth, with full back, CJ 536E (Charles James Associates); black wool (Gypsy Rose Lee). **1959** black brocade (Muriel Bultman Francis); navy metallic Ducharne silk brocade, one long skirt, one short skirt @ $975 (Mary Ellen Hecht).
Patterns: paper 57.151.94
References: U.S. Vogue, Sept. 15, 1955, p. 98; New York Times, Oct. 10, 1955, p. 13; U.S. Harper's Bazaar, Sept. 1956, p. 37; New York Times, Feb. 12, 1962.
The Brooklyn Museum, Gift of Mrs. Jean de Menil 57.151.14a–d
[Homer Layne]

351 DINNER SUIT, 1956
(see cat. illustration 210)

Jacket — hip length; wide stand-away shawl collar with deep arc pointed revers; V-yoke in back; inset, elbow-length bell sleeves; Empire waist. Skirt — flared and arced. Designed initially for Mrs. Charles James (fabrics unknown).

Additional versions: **1956** white rayon matelassé red-brown taffeta @ $775, labeled "An Original Design/by/Charles James" (Mrs. Jean de Menil).
Patterns: paper 57.151.13c
References: U.S. Harper's Bazaar, Sept. 1956, p. 37.
The Brooklyn Museum, Gift of Mrs. Jean de Menil 57.151.13a–c

352 SUIT, ?1956

Jacket — hip length; shawl collar; inset sleeves; arced front dipping to back; diagonal two-button neckline closure; inseam diagonal pockets (see cat. no. 354). Skirt — street-length sheath; arced waistline; front side paired darts. Initial fabrics and client unknown.

Additional versions: **?1956** grey-and-white wool tweed, steel-grey taffeta, labeled "An Original Design/by/Charles James" (Mrs. Douglas Fairbanks, Jr.).
References: The Brooklyn Museum sketches 57.218.27f and 57.218.3.
The Brooklyn Museum, Gift of Mrs. Douglas Fairbanks, Jr. 81.25.2a&b

353 SUIT, 1956

Jacket — round collar with round lapels; three-button bustline closure; slanted pockets; semi-fitted torso, ending in arced, dipping, flared, thighline skirt. Skirt — see cat. no. 269. Initial fabrics and client unknown.

Additional versions: **1956** black wool, black crepe.
Homer Layne

354 JACKETED DRESS, ?1956
(see also cat. nos. 188 and 352)

Jacket — hip length; notched collar; inset sleeves; arced front dipping to back; five-button closure; inseam diagonal pockets. Jacket — deep V-neck; inset sleeves; fitted torso; raised waist with deep, arced, stiffened peplum; diagonal, two-button front closure. Bolero bodice — round tie neckline; stand-away pointed revers; diagonally-slashed breast pockets with arc-shaped flaps; inset elbow-length sleeves. Dress — V-neck; Empire-waisted bodice; sleeveless; straight-sheath skirt. Initial fabrics and client unknown.

Additional versions: **?1956** almond-green wool broadcloth, satin, and taffeta, labeled "An Original Design/by/Charles James" @ $625 with an extra jacket @ $325 (Muriel Bultman Francis); almond-green wool broadcloth and satin, labeled "An Original Design/by/Charles James" (Mrs. Cornelius Vanderbilt Whitney).
The Brooklyn Museum, Gift of Muriel Bultman Francis 66.147.10a–d
[MMA]

355 SUIT, ?1956

Jacket — shallow shawl collar; yoke with point over bust; inset sleeves; three bustline buttons; curved, inseam, slanted pockets; cut-away front. Skirt — street-length sheath; high-rise waistband. Initial fabrics and client unknown.

Additional versions: **?1956** navy wool, labeled "An Original Design/by/Charles James" (Grete Wootton).
References: Sales catalogue, Sotheby-Parke Bernet, Dec. 4, 1980, lot #163.

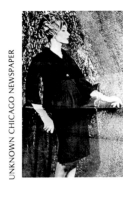

UNKNOWN CHICAGO NEWSPAPER

356 TAILLEUR, 1961

Jacket — wide back scoop neck with fold-over revers; deep V-neck in front; waistline button closure; fantail hemline. Dress — street-length sheath; scoop neck; sleeveless, fitted torso with inverted-Y hipline darts. Designed initially for the National Association of Woolen Manufacturers to commemorate James's "Golden Citation" award for 30 years of contributions to fashion design (fabrics unknown).

Additional versions: **1961** brown wool (Mrs. Jean de Menil); grey-black wool (Mrs. Jean de Menil).
References: Chicago Daily News (magazine), Nov. 1, 1961, p. 10; Herbert Callister, *Dress from Three Centuries* (Hartford, CT: Wadsworth Atheneum, 1976, p. 80.
Wadsworth Atheneum, Gift of Mrs. Jean de Menil 1964.151

357 COCKTAIL DRESS AND JACKET, 1961

Jacket — wide back scoop neck; V-front with fold over revers; elbow-length kimono sleeves; elliptical raised-front waist dipping in back (see cat. no. 356). Dress — deep scoop neck with bodice fullness folded in; knife-pleated short skirt in front; stitched pleats forming hipline yoke. Initial fabrics and client unknown.

Additional versions: **1961** white satin, white taffeta, black silk faille (Mrs. Jackson Pollock).
The Metropolitan Museum of Art, Gift of Lee Krasner 1975.52.1

358 SUIT, 1976

Jacket — jewel neck; dolman sleeves; waist length with dipping crossover triangular points. Skirt — shin length; notched waistband; side front closure above full-length knife pleats forming an apron front. Blouse — jewel neck; three-quarter-length kimono sleeves; tailored torso. Designed initially for Muriel Bultman Francis (fabrics unknown).

Additional versions: **1980** cinnamon brown, purple silk, labeled "A Charles James Design 1976/Executed by Homer Layne 1980" (Muriel Bultman Francis).
Muriel Bultman Francis

Coats

U.S. HARPER'S BAZAAR

359 EVENING COAT, 1933 London ●
(see cat. illustration 10)

Draped blouson bodice with short kimono-like sleeves; shawl collar; fitted waist and through hips; flared skirt with slight train. Designed initially in black velvet for an unknown client.

Additional versions: **?1933** aubergine silk faille, labeled "James/15 Bruton St./London W." (Anne, Countess of Rosse).
References: U.K. *Harper's Bazar*, June 1933, p. 13.
Anne, Countess of Rosse

360 EVENING WRAP, 1933 Chicago

Scarf draped over one shoulder and forming full loose sleeve at other end. Initial fabrics and client unknown.

Additional versions: **1934** "hairy white fabric that looks like wet feathers" (offered by Herman Patrick Tappé).
References: U.S. *Harper's Bazaar*, Jan. 1934, p. 48.

361 EVENING WRAP, ?1933 London

V-neck shawl collar; Grecian, draped sleeves; draped closure. Designed initially in black velvet for an unknown client.

Charles James Archives

362 DAY COAT, ?1934 London

Faced, folded drape stand collar; eyelet closure neckline; inset tapered sleeves; center front panels from neck to hem; back yoke; side and back bodice seamed to slightly flared street-length skirt. Initial fabrics and client unknown.

Additional versions: **?1934** spring-weight black novelty-weave ribbed wool, white pique, labeled "James/15 Bruton St./ London W." (Philippa Barnes).
References: The Brooklyn Museum sketches 57.218.11d.
Victoria and Albert Museum, Gift of Miss Hawthorne Barnes T291.1978

363 EVENING WRAP, 1935 London ●

Shawl collar; dolman sleeves with large pushed-back cuffs; clutch closure; dipping, pouched back; three-quarter or full-length. Initial fabrics and client unknown.

Additional versions: **1935** polychrome floral, grey silk brocade, labeled "James/15 Bruton St./London W." (Marit Guinness Aschan); polychrome floral, apple-green silk brocade. **1936** black and gold silk brocade.
References: U.K. *Harper's Bazar*, Aug. 1935, pp. 16–17.
Marit Guinness Aschan

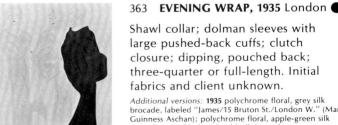

U.K. HARPER'S BAZAAR/LUZA

364 COAT, ?1936 London

V-neck with large bow tie; rectangular yoke; tapered sleeves with wing-cut projection along outer edge. Initial fabrics and client unknown.

Additional versions: **1936** nubby wool (Anne, Countess of Rosse).
References: The Sketch, April 8, 1936, p. 86.

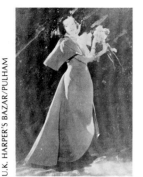

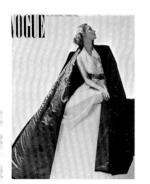

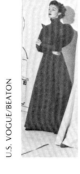

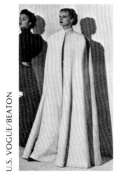

365 SHORT COAT, ?1936 London

Fur-faced shawl collar; fitted torso with tapered and flared center-front pendant panels; flared hipline skirt. Initial fabrics and client unknown.

Additional versions: **1936** black wool, mink collar.
Charles James Archives

366 EVENING COAT, 1936 London

Stand-away wing collar; shoulder with wing-like cape projections in back; fitted torso; floor-length skirt draped to back from arc-rounded front edges; contrasting color waistline back-tied bow. Initial fabrics and client unknown.

Additional versions: **?1936** hot-pink cellophane cloth, geranium velvet (Mrs. St. John Hutchinson). **1937** light-blue grosgrain (Lady Charles Cavendish).
References: U.K. *Harper's Bazar,* April 1937, p. 86.
Charles James Archives

367 EVENING CAPE, ?1936 London

Stand collar; narrow shoulders; unfitted floor-length fall. Designed initially in black faille and rust-red satin for an unknown client.

References: U.S. *Vogue,* Nov. 15, 1936, cover; U.K. *Vogue,* Jan. 6, 1937, cover.

368 EVENING COAT, 1936 Paris

Stand collar; shoulderline epaulette continuing as tapered fin down sleeve back; top-stitched seam detailing on fitted bodice with dipping back waistline; flared floor-length skirt. Initial fabrics and client unknown.

Additional versions: **1936** fabrics unknown (Elizabeth Arden); green billiard cloth (offered by Sally Milgrim and by Harrods). **?1936** emerald-green Colcombet grosgrain, labeled "James/15 Bruton St./London W." and "Made in France."
References: U.K. *Harper's Bazar,* Oct. 1936, p. 50; U.K. *Vogue,* Oct. 14, 1936, p. 10; U.S. *Vogue,* Nov. 1, 1936, pp. 54–55; Sales catalogue, Christie's South Kensington, Aug. 18, 1977, lot #225.
Victoria and Albert Museum T.420.1977

369 GREAT CAPE, ?1936 London

Stand collar; padded shoulders; free-fall, V-shaped, front-center panel to floor; axis-cut yoke fitted to small of back. Initial fabrics and client unknown.

Additional versions: **1936** horseguard's wool or grosgrain (offered by Hattie Carnegie and by I. Magnin); white whipcord (offered by Harrods).
References: U.S. *Vogue,* Nov. 1, 1936, pp. 54–55; U.K. *Vogue,* Oct. 14, 1937, p. 10.

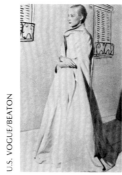

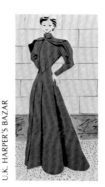

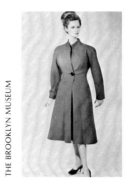

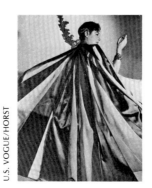

370 EVENING CAPE, 1936 Paris

Stand collar; waistline arm slits; fitted at back waist; floor-length skirt. Initial fabrics and client unknown.

Additional versions: **1936** black grosgrain (Ruth Ford, Countess of Oxford and Asquith); pale blue-grey Colcombet grosgrain (offered by Harrods); pale blue-grey Colcombet rayon grosgrain (offered by Herman Patrick Tappé). **1975** wool broadcloth (Mrs. A. Frederick Bultman, Jr.).
References: U.K. *Harper's Bazar,* Oct. 1936, p. 50; U.K. *Vogue,* Oct. 14, 1936, p. 103; U.S. *Vogue,* Nov. 1, 1936, pp. 54–55.
Mrs. A. Frederick Bultman, Jr.

371 EVENING WRAP, 1936 Paris

Arced stand collar; petal-shaped shoulderline yoke; fitted bodice; flared floor-length skirt. Initial fabric and client unknown.

Additional versions: **1936** deep-red Colcombet grosgrain (offered by Bergdorf Goodman, Inc., and by Harrods).
References: U.K. *Harper's Bazar,* Oct. 1936, p. 50; U.K. *Vogue,* Oct. 14, 1936, p. 10; U.S. *Vogue,* Nov. 1, 1936, pp. 54–55.

372 STREET COAT, ?1936 London

Wide, triangular revers; tapered sleeves with welt running from cuff to shoulder and extending down back to waist as a V-yoke; street length. Initial fabrics and client unknown.

Additional versions: **?1936** brown and white wool plaid tweed, labeled "Charles James/15, Bruton Street, W1."
Fashion Institute of Technology, Gift of Mrs. W. A. Birge 67.42.12

373 "LYRE" COAT, 1936 ?Paris
[CJ 600]

Round stand neckline; lyre-shaped yoke extending over shoulderline; front and back sleeves cut in one with lower bodice pieces; slightly flared street-length skirt; top-stitched detailing; hook closure with waistline button. Initial fabrics and client unknown.

Additional versions: **1945** red wool artillery drill, yellow Chinese silk satin, labeled "Ch. James/45" (Millicent Rogers). **?1946** red wool.
Patterns: paper 49.233.93; muslin 49.233.66; half muslin model 49.233.34.
References: The Brooklyn Museum sketches 57.218.3
The Brooklyn Museum, Gift of Millicent Rogers 49.233.13
[Charles James Archives]

374 "RIBBON" EVENING CAPE, ?1937 Paris ●
(see also cat. no. 36)

Six-and-a-half-inch-wide colored ribbons tapering at shoulders and flaring into two vast wings; pointed hemline. Initial fabrics and client unknown.

Additional versions: **1937** silk taffeta, scarlet, turquoise, pink, and chartreuse (Marit Guinness Aschan); fabrics unknown (Mme. Arturo Lopez-Willshaw). **?1937** satin-faced silk taffeta ribbons, pearl-grey, citron-yellow, pale-pink, lemon-cream, pewter, labeled "James/15 Bruton St./London W." (Nancy Beaton or Barbara Beaton). **?1938** fabrics unknown (commissioned by Syndicat de Rubans, St. Etienne, and shown in the Pavillon de L'Elégance, Paris). **1940** lilac and emerald satin cabana stripes lined with yellow (offered by Arthur Falkenstein).
References: U.S. *Vogue,* March 1, 1940, pp. 90–91; The Brooklyn Museum sketches 57.218.3.
Marit Guinness Aschan
[V&A]

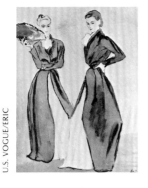

375 "TULIP" EVENING COAT, ?1937 London

Deep V-neck drape; narrow tapered sleeves; waistline closure; floor-length skirt bells out at knee and in again at hem. Initial fabrics and client unknown.

Additional versions: **1937** black faille, lime-green silk (offered by Bonwit Teller); heliotrope velvet undershot with blue, pink satin (offered by Jay Thorpe); black faille, jet-black silk (offered by Miller & Cie).
References: U.S. *Vogue,* Oct. 15, 1937, p. 82; U.S. *Harper's Bazaar,* Nov. 1937, p. 61; U.K. *Harper's Bazar,* Dec. 1937, p. 40.

376 BOX JACKET, ?1937 London

Modified V-neck; full three-quarter-length sleeves; sawtooth hipline; lattice diamond-shaped quilting. Initial fabrics and client unknown.

References: The Brooklyn Museum sketches 57.218.2.

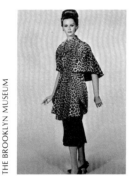

377 CAPE, ?1937 London [CJ 608] ●

Shoulder cape; folded-in lapel; top-stitched welted bustline seam; semi-circular back cape; knee-length pendant front in triple thickness (pendant folded on later versions); inner waistband. Designed initially in black grosgrain for an unknown client.

Additional versions: **1937** blue/old-rose changeable silk grosgrain, labeled "James/15 Bruton St./London W." (Mrs. H. S. H. Guinness); gold and rose brocade (Lady Leucha Warner). **1944** fabrics unknown (offered by Elizabeth Arden). **?1944** black Catoir silk satin (Millicent Rogers); back double-faced duchesse satin, violet taffeta (Millicent Rogers); leopard skin, black satin (Millicent Rogers). **?1945** fabrics unknown (Gypsy Rose Lee; offered by The Dayton Co.); emerald-green, grey-white silk (offered by Neiman Marcus).
Patterns: paper 49.233.95; muslin 49.233.69
The Brooklyn Museum, Gift of Millicent Rogers 49.233.10 [Marit Guinness Aschan, CJA, RISD]

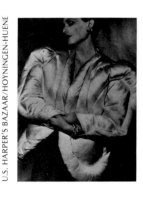

378 EVENING JACKET, 1937 London

Box jacket; V-neck; thick, soft roll around edges and as rib down sleeves; concentric heart-shaped quilting in back. Designed initially in white silk satin, quilted and padded with eiderdown, for Mrs. Oliver Burr Jennings.

Additional versions: **1938** fabrics unknown (offered by Hattie Carnegie).
References: U.S. *Harper's Bazaar,* Oct. 1938, p. 67; U.K. *Harper's Bazar,* Nov. 1938, p. 61; *Esquire,* April 1973, pp. 100–102; New York *Daily News,* Feb. 3, 1975, p. 36; Prudence Glynn and Madeleine Ginsburg, *In Fashion* (London: Allen and Unwin, 1978), p. 37.
Victoria and Albert Museum T385.1977

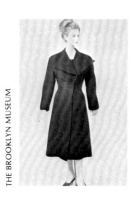

379 "LYRE" COAT, ?1937 Paris

Round stand neckline; lyre-shaped yoke extending over shoulderline as wide triangular revers; front and back of sleeves cut in one with lower bodice pieces; slightly-flared, street-length skirt; hook-and-eye closure. Initial fabrics and client unknown.

Additional versions: **1946** black wool melton, bright-orange satin-faced Chinese silk brocade, labeled "Ch. James/46" (Millicent Rogers).
The Brooklyn Museum, Gift of Paul and Arturo Peralta-Ramos 54.141.68

380 EVENING COAT, 1938 London

Stand-away collar with shallow V-back yoke; lyre-shaped front yoke and back shoulder epaulettes outlined with knotted fringe; knife-pleated upper arm; leg-of-mutton sleeves; double-hook waistline closure; princess-line torso with flared floor-length skirt. Designed initially in black velvet, black silk fringe, and black satin for Anne, Countess of Rosse.

Additional versions: **?1938** fabrics unknown (Lady Smilie).
Anne, Countess of Rosse

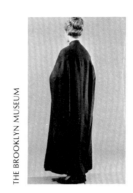

381 "COCOON" EVENING CAPE, ?1958 Paris

Stand collar; curved front bustline crossover; trapezoidal bustline yoke; triple horizontal-band back yoke; vertical arm slashes; front hemline flare; barrel-shaped back tapering in at hem. Initial fabrics and client unknown.

Additional versions: **?1958** garnet wool broadcloth, burgundy velvet (Muriel Bultman Francis); fabrics unknown (Mrs. Cornelius Vanderbilt Whitney).
The Brooklyn Museum, Gift of Muriel Bultman Francis 66.147.14

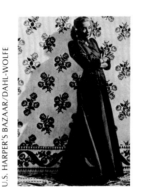

382 EVENING COAT, ?1940

Cut-away stand collar echoing heart-shaped, welted, top-stitched lapels; straight sleeves; slightly flared floor-length skirt. Initial fabrics and client unknown.

Additional versions: **1940** violet leaf-green Catoir silk (offered by Jay Thorpe).
References: U.S. *Harper's Bazaar,* Oct. 1940, pp. 84–85.

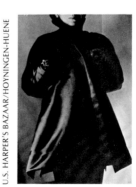

383 COAT, 1943 [CJ 606]

High, folded-back, pointed collar; arced and seam welted; mellon sleeves; concealed placket closure; flared torso with side seams caught with stay bars. Designed initially in black wool and deep-rose faille for Millicent Rogers.

Additional versions: **1943** mulberry Catoir satin, black sealskin (offered by Gunther Jaeckel). **?1943** double-faced Catoir mulberry satin, peacock faille, detachable mink lining (Millicent Rogers). **1944** black satin (offered by Elizabeth Arden); fabrics unknown (Mrs. Walter Keith, Mrs. Edmond O'Brien, Mrs. William S. Paley, Mrs. George Perkins Raymond, Mrs. Jack Sarnoff, Mme. Arturo Lopez-Willshaw).
Patterns: paper 49.233.94; muslin 49.233.68; half muslin model 49.233.23
References: U.S. *Harper's Bazaar,* Jan. 1943, p. 40; U.S. *Vogue,* July 1944, p. 59.
The Brooklyn Museum, Gift of Millicent Rogers 49.233.15

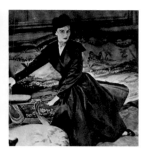

384 THEATRE COAT, 1944

Broad triangular revers; arced sleeves inserted below shoulderline yoke; vase-shaped front yoke terminating in front and back hipline point below which falls box-pleated, inserted godets to form mid-calf-length skirt. Designed initially for Millicent Rogers (fabrics unknown).

Additional versions: **1947** black double-faced Catoir satin (Millicent Rogers). **1948** black silk satin and taffeta (Mrs. William Randolph Hearst, Jr.); navy faille, windsor-rose silk, with stand collar and fitted bodice, labeled "Charles James/48" (Alice Topp-Lee). **1949** black Catoir satin (Charles James inventory); black wool melton, tomato-red satin, labeled "Charles James/49" (Mrs. Robert Langdon). **1950** black double-faced duchesse satin, scarlet peau de soie (Mrs. Edmond G. Bradfield). **?1951** black faille, red satin.
Patterns: muslin 49.233.70
References: U.S. Harper's Bazaar, Nov. 1949, p. 113; Holiday, Oct. 1948, p. 131.
The Brooklyn Museum, Gift of Mrs. Robert Langdon 69.65 [CJA]

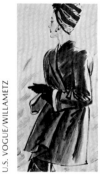

385 "TWO LAYER" SHORT COAT, ?1944

Stand neckline; clutch closure; full-cut; turned-back, faced cuffs. Designed initially in black satin and offered by Elizabeth Arden.
References: U.S. Vogue, July 1944, p. 59.

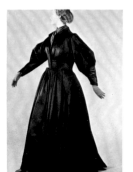

386 SHORT EVENING COAT, 1945
[CJ 605]

High, draped stand-up collar; inset, full dolman sleeves fitted tight around wrist; clutch closure; flared, thigh-length skirt. Designed initially for Carmel Snow and made from two steamer blankets of orange, wine, cobalt-blue, gold, and white wool plaid tweed.

Additional versions: **1945** fabrics unknown (offered by Charles James and by The Dayton Co.). **1946** wool plaid (Mrs. Jean de Menil); yellow silk (Mrs. Jean de Menil); fabrics unknown (Gypsy Rose Lee). **1947** black satin, bright-yellow taffeta, labeled "Charles James/47" (Jean Auerbacher); fabrics unknown (Mrs. William Randolph Hearst, Jr.); two steamer blankets (Millicent Rogers); golden-yellow faille, ice-blue satin (offered by Charles James and by The Dayton Co.).
Patterns: muslin 49.233.67
References: U.S. Harper's Bazaar, Nov. 1945, cover; U.S. Vogue, Aug. 1947, p. 113.
Goldstein Gallery, University of Minnesota 78.101 [Homer Layne]

387 EVENING COAT, ?1946

Asymetrically draped; collar turned under front; round back yoke forming Y with princess line at back torso and skirt; balloon sleeves with diagonal unpressed pleats at cuff; flared floor-length skirt with cartridge pleats at front waist. Initial fabrics and client unknown.

Additional versions: **1946** black satin, black taffeta, labeled "Ch. James/46" (Mrs. Joseph Love).
The Brooklyn Museum, Gift of Mrs. Joseph Love 67.261

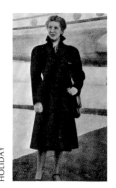

388 TRAVEL COAT, ?1946

Initial fabrics and client unknown. □
Additional versions: **?1946** black broadcloth (Toni Frissell).
References: Holiday, Nov. 1946, p. 67.

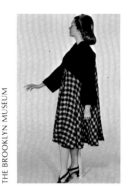

389 "TRAPEZE" or PYRAMID COAT, ?1946

Small foldover pointed collar; arced Empire front yoke; V back-yoke; inset full sleeves; flared street-length skirt; fitted inner waistband. Initial fabrics and client unknown.

Additional versions: **1946** beige vicuna, mushroom silk charmeuse (Mrs. Edmond G. Bradfield); fabrics unknown (Mrs. Harrison Williams). **?1947** black satin, flame silk (Mrs. Edmond G. Bradfield); dark-brown wool broadcloth, beige, brown, black, and gold wool plaid, taupe satin (Muriel Bultman Francis). **1948** black silk ottoman with royal-purple silk shantung @ $1,200 (Mrs. Edmond G. Bradfield). **1949** fabrics unknown (Mrs. Winthrop Rockefeller). **?1950** mink (offered by Gunther Jaeckel).
The Brooklyn Museum, Gift of Muriel Bultman Francis 66.147.1 [CJA, V&A]

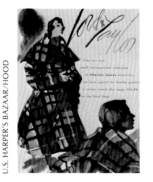

390 "BLANKET" GREAT COAT, 1946

Deep shoulderline; pointed shawl collar; diamond-cut back; flared street-length skirt. Designed initially for Mrs. William Randolph Hearst, Jr., and made from two wool Royal Stuart plaid double-faced with navy-blue steamer rugs and blue velvet.

Additional versions: **1949** two wool plaid steamer rugs (Mrs. Robert Horne Charles); plaid Linton wool tweed @ $225 (offered by Lord & Taylor).
References: U.S. Harper's Bazaar, Oct. 1949, p. 19.
Mrs. William Randolph Hearst, Jr.

391 CAPE COAT, 1947

Shawl collar; cut full to hip length; double front. Initial fabrics and client unknown.

Additional versions: **1947** hand-loomed white goat's hair cloth, buttermole fur (Alice Topp-Lee).
Missouri Historical Society

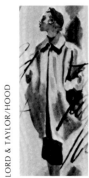

392 COAT (DOLMAN or COCOON or CIRCULAR WRAP), 1947
[CJ 630]

Draped wrap, dolman sleeves; three-quarter length; clutch closure. Designed initially in vicuna and duchesse satin for Lily Pons.

Additional versions: **1947** fabrics unknown (Mrs. William Randolph Hearst, Jr.). **1950** vicuna with bitter-orange Italian silk duchesse satin lining (Mrs. Edmond G. Bradfield); chocolate vicuna with lilac silk satin lining (Margaret Case); cinnamon vicuna with orange Roman silk satin lining (offered by Lord & Taylor and by Julius Garfinckel); fabrics unknown (merchandised by Ohrbach's). **1951** gilt-edge vicuna with pale-mauve silk satin lining @ $350 (Mrs. George Perkins Raymond). **1952** chocolate vicuna with lilac silk satin lining (Mrs. William Randolph Hearst, Jr.); fabrics unknown (Mrs. Charles James; merchandised by Lord & Taylor, marketed by William S. Popper — manufacturer of "Dressmaker

Casuals"). **1953** fabrics unknown (Millicent Rogers). **1956** venetian-red; geranium cashmere (Mrs. Oliver Burr Jennings); greige silk duchesse satin with feuille morte Lyon velvet lining @ $525 (Gypsy Rose Lee); fabrics unknown (20 versions made by Charles James Manufacturers, Inc.). **?1956** garnet velvet with garnet silk satin lining (Mrs. William Randolph Hearst, Jr.); fabrics unknown (Mrs. Charles James). **1957** black velvet with white lining (offered by Charles James Associates). **1958** client-supplied gold silk damask drapery fabric, self material lining @ $395 (Mrs. Eugene A. Davidson). **?1964** cyclamen American wool rep, fuchsia silk rep and silk crepe lining. **?1970** fabrics unknown (Elsa Peretti); black wool.

References: U.S. Harper's Bazaar, Oct. 1950, p. 7, and Nov. 1950, p. 151; American Fabrics, Summer 1956, p. 43; The Brooklyn Museum sketches 57.281.25a.
The Brooklyn Museum, Gift of Mrs. William Randolph Hearst, Jr. 64.231.2
[CJA, CHS, CAM, FIT, PAM]

393 STREET COAT, 1947

One-sided asymmetrical collar; high yoke with single-button off-side closure; curved sleeves with deep rolled-back cuff; straight front; bombe back; slash pockets; street length. Initial fabrics and client unknown.

Additional versions: **?1947** navy melton wool. **1952** fabrics unknown (marketed by William S. Popper). **?1952** fabrics unknown (Marit Guinness Aschan). **?1953** russet wool and mohair, black satin, black taffeta, labeled "Dressmaker/ Casuals, Inc./with/Charles/James/Imported Fabric"; Pumpkin wool tweed, olive, with matching sheath skirt and dress lined in gold (Alice Topp-Lee). **1957** red wool face cloth (Mrs. Edmond G. Bradfield).
The Metropolitan Museum of Art, Gift of W. Geoffrey Grout 1978.111.3
[Marit Guinness Aschan, CJA, MHS]

394 COAT, ?1948

Broad pointed revers over narrow shoulders; balloon sleeves; three-quarter-length flared skirt; large neckline bow tie. Initial fabrics and client unknown.

Additional versions: **1948** Hammerbrand black Russian broadtail, red-orange silk (offered by Hattie Carnegie and I. Magnin); fabrics unknown (offered by L. S. Ayers).
References: U.S. Vogue, July 1948, p. 89.

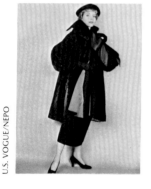

395 COAT, ?1948

Stand collar; rectangular yoke; in-seam bustline pockets; inset sleeves; three-button closure; back vent from yoke to street-length hemline. Initial fabrics and client unknown.

Additional versions: **1948** fabrics unknown (Mrs. William S. Paley). **1949** fabrics unknown (Muriel Bultman Francis). **1950** fabrics unknown (merchandised by Ohrbach's).
References: The Brooklyn Museum sketches 57.218.20b.

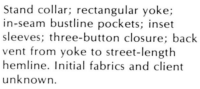

396 COAT, ?1948

Double-pointed stand collar; sawtooth front yoke extending into raglan sleeves with diagonal cuff; diamond-shaped back yoke; barrel-shaped front torso; flared back with inverted box pleat; slashed welted pockets; neck and waistline button closure. Initial fabrics and client unknown.

Additional versions: **?1949** beige vicuna, dark-violet satin (Muriel Bultman Francis).
The Brooklyn Museum, Gift of Muriel Bultman Francis 68.196.1

397 EVENING WRAP, ?1948

Gathered bertha collar; loosely draped bodice; slashed and faced kimono sleeves. Initial fabrics and client unknown.

Additional versions: **?1948** pink faille (Millicent Rogers); chrome-yellow silk, black velvet (Mrs. Leland Hayward).
References: Town & Country, Oct. 1949, p. 71.

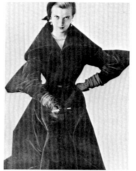

398 EVENING COAT, ?1949 ●

Broad coachman's cape collar; back draped; right-angle-shaped sleeves; arced hipline side gores; waistline closure. Initial fabrics and client unknown.

Additional versions: **1949** garnet velvet (offered by Lord & Taylor). **?1949** garnet velvet, gold faille (Millicent Rogers).
References: U.S. Vogue, Oct. 15, 1949, p. 63.
The Brooklyn Museum, Gift of Paul and Arturo Peralta-Ramos 54.141.69

399 "COCOON" TOP COAT, 1949
[CJ 675]

Stand collar; square, inset, curved sleeves; barrel-shaped torso with front and back pointed insets angled to form hipline pockets; back vent; street length. Initial fabrics and client unknown.

Additional versions: **1949** men's coating CJ 675A. **1958** black haircloth, purple.
References: The Brooklyn Museum sketches 57.218.20a.

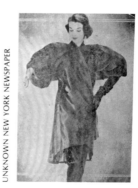

400 BALL WRAP, 1950 ●

Clutch closure; padded pneumatic arc sleeves pleated at front neckline; V-yoke back outlined with cartridge pleats. Initial fabrics and client unknown.

Additional versions: **1950** brown satin, lavender satin, black velvet (offered by Ohrbach's).
The Brooklyn Museum, Gift of Mr. Jerome K. Ohrbach 54.170.1

401 GREAT COAT, ?1950

Sculptured sleeve. Worn with matching fringed stole. Initial fabrics and client unknown. □

Additional versions: **?1950** camel British wool tweed, Russian mink (Alice Topp-Lee).
Missouri Historical Society, Gift of Alice Topp-Lee

402 COAT, 1951 [CJ 634]

Initial fabrics and client unknown. □

Additional versions: **1951** cashmere wool @ $675 (Mrs. Rudolph A. Bernatschke); cashmere wool @ $575 (Princess Bon Compagne); cashmere CJ 634A @ $675 (Martha Roundtree); CJ 634A @ $725 (Alice Topp-Lee); cashmere wool @ $775 (offered by Lord & Taylor).

403 JACKET COAT, ?1951 [CJ 637]

Initial fabrics and client unknown. □

Additional versions: **1951** navy wool @ $425 (Mrs. Vernon Taylor).

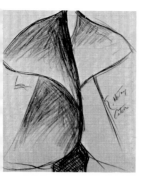

404 CIRCULAR CAPE, 1951 [CJ 638] ●

Stand collar; folded-over circle; arm slits. Initial fabrics and client unknown.

Additional versions: **1951** black and brown silk tulle, black nylon mesh (Mrs. William Randolph Hearst, Jr.); Catoir silk @ $350 (Mrs. Cornelius Vanderbilt Whitney); red velvet @ $616.25 (Charles James inventory). **?1952** emerald-green satin (Mrs. William Randolph Hearst, Jr.).

References: The Brooklyn Museum sketches 57.218.22a.

The Brooklyn Museum, Gift of Mrs. William Randolph Hearst, Jr. 59.217
[FIT]

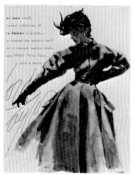

405 "COSSACK" or TOWN COAT, ?1951 [CJ 640]

Peter Pan collar; bulbous, arced, mellon, dolman sleeves tapering at wrist; fitted bodice with placket closure and button at waist; two large hipline slash pockets and flaps; full street-length skirt with inverted box pleats adjacent to pockets. Initial fabrics and client unknown.

Additional versions: **?1951** blue wool. **1951** navy-blue @ $875 (Mrs. Joseph E. Davies); cinnamon-brown wool artillery drill, mauve satin @ $875 (Millicent Rogers); fabrics unknown @ $850 (Mrs. Vernon Taylor); fabrics unknown @ $875 (Alice Topp-Lee); artillery drill cloth @ $875 (Mrs. Cornelius Vanderbilt Whitney); fabrics unknown @ $875 (purchased for developmental purposes by Lord & Taylor); melton @ $199.50 (merchandised by Lord & Taylor). **1952** dark-brown wool melton, taupe satin, labeled "Ch. James/52" (Muriel Bultman Francis). **?1952** fabrics unknown (Baroness W. Langer von Langendorff).

References: U.S. The Brooklyn Museum, Gift of Paul and Arturo Peralta-Ramos 55.26.52
[CJA]

406 SUIT COAT ?1951

Worn with dress. Initial fabrics and client unknown. ☐

Additional versions: **1951** navy shetland wool @ $875 (Alice Topp-Lee).

Missouri Historical Society, Gift of Alice Topp-Lee

407 SHORT JACKET, ?1951 [CJ 641]

Roll collar; arc sleeves; shoulderline slash pockets with stand cuff; tailored torso with concealed placket; shallow flared hipline peplum. Initial fabrics and client unknown.

Additional versions: **1951** beige artillery drill cloth (Millicent Rogers); fabrics unknown @ $425 (Mrs. Cornelius Vanderbilt Whitney); artillery drill cloth (offered by Lord & Taylor). **?1951** black broadcloth (Muriel Bultman Francis); fabrics unknown (Mrs. Ivan Obolensky).

References: U.S. Harper's Bazaar, July 1951, p. 41.

The Brooklyn Museum, Gift of Paul and Arturo Peralta-Ramos 55.26.257

408 CHESTERFIELD, 1952

Collar and revers; smooth back; forward-curving hipline; extended pocket flaps. Initial fabrics and client unknown.

Additional versions: **1952** brown-and-black lacey Stroock wool, black broadcloth.

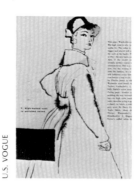

409 STREET COAT, 1952

Curved stand-away collar and revers; fitted front bodice with three-button closure; dropped shoulder; inset, shaped sleeves; full back of unpressed pleats caught with curved quarter belt; straight front; semi-circular back; street-length skirt; two hipline slanted pockets with curved flaps. Designed initially for, and marketed by William S. Popper.

Additional versions: **1952** navy-green Worumbo wool tweed (offered by Lord & Taylor, Julius Garfinckel, and I. Magnin); Angelo fur fabric (merchandised by Lord & Taylor, Stewart Dry Goods Co., and I. Magnin). **1953** cranberry mohair wool, red satin damask, labeled "Charles James/53" (Mrs. Cornelius Vanderbilt Whitney). **?1953** black mohair wool, black crepe, labeled "A Charles James Design" (Mrs. Jack Livingston).

References: U.S. Vogue, Aug. 1, 1952, p. 62; Town & Country, Nov. 1952, p. 101.

The Metropolitan Museum of Art, Gift of Eleanor S. W. McCollum 1975.246.1
[WA]

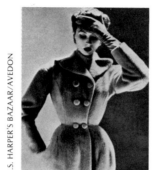

410 STRAIGHT-FRONT CHESTERFIELD, 1952

Curved stand-away collar and revers; inset sleeves; fitted double-breasted bodice with three pairs of buttons; full back of unpressed pleats caught with a curved trisected belt; straight, semi-circular back; street-length skirt; hipline slanted pockets. Designed initially for, and marketed by William S. Popper. Variant of cat. no. 409.

Additional versions: **?1952** beige brushed cashmere, light-brown satin; Forstmann cashmere (merchandised by Lord & Taylor).

References: U.S. Harper's Bazaar, July 1952, p. 184; The Brooklyn Museum sketches 57.218.27d.

The Brooklyn Museum, Gift of Mrs. Frances Carpenter 65.222.2

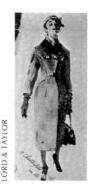

411 CHESTERFIELD, 1952 [CJ 651]

Rounded collar with pointed revers; fitted double-breasted torso with in-seam slanted pockets; straight street-length skirt. Designed initially for, and marketed by William S. Popper.

Additional versions: **?1952** black wool; fabrics unknown (Mrs. Jean de Menil). **1955** wool with faced collar (merchandised by Lord & Taylor). **1957** brown tweed (Charles James Associates); black cashmere, CJ 651B (Charles James Associates).

References: New York Times, Oct. 2, 1955, p. 13.

Charles James Archives

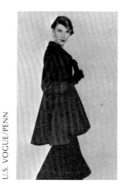

412 SHORT EVENING/DAY COAT, 1952

Shawl collar; S-curve yoke in front, round in back; inset sleeves; semi-fitted high waist; flaring, dipping hem. Designed initially for, and marketed by William S. Popper.

Additional versions: **1952** burgundy-red Botany pressed wool broadcloth (merchandised by The Blum Store, Lord & Taylor, and I. Magnin).

References: U.S. Vogue, Sept. 1, 1952, p. 181.

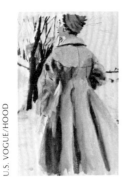

413 EMPIRE COAT, 1952

Shawl collar; round back yoke; full three-quarter-length sleeves; princess-line flared skirt. Designed initially for, and marketed by William S. Popper.

Additional versions: **?1952** wool fleece @ $250 (merchandised by Lord & Taylor).
References: U.S. Vogue, Sept. 1, 1952, p. 17.

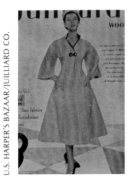

414 AFTERNOON COAT, 1952
[CJ 663]

Street length; faced stand-collar with notched lapel; fitted torso; bell-shaped raglan sleeves; inverted-V back yoke; flared skirt with curved, diagonal, slashed hip pockets. Initial fabrics and client unknown.

Additional versions: **?1952** putty Juilliard Julpapa worsted wool, black velvet, black taffeta, labeled "An Original Design/by/Charles James" @ $225 (Mrs. Jean de Menil); fabrics unknown (Mrs. Huntington Hartford, Baroness W. Langer von Langendorff, Mrs. Cornelius Vanderbilt Whitney; merchandised by Lord & Taylor, John Wanamaker, and Stewart Dry Goods Co.; marketed by William S. Popper). **1958** grey haircloth.
References: U.S. Harper's Bazaar, March 1953, p. 12.
The Brooklyn Museum, Gift of Mrs. Jean de Menil 57.151.8a
[MMA]

415 FUR COAT, 1953

Shawl collar; full two-thirds-length sleeves with one-third cuff, turned-up tab; fitted bodice without waist seam; four-button closure to waist; hipline slash pockets; slightly flared front skirt, dipping to full back; one-half circumference belt with central buckle and tab. Initial fabrics and client unknown.

Additional versions: **1953** black Alaskan sealskin, russet satin, labeled "Gunther Jaeckel/New York" (Mrs. Charles James).
References: U.S. Vogue, Sept. 1, 1953, p. 205.
Homer Layne

416 STREET COAT, 1953

Fold-over pointed collar; round yoke with two-button pendant tab; pleats off yoke; semi-fitted torso. Initial fabrics and client unknown.

Additional versions: **?1953** red wool.
Charles James Archives

417 "MELON" THEATRE COAT, 1954

Stand-away shawl collar; trapezoidal bustline yoke; double-breasted bustline closure; inset tapered sleeves; unpressed pleated torso; full two-thirds-length skirt. Initial fabrics and client unknown.

Additional versions: **1954** peacock-blue Celanese acetate Marché slipper satin (Celanese Corporation, Mrs. William Randolph Hearst, Jr.); white, pink, navy, black (offered by Lord & Taylor, Julius Garfinckel, and Neiman Marcus).
References: U.S. Vogue, Oct. 15, 1954, pp. 14–15, 79.

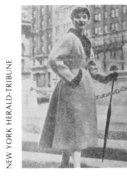

418 STREET COAT, 1954

Initial fabrics and client unknown. Variant of cat. no. 409.

Additional versions: **1954** mustard herringbone tweed, black velvet (offered by Lord & Taylor, The Dayton Co., J. L. Hudson Company, and I. Magnin); tiger Montagnac wool tweed, black silk velvet (purchased by Dressmaker Casuals for developmental purposes). **?1958** tiger tweed.
References: U.S. Vogue, Aug. 15, 1954, cover; New York Herald-Tribune, Oct. 12, 1954.

419 COAT, 1954

Peter Pan collar; raised Empire waist notched in front; five self-covered buttons; inset straight sleeves; hipline, horizontal slashed pockets; street-length sheath skirt. Initial fabrics and client unknown.

Additional versions: **1954** red brushed wool, apricot satin (Mrs. William Randolph Hearst, Jr.).
The Brooklyn Museum, Gift of Mrs. William Randolph Hearst, Jr. 60.86.1

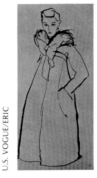

420 EMPIRE COAT, 1954

Fur-faced shawl collar; high, upswept bustline yoke outlined with bow; full, flared street-length skirt with rounded, angled godets above hemline panel; slanted slash pockets. Initial fabrics and client unknown.

Additional versions: **1954** black wool, black fox, black satin (merchandised by The Dayton Co., Julius Garfinckel, and Saks Fifth Avenue). **?1954** grey haircloth.
References: U.S. Vogue, Aug. 1954, p. 131.

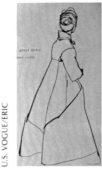

421 GOTHIC COAT, 1954

Peter Pan collar; narrow-cut, high, upswept bustline yoke; full, stiffened street-length skirt with rounded, angled godets above hemline panel. Variant of Empire coat. Designed initially for, and marketed by William S. Popper.

Additional versions: **1954** black wool broadcloth, black satin @ $190 (merchandised by The Dayton Co., I. Magnin, Lord & Taylor, Saks Fifth Avenue, and John Wanamaker).
References: U.S. Vogue, Aug. 1, 1954, p. 130; U.S. Harper's Bazaar, Sept. 1954, p. 181.

422 DAY COAT, 1954

Top-stitched, wide, silk-faced bertha collar; rounded in back; squared-over shoulder with big neckline bow; inset sleeves; fitted X-construction back; loose double-breasted hook-closure front; flared street-length skirt. Initial fabrics and client unknown.

Additional versions: **1954** black (Grete Wootton). **?1954** black brushed wool fleece, black satin, black taffeta, labeled "An Original Design/by/Charles James" (Mrs. Rudolf A. Bernatschke).
The Metropolitan Museum of Art, Gift of Mrs. Rudolf A. Bernatschke 1973.186.2

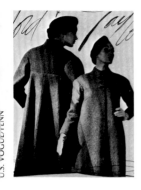

423 COAT, 1954

Stand collar; Empire waist with button closure; inset sleeves; back-flared, street-length skirt. Initial fabrics and client unknown.

Additional versions: **1954** fabrics unknown (merchandised by Lord & Taylor @ $165).
References: U.S. *Vogue*, Oct. 1, 1954, p. 15.

424 GOTHIC COAT, 1954

Stand-away shawl collar; high Empire yoke; button closure; back yoke bisected down center back with skirt; inset arc sleeves; hipline slash pocket, below top-stitched curved godet. Initial fabrics and client unknown.

Additional versions: **1954** pink cashmere fleece, flesh silk satin, labeled "An Original Design/by/Charles James" (Mrs. Jean de Menil). **1954** pink cashmere fleece (Mrs. Charles James); brick-red brushed wool (Muriel Bultman Francis); camel and grey wool Harris tweed, labeled "An Original Design/by/Charles James" (Mrs. Charles James). **1955** grey wool fleece (Mrs. William Randolph Hearst, Jr.).
References: The Brooklyn Museum sketches 57.218.27d.
*The Brooklyn Museum, Gift of Mrs. Jean de Menil 57.151.11 a&b
[MMA, RISD]*

425 DOLMAN COAT, ?1954

Stand-up collar; dolman sleeves to hemline; inverted back pleat. Initial fabrics and client unknown.

Additional versions: **?1954** grey-blue wool (Grete Wootton).
References: Sales catalogue, Sotheby Parke-Bernet, Dec. 4, 1980, lot #159.

426 COAT, 1954

Collar reaching tips of shoulders; faced with fur; high-waisted back; bound pockets. Part of Coty Award collection. Initial fabrics and client unknown.

Additional versions: **1954** beige wool fleece, brown beaver facing, labeled "An Original Design/by/Charles James" (Mrs. Rodman Arturo de Heeren).
Cincinnati Art Museum, Gift of Dayton Art Institute 1976.93

427 COAT, 1954

Deep cape collar; fitted torso with inverted box pleat in center-back skirt. Part of Coty Award collection. Initial fabrics and client unknown.

Additional versions: **?1954** red wool.
Charles James Archives

428 COAT, ?1954

Front skirt arced over hips; back bodice with fluted pleats held to high waistline by half belt with central bow. Initial fabrics and client unknown.

Additional versions: **?1954** black Angelo mohair fur.

429 COAT, ?1954 [CJ 669]

Initial fabrics and client unknown. □
Additional versions: **?1958** yellow Dove cloth, maroon.

430 COAT, ?1954 [CJ 670]

Initial fabrics and client unknown. □
Additional versions: **?1958** mauve Dove cloth.

431 TRAVEL COAT, ?1954 [CJ 671]

Initial fabrics and client unknown. □
Additional versions: **1957** checked tweed, CJ 671A (Charles James Associates). **1958** black wool, red satin.

432 COAT, ?1954 [CJ 672]

Initial fabrics and client unknown. □
Additional versions: **?1958** fabrics unknown (Muriel Bultman Francis).

433 COAT, ?1954 [CJ 673]

Initial fabrics and client unknown. □
Additional versions: **?1958** red Dove cloth, white; grey diagonal nub.

434 COAT, ?1954 [CJ 676]

Initial fabrics and client unknown. □
Additional versions: **?1958** grey striped wool.

435 COAT, ?1954 [CJ 680]

Initial fabrics and client unknown. □
Additional versions: **?1958** white cashmere.

436 EMPIRE COAT, ?1954 [CJ 682]

Initial fabrics and client unknown. □
Additional versions: **1957** pink, CJ 682A (Charles James Associates); blue tweed, CJ 682B (Charles James Associates); Empire coat, CJ 682B (Charles James Associates). **?1958** mauve Dove cloth.

437 COAT, ?1954 [CJ 683]

Initial fabrics and client unknown. □
Additional versions: **?1958** brown haircloth.

438 COAT, ?1954 [CJ 685]

Initial fabrics and client unknown. □
Additional versions: **?1958** heather tweed.

439 COAT, ?1954 [CJ 690]

Initial fabrics and client unknown. □
Additional versions: **?1958** black and brown.

440 PROFILE COAT, ?1954 [CJ 691]

Initial fabrics and client unknown. □
Additional versions: **1957** pink, CJ 691A (Charles James Associates). **?1958** tube coat, CJ 691B.

441 COAT, ?1954 [CJ 692]

Initial fabrics and client unknown. □
Additional versions: **1957** pink (Charles James Associates); beige "tweedledee" (Charles James Associates). **?1958** black; winter rose, CJ 692A.

442 COAT, ?1954 [CJ 693]

Initial fabrics and client unknown. □
Additional versions: **?1958** grey haircloth.

443 COAT, ?1954 [CJ 694]

Initial fabrics and client unknown. □
Additional versions: **?1958** tan camel; red fleece.

444 COAT, ?1954 [CJ 695]

Initial fabrics and client unknown. □
Additional versions: **?1958** rust fleece, carmine.

445 COAT, ?1954 [CJ 696]

Initial fabrics and client unknown. □

Additional versions: ?1958 white cashmere.

446 COAT, ?1954 [CJ 697]

Initial fabrics and client unknown. □

Additional versions: ?1958 grey haircloth.

447 OVERCOAT, 1955

Shawl collar with wide revers; back cut with yoke and raised waistline accented with strip-belt folded into bow; simulated double-breasted front; slanted, slashed hipline pockets; flared street-length skirt. Initial fabrics and client unknown.

Additional versions: 1955 beige novelty-weave wool, black satin @ $225 to $495 (merchandised by Lord & Taylor).
References: New York Times, Oct. 2, 1955, p. 13.
The Brooklyn Museum

448 COAT, 1955

Fur faced; round collar cut in one with front yoke; single-breasted, Empire-cut flared front; concealed placket-closure pockets; back with half belt with folded bow over high waist; arced center-back panels flanking inverted box pleat; street-length skirt. Initial fabrics and client unknown.

Additional versions: 1955 bright-scarlet wool melton, black beaver, black satin, labeled "Charles James/55" (Mrs. Douglas Fairbanks, Jr.).
The Brooklyn Museum, Gift of Mrs. Douglas Fairbanks, Jr. 81.25.1

449 COAT, 1955 [CJ 6602]

Initial fabrics and client unknown. □

Additional versions: 1957 red cashmere (Charles James Associates).

450 "DIRECTOIRE" COAT, 1955 [CJ 6605]

Initial fabrics and client unknown. □

Additional versions: 1957 green Rodier wool (Charles James Associates).

451 EMPIRE COAT, ?1955 [CJ 6607]

Initial fabrics and client unknown. □

Additional versions: 1957 white tweed (Charles James Associates).

452 CAPE, ?1956 [CJ 6613]

Initial fabrics and client unknown. □

Additional versions: 1958 fabrics unknown (Muriel Bultman Francis).

453 CAPE, ?1956 [CJ 6614]

Initial fabrics and client unknown. □

Additional versions: ?1958 fabrics unknown (Mrs. Jean de Menil).

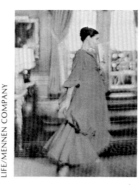

LIFE/MENNEN COMPANY

454 BALLOON OPERA COAT, 1956 ● [CJ 6610]

Peter Pan collar; rounded back yoke, rectangular in front; narrow, Empire, high-bustline band; trumpet-shaped sleeves; flared princess-line torso flowing into undulating knee/thighline pouff; flared hemline. Initial fabrics and client unknown.

Additional versions: 1956 black velvet, black taffeta @ $975 (Mrs. Jean de Menil); red velvet @ $978 (Grey Advertising for the Mennen Company); fabrics unknown (purchased for developmental purposes by Lane Bryant); black Lyon Martin velvet, black taffeta, labeled "An Original Design/by/Charles James" and "Lord & Taylor/Fifth Avenue" (offered by Lord & Taylor).
Patterns: muslin 51.151.10b
References: Life, Jan. 21, 1957, p. 32.
The Brooklyn Museum, Gift of Mrs. Jean de Menil 57.151.10a&b.
[MMA]

CHICAGO DAILY TRIBUNE

455 "PETAL" STOLE, ?1956 ●

Reversible pentagon-shaped petals forming sawtooth edges; one end can be drawn through eyelet which can also serve as an armhole. Initial fabrics and client unknown.

Additional versions: 1956 wine velvet (Mrs. Byron Harvey, Sr.); black Lyon velvet, ivory satin (Mrs. William Randolph Hearst, Jr.). 1957 red velvet and pink satin @ $375 (Gypsy Rose Lee). ?1960 wine corded silk velvet, pinkish-mauve satin (Mrs. Eugene A. Davidson). ?1961 deep-raspberry Italian velvet and dusty-pink satin; black velvet and rose velvet; crimson velvet and rose satin @ $325.
References: Town & Country, April 1957, p. 77; Gypsy Rose Lee, Gypsy (New York: Harper & Bros., 1957), p. 307; Chicago Daily Tribune, Nov. 18, 1958; Sales catalogue, Plaza Art Galleries, April 20, 1978, lot #113.
The Brooklyn Museum, Gift of Mrs. William Randolph Hearst, Jr. 64.254
[CHS, Homer Layne]

456 CAPE COAT, 1956
(see also cat. no. 476)

Adult version developed from infants' cape coat; initial fabrics and client unknown.

Additional versions: 1956 Venetian-red flecked with white Ducharne long-haired wool, rose duchesse satin, labeled "An Original Design/by/Charles James" (Mrs. Edmond G. Bradfield). ?1956 fabrics unknown (Felice Maier).
References: The Brooklyn Museum sketches 57.218.26c.
Art Students League, New York

457 CAPE COAT, ?1956
(see also cat. no. 476)

V-neck with neckline button closure; dolman sleeves; straight front; curved cut-away. Initial fabrics and client unknown.

Additional versions: ?1956 orange-red wool (Grete Wootton).
References: Sales catalogue, Sotheby Parke Bernet, Dec. 4, 1980, lot #157.

458 CAPE COAT, ?1956
(see also cat. no. 476)

V-neck with round collar; half-cuff on dolman sleeves; curved cut-away front. Initial fabrics and client unknown.

Additional versions: ?1956 royal-blue wool, orange-and-blue plaid taffeta (Grete Wootton).
References: Sales catalogue, Sotheby Parke Bernet, Dec. 4, 1980, lot #158; The Brooklyn Museum sketches 57.218.26c.

LORD & TAYLOR/HOOD

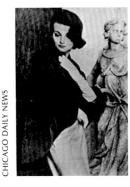

459 CAPE COAT, ?1956

Shawl collar; hip-length, one-sleeved jacket evolving into semicircular cape. Initial fabrics and client unknown.

Additional versions: **?1959** red American wool. **1972** cerise matelassé, black wool (Elizabeth Strong de Cuevas).
References: Chicago Daily News, Nov. 1, 1961, pp. 8–10.
Elizabeth Strong de Cuevas

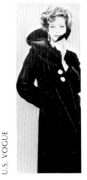

460 OVERCOAT, 1957

Wide shawl collar with deep pointed revers; flared street-length skirt; slanted hipline pockets. Designed initially for, and marketed by Albrecht Furs.

Additional versions: **1957** navy-blue Borgana — Orlon and Darlan — fur fabric @ $150 (merchandised by Jay Thorpe, and Marshall Field & Co.).
References: U.S. Vogue, Dec. 1957, p. 160.

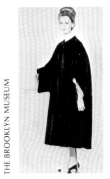

461 OPERA CAPE, 1957

Round neck; deep dolman sleeves; gives appearance of cape with sleeves; voulant cuffs; clutch closure. Designed initially for, and marketed by Albrecht Furs.

Additional versions: **1957** navy-blue Borgana, man-made plush, white rayon satin, tangerine rayon satin. **1958** celestial-blue Borgana (Mrs. Lee Hyland Erickson). **?1958** navy-blue Borgana, man-made plush, white rayon satin, tangerine rayon satin (Peg Zwecker).
The Brooklyn Museum
[CHS]

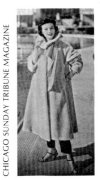

462 TRAVEL COAT, 1957

Circular collar; dolman sleeves; neckline closure; street-length flaring skirt. Designed initially for, and marketed by Albrecht Furs; offered by Marshall Field & Co., in bone plush @ $139.95.

References: Chicago Sunday Tribune (magazine), Nov. 10, 1957, p. 11.

463 SHORT COAT, 1957

Stand-up collar; dolman sleeves; full-cut, belted-in at waistline above flaring, hip-length peplum. Designed initially for, and marketed by Albrecht Furs in white fur plush and gunmetal leather.

References: New York Daily News, Nov. 14, 1957.

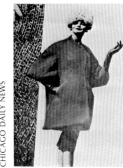

464 "GREAT COAT", 1959

Round neck; tortoise back; widely-curved seams; dolman sleeves; high-rise skirt. Initial fabrics and client unknown.

Additional versions: **1959** fabrics unknown (Mary Ellen Hecht). **1961** emerald-green wool tweed (Mrs. A. Frederick Bultman, Jr.). **?1961** black-and-red wool plaid, black faille (Muriel Bultman Francis); greige wool fleece, brown and grey satin, worn with matching skirt (Mrs. Jackson Pollock).
References: Chicago Daily News, Nov. 1, 1961, pp. 8–10; New York *Times*, Feb. 12, 1962, p. 29; The Brooklyn Museum sketches 57.218.23c.
The Brooklyn Museum, Gift of Muriel Bultman Francis 67.215.6
[MMA]

Children's Wear

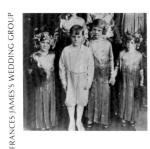

465 BRIDESMAID DRESSES, 1929
London

Jewel neck; long sleeves; low yoke with attached rounded-end ankle-length panels; stitched to hipline, pleated below. Designed initially for bridal attendants at Frances James's wedding in gold lamé (Audrey Ann Connell, Marit Guinness, Virginia Legg, et al).

References: Photograph (*Collection: Marit Guinness Aschan*).

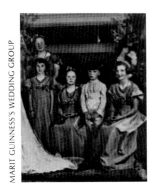

466 BRIDESMAID DRESSES, 1937

V-neck; draped bodice with short puff sleeves; long flaring skirt with back harem drape. Designed initially for bridal attendants at Marit Guinness's wedding in coral taffeta.

References: Photograph (*Collection: Marit Guinness Aschan*).

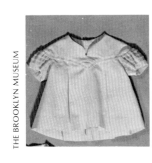

467 DRESS, 1956 [CJ 101]

V-shaped yoke edged with nylon ruffle; short puff sleeves made from bands of pleated nylon lace; box-pleated skirt. Designed initially for, and marketed by Alexis Infants' Wear in pink cotton with pink and white trim (CJ 101A).

Additional versions: **1956** pale-blue and white or pink broadcloth (CJ 101A); white sateen, blue trim with bloomers and coat (CJ 101B); pink with white sleeves and piping (CJ 101C); satin bodice, organdy sleeves and skirt (CJ 101E); lace sleeves (CJ 101K); "teardrop" design (CJ 101P).
Patterns: paper 57.151.23c
References: The Brooklyn Museum sketches 57.218.30p.
The Brooklyn Museum, Gift of Mrs. Jean de Menil 57.151.23a&b

468 **JACKET** or **COAT, 1956** [CJ 102]

Designed initially for, and marketed by Alexis Infants' Wear in yellow and white polka dot; for boys (CJ 102C). ☐

469 **SKIRT, 1956** [CJ 110]

Designed initially for, and marketed by Alexis Infants' Wear (fabrics unknown). ☐

Additional versions: **1956** cowboy variation (CJ 110?); butcher shirt (CJ 110D); vest (CJ 110H); shirt with yoke for boys' and girls' year-round wear, CJ 110L; shirt with striped bib (CJ 110O).

470 **SHIRT** or **CABANA COAT, 1956** [CJ 111]
(see also cat. no. 502)

Box shirt; pointed collar; yoke with off-shoulder set-in short sleeves; patch pockets with flap. Shirt in blue Everfast polished cotton; coat in white sharkskin (CJ 111E). Designed initially for, and marketed by Alexis Infants' Wear.

Additional versions: **1956** shirt in pink, black, and white striped cotton, collarless with self bow at neck (CJ 111A).
The Brooklyn Museum, Gift of Mrs. Jean de Menil 57.151.15a–c
[FIT]

471 **JACKET, 1956** [CJ 112]

Rounded notched collar; short sleeves; rounded flared waist. Designed initially for, and marketed by Alexis Infants' Wear in white cotton piqué (CJ 112C).

Additional versions: **1956** dentist coat with asymmetrical closing (CJ 112?); white polished cotton with blue trim (CJ 112?); dentist jacket — worn with boxer shorts (CJ 112A); lumber jacket (CJ 112D).
Patterns: paper 57.151.25b
The Brooklyn Museum, Gift of Mrs. Jean de Menil 57.151.25a&b

472 **BOY'S** or **GIRL'S SHIRT, 1956** [CJ 115]

Designed initially for, and marketed by Alexis Infants' Wear (fabrics unknown). ☐

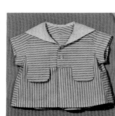

473 **CABANA COAT, 1956** [CJ 116]

Sailor collar; short sleeves cut in one with back yoke; two pendant drops simulating pockets from waistline-end of front yoke; pleated back vent. Designed initially for, and marketed by Alexis Infants' Wear in blue, grey, and white striped Fuller cotton poplin with white collar — to be worn with boxer shorts or sun suit (CJ 116A).

Patterns: paper 57.151.16b
The Brooklyn Museum, Gift of Mrs. Jean de Menil 57.151.16a&b

474 **CRAWLER WITH TOP, 1956** [CJ 119]

Designed initially for, and marketed by Alexis Infants' Wear (fabrics unknown). ☐

Additional versions: at least six are known to have been devised.

475 **BLOOMER ROMPERS** or **CRAWLER, 1956** [CJ 120]

V-shaped front yoke; gathered cap sleeves; balloon, buttoned, elasticized legs. Designed initially for, and marketed by Alexis Infants' Wear in printed pink-and-white cotton.

Patterns: paper 57.151.20b
The Brooklyn Museum, Gift of Mrs. Jean de Menil 57.151.20a&b

476 **CAPE COAT, 1956** [CJ 124]

Peter Pan collar; full flared back with arc sleeves in front; rounded front yoke. Designed initially for, and marketed by Alexis Infants' Wear in pale-blue wool flannel, white cotton piqué collar, white taffeta lining.

Additional versions: **1956** luxury wool with French flower sprigged Staron brocade or velvet, satin lining — promoted as the holiday gift for the "baby who has everything." Other versions employed synthetic fur, real fur, cloth, and satin.
Patterns: paper 57.151.22b
References: New York Herald-Tribune, Oct. 5, 1956.
The Brooklyn Museum, Gift of Mrs. Jean de Menil 57.151.22a&b

477 **GIRL'S TOP, 1956** [CJ 125]

Designed initially for, and marketed by Alexis Infants' Wear (fabrics unknown). ☐

478 **ALL-IN-ONE, 1956** [CJ 127]

Designed initially for, and marketed by Alexis Infants' Wear (fabrics unknown). ☐

479 **ALL-IN-ONE, 1956** [CJ 129]

Designed initially for, and marketed by Alexis Infants' Wear in red-and-white stripes. ☐

480 **SUNSUIT, 1956** [CJ 203]

Vest top. Designed initially for, and marketed by Alexis Infants' Wear (fabrics unknown). ☐

481 **SUNSUIT, 1956** [CJ 210]

Designed initially for, and marketed by Alexis Infants' Wear in chambray stripe (864 garments sold). ☐

482 **SUNSUIT, 1956** [CJ 211]

Designed initially for, and marketed by Alexis Infants' Wear in striped fabric with ruffle trim around pocket (996 garments sold). ☐

483 **"FRONTIE" PANTS, 1956** [CJ 213]

Designed initially for, and marketed by Alexis Infants' Wear in red velveteen. Worn with white sharkskin shirt and Tattersall-check waistcoat in black, red, and white. ☐

Additional versions: **1956** high waist, (CJ 213A); low waist and other versions, (CJ 213B).
The Brooklyn Museum

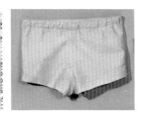

484 BOXER SHORTS, 1956 [CJ 212]
(see also cat. no. 502)

Initially designed for, and marketed by Alexis Infants' Wear in blue polished Everfast pima cotton.

Patterns: paper 57.151.15c
References: Ladies Home Journal, 1956.
The Brooklyn Museum, Gift of Mrs. Jean de Menil 57.151.15a–c

485 BOY'S SUNSUIT, 1956 [CJ 214]

Back-crossed shoulder straps; curved Y-shaped front seams; back welt pockets. Designed initially for, and marketed by Alexis Infants' Wear in blue poplin (CJ 214A).

Additional versions: 1956 Fuller cotton print (CJ 214); corduroy (CJ 214); balloon dress (CJ 214B).
Fashion Institute of Technology, gift of Warren Featherbone 79.164.5

486 SUNSUIT, 1956 [CJ 220]

Designed initially for, and marketed by Alexis Infants' Wear in striped Hope Skillman fabric (792 garments sold). □

487 BOY'S or GIRL'S SUNSUIT, 1956 [CJ 221]

Designed initially for, and marketed by Alexis Infants' Wear (fabrics unknown; 1,200 garments sold). □

488 BOY'S or GIRL'S SUSPENDER PANTS, 1956 [CJ 222]

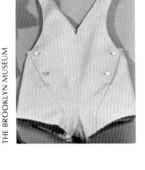

Straps cut in one with front and buttoned panel; back gussets into which pockets are cut. Designed initially for, and marketed by Alexis Infants' Wear in pink cotton piqué.

Additional versions: 1956 fabrics unknown (Princess Grace of Monaco).
The Brooklyn Museum, Gift of Mrs. Jean de Menil 57.151.18

489 SUNSUIT, 1956 [CJ 223]

Large leg. Designed initially for, and marketed by Alexis Infants' Wear (fabrics unknown; 348 garments sold). □

490 SUNSUIT, 1956 [CJ 224]

Suit with slant pockets. Designed initially for, and marketed by Alexis Infants' Wear. Suit in pale-beige cotton faille with Tattersall-check top (CJ 224A). □

491 BOXER SHORTS SUNSUIT, 1956 [CJ 225]

Designed initially for, and marketed by Alexis Infants' Wear in red velvet (732 garments sold). □

References: The Brooklyn Museum sketches 57.218.30m.

492 SUNSUIT, 1956 [CJ 226]

Tailored; strapped; buttoned, pear-shaped front panel; slant pockets. Designed initially for, and marketed by Alexis Infants' Wear in blue-and-white Hope Skillman cotton stripe (CJ 226B).

Additional versions: 1956 yellow Avondale cotton stripe with square-design yellow front (CJ 226E); washed blue-and-white sateen Hope Skillman fabric (CJ 226E); Fuller print in wallpaper pattern — for girls (CJ 226); pinafore effect, suggestion of drape at high-waist bodice, narrow ruffle of white eyelet embroidery in navy and tiny cotton print of navy and red on white ground — for girls (CJ 226C); in pink with pink-and-white checked front and satin bows set at shoulder and right pant leg (CJ 226N).
References: Ladies Home Journal, 1956.
Fashion Institute of Technology, Gift of Warren Featherbone 79.164.3-4

In entries 493, 494, and 497, "handi-panti" is a trade marketing term created by Alexis Infants' Wear, and refers to the lower portion of a sunsuit. Examination of correspondence between Charles James and the Alexis company does not reveal the nature of the construction, or whether more than one construction was possible. It is also not known if James accepted or adapted the preexisting construction(s).

493 SUNSUIT SET, 1956 [CJ 228]

Sunsuit — includes "handi-panti." Jacket — V-opening and three rows of ruffles as trim; front and back yoke. Designed initially for, and marketed by Alexis Infants' Wear. Sunsuit fabrics unknown; jacket in white sharkskin with pink and white trim.

494 SUNSUIT SET, 1956 [CJ 229]

Sunsuit — bib top; shaped strap; lowered waistline, "handi-panti." Jacket — rounded notched collar; short sleeves; rounded flared waist (CJ 112, cat. no. 471). Designed initially for, and marketed by Alexis Infants' Wear (fabrics unknown).

495 SUNSUIT, 1956 [CJ 233]

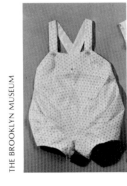

Narrow crossover straps from dart in seat back; bib front; high Empire waist above draped pants. Designed initially for, and marketed by Alexis Infants' Wear in pink-and-white printed cotton (CJ 233A).

Patterns: paper 57.151.21b
The Brooklyn Museum, Gift of Mrs. Jean de Menil 57.151.21a&b

496 "FRONTIE PANTIE," 1956
[CJ 235]

Shorts with elliptical front cut folded up; accented by mother-of-pearl buttons. Designed initially for, and marketed by Alexis Infants' Wear in Japanese-red velveteen.

Additional versions: **1956** blue velveteen (Marit Guinness Aschan).
Patterns: paper 57.151.17b; muslin 57.151.17c
References: The Brooklyn Museum sketches 57.218.30i.
The Brooklyn Museum, Gift of Mrs. Jean de Menil 57.151.17a–c

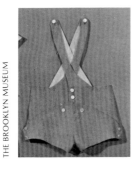

497 SUNSUIT, 1956 [CJ 237]

Shorts with elliptical front cut folded up (CJ 235, cat. no. 496); joined with front-crossing straps which form V-neck; button on shoulder. Designed initially for, and marketed by Alexis Infants' Wear in washed blue denim with white cotton lining (948 garments sold).

Additional versions: **1956** red, white and blue-grey poplin, labeled "handi-panti/by Alexis/Reg." and "designed/by Charles/James" and "Lilliputian Bazar/Best & Co."
Patterns: paper 57.151.19b
The Brooklyn Museum, Gift of Mrs. Jean de Menil 57.151.19a&b
[FIT, Homer Layne]

498 BOY'S SUSPENDER PANTS, 1956
[CJ 239]

Designed initially for, and marketed by Alexis Infants' Wear in white ribbed piqué. □

Additional versions: **1956** fabrics unknown (Princess Grace of Monaco).

499 INFANT'S GARMENT, 1956
[CJ 350]

Designed initially for, and marketed by Alexis Infants' Wear (fabrics unknown). □

500 BOY'S or GIRL'S JACKETED SUNSUIT, 1956 [CJ 510]

Designed initially for, and marketed by Alexis Infants' Wear (fabrics unknown; 1,104 garments sold). □

501 INFANT'S GARMENT, 1956
[CJ 527]

Designed initially for, and marketed by Alexis Infants' Wear (fabrics unknown; 1,080 garments sold). □

502 TOPPER SET, 1956 [CJ 550]

Box shirt — pointed collar; yoke with off-shoulder set-in short sleeves; patch pockets with flap (CJ 111, cat. no. 470). Boxer shorts (CJ 212, cat. no. 484). Designed initially for, and marketed by Alexis Infants' Wear in blue polished Everfast pima cotton.

Patterns: paper 57.151.15c
References: Ladies Home Journal, 1956.
The Brooklyn Museum, Gift of Mrs. Jean de Menil 57.151.15a–c

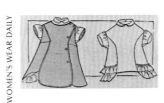

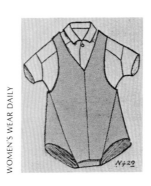

503 INFANT'S GARMENT, 1956
[CJ 552]

Designed initially for, and marketed by Alexis Infants' Wear in polished cotton. □

504 BOY'S TOPPER SET, 1956
[CJ 564]

Round-neck shirt with short sleeves; curved side closure with appliqué trim. Boxer shorts. Designed initially for, and marketed by Alexis Infants' Wear with shirt in white cotton with plaid appliqué, and matching shorts in blue, green, black, and white.

Fashion Institute of Technology, Gift of Warren Featherbone 79.164.6a&b

505 INFANT'S GARMENT, 1956
[CJ 915]

Designed initially for, and marketed by Alexis Infants' Wear in a choice of white, white with pink, or white with blue lace trim on leg (7,224 garments sold). □

506 TUNIC DRESS, BLOUSE-SLIP, 1956

Overdress — lobed, apron front; flared skirt. Underdress — Peter Pan collar; cap sleeves; ruffled side hemline. Designed initially for, and marketed by Alexis Infants' Wear in red velveteen and white dacron cotton at $7.

References: Women's Wear Daily, July 31, 1957.

507 BOY'S SUIT SET, 1956

Suit with spade-shape front; Shirt with yoke and cap sleeves. Designed initially for, and marketed by Alexis Infants' Wear in red velveteen and white dacron cotton at $6.

References: Woman's Wear Daily, July 31, 1957.

Undergarments

508 SLIP, 1934 London

Full length; arced bust; V-back; high waist; sheath skirt. Initial fabrics and client unknown.

Additional versions: **1934** white satin (Marit Guinness Aschan).
Marit Guinness Aschan

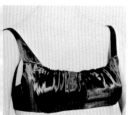

509 CORSET, 1958

Initial fabrics and client unknown. □

Additional versions: fabrics unknown @ $165 (Suzette Morton Zurcher).

References: The Brooklyn Museum sketches 57.218.39.

510 FOUNDATION/UNDER BODICE, ?1950

Scoop neck with tapered shoulder straps; elasticized gussets; hook-and-eye back closure. Initial fabrics and client unknown.

Additional versions: **?1950** pink satin (Marit Guinness Aschan). **1951** fabrics unknown @ $125 (Mrs. S. Bronfman, Mrs. James T. Cunningham); fabrics unknown @ $75 (Mrs. William Randolph Hearst, Jr.); fabrics unknown @ $165 (Mrs. Joseph E. Davies). **1956** boned @ $175 (Gypsy Rose Lee); fabrics unknown @ $100 (Eleanor Lambert); satin @ $125 (Mrs. Spyras Skouras). **1959** fabrics unknown @ $125 and @ $110 (Mary Ellen Hecht); fabrics unknown @ $330 and @ $175 (Mrs. Vernon Taylor); fabrics unknown @ $75 (Janet Walsh). **?1961** black (Grace Kazazian); black taffeta, and white taffeta (Mrs. Jackson Pollock).

The Brooklyn Museum
[MMA]

511 UNDERSKIRT, ?1952 [CJ 70C]

Initial fabrics and client unknown. □

512 UNDERSKIRT, 1952 [CJ 85]

Infanta-shaped petticoat stiffened with elliptical boning. Initial fabrics and client unknown.

Additional versions: **1958** white rayon acetate, boning, nylon mesh (Mrs. Jean de Menil).

Patterns: paper 58.144.2b; muslin 58.144.2c

The Brooklyn Museum, Gift of Mrs. Jean de Menil 58.144.2a–c

513 UNDERSKIRT, 1952 [CJ 86]

Bell-shaped petticoat stiffened with boning. Initial fabrics and client unknown.

Additional versions: **1958** white rayon acetate, boning, nylon mesh (Mrs. Jean de Menil).

Patterns: paper 58.144.1b; muslin 58.144.1c

The Brooklyn Museum, Gift of Mrs. Jean de Menil 58.144.1a–c

514 UNDERSKIRT, ?1952 [CJ 87]

Initial fabrics and client unknown. □

515 VEST, ?1955 [CJ 1005]

Round neck; triangular revers; narrow, double-breasted button closure; elastic side gussets. Initial fabrics and client unknown. Based on a late eighteenth-century boy's waistcoat (*Collection: The Brooklyn Museum*).

Additional versions: **?1956** gold faille, gold cotton sateen, black elastic.

Stage Costumes

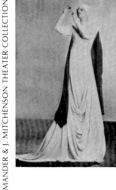

516 LONG GOWN, 1934 London

Jewel neck; long bat-wing sleeves; diagonally-cut torso ending in a deep asymmetrical hip to trained-hemline drape. Designed with Cecil Beaton for the Cochran Revue "Streamline" and worn by Tilly Losch, ?June Hart, ?La Jana and ?Kyran Nijinsky (fabrics unknown).

References: Raymond Mander and Joe Mitchenson. *Revue, A Story in Pictures* (New York: Taplinger Publishing Co., 1970); Robert Baral, *Revue, The Great Broadway Period* (New York: Fleet Press Corp., 1972), p. 286.

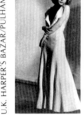

517 LONG GOWN, 1936 London

Waist-deep V-neck with wide pointed revers filled with contrasting gilet; waist-deep armholes; slightly-flared skirt worn over petticoat. Designed for the Cochran Revue "Follow the Sun" and worn by Claire Luce (white Marcella, black sequin gilet and petticoat), and June Hart (fabrics unknown).

References: U.K. *Harper's Bazar*, Feb. 1936, p. 32.

518 GOWN, 1937 London

V-neck with wide shoulders; fitted back-pointed bodice; undulating bustle over double-draped and flounced skirt in front, with side panels and back cascade. Designed with Norman Hartnell for Cochran's Coronation Revue "Home and Beauty" and worn by Gitta Alpar in cellophane lamé and vermillion tulle.

References: U.K. *Harper's Bazar*, Jan. 1937, pp. 60–61.

519 LONG COAT, 1937 London

Stand collar with neckties; tubular torso; sling sleeves. Designed with Norman Hartnell for Cochran's Coronation Revue "Home and Beauty" and worn by Gitta Alpar in checked wool tweed.

References: U.K. *Harper's Bazar*, Jan. 1937, pp. 60–61.

520 STREET COAT, 1937 London

Arced neckline; broad, square shoulders; tight sleeves; fitted torso; flared skirt with front inverted spearhead panel from under arms extending in fin-like projections at hipline and ending in point at hemline. Designed with Norman Hartnell for Cochran's Coronation Revue "Home and Beauty" and worn by Gitta Alpar in green billiard cloth.

References: U.K. Harper's Bazar, Feb. 1937, p. 57.

521 STAGE COSTUME, 1939
 [?CJ 100]
(see also cat. no. 48)

Horizontally tucked bodice; skirt shirred in back and on either side of funnel-shaped front panel; bias-cut hemline flounce. Version of "La Sirène" evening dress designed initially in 1938 for Mrs. Oliver Burr Jennings. Costume worn by Gypsy Rose Lee in the finale of "Star and Garter" (fabrics unknown).

References: Photograph (collection: Mrs. George Perkins Raymond).

522 RIDING OUTFIT, 1939

Short jacket; top hat. Designed initially for "Swingin' the Dream" and worn by Ruth Ford with jacket in black, white, and pale-pink leather, and hat in white felt with black band. Also worn by Eleonor Lynn, Dorothy McGuire, and Catheryn Laughlin (fabrics unknown). □

523 DRESS, 1945

Spiral pouff. Designed for "Beggars are Coming to Town" and worn by Dorothy Comingore in black satin, and Adrienne Ames (fabrics unknown). □

References: Women's Wear Daily, Oct. 31, 1945.

524 CAPE, 1946

Layered wrap of quarter-circles over tulle; layers comprise seven inches of ermine, twelve inches of starched lace, seventeen inches of taffeta, and twenty-five inches of lace and satin. Designed with Cecil Beaton for "Camille."

References: The Brooklyn Museum sketches 57.218.34b.

525 STRIP ENSEMBLE, ?1955

Two-piece. Designed for Gypsy Rose Lee in black wool. □

References: Sale catalogue, Plaza Art Galleries, April 20, 1978, lot #116.

526 LEOTARD, 1957

Strapless; high bustline; two-part leaf-like bustle in back; short legs. Designed for Janet Gaynor in black and pink satin.

Homer Layne

527 "DIAMOND" DRESS, 1957
(see also cat. no. 125)

Strapped scoop neck; fitted bodice; arced up in front and down to kneeline point in back; inset, hourglass-shaped, center-back panel; fitted torso extending into cloverleaf-shaped fishtail skirt train. In white satin, mushroom gros de Londres, and black velvet @ $1,250 for Marguerite Piazza, and worn by her for her act at the Sands Hotel, Las Vegas.

References: Harrisburg Evening News, Pennsylvania, July 27, 1957; Chicago Tribune, Nov. 18, 1958.

528 MEDEA COSTUME, 1958

Gown and cape with two veils. Designed with Halston for "Medea" and worn by Eileen Farrell in embroidered ruby velvet, cerise panné velvet, rose-red crepe, and gold lamé cape lining. □

Hats

529 CLOCHE, 1926 Chicago

Deep rounded crown with random tucks and projections; rolled-back front brim. Designed under James's trading name "Boucheron." Initial fabrics and client unknown.

*Additional versions: **1926** beige felt (Louise Kent Chandler).*

530 CLOCHE, 1926 Chicago

Deep rounded crown with left side self-fabric bow. Designed under James's trading name "Boucheron." Initial fabrics and client unknown.

*Additional versions: **1926** felt (Katharyne Kent Chandler).*

531 HAT, ?1928 Chicago

Dome crown cut in one with brim turned up on left-side; diagonally-tapered pleat at back right. Designed under James's trading name "Boucheron." Initial fabrics and client unknown.

Additional versions: **?1928** chocolate-brown felt, labeled "Mme. de Launay" (Helen Pauling).
Chicago Historical Society, Gift of Mrs. H.P. Donnelly 1980.261.6

532 HAT, ?1928 Chicago

Dome crown cut in one with center back pleated brim. Designed under James's trading name "Boucheron." Initial fabrics and client unknown.

Additional versions: **?1928** royal-blue felt, labeled "Mme. de Launay" (Helen Pauling).
Chicago Historical Society, Gift of Mrs. H. P. Donnelly 1980.261.7

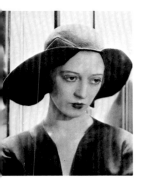

533 HAT, ?1929 London

Round crown; two broad inset side-wings folded towards side back. Designed under James's trading name "Boucheron." Initial fabrics and client unknown.

Additional versions: **1929** felt (Marianne Van Rensselaer.

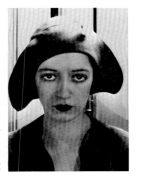

534 HAT, ?1929 London

Round crown, spirally cut in one with brim turned back in front with tuck on left side. Designed under James's trading name "Boucheron." Initial fabrics and client unknown.

Additional versions: **1929** felt (Marianne Van Rensselaer).

535 HAT, 1929 London

Domed crown; draped, upturned brim with wing-like projections at sides. Designed initially for Louise Brega James (fabrics unknown).

Additional versions: **1930** mauve-brown baku straw, labeled "Boucheron of London" (Mrs. E. P. York).
Museum of Art, Rhode Island School of Design, Gift of Mrs. John W. Lincoln 66.074.1

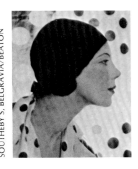

536 TURBAN, ?1930 London

Round crown; rolled-back front brim; bow at nape of neck. Designed under James's trade name "Boucheron." Initial fabrics and client unknown.

Additional versions: **1930** felt (Tilly Losch).
References: U.S. Vogue, May 10, 1930, p. 62.

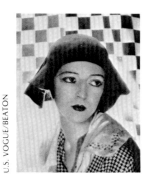

U.S. VOGUE/BEATON

537 HAT, ?1930 London

Round crown; rolled-up front brim; irregularly-draped side wings. Designed under James's trading name "Boucheron." Initial fabrics and client unknown.

Additional versions: **1930** (Marianne Van Rensselaer).
References: U.S. Vogue, May 10, 1930, p. 63.

538 HAT, ?1930 London

Petal-shaped. Initial fabrics and client unknown. □

Additional versions: **?1930** fabrics unknown (Frances James).

539 PICTURE HAT, 1932 London
(see cat. illustration 134)

Domed crown; broad brim turned-up in back. Designed initially for Frances James (fabrics unknown).

540 PICTURE HAT, ?1933 London
(see cat. illustration 9)

Round, asymmetrical crown; broad brim with draped pleat on right side. Designed initially for Anne, Countess of Rosse (fabrics unknown).

541 HAT, ?1934 London

Initial fabrics and client unknown. □

Additional versions: **1934** duck-egg-blue and green (Mrs. H. S. H. Guinness).

542 HAT, ?1934 London

Two discs sewn together at the back and sides, separating in front. Initial fabrics and client unknown.

Additional versions: **1934** fabrics unknown (Marshall Field & Co.).
References: Chicago American, Jan. 9, 1934.

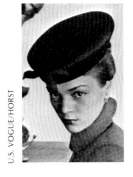

U.S. VOGUE/HORST

543 FRENCH SAILOR'S BERET, 1934

Disc-shaped crown; narrow stand; worn at angle. Initial fabric and client unknown.

Additional versions: **1934** fabrics unknown (Mrs. Arthur Bissell). **?1934** navy and straw (Mrs. H. S. H. Guinness). **1948** black felt (marketed by Charles James).
References: Chicago American, Jan. 9, 1934; U.S. Vogue, Oct. 1, 1948, p. 141.

544 POKE BONNET, ?1935 London

Rounded crown; projecting front brim with bow in center front; stitched form. Initial fabrics and client unknown.

Additional versions: **1935** fabrics unknown.
References: U.K. Harper's Bazar, Feb. 1935, p. 56.

545 HAT, ?1936 London

Folded lozenge shape, forming triangle. Initial fabrics and client unknown.

Additional versions: **1936** black grosgrain ribbon (Philippa Barnes).
Victoria and Albert Museum, Gift of Miss Hawthorne Barnes T297.1978

U.K. HARPER'S BAZAR

SOUTHEBY'S, BELGRAVIA/BEATON

MUSEUM OF ART, RISD

SOTHEBY'S, BELGRAVIA/BEATON

546 "NANNY'S CAP," ?1948

Arced triangular crown with shallow edge; two long notched-end streamers. Based on late nineteenth-century cap. Initial fabrics and client unknown.

Additional versions: **1948** dark-brown velvet, champagne satin, dark-brown taffeta, labeled "Charles James /48" (Muriel Bultman Francis).

547 "YUGOSLAVIAN" CAP, 1948

Teardrop-shaped crown; shallow stand with rolled coil in back; thick tassel through eyelet on crown. Initial fabrics and client unknown.

Additional versions: **1948** one each in red silk, red wool, gold faille, emerald-green velvet, and black velvet (Muriel Bultman Francis); fabrics unknown (merchandised by Lord & Taylor).
References: U.S. Vogue, March 1, 1948, p. 214.
The Brooklyn Museum, Gift of Muriel Bultman Francis 81.49.1

548 CLOVERLEAF HAT, 1948

Segmented quatrefoil crown; two side bows. Initial fabrics and client unknown.

Additional versions: **1948** midnight-blue satin, labeled "Charles James/48" (Muriel Bultman Francis); black velvet (without bows), labeled "Charles James/48" (Mrs. A. Moore Montgomery); black satin (marketed by Charles James; merchandised by Carson, Pirie, Scott & Co.).
References: U.S. Vogue, Aug. 15, 1948, p. 158.
The Metropolitan Museum of Art, Gift of Mrs. A. Moore Montgomery 1973.271.2

549 MATADOR'S HAT, 1948

Domed crown with segmented, alternating shirred-and-pleated panels. Initial fabrics and client unknown.

Additional versions: **1948** black velvet and satin, labeled "Charles James/48" (Mrs. Robert Langdon).
The Brooklyn Museum, Gift of Mrs. Robert Langdon 69.101

550 HAT, ?1948

Ovoid-shape domed-crown wrapped with encircling band. Designed initially in burgundy silk velvet for Mrs. William Randolph Hearst, Jr.

Mrs. William Randolph Hearst, Jr.

551 THEATRE HAT, ?1951 ●

Heart-shaped crown; large feather cockade; veiled. Initial fabrics and client unknown.

Additional versions: **1951** egret plume, black velvet, black-spotted net (Audrée Nethercott).
References: J. Herbert Callister, Dress from Three Centuries (Hartford, Connecticut: Wadsworth Atheneum, 1976), p. 70.
Wadsworth Atheneum, Gift of Audrée Nethercott 1970.48

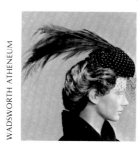

552 HAT, ?1951

Initial fabrics and client unknown. □
Additional versions: **1951** black @ $65 (Mrs. Vernon Taylor).*

553 HELMET HAT, 1952

Designed initially in grey felt and beige satin for an unknown client. □

Additional versions: **1952** fabrics unknown (Mrs. Cornelius Vanderbilt Whitney; merchandised by Lord & Taylor).
References: U.S. Vogue, April 1, 1952, cover and p. 77; Look, Sept. 1952, p. 93.

554 "BERET," 1954

Circular crown; shallow stand; notched up with single plucked-feather plume. Designed initially in magenta wool tweed for Lane Bryant.

The Brooklyn Museum, Gift of Lane Bryant 61.104.2c

Fashion Accessories etc.

555 BATHING or SUNSUIT, 1935
Capri

Draped figure "8." Initial fabrics and client unknown. □
References: The Brooklyn Museum sketches 57.218.1.

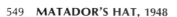

556 BATHING or SUNSUIT, 1935
Capri

Narrow neckstraps brought up from back and tie at bustline; short pants. Initial fabrics and client unknown.
References: The Brooklyn Museum sketches 57.218.1.

557 BATHING SUIT, ?1952

Fitted bustline; elastic front stomacher and shaped hipline panel cut up legs. Designed initially for Lisa Kirk (fabrics unknown).

References: The Brooklyn Museum sketches 57.218.32uu.

558 BEACHWEAR, 1935 Capri

Sunsuit — shoulder straps; cut-in-one body with high cups; fitted torso. Cape — rectangular, with pockets; calf-length. Full-length stockings. Sunsuit initially designed in white silk jersey with cape in heavy red silk and stockings of yellow silk (client unknown).

References: The Brooklyn Museum sketches 57.218.1.

559 BEACHWEAR or SUNSUIT, 1936 London

Knitted fabric with diagonal stripe; fitted torso with thigh cuffs. Designed initially for Marit Guinness Aschan in a hand-knitted fabric.

560 BELT CLASP, ?1935 London

Pair of elongated, clasped hands; hook clasp. Initial material and client unknown.

Additional versions: blackish-brown Bakelite composition, incised in script "Victor Linton" (Philippa Barnes; merchandised by Harrods).
Victoria and Albert Museum, Gift of Miss Hawthorne Barnes T293.1978.

561 BELT, ?1951

Initial material and client unknown. □

Additional versions: 1951 white kid @ $12.50 (Millicent Rogers); material unknown @ $12.50 (Mrs. Vernon Taylor).

562 CONTOUR BELT, 1954 [?CJ 420]

Contoured; horizontal center seam; central diamond-shaped tab over unpressed pleats; back belt closure. Designed initially for, and marketed by Bruno Belts. Merchandised by Lord & Taylor in black satin faced with rust calf @ $18.95, labeled "Design By/ Charles James/for/Bruno Models."

References: New York Herald-Tribune, Sept. 13, 1954, p. 12.
Homer Layne

563 BELT, 1954

Piped edge; center-front fan-shaped raised notch; back buckle closure. Designed initially for, and marketed by Bruno Belts. Merchandised by Lord & Taylor in a choice of black, red, or navy calf @ $14.95.

References: New York Times, March 4, 1954, p. 7; New York Herald-Tribune, Sept. 13, 1954, p. 12.

564 CONTOUR BELT, 1954

Wedge-shaped, up-swept raised front waistline; front buckle closure. Designed initially for, and marketed by Bruno Belts. Merchandised by Lord & Taylor in leather.

References: New York Times, March 4, 1954, p. 7.

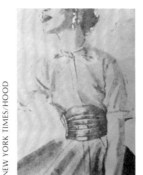

565 CONTOUR BELT, 1954

Deep cummerbund; back buckle closure. Designed initially for, and marketed by Bruno Belts. Merchandised by Lord & Taylor in leather.

References: New York Times, March 4, 1954, p. 7.

566 CONTOUR BELT, 1954

Bracket-shaped; down-pointing belt; back buckle closure. Designed initially for, and marketed by Bruno Belts. Merchandised by Lord & Taylor in leather.

References: New York Times, March 4, 1954, p. 7.

567 CONTOUR BELT, 1954

Bracket-shaped; upward-pointing belt; back buckle closure. Designed initially for, and marketed by Bruno Belts. Merchandised by Lord & Taylor in leather.

References: New York Times, March 4, 1954, p. 7.

568 BELT, 1954

Strap with parallel front tab closure. Designed initially for, and marketed by Bruno Belts. Merchandised by Lord & Taylor in leather.

References: New York Times, March 4, 1954, p. 7.

569 CONTOUR BELT, 1954

Narrow cummerbund shape, back buckle closure. Designed initially for, and marketed by Bruno Belts. Merchandised by Lord & Taylor in leather.

References: New York Times, March 4, 1954, p. 7.

570 BUTTONS, 1935 Capri

Rose shape. Designed initially in pink china. Client unknown.

References: The Brooklyn Museum sketches 57.218.1.

571 BUTTONS, 1935 Capri

Cameo in tortoiseshell frame. Client unknown.

References: The Brooklyn Museum sketches 57.218.1.

572 BUTTONS, 1935 Capri

Pieces of coral with gold band in center. Client unknown.

References: The Brooklyn Museum sketches 57.218.1.

573 COAT BUTTON, ?1936 London

Domed heartshape with shank; 2 x 2 inches. Initial material and client unknown.

*Additional versions: **?1936** black calf over composition.*
Victoria and Albert Museum, Gift of Miss Hawthorne Barnes T295.1978

574 TOGGLED BUTTONS, ?1936 London

Teardrop heart-shape; three-point sewing holes; 1¾ x 1¾ inches. Initial material and client unknown.

*Additional versions: **?1936** mother of pearl, three pairs.*
Victoria and Albert Museum, Gift of Miss Hawthorne Barnes T296.1978

575 FAN, ?1935 London ●

Heart-shaped wingspread with two layers of glued feathers. Initial material and client unknown.

*Additional versions: **1935** two scarlet magpie wings. **?1935** dyed red feathers (Marit Guinness). **1947** dyed dark olive-green feathers; dyed peach and white feathers. **?1947** dyed light olive-green feathers.*
References: U.K. Harper's Bazar, Aug. 1935, pp. 16–17; U.K. Harper's Bazar, Oct. 1936, p. 50; U.S. Harper's Bazaar, April 1947, p. 181; Collier's, Sept. 1947, p. 100; Holiday, Jan. 1949, p. 121.
The Brooklyn Museum

576 SETTEE or CHAISE LONGUE, ?1947

Iron frame; birchwood slats; saffron faille and quilted white satin. Client unknown.

References: The Brooklyn Museum sketches 57.218.38d.

577 "BUTTERFLY" SOFA, 1952
(see also cat. illustration 121)

Two parts, placed together and slightly turned towards each other; molded curves. Designed initially with construction assistance from Harold Stevenson and upholstery by Brierleigh Ltd. Initial fabrics and client unknown.

*Additional versions: **1954** spring, horsehair and felt construction, muslin, @ about $960 (Mr. & Mrs. Jean de Menil — 4 sets; upholstery by the Sealy Company; merchandised by Lord & Taylor). **1958** fabrics unknown (Mrs. Jean de Menil). **1975** (Mrs. & Mrs. Roberto Polo).*
References: Look, Sept. 1952, pp. 91–93; New York Herald-Tribune, Sept. 13, 1954, p. 12; Women's Wear Daily, Oct. 11, 1954; Joseph Butler, American Antiques 1800–1900 (New York: Odyssey Press, 1965) p. 181; U.S. Vogue, April 1, 1966, pp. 187–199.
Mrs. Jean de Menil
[Mr. & Mrs. Roberto Polo]

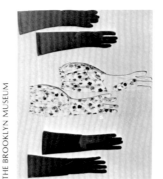

578 GLOVES, ?1935–?1955 ●
(see also cat. no. 579)

Various lengths; flared or bulbous-shaped gauntlet; pyramid-pointed wristline; jersey palm. Initial fabrics and client unknown.

*Additional versions: **1951** fabrics unknown @ $17.50 (Mrs. Richard Reynolds — two pairs); white faille @ $17.50 (Mrs. Cornelius Vanderbilt Whitney). **?1951** garnet satin (Gypsy Rose Lee). **1955** pink silk taffeta @ $35. **?1950-55** claret velvet and silk jersey (Mrs. William Randolph Hearst, Jr.); purple silk satin-backed twill and purple silk jersey (Mrs. William Randolph Hearst, Jr.); cream silk with orange, brown and yellow printed pile flowers (Mrs. William Randolph Hearst, Jr.).*
References: Collier's, Sept. 1947, p. 100; Holiday, Jan. 1949, p. 181.
Mrs. William Randolph Hearst, Jr.

579 HANDBAG, ?1951

Pouch; lobe shape; entwined handles. Initial fabrics and client unknown.

*Additional versions: **?1951** garnet satin (Gypsy Rose Lee).*
References: Photograph (collection: March of Dimes Photo Archives).

580 HANDBAG, 1953

Clutch, triangular log; zipper closure. Initial fabrics and client unknown. □

References: The Brooklyn Museum sketches 57.218.37.

581 HANDBAG, 1953

Pouch form with flaring flap over cuff. Initial fabrics and client unknown.

*Additional versions: **?1953** Fabrics unknown (Muriel Bultman Francis).*
References: The Brooklyn Museum sketches 57.218.37.

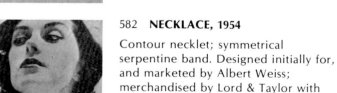

582 NECKLACE, 1954

Contour necklet; symmetrical serpentine band. Designed initially for, and marketed by Albert Weiss; merchandised by Lord & Taylor with rhinestones @ $70.

References: New York Herald-Tribune, Sept. 13, 1954, p. 12.

583 NECKLACE, 1954

Necklace/choker. Designed initially for, and marketed by Albert Weiss with rhinestones.

References: Photograph (collection: Homer Layne)

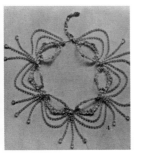

584 NECKLACE, 1954

Contoured choker; floating swag and tassels. Designed initially for, and marketed by Albert Weiss.

Additional versions: **1955** colored stones @ $70 (merchandised by Lord & Taylor).
References: U.S. Harper's Bazaar, April 1955, p. 184.

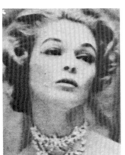

U.S. HARPER'S BAZAAR/WILSON

585 NECKLACE, 1954

Front, double-tiered choker. Designed initially for, and marketed by Albert Weiss with rhinestones.

References: U.S. Harper's Bazaar, April 1954, p. 155.

THE BROOKLYN MUSEUM

586 LEAF BROOCH MAQUETTE, ?1963

Single-leaf form; intended to be executed in enamelled gold and set with diamonds and a pearl. Designed initially for Muriel Bultman Francis. Maquette made from base metal, paste stones, and a pearl.

The Brooklyn Museum, Gift of Muriel Bultman Francis 81.49.2

587 RINGS, BUCKLES, BROOCHES, 1963

Pieces designed by James on a speculative basis with the unachieved objective of the collection being marketed by Corocraft Jewelry. Materials unknown.

Homer Layne

THE BROOKLYN MUSEUM

588 SCARF, 1932 London ●

Twisted, endless tube; usually worn in pairs; when entwined can be worn as head piece, neck scarf, sham waistcoat, or belt. Designed initially for Mrs. Oliver Burr Jennings (fabrics unknown).

Additional versions: **?1932** fabrics unknown (merchandised by Fortnum & Mason). **1934** fabrics unknown (merchandised by Marshall Field & Co.). **?1936** beige and green (Mrs. H. S. H. Guinness.) **1950** pink silk satin and pale-aqua taffeta (Mrs. George Perkins Raymond): emerald-green taffeta and salmon silk (Nancy White). **1932-1954** blue satin and lilac satin; pink slipper-satin; pale-pink and green (Ruth Ford); brass faille (Mrs. William Randolph Hearst, Jr.); brass satin (Mrs. William Randolph Hearst, Jr.); brown satin and pink satin (Alice Topp-Lee); fabrics unknown (Frances James, Mrs. Edmond G. Bradfield).

Fashion Institute of Technology, Gift of Nancy White [MHS, Marit Guinness Aschan, Mrs. William Randolph Hearst, Jr., Ruth Ford, Frances James, Homer Layne, Mrs. George Perkins Raymond]

589 SCARF, ?1947

Trumpet shaped; composed of wedges of ribbon; double thickness. Initial fabrics and client unknown.

Additional versions: **1948** pink satin, pearl-grey satin, saffron taffeta, pink faille (Alice Topp-Lee). **1950** pale-mauve satin, powder-blue taffeta faille, pale-taupe satin, pink taffeta faille (Mrs. George Perkins Raymond).
Homer Layne [Mrs. George Perkins Raymond]

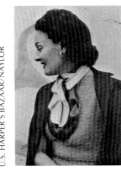

U.S. HARPER'S BAZAAR/NAYLOR

590 SCARF, 1948

Lappet-like, with rounded ends and bulbous central form; each end a different color. Designed initially for Lenthéric, Inc., (fabrics unknown).

Additional versions: **1948** taffeta satin in two shades. **?1948** mustard faille and lilac moiré (Marit Guinness Aschan); purple and old-rose satin (Mrs. H. S. H. Guinness). **?1954** lilac and pale-aqua satin (Grete Wootton). **?1955** brown taffeta and cerise satin (Ruth Ford).
References: U.S. Harper's Bazaar, Sept. 1948, p. 195.
Marit Guinness Aschan [Ruth Ford, Homer Layne]

THE BROOKLYN MUSEUM

591 SCARF TIE, ?1950

Narrow neck band with triangular flared ends. Initial fabrics and client unknown.

Additional versions: **1951** pale dusty-rose corded silk faced with tobacco-brown satin (Muriel Bultman Francis).
The Brooklyn Museum, Gift of Muriel Bultman Francis 66.147.7c

THE BROOKLYN MUSEUM

592 SCARF TIE, ?1950

Narrow neck band with double-lobed ends. Initial fabrics and client unknown.

Additional versions: **1951** taupe satin (Muriel Bultman Francis).
The Brooklyn Museum, Gift of Muriel Bultman Francis 66.147.7d

593 SCARF, ?1950

Initial fabrics and client unknown. ☐

Additional versions: **1951** fabrics unknown @ $22.50 (Alice Topp-Lee).

594 SCARF, ?1950

Initial fabrics and client unknown. ☐

Additional versions: **1951** fabrics unknown @ $65 (Mrs. William Randolph Hearst, Jr.).

595 SCARF, ?1950

Initial fabrics and client unknown. ☐

Additional versions: **1951** fabrics unknown @ $17.50 (Mrs. Rudolph A. Bernatschke).

596 SHOES, ?1937 London

Pumps with a wing motif appliqué. Initial client and materials unknown. ☐

597 SHOES, 1953

Pumps with triangular heel. Designed initially in leather for an unknown client. ☐

References: The Brooklyn Museum sketches 57.218.37

598 SLEEVES, ?1947

Separate, melon-shaped sleeves with long trapezoidal ties which wrap around back and tie in front, at neck. Designed "to dress-up a little black dress" for an unknown client (fabrics unknown).

Additional versions: **?1947** pale-aqua taffeta and café-au-lait taffeta (Mrs. George Perkins Raymond). **?1948** fabrics unknown (Mrs. William Randolph Hearst, Jr.).

Mrs. George Perkins Raymond

599 STOLE, 1934 London
(see cat. illustration 17)

Swath of tulle. Initial client unknown.

Additional versions: **1934** tulle (Anne, Countess of Rosse).
References: U.K. *Harper's Bazar,* Nov. 1934, p. 56.

600 STOLE, 1937 London

Ribbons stitched together in rectangular form. Initial fabrics and client unknown.

Additional versions: **1937** pink silk satin, mustard satin, pale-blue paper silk taffeta ribbons (Anne, Countess of Rosse).

Anne, Countess of Rosse

601 STOLE, ?1946
(see cat. illustration 55)

Rectangular swath of fabric. Initial fabrics and client unknown. □

Additional versions: **1947** silk illusion net. **?1948** fabrics unknown (Mrs. William Randolph Hearst, Jr.).
References: U.S. *Vogue,* April 15, 1947, p. 122; *New York Daily Mirror,* Jan. 3, 1957.

602 STOLE, ?1949

Initial fabrics and client unknown. □

Additional versions: **1950** bright-green backed with apricot.
References: U.S. *Harper's Bazaar,* April 1950, p. 178.

603 STOLE, ?1950

Initial fabrics and client unknown. □

Additional versions: **1951** two versions, fabrics unknown, each @ $550 (Jennifer Jones).

604 STOLE, ?1950

Initial fabrics and client unknown. □

Additional versions: **1951** silk taffeta @ $75 (Millicent Rogers).

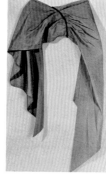

605 STOLE, 1957 ●

Bias cut with deep endpoints and central shirring concealed beneath piped band. Initial fabrics and client unknown.

Additional versions: **1957** taupe faille, black velvet (Mrs. Morehead Patterson).

The Brooklyn Museum, Gift of Mrs. Morehead Patterson 72.22.1

Bibliography

BOOKS AND MANUSCRIPTS

Bettina Ballard, *In My Fashion* (New York: David McKay Co. Inc., 1960).

Robert Baral, *Revue, The Great Broadway Period* (New York: Fleet Press Corp., 1972).

Michael and Ariane Batterberry, *Mirror Mirror* (New York: Holt, Rinehart & Winston, 1977).

Martin Battersby, *The Decorative Thirties* (New York: Walker & Co., 1971).

Cecil W.H. Beaton, *The Best of Beaton* (New York: The Macmillan Co., 1968).

——, *Fashion* (London: Victoria & Albert Museum, 1971).

——, *The Glass of Fashion* (Garden City, N.Y.: Doubleday & Co., 1954).

——, *Photobiography* (Garden City, N.Y.: Doubleday & Co., 1951).

Edith Becker, "Sternberg & Enders Family Records," Daughters of the American Revolution Library, Washington, D.C.

Marlyn Bender, *The Beautiful People* (New York: Coward McCann, Inc., 1967).

Stella Blum and Louise Hamer, *Fabulous Fashion 1907–1967 from The Costume Institute, The Metropolitan Museum of Art, New York* (Victoria: International Cultural Corporation of Australia Limited, 1981).

Joseph T. Butler, *American Antiques 1800–1900: A Collector's History and Guide* (New York: Odyssey Press, 1965).

J. Herbert Callister, *Dress from Three Centuries* (Hartford, CT.: Wadsworth Atheneum, 1976).

Ernestine Carter, *With Tongue in Chic* (London: Michael Joseph, 1977).

Bernice Chamber, *Color & Design* (New York: Prentice Hall, 1957).

Randolph S. Churchill, *Winston S. Churchill, Youth 1874–1900* (Boston: Houghton Mifflin Co., 1966).

Mila Contini, *Fashion: From Ancient Egypt to the Present* (New York: Odyssey Press, 1965).

M.D.C. Crawford, *The Ways of Fashion* (New York: Fairchild Publishing Co., 1948).

Current Biography: Who's News and Why, vol. 17 no. 7 (New York: The H.W. Wilson Co., 1956).

Current Biography Yearbook 1956 (New York: The H.W. Wilson Co., 1957).

Bea Danville, *Dress Well On $1 A Day* (New York: Collier Books, 1962).

Jessica Daves, et al. ed., *The World in Vogue* (New York: Viking Press, 1963).

Christian Dior, *Christian Dior and I* (New York: E.P. Dutton & Co., 1957).

Jane Dorner, *Fashion: The Changing Shape of Fashion Through the Years* (New York: Octopus Books, 1974).

——, *Fashion in the Forties and Fifties* (New Rochelle, N.Y.: Arlington House Publishers, 1975).

John Drury, *Old Chicago Houses* (Chicago: The University of Chicago Press, 1941).

Edward F. Dunne, *Illinois, The Heart of the Nation*, vol. II (Chicago: Lewis Publishing Co. Inc., 1933).

Enders Family Association, "The Enders Family 1740–1933," Daughters of the American Revolution Library, Washington, D.C.

Washington Frothingham, *History of Montgomery County* (Syracuse, N.Y.: D. Mason & Co., 1892).

Prudence Glynn with Madeleine Ginsburg, *In Fashion, Dress in the 20th Century* (London: George Allen & Unwin Ltd., 1978).

Nancy Hall-Duncan, *The History of Fashion Photography* (New York: Alpine Book Co., 1979).

Paul F. Healy, *Cissy, A Biography of Eleanor M. "Cissy" Patterson* (Garden City, N.Y.: Doubleday & Co., 1966).

Georgiana Howell, *In Vogue* (New York: Penguin Books, 1979).

Alan Jenkins, *The Thirties* (New York: Stein & Day, 1976).

Phillippe Jullian, *Dictionnaire du Snobisme* (Paris: Librairie Plon, 1958).

Eleanor Lambert, *World of Fashion, People, Places, Resources* (New York and London: R.R. Bowker Co., 1976).

Gypsy Rose Lee, *Gypsy* (New York: Harper & Brothers, 1957).

Sarah Tomerlin Lee, *American Fashion* (New York: Quadrangle, New York Times Book, 1975).

John W. Leonard, ed., *The Book of Chicagoans* (Chicago: A.N. Marquis & Co., 1905).

Phyllis Lee Levin, *The Wheels of Fashion* (New York: Doubleday & Co. Inc., 1965).

Alfred Allen Lewis and Constance Woodworth, *Miss Elizabeth Arden, An Unretouched Portrait* (New York: Coward, McCann, Geoghegan, Inc., 1972).

Alexander Liberman, *The Art & Technique of Color Photography* (New York: Simon & Schuster, 1951).

Ruth Lyman, *Couture — An Illustrated History of the Great Paris Designers and Their Creations* (Garden City, N.Y.: Doubleday & Co., 1972).

Raymond Mander and Joe Mitchenson, *Revue, A Story in Pictures* (New York: Taplinger Publishing Co., 1970).

Stanley Marcus, *Minding the Store, A Memoir* (New York: New American Library, 1975).

Minnesota Museum of Art, *A Century of Fashion 1880–1980* (St. Paul: Minnesota Museum of Art, 1981).

Nigel Nicolson and Joanne Trautmann, eds., *The Letters of Virginia Woolf Vol. V 1932–1935* (New York and London: Harcourt Brace Jovanovich, 1979).

Irving Penn, *Moments Preserved* (New York: Simon & Schuster, 1960).

Polks Chicago City Directory, 1928.

Robert Riley and Walter Vecchio, *The Fashion Makers* (New York: Crown Publishers, 1967).

Francis Rose, *Saying Life, The Memories of Sir Francis Rose* (London: Cassell, 1961).

Robert Ruark, *The Honey Badger* (New York: McGraw Hill Book Co., 1965).

St. Louis City Directory, 1872.

Lyn Tornabene, *Long Live the King* (New York: G.P. Putman's Sons, 1976).

David Vaughan, *Frederick Ashton and His Ballets* (New York: Alfred A. Knopf, 1977).

Wadsworth Atheneum, *The Sculpture of Style* (Hartford, CT.: Wadsworth Atheneum, 1964).

Josephine Ellis Watkins, ed., *Who's Who in Fashion* (New York: Fairchild Publications, Inc., 1975).

Evelyn Waugh, *The Diaries of Evelyn Waugh, The Twenties Diary 1924–28*, ed. Michael Davie (London: Weidenfeld & Nicolson, 1976).

R. Turner Wilcox, *The Mode in Costume* (New York: Charles Scribner's Sons, 1958).

Who's Who in America vol. 30, 1958–59 (Chicago: Marquis, Who's Who, 1959).

Harold Waldo Yoxall, *A Fashion of Life* (New York: Taplinger Publishing Co. Ltd., 1966).

PERIODICALS, NEWSPAPERS, AND AUCTION CATALOGUES

American Fabric: Sketch of coat, vol. 37 (Summer 1956), p. 43.

American Fabrics and Fashions: "Charles James Exhibit at the Everson Museum," vol. 104 (Summer 1957); "Charles James: The Majority of One," vol. 98 (Fall 1973), pp. 18–19.

American Weekly: Charles James, "The Romantic Life and Tragic Death of Millicent Rogers," Mar. 22, 1953, pp. 12–13.

Boston Post, Massachusetts: Grace Davidson, "Fashion Awards," Oct. 14, 1950.

Brooklyn Eagle, New York: Gertrude McAllister, "Millicent Rogers Presents Museum with Fashion Collection," Nov. 1, 1948; "Museum is given Collection of Clothes Designed by Charles James," Nov. 10, 1948.

Buffalo Courier-Express, New York: Alice Hughes, "Top Stylist Gets New Post," Aug. 2, 1959.

Chicago American, Illinois: The Chaperon column, "Charlie James Atwit over Feud with Mrs. Letts as Fashion Show Nears," Jan. 8, 1934, p. 7; The Chaperon column, "Most Chic of All Society Sees Latest Dress Creations of Charlie James," Jan. 9, 1934; "Here's How Feminine Fashions Are Born," Jan. 9, 1934; Cholly Knickerbocker, "Dearborn," Oct. 28, 1948, p. 16; Joyce Fenley, "Rich Fashions Star Femininity," March 15, 1955, p. 15; "U of C Service League Fashion Show Monday," Nov. 13, 1958.

Chicago Daily News, Illinois: "Urges Revolution in Style School," Nov. 18, 1958; Peg Zwecker, "There's Hope James Will Teach Here," 1958; Peg Zwecker, "Collection of James Designs Goes to Museum," 1958; Peg Zwecker, "James Genius Prevails," Nov. 1, 1961, *Chicago Life*, pp. 8–10.

Chicago Sun-Times, Illinois: "Triumphant Home Coming for a Designer," Nov. 19, 1958, p. 44.

Chicago Tribune, Illinois: "High Style," Nov. 10, 1957, (magazine) p. 11; "Mr. James Fashions Gives Service Groups Glamorous Party," Nov. 18, 1958, pp. 4–5.

Christie's East, New York: *Important 20th Century Designer Clothes*, May 10, 1979, lots 71, 73, ?74, 75, 76, 78; *Fine 19th and 20th Century Clothing and Oriental Textiles*, Nov. 28, 1979, lots 334–339; *19th and 20th Century Costume, Fans, Quilts and Oriental Textiles*, Feb. 18, 1981, lot 21.

Christie's South Kensington, London, England: *Costumes, Textiles, Embroidery and Fans*, Aug. 18, 1977, lot 225.

Colliers: Amy Porter, "Young Man of Fashion," Sept. 20, 1947, pp.100–101.

Coronet: Ruth Orkin, "The World of Fashion," Dec. 1948, pp. 77–92.

Cue: "Designing G.I.'s," June 21, 1947, p. 9.

Dallas News, Texas: "Orcel Team First French Milliners to get Coveted N-M Fashion Award," Sept. 6, 1953; Ruth Holman "World-Famous Designers Honored at 16th N-M Fashion Exposition," Sept. 8, 1953, pp. 1–2; "James Plans to Continue Mistakes," Sept. 8, 1953.

Dallas Times Herald, Texas: Alice Hughes, "Charles James Engineers New Concept of Fashion," Aug. 7, 1959.

Dallas Wall Street Journal, Texas: Alice Hughes, "Ballgown by James, Pretty Enough for a Queen," June 29, 1955.

Diplomat: Charles James, "Fashion Foibles," May 1955, p. 59; Charles James, "Fashion Story," Sept. 1955, p. 56; Charles James, "Christian Dior," Dec. 2, 1955.

Esquire: "Rags by the Trade," April 1973, pp. 96–105; Patricia Bosworth, "Who Killed High Fashion," May 1973, pp. 124–128, 214, 216, 218; Taki, "Arbiter of Chic," May 1981, pp. 101–103.

Fashion: Two photographs, Fall/Winter 1956, p. 26.

Fashion World Daily: Jeffrey Barr, "Charles James Master of Couture," vol. 1, no. 1 (Aug. 1978).

Flair: "Lid On, Lid Off," and "The Flower," May 1950, pp. 24, 46–47.

Flint Journal, Michigan: Elizabeth Toomy, "Snug Skirts Designed for Sway-Back Women," Aug. 9, 1955.

Galion Inquirer, Ohio: "Brooklyn Museum Gets Gift from Galion Industrialist," July 18, 1959.

Harper's Bazaar: Robert Riley, "Advise without Consent," Sept. 1963, pp. 202–203, 275.

Harper's & Queen, London, England: Gay Bryant, "Charles James, 1906–1978," Sept. 1979, pp. 198–203, 290–291.

Harrisburg News, Pennsylvania: Mary Lee Thompson, "Good Design Gives Jewels, Fashion a Timeless Beauty," July 24, 1957.

Houston Post, Texas: "Brooklyn Museum Receives Gift of Pattern Library," July 27, 1959; "American Tourists Dress for Comfort," Aug. 23, 1959.

Interview: Roberto Polo, "Robert Motherwell talks about fashion as fantasy," Jan. 1976, p. 19; Bary McKinley, "Barbara Allen at Christie's," May 1979.

Kansas City Times Missouri: Nell Snead column, Aug. 6, 1958.

Kokomo Tribune, Indiana: "Diamonds in Clover," July 10, 1957.

Ladies Home Journal: Sketch of suit, June 1955; Laura Date Riley, "America's Best Dressed Women, the Fashionable Few," March 1958, pp. 65–66, 118, 120, 122–125.

Le Monde, Paris, France: Jacqueline Demornex, "Hotel Chelsea, 222 West 23rd St." Feb. 8–9, 1976.

Life: "An Unknown Wins a Winnie," Oct. 23, 1950, pp. 129–30.

Long Island Daily Press: Mary Lee Thompson, "Those Fine Feathers Make the Lady," July 23, 1957.

Look: "Charles James Stages a Rebellion Against Old Style Rigid Forms, Creates His Own Dummies," Jan. 2, 1951, pp. 52–53; "Charles James Designs Sofas, and Redesigns Women," Sept. 1952, pp. 91–93; "The Big Five for Fall," Sept. 22, 1953, pp. 70–74.

Los Angeles Herald-Express, California: "Decade of Design," Nov. 12, 1948.

Mademoiselle: Photographs of coats, July 1952; Photographs of coats, Sept. 1952.

Manhattan Catalogue: Beverly Birks, "People Come to Understand Art When they See the Greatest Examples Put Before Them," vol. 2, no. 10, pp. 44–45.

Mansfield News-Journal, Ohio: "Cobey of Galion Aids Fashion Study Project," July 29, 1959.

Metropolis Magazine: Charles James, "Charles James at Large," 1975, pp. 4–5.

Miami Herald, Florida: Mary Goodfellow column, Aug. 23, 1959, p. 6E.

New Bedford Standard-Times, Massachusetts: "Rogers Kin Presents Outstanding Collection, A Decade of Fashions, to New York Museum," Nov. 14, 1948.

New York Herald-Tribune: "Dunhill's Store Opens in Rockefeller Center," Nov. 20, 1933; Katherine Vincent, "B. Altman Puts New Lounging Styles on Show," Jan. 3, 1941; Charles James, "Paris Versus New York Fashions," June 29, 1947; Jerry Finkelstein, "French Designers to Be Invited to Participate in Exhibit of U.S. Apparel Industry," July 17, 1947; Eugenia Sheppard, "Exhibit Shows Ten Years of Styles by an American," Nov. 10, 1948; "Styles of 1933 Win London Plaudits," July 22, 1949; Eugenia Sheppard, "Charles James Advocates New Lines in Styles," Jan. 2, 1950; "Ohrbach's Puts Price Tag on James Fashions," Sept. [?], 1950; "Today's Living-Styles for Few on Way to Many at Ohrbach's," Sept. 8, 1950; "Winnies Given to Charles James and Bonnie Cashin," Oct. 13, 1950; "Designer Calls U.S. Women Rich and Poor, Worse Dressed with Just a Few Exceptions," Nov. 15, 1950; Eugenia Sheppard "Dress Shapes All Look Alike Designer Says," June 20, 1952; "Five to Receive Fashion Prizes," Aug. 10, 1953; "Fur Design Debut Called A Triumph," Oct. 6, 1953; "Miss Nancy Lee Gregory Married to Charles James at St. Bartholomews, Park Ave., New York City," July 9, 1954; "Fashion Designed in New Quarters," Sept. 8, 1954; "Radical New Sofa Shaped to Conform to Body's Lines," Sept. 13, 1954, p. 12; Eugenia Sheppard, "American Designers Win Fashion Awards," Oct. 12, 1954; "James Juggles Fashion Dimensions," June 23, 1955; "Charles James Designs for Super Markets," May 8, 1956; "James Plans Infants Line," Aug. 6, 1956; Eugenia Sheppard, "Charles James Designs for Junior," Oct. 5, 1956; "Judge Irving Levey calls for Action to Curb Style Piracy," Nov. 21, 1956; Eugenia Sheppard, "Charles James Organizing Fashion Designers Equity," ?1957; "Inside Fashion — Apologies to Charles James," April 19, 1957; Birth of Charles James daughter, ?1957; Report of theft of models from workrooms on East 57th Street, July 9, 1957; "Famed Style Designer Shut by Tax Claim," July 28, 1957; Eugenia Sheppard, "Charles James Setting up a Fashion Foundation," March 7, 1958; "James Collection of Fashion Drawings Acquired by the Brooklyn Museum, Dept. of Industrial Design," June 24, 1958; Eugenia Sheppard "Inside Fashion — Salvador Dali Picking Charles James to Write About Fashion," March 6, 1959; "Inside Fashion — Charles James is preparing a small couture collection," June 12, 1959; "New Library of Patterns In Brooklyn," July 22, 1959; "The Calculus of Fashion to Be Taught," Oct. 17, 1960, p. 16; Priscilla Tucker, Tarquin Ebker, July 11, 1961; letter to the editor from Charles James, July 26, 1961; Eugenia Sheppard, "Inside Fashion-Thirty Years with James," Feb. 12, 1962; "Charles James at

Korvette," Feb. 1, 1962, p. 11; "E.J. Korvette Fetes James and New 5th Avenue Store," Feb. 23, 1962; "Charles James for Korvette," May 18, 1962; Priscilla Tucker, "Charles James & Korvette," May 18, 1962; Eugenia Sheppard, "Charles James Debut at E.J. Korvette," July 13, 1962, "Charles James Debut in Wadsworth Atheneum Show," May 3, 1964.

New York Journal American, "Decade of Design," Oct. 31, 1948; Austine, "These Charming People," Nov. 6, 1948; "James Designs Go on Exhibition," Nov. 9, 1948; "Modes in Museum," Nov. 10, 1948; Barbara Bruce "Fashion Exhibit opens at Brooklyn Museum," Nov. 10, 1948; Cholly Knickerbocker "The Smart Set," Nov. 15, 1948; Phyllis Batelle, "Rebel Stylist Designs for Clientele and Trade," Aug. 1, 1953; John Watson, "At War with Mediocrity," Sept. 14, 1954, p. 13; Barbara Bruce "James Invites the Fashion Thunder," Jan. 10, 1956; "A Library Given to Museum," July 23, 1959; "James to Design for Korvette," Feb. 12, 1962, p. 8.

New York Magazine: John Duka, "The Ghost of Seventh Avenue," Oct. 16, 1978, pp. 81-84, 88, 89; Joan Kron, "Exhibition-ism: History as Fashion Power," Jan. 12, 1976, pp. 76-78.

New York Mirror: Jack Thompson column, 1940; Photograph of Charles James and Lillian Greneker, Nov. 11, 1948; Jerome Zerbe, "Now Fabulous Millicent Becomes a Living Museum Piece," Jan. 2, 1949; Photograph, Jan. 3, 1957.

New York News: Eileen Callahan, "Nothing New in New Look, Designer Says, Proving It," April 4, 1948; Decade of Design Exhibition, Oct. 29, 1948; Nancy Randolph, "Horse, Fashion, Gem Shows Will Spark Society Season," Nov. 1, 1948; "Millicent Huddleston Rogers, Gift to Brooklyn Museum," Oct. 29, 1948; Danton Walker, "Broadway," Nov. 13, 1948; Eileen Callahan, "Winter Time Style Features Drama," Nov. 14, 1957; "Museum Gets Big Collection of Patterns," July 27, 1959; Nancy Mills, "Fashion Display of 20th-Century Designers Best," Nov. 7, 1971, p. 107; Bill Cunningham, "Is New Sub-Culture Uniform Getting You Down?," Feb. 5, 1975, p. 6.

New York Post: Joan Martin, "N.Y. Shop Sponsors American Designer," ?1950; Charles James, "Dior is no Angel, Says U.S. Fashion Designer," Dec. 2, 1955, p. 68; Charles James, "Designer Analyzes Dior's Success Story," Dec. 3, 1955; "One Great Designer Writes an Obit for Another," Oct. 24, 1957, p. 34; Ruth Preston, "The Training of a Designer," Nov. 18, 1958, p. 21; "Metal Module Patterns will Streamline Fashion," Nov. 18, 1958; Ruth Preston, "Fashion Design Is a Science," Oct. 18, 1960.

New York Soho Weekly News: Bill Cunningham, "Charles James," Sept. 28, 1978, pp. 31-33.

New York Sun, "Museum Opens Dress Exhibit," Nov. 10, 1948.

New York Supplement, vol. 152 (2nd series), Supreme Court, Trial Term, Part XVIII, Justice Irving L. Levey, "Samuel Winston, Inc., vs. Charles James Services," Nov. 20, 1965, pp. 716-719.

New York Times: Advertisement for Boucheron hats (Best & Co.), Feb. 16, 1930; "Returns to U.S.," Oct. 15, 1939, p. 22; "Dress of Black silk faille has new envelope skirt which buttons onto waist," Dec. 24, 1940; "Women's styles displayed Paris," July 12, 1947, p. 16; "Designs by Charles James for Mrs. Hearst, Jr.," July 30, 1948; "Museum exhibits C. James fashion given by Mrs. M.H. Rogers," Nov. 10, 1948, p. 34; Virginia Pope, "Styles of Decade in Museum Exhibit," Nov. 10, 1948; "Ohrbach's buys C. James-designed collection for N.Y. and Los Angeles stores," Sept. 13, 1950, p. 34; "C. James say U.S. women are worst dressed in world," Nov. 15, 1950, p. 34; Virginia Pope "Designer Shifting to Ready-to-Wear," June 17, 1952; "Today's Living," June 20, 1952; Virginia Pope "Architect of Dress Design," July 13, 1952; Lord & Taylor advertisement, Oct. 5, 1952; Virginia Pope, "Fashion Designer Marks 25th Year," Jan. 4, 1955, p. 22; Lord & Taylor advertisement, Oct. 2, 1955, p. 13; "New York Supreme Court Justice Levey Dismisses Designer C. James claim of style piracy against S. Winston Inc.," Nov. 21, 1956, p. 56; "Paris Sets Pace, but Creative Fashion Talent, Critics Agree, Exists in U.S.," May 20, 1958, p. 37; Marylin Bender "James to Design for Discount House," Feb. 12, 1962, p. 29; Bernadine Morris "Retrospective Show of Clothes that Made Charles James Fashion Hero," Dec. 17, 1969; Announcement of Guggenheim Fellowship, April 13, 1974.

New York World-Telegram: Charles Ventura, "Society Today," Oct. 27, 1948.

The New Yorker: Lois Long "On and Off the Avenue, Feminine Fashions," Sept. 24, 1955, p. 114.

Nova, Charles James, "Portrait of a Genius by a Genius," July 1974, pp. 44-51.

Oklahoman, Oklahoma City: Alice Hughes, "Smooth as Silk," Dec. 30, 1951.

Philadelphia Bulletin, Pennsylvania: Blanche Krause column, Jan. 28, 1959; Blanche Krause column, July 26, 1959; Phyllis Feldkamp, "Art," July 4, 1976.

Philadelphia Inquirer, Pennsylvania: "Young American Designers Herewith Present Charles James," June 3, 1934.

Plaza Art Galleries, New York: *Important Costumes, Period Clothes, Furniture and Decorations,* April 20, 1978, lots 63, 64, 64A, 133.

Rhode Island Bulletin, Providence: Gwen Morgan, "He Was a Man for All Women," Sept. 12, 1980.

Richmond News Leader, Virginia: Sylvia Costin, "Couturier Battles Style's Stereo Types," March 19, 1976, p. 10.

St. Louis Post-Dispatch, Missouri: Oct. 30, 1955, p. 1-2.

Sotheby Parke-Bernet, New York: *Collector's Carrousel,* Dec. 4, 1980, lots, 156-165.

Syracuse Herald-Journal, New York: Patricia Corbett, "Famed Designer Visits Syracuse," June 27, 1975, p. 7; Ann Hartranft, "Wide Range of Exhibits on View at Everson," Aug. 3, 1975.

Syracuse Post-Standard, New York: Gordon Muck, "Art Views & News," Aug. 4, 1975, p. 10.

Tacoma News-Tribune, Washington: Gail Dugas, "Fake Fur for Cold Weather," Nov. 24, 1957.

The Tatler, London, England: Bradley's advertisement, Sept. 29, 1937, p. XXIII.

This Week Magazine: "All in the Shape," July 24, 1955, p. 30.

Town & Country: Photographs of Millicent Rogers, July 1948, pp. 38-39; Lois Long, "Prophet . . . with Honor," Oct. 1949, pp. 70-71, 106, 108, 111; "14 Rue de Centre, Neuilly," April 1950, pp. 40-43; Jeanine Lormoth, "Vintage Couture," Dec. 1979, pp. 188-197.

Tulsa World, Oklahoma: "Jewelers of Fifth Avenue Reveal Gems," July 23, 1957.

Washington Evening Star, District of Columbia: Eleni Saks, "Washington Host to 'Charlie'," Oct. 19, 1953; Eleni Saks, "Charles James Is Planning a New Design Concept," 1958; "Brooklyn Museum Gets Charles James Drawings," Aug. 11, 1958, p. B-4; "Industry and Fashion Combined in Gift," Sept. 8, 1959.

Wichita Eagle, Marilyn Mercer, "Skirting in New York," July 10, 1957.

Women's Wear Daily, New York: "Charles James, English Designer, to Visit U.S.," Feb. 15, 1933; B.J. Perkins, "Charles James, A former Architect Uses Structural Idea in Designing," Feb. 21, 1933, p. 17; Photograph of Charles James, Feb. 23, 1933; "Charles James of London Holds Trade Showing," April 5, 1933; "Charles James, London Designer, Presents Models to Trade and English Notables," April 12, 1933; "Charles James Opens New London Quarters," June 19, 1933; "Charles James Showing Collection Tomorrow," Aug. 3, 1933; "Charles James Sailing for U.S. Tomorrow," Sept. 26, 1933; "Charles James Defers Sailing till Tomorrow," Oct. 3, 1933; Alice Hughes, "New Style Gowns Stirs Enthusiasm," Oct. 23, 1933; "Trousers de Luxe," March 27, 1940; "Impressions of 3 Dresses Presented by Elizabeth Arden," May 5, 1944; Two photographs of dresses, Aug. 24, 1944; "Charles James Introduces Oriental Ideas in Madison Ave. Salon and Workrooms," Aug. 20, 1945; "Beggars Are Coming to Town," Oct. 31, 1945; "James Forms Own Training Shop for Apprentices," March 11, 1946; "Dayton Co. Show Includes C. James Originals," Oct. 25, 1946; "Charles James to Show N.Y. Models in Paris," April 29, 1947; "Charles James Previewe of Collection to Be Shown in Paris for American Prestige," June 12, 1947; "Charles James Lauds Paris as Lasting Fashion Center," July 11, 1947; "Charles James Plans New Paris Workroom," July 18, 1947; "James Will Address Boston Style Group," Nov. 6, 1947; "Urges Establishment of American

Couture," Sept. 22, 1947; "D.H. Holmes Sponsors Charles James Custom Showing," Nov. 6, 1947; "C. James in Beaton Photograph for Vogue Romantics," March 3, 1948; "Chas. Designs for Millicent Rogers in Museum Display," Oct. 29, 1948; "Greneker Corp. Mannequins for Millicent Rogers — Charles James Exhibition at The Brooklyn Museum," Nov. 9, 1948; "Charles James' Latest Design," Nov. 11, 1948; "James to Style for Nanty Firm," Jan. 31, 1949; "Charles James States Plans to Make Dress Forms in Europe and N.Y.," Dec. 29, 1949; "Hear Ohrbach's Will Sell James Fashions," Sept. 12, 1950; Glen Fowler, "Ohrbach's Will Launch Charles James Fashions," Sept. 13, 1950; "Fashion Critics Award," Oct. 13, 1950; "Charles James to Speak at Fur Forum," Dec. 4, 1950; "Charles James, Designer, Participates in Retail Phase at Fur Forum," Dec. 12, 1950; Tobé-Coburn "Alumni Hear Charles James," Jan. 12, 1951; "Charles James Lines for Lord & Taylor," March 31, 1952; "Correction: Milmont Gowns Handling Dress Fall Lines," April 1, 1952; "Charles James Incorporates Theory of Figure Proportions in Ready-to-Wear Collections," April 22, 1952; "Designers Discuss New Ways to Size and Grade Corsets," May 1, 1952; Reply by Walter H. Lowy (Formfit Co.) to Charles James comments on girdles, July 3, 1952; "Posture Comment by Walter Lowy Draws James Reply," July 24, 1952; "Charles James on Trip Showing New forms," Sept. 2, 1952; "Designer Pays Tribute to a Fashion Inspiration," Jan. 8, 1953; Charles James, "Dior Cited as Great Artist," July 30, 1953; "Neiman Marcus Award Winners," Aug. 10, 1953; "James to Design Lines for Custom Craft," Sept. 17, 1953; "Capital Fashion Group to Hear Designer Monday," Oct. 14, 1953; "Charles James Designing Bruno Belt Collection," Nov. 20, 1953; "Charles James to Design Shoulder Pads," Dec. 9, 1953; "Charles James to Design Line of Shoulder Shapes," Dec. 11, 1953; Glen Fowler, "Charles James Has New Set Up for Wholesale," Jan. 29, 1954, pp. 2, 50; "Charles James New Venture Seen as Designers Dream," July 3, 1954; "Charles James To Design Another Fur Group," July 3, 1954; "Charles James Marries Tomorrow," July 7, 1954; Harriet Morrison, "Radical New Sofa Shaped to Conform to Body's Lines," Sept. 13, 1954; Advertisement for Charles James Services, Inc., Oct. 11, 1954; "Dress Maker Casuals Is Sued Over Use of 'Charles James'," Oct. 26, 1954; "Winston Sues Charles James for $61,341 on Pact," Nov. 4, 1954; "Charles James Denies Breaching Pact with Samuel Winston, Inc.," Nov. 9, 1954; "Charles James Sues Samuel Winston, Inc., Others for $250,000," Feb. 3, 1955; "Dress Maker Casuals Restrained on Use of 'Charles James'," Feb. 8, 1955; "Better Label Data for Dry-Cleaners Urged by James," March 8, 1955; "Charles James Urges Better Label Data as Cleaning Safeguard," March 9, 1955; "U.S. Designer, Charles James, Meets Challenges to Make Anything Fashion Needs," March 27, 1955; Earl Dash, "Charles James to Enter Apparel Production Field," May 25, 1955; Virginia Pope, "Fashion Designer Marks 25th Year," May 31, 1955; "Charles James Not Showing Today," June 20, 1955; "Designer Warns Dependence on Revivals a Dangerous Parasitism," Jan. 15, 1956; "Charles James Charges Scheme to Deprive Him of Profits," May 2, 1956; "Checkers Uniforms Combine Trimness with Functionalism," May 14, 1956; "Checkers Uniform on Market Soon," May 20, 1956; "Promising Future Cited for Chicago Fashion Apparel," June 5, 1956; "Trial Gets Under Way of Charles James Claim on Winston," June 13, 1956; "Reserves Decision of Charles James' Claim on Winston," June 29, 1956; "Discussion Held on Tie Up between Cardin and James," July 5, 1956; "Fashion Designers are Forming Group," Aug. 3, 1956; "To Meet on August 16th," Aug. 6, 1956; "Name Elroy Head of Design Group, Aims Made Known," Aug. 20, 1956; "A New Shape Built into Infants Wear," Oct. 5, 1956; "Court Urges Action Against Style Pirates," Nov. 21, 1956; Earl Dash, "Judge's Stand Spurs Hope in Piracy Battle, New Efforts Seen in Fashion," Nov. 23, 1956; Charles James, letter to Editor re: "Piracy," Dec. 3, 1956; "Styles Not Engineering, Shoe Women Are Told," March 1, 1957; "Fashion Piracy Is Termed Natural Trade Phenomenon," April 9, 1957; "U.S. Woolens Trade Held Deficient in Creative Trades," May 9, 1957; Paul Honig reply to criticism of U.S. Woolens, June 3, 1957; "Charles James to Consult on Greenwood Garments," June 4, 1957; "Greenwood Gets James Label," June 26, 1957; "Charles James Plans to Continue When Tax Snags Clear," July 29, 1957; "Foundation is Set by Charles James to Aid Designers," Dec. 18, 1957; "Charles James in Tie-In With Dansant Frocks," April 21, 1958; "James Deplores Current Design Education Plans," Nov. 19, 1958; "Says Economic Climate Deters Style Creativity," Dec. 1, 1958; "Charles James to Make New Form for Carlyle Dress," Dec. 19, 1958; Charles James, "James Answers Deiche's View," Feb. 3, 1959; "Brooklyn Museum Gets Gift of Pattern Library," July 22, 1959; Charles James, letter to Editor re; Moscow Exhibit, July 27, 1959; "Charles James Speaks at Hofstra, 'Importance of Design Education to Industrial Employment'," Nov. 23, 1959; "Charles James Launches College Fashion Seminars 'Calculus of Fashion'," Oct. 17, 1960; "Charles James Designs for Women's Wear Daily," Nov. 29, 1960; "Eye on Copy Cats," Jan. 3, 1961; E.V. Massai, "Italian Preview," Jan. 3, 1961; "Charles James Conducts a Class," Jan. 9, 1961; "Charles James — 3 Decade Record, Is Writing His Memoirs," Aug. 3, 1961; Sy Epstein, "Korvette 5th Ave. to Open 3 Nights," Jan. 30, 1962; "Eye on the Market — Here's Charley," Feb. 16, 1962; Dan Dorfman, "Korvette Stressing Own Male Wear Label," May 21, 1962; "Late Arrival at Korvette," May 28, 1962; "There's Charlie," July 13, 1962; "Rites Held For Designer Charles James," Sept. 28, 1978, p. 22; "Pouffing Along to Parties," July 11, 1979, p. 4.

World Telegram & Sun, New York: "Cleverly Cut Slacks," Jan. 3, 1941; Anne Yates Clarke, "Charles James Joins E.J. Korvette," Feb. 22, 1962.

List of Known Clients

INDIVIDUALS

Laddy Abdy (see Gay)
Josephine Abercrombie (see Robinson)
Amy Adams (see Mrs. Robert R. McCormick)
Mrs. Gilbert Adrian (see Gaynor)
Nancy Lee Allen
Gitta Alpar
Adrienne Ames
Judith Anderson
Mrs. Anthony Aquaviva (see Joni James)
Elizabeth Arden (née Florence Nightingale
 Graham, see also Evanloff, and Lewis)
Mrs. Laurance H. Armour
Mrs. Lester Armour
Mrs. Philip Armour
Rachel Armour
Mrs. Ronald Armstrong-Jones (see Rosse)
Marit Guinness Aschan
Margo Asquith (see Countess of Oxford and
 Asquith)
Adele Astaire (see Cavendish)
Mrs. Vincent Astor (née Mary B. Cushing,
 see also Fosburgh)
Jean Auerbacher

Kitty Bache (see Miller)
Toni Frissell Bacon
Mary Baker
Mrs. Walter Baker
Mrs. Ronald Balcon (née Rogers, see also
 Peralta-Ramos, and von Hoogstraten)
Philippa Barnes
Natalie Barney
Barbara (Baba) Beaton (see Hambro)
Mrs. Ernest Beaton
Nancy Beaton (see Smilie)
Maria Belita
Mrs. Charles Bell
Mrs. Seymour Berkson (see Lambert)
Mrs. Rudolf A. (Cathalene) Bernatschke (see
 Crane)
Mme. Eloui Bey
Cordelia D. Biddle (see Mrs. T. Markoe
 Robertson)
Margaret Thompson Biddle
Mrs. Payne Bingham
Mrs. Arthur Bissell (see Mrs. Morehead
 Patterson)
Mrs. Henry Black (see Isabelle May Fuller)
Lucy McCormick Blair (see Linn)
Mary Lasker Block
Mrs. George Blow
Mme. Eric Boissonas
Princess Bon Compagne
Mrs. Bondi
Mrs. Walter Borden (née Rue Winterbotham,
 see also Mrs. John Alden Carpenter, and
 Shaw)
Charlotte Borg (see Erickson)
Marie Louise Bousquet
Mme. Lucienne Boyer
Mrs. M.J. Boylan
Mrs. Edmond G. (Sunny) Bradfield
Hermione Bradley
Mrs. Mario Braggiotti (see Clow)
Mrs. Walter Brewster
Mrs. S. Bronfman
Romaine Brooks
Mrs. Masten Brown

Mrs. Bruce (see Karsavina)
Mrs. A. Frederick Bultman, Sr.
Mrs. A. Frederick (Jeanne) Bultman, Jr.
Caroline Burke
Katherine Butler

Mrs. Quincy S. Cabot
Mrs. Morris (Gwen) Caffritz
Mrs. William (Nancy) Cameron
Diane Carter Campbell
Janet Campbell
Marchioness of Carisbrooke
Elizabeth S. Carmichael (née Elizabeth Strong
 de Cuevas)
Countess of Carnarvon (see Losch)
Mrs. John Alden Carpenter (née Rue
 Winterbotham, see also Borden, and Shaw)
Mrs. William du Pont Carpenter
Mrs. Walter Scott (Mary) Carr
Marchesa Luisa Casati
Gloria Case (see Whitlock)
Margaret Case
Countess Igor Cassini (née Austine McDonnell,
 see also Mrs. William Randolph Hearst, Jr.)
Irelen Castle (see Mrs. Frederick McLaughlin)
Lady Charles Cavendish (née Adele Astaire)
Mrs. James Cecil
Katharyne Kent Chandler
Louise Kent Chandler (see Krell)
Carbrielle (Coco) Chanel
Mrs. Gilbert W. Chaplin (née Elizabeth B. Fuller,
 see also Goodspeed)
Mrs. Robert Horne Charles (née Marion Oates,
 see also Leiter)
Ruth Chatterton
Mrs. William (Babs) Clow (see Braggiotti)
Mrs. Herbert T. (Phyllis) Cobey
Mrs. H. Coffina
Constance Collier
Dorothy Commingore
Mrs. William J. Condon (see Piazza)
Mrs. Danny McMann Conlon
Audrey Ann Connell
Helga G. Connelly (née Helga Guinness,
 see also Greene)
Mrs. Robert Coulson (née Cynthia
 Cunningham)
Fleur Cowles (see Meirs)
Marjorie Craigie
Mrs. Ambrose C. (Mary) Cramer (see Meeker)
Mrs. Cornelius Crane, Jr. (see Bernatschke)
Violet Cripps (see 2nd Duchess of Westminster)
Rose Cummings
Cynthia Cunningham (see Coulson)
Mrs. James T. (Elizabeth) Cunningham
Mrs. Harry Curtis (see Fargo)
Barbara Cushing (see Mortimer, see also
 Paley)
Mary B. Cushing (see Astor, see also Fosburgh)

Mme. Salvador (Jula) Dali
Mrs. Marcus Daly
Jessica Daves
Mrs. Eugene A. Davidson (see Zurcher)
Mrs. Joseph E. Davies (see Post)
Mrs. Joseph E. (Marion) Davies
Lady Mortimer Davis (see Loder)
Comtesse Etienne de Beaumont

Countess de Bonchamps (see Mahana)
Mme. de Cardenas
Anne Marie de Castro
Marta de Cedercrantz (see Raymond)
Elizabeth Strong de Cuevas (see Carmichael)
Marquis de Cuevas
Comtesse Elie de Ganay
Duchess de Gramont (see Hugo)
Mrs. Rodman Arturo (Aimee) de Heeren
Mme. Aure de la Neux
Mme. Fauchier de la Vigne
Dolores del Rio
Mrs. Jean (Domenique) de Menil
Marie-Christophe de Menil
Isabelle de Rivas (see Jennings)
Baroness Alphonse de Rothschild
Marquise de San Carlos
Comtesse de Ste. Croix
Ninette de Valois (see Stannus)
Marlene Dietrich
Mrs. Delman (née Yeffee Kimball, see also
 Slatin)
Bachoo Dinsha
Edalgi F. Dinsha
Jane Doggett
Anton Dolin
Mrs. Henri Doll
Mrs. H. P. Donnelley (née Helen Pauling)
Florence Downs (née Florence R.B. Harris,
 see also Schlubach, and Van der Kemp)
Mrs. Harry L. Drake
Mrs. John Drake, Sr.
Muriel Draper
Mrs. Eddie Duchin (see Oetrichs)
Katharine Dudley
Lady Diana Duff-Cooper
Doris Duke
Mrs. Duncan
Mrs. Robert Dunham

Jean Eagles
Irene Eisinger
Mrs. Corson Ellis
Mrs. Lincoln Ellsworth (see Ulmer)
Lelia Emery (see McIntosh)
Mrs. Thomas Emery
Margaret Enders
Mrs. Julius Epstein (see Franklin)
Charlotte Erickson (see Borg)
Mrs. Lee Hyland Erickson
Mrs. Michael Evanloff (née Graham, see also
 Arden, and Lewis)
Jane Ewing (see Heinz)

Elizabeth Fairall
Mrs. Douglas (Mary Lee) Fairbanks, Jr.
Grace Fargo (see Curtis)
Eileen Farrell
Mrs. John V. (Margaret) Farwell, III
Josephine F. Feles
Mrs. Miguel Ferreras
Mrs. Bertram Field (see Peters)
Mrs. Stanley Field
Mrs. Henry Field Finan (see Sturges)
Jean Fleming (see Mrs. Andrew Holt)
Mrs. Henry Fonda
Ruth Ford (see Scott)
Mrs. James W. Fosburgh (née Mary B. Cushing,
 see also Astor)
Genevieve Fox
Mrs. Lyttleton Fox
Mrs. Byron Foy
Muriel Bultman Francis
Nancy Franklin (see Epstein)
Mrs. Andrew Fraser
Toni Frissell (see Bacon)
Jane Frohman
Charlotte Frost
Lady Fry
Elizabeth B. Fuller (see Chaplin, see also
 Goodspeed)
Isabelle May Fuller (see Black)

Greer Garson
la Gay (see Abdy)
Janet Gaynor (see Adrian)
Mrs. Peter Gerry
Paulette Goddard
Mrs. Barney Goodspeed (see Elizabeth B. Fuller,
 see also Chaplin)
Mrs. Thomas Gosselin
Eleanor Graham
Florence Nightingale Graham (see Arden,
 see also Evanloff, and Lewis)
Mrs. Hugh Carleton Greene (née Helga
 Guinness, see also Connelly)
Nancy Lee Gregory (see Mrs. Charles James)
Mrs. Robert Guggenheim (see Logan, see also
 Wagner)
Mrs. Bryan Guinness (née Diana Mitford,
 see also Mosley)
Mrs. H.S.H. (Alfhild) Guinness
Helga Guinness (see Connelly, see also Greene)
Ingrid Guinness (see Mrs. Winston Williams)
Marit Guinness (see Aschan)
Sacha Guitry
Countess Felicia Gysigka

Kay Halle
Mrs. Alec Hambro (née Barbara Beaton)
Mrs. John Hays Hammond (née Esme O'Brien)
Mrs. Simon Harcourt-Smith
Mrs. Lester Hano (see Preise)
Mrs. Oliver Harriman
Florence R.B. Harris (see Downs, see also
 Schlubach, and Van der Kemp)
Miss Honey Harris
Miss Karen Harris (see Lancaster)
June Hart
Mrs. Huntington Hartford
Mrs. Byron Harvey, Sr.
Mrs. Byron Harvey, Jr. (née Kathleen Whitcomb)
Mrs. Dorothy Dudley Harvey
June Havoc
Helen Hayes
Mrs. Leland Hayward
Mrs. William Randolph Hearst, I
Mrs. William Randolph Hearst, Jr. (née Austine
 McDonnell, see also Cassini)
Mary Ellen Hecht
Mrs. Jack Heinz, II (see Ewing)
Lady Anne Hill
Mrs. John Hill
Mrs. W. Burrell Hoffman
Toni Hollingsworth
Celeste Holme
Eleanor Holmes (see Rose)
Mrs. Andrew Holt (see Fleming)
Mrs. Henry Holt
Nora Holt
Mrs. Deering (Polly) Howe
Julia M. Hoyt (see Julia Welldone)
Marie Victor Hugo (see de Gramont)
Dawn Hunter
Mrs. William (Jeanette) Hunt
Mrs. St. John (Mary) Hutchinson
Mrs. James Hazen Hyde

Mrs. Vladimir Ivanovitch

Mrs. Max Jacobson
Mrs. Charles James (née Nancy Lee Gregory)
Frances James
Joni James (see Aquaviva)
Louise Brega James
Margaret James
Mrs. Walter (Kathleen) Jeffords
Mrs. Oliver Burr (Isabelle) Jennings (see
 de Rivas)
Mrs. Andrew Johnson
Mrs. Robert Johnson
Jennifer Jones (see Selznick, see also Simon)

Mrs. Otto Kahn
Mrs. Gilbert Kahn
Tamara Karsavina (see Bruce)
Grace Kazazian

Mrs. Stanley Keith (see Shedd)
Mrs. Walter Keith
Kay Kerr
Yeffee Kimball (see Delman, see also Slatin)
Lisa Kirk
Mrs. Alfred (Blanche) Knopf
Susan Kohner
Lee Krasner (see Pollock)
Mrs. George Krell (née Louise Kent Chandler)

LaJana
Eleanor Lambert (see Berkson)
Mrs. Osbert Lancaster (née Karen Harris)
Mrs. Robert Langdon (see Mallison)
Mme. Jean Lariviere
Catheryne Laughlin
Lady Lavery (see Martin)
Gertrude Lawrence
Pepi Lederer
Gypsy Rose Lee
Jane Lee (née Love)
Mrs. Morton Lee (see Topp-Lee)
Mrs. Sidney Kent Legaré
Mrs. Sidney Legendre
Virginia Legg
Mrs. Thomas Leiter (née Marion Oates, see also
 Charles)
Mrs. Lucien Lelong (see Princess Natalie Paley)
Mrs. Thomas Jenkins Lewis (née Graham,
 see also Arden, and Evanloff)
Mrs. Howard Linn (née Lucy McCormick Blair)
Mrs. Jack Livingston
Mrs. Eric Loder (see Davis)
Rebecca Pollard Logan (see Guggenheim,
 see also Wagner)
Mary Anita Loos
Mme. Arturo Lopez-Willshaw
Tilly Losch (see Carnarvon)
Jane Love (see Lee)
Mrs. Joseph Love
Mrs. Fred H. (Rosamund) Lowell
Claire Luce
Florence Lustig
Eleanor Lynn

Mary Frost Mabon
Mrs. George S. Mahana (see de Bonchamps)
Mrs. Philip B. Maher
Felice Maier
Clare Mallison (see Langdon)
Alicia Markova
Mae March
Hazel Martin (see Lavery)
Mme. Materadzo
Lisa Maugham
Mrs. Leonard McCollum (see Whitney)
Mrs. Chauncy McCormick
Mrs. Robert R. McCormick (see Adams)
Virginia Hamilton McCormick
Marie McDonald
Austine McDonnell (see Cassini, see also
 Mrs. William Randolph Hearst, Jr.)
Miss McGuinness
Dorothy McGuire
Mrs. Allie McIntosh (see Lelia Emery)
Mrs. Frederick McLaughlin (see Castle)
Hattie McLaughlin
Mary Meeker (see Cramer)
Fleur C. Meirs (see Cowles)
Mrs. Joseph (Clara) Mellen
Mrs. Charles Meyer
Mrs. Gilbert Miller (see Bache)
Mrs. Ogden Mills
Diana Mitford (see Mrs. Bryan Guinness,
 see also Mosley)
Princess Grace of Monaco
Mrs. A. Moore Montgomery
Viscountess Moore
Mrs. William H. Moore
Mrs. Jasper Morgan
Lady Ottoline Morrell
Barbara Cushing Mortimer (née Cushing,
 see also Mrs. William S. Paley)
Mrs. Stanley Mortimer, Jr.

Mrs. Sterling Morton
Lady Diana Mosley (née Diana Mitford, see also
 Mrs. Bryan Guinness)
Patrice Munsel
Princess Helene Murat

Marguarite Namara
Mrs. Condé Nast
Audrée Nethercott
Mrs. Albert H. Newman
Mrs. S.S. Niarchos
Kyra Nijinsky
Anna Q. Nilsen
Marni Nixon

Marion Oates (see Charles, see also Leiter)
Helene Obolensky
Mrs. Ivan Obolensky
Esme O'Brien (see Hammond)
Mrs. Esmond O'Brien
Marjorie Oetrichs (see Duchin)
Edith Oliver
Mary Ormsby-Gore
Lady (Doris) Orr-Lewis
Melba McMartin Orr
Mme. Jean Paul Ouvre
Countess of Oxford and Asquith (see Asquith)

Mrs. Benjamin Page
Mrs. Ralph Delahayne Paine, Jr. (see White)
Princess Natalie Paley (see Lelong)
Mrs. William S. Paley (née Barbara Cushing,
 see also Barbara Cushing Mortimer)
Mrs. Honoré Palmer
Mrs. Potter Palmer
Mrs. Mario Pansa (see Sanford)
Eleanor (Cissy) Patterson
Mrs. Joseph Patterson
Mrs. Morehead Patterson (see Bissell)
Helen Pauling (see Mrs. H.P. Donnelly)
Mrs. Frederick Payne
Mrs. Toykeo Payne
Marietta Peabody (see Tree)
Mrs. Arturo Peralta-Ramos (née Rogers, see also
 Balcom, and von Hoogstraten)
Marquise de Talleyrand Perigord
Elsa Peretti
Mrs. Warren Pershing
Roberta Peters (see Mrs. Bertram Field)
Marguerite Piazza (see Condon)
Grace Parker Pickering
Betsey Pickering (see Theodoracopulos)
Rosmund Pinchot
Mrs. John Pirie, Sr.
Mrs. John Pirie, Jr.
Margaret Pirie (see Withers)
Mrs. Jackson Pollock (née Lee Krasner)
Mr. and Mrs. Roberto Polo
Lily Pons
Duchess of Portland
Loelia Ponsonby (see 3rd Duchess of
 Westminster)
Marjorie Merriweather Post (see Mrs. Joseph E.
 Davies)
Mrs. Lee Preise (see Hano)
Ranee of Pudukota

Mrs. Peter Quennell

Princess Stanislas Radziwill
Mrs. William Rand
Baroness Ravensdale
Mrs. George Perkins Raymond (née Marta
 de Cedercrantz)
Caroline Dudley Reagan
Mrs. Richard Reynolds
Anne Blumenthal Robertson
Mrs. T. Markoe Robertson (see Cordelia D.
 Biddle)
Mrs. H. Burnett Robinson (née Josephine
 Abercrombie)
Mrs. Winthrop Rockefeller
Millicent Huddleston Rogers (see Balcom,
 see also Peralta-Ramos, and von Hoogstraten)

Mrs. Billy Rose (see Holmes)
Princess Francesco (Laura) Rospigliosi
Oriel Ross
Anne, Countess of Rosse (see Armstrong-Jones)
Martha Roundtree
Miss H. Rozen
Mrs. Clive (Mary) Runnells
Mrs. Donald M. Ryerson
Mrs. Edward (Nora) Ryerson

Dolores Sainsbury
Jane Sanford (see Pansa)
Mrs. Jack Sarnoff
Mrs. Robert Sarnoff
Mrs. Walter Savory
Mrs. Frederick Schermerhorn
Florence Schlubach (née Florence R.B. Harris,
 see also Downs, and Van der Kemp)
Elsa Schiaparelli
Mrs. Zachary Scott (see Ford)
Mrs. Henry B. Sell
Mrs. David Selznick (see Jones, see also Simon)
Dorothy Shaver
Mrs. Alfred Shaw (née Rue Winterbotham,
 see also Borden, and Mrs. John Alden
 Carpenter)
Mrs. John Shearman (née Jane Smith)
Helen M. Shedd (see Mrs. Stanley Keith)
Ruth Sheradski
Mrs. Norton Simon (see Jones, see also Selznick)
Babs Simpson
Mrs. Spyras Skouras
Mrs. Harvey Slatin (neé Yeffee Kimball, see also
 Delman)
Lady Smilie (see Nancy Beaton)
Jane Smith (see Shearman)
Carmel Snow
Mrs. Mortimer (Gladi) Solomon
Mrs. Louis Soles
Cecile Sorel
Queen Ena of Spain
Edris Stannus (see de Valois)
Mrs. Adlai Stevenson, Sr.
Risë Stevens
Betty Sturges (see Finan)
Baroness Naneto Styrcea
Gloria Swanson
Mme. Sze

Mme. Ninon Talon-Karlweiss
Lilyan Tashman
Mrs. Murray Taylor
Mrs. Vernon Taylor
Stephen Tennant
Maggie Teyte
Mrs. Copley Thaw
Mrs. Harilaos Theodoracopulos (see Betsey
 Pickering)
Clara Fargo Thomas
Mrs. Dylan Thomas
Elizabeth Finley Thomas
Sylvia Thompson
Alice Topp-Lee (see Mrs. Morton Lee)
Mrs. Ronald Tree (née Marietta Peabody)
Mme. Flor Trujillo
Mme. Maria Tuos
Mrs. Jepson Turner
Mrs. Tweedy

Mary Louise Ulmer (see Ellsworth)

Florence Van der Kemp (née Florence R.B. Harris,
 see also Downs, and Schlubach)
Mrs. Graham Fair Vanderbilt
Marianne Van Rensselaer
Countess Mona von Bismark (see Williams)
Countess L. Salm von Hoogstraten (née Rogers,
 see also Balcom, and Peralta-Ramos)
Baroness W. Langer von Langendorff
Princess Hohenlohie von Langenfeld
Mrs. T. Reed (Diana) Vreeland

Mme. Firoza Wadia

Mrs. Wagner (see Guggenheim, see also Logan)
Janet Walsh
Louise Walter
Lady Leucha Warner
Mary Warner
Julia Welldone (see Hoyt)
Mrs. Samuel Welldone
2nd Duchess of Westminster (see Cripps)
3rd Duchess of Westminster (see Ponsonby)
Mrs. Horace Wetmore
Mrs. Richard T. Wharton
Kathleen Whitcomb (see Mrs. Byron Harvey, Jr.)
Nancy White (see Paine)
Mrs. Emmet Whitlock (see Gloria Case)
Mrs. Cornelius Vanderbilt (Eleanor) Whitney (see
 McCullum)
Hoytie Wiboy
Mrs. Harrison (Mona) Williams (see Countess von
 Bismark)
Mrs. Winston Williams (née Ingrid Guinness)
Mrs. John Winterbotham
Rue Winterbotham (see Borden, see also
 Mrs. John Alden Carpenter, and Shaw)
Mrs. Pickett Withers (née Margaret Pirie)
Beverly Woodmer
Mrs. William Woodward, Jr.
Constance Warburg Woodworth, Jr.
Grete Wootton
Oliva Wyndham

Mrs. E.P. York
Queen of Yugoslavia

Mrs. Hans Zinsser
Suzette Morton Zurcher (see Davidson)
Peg Zwecker

STORES/COMPANIES

Abood Knit Mills
Albrecht Furs & Sons, St. Paul
Alexis Infants' Wear (Alexis Corporation),
 Atlanta and Gainesville
B. Altman & Co., New York
American Bemberg Co.
American Rayon Institute
Elizabeth Arden, New York
L.S. Ayers, Indianapolis

L. Bamberger & Co., Newark
Henri Bendel, New York
Bergdorf Goodman, Inc., New York
Best & Co., New York
Bloomingdale's, New York
The Blum Store, San Francisco
Bonwit Teller, New York
Bradley's, London
Bramson's, Chicago and Palm Beach
Brierleigh Ltd., New York
Bruno Belt Co., New York
Burdine's, Miami

Hattie Carnegie, New York
Cable Co., London
Carlyle Dress Co., St. Louis
Carson, Pirie, Scott & Co., Chicago
Casino Frocks
Cavanaugh Form Co.
Celanese Corporation, New York
Chen Yu
City of Paris, San Francisco
Colcombet, St. Etienne, France
Corocraft Jewelry, New York
Custom Craft Mfg.

Dansant, New York
The Dayton Co., Minneapolis
De Angelis Sportwear, New York
de Pinna, New York
Dressmaker Casuals, Inc., Newark
Alfred Dunhill, London and New York
Du Pont Company, Wilmington
Nan Duskin, Philadelphia

Arthur Falkenstein, New York
The Fashion House, Houston
Fortnum & Mason, London and New York

Garland's, St. Louis
Julius Garfinckel, Washington, D.C.
Gossard Co.
Greenwood Furs
Amelia Grey, Beverly Hills
Grey Advertising, New York

Halston, Ltd. New York
Henry Harris, Cincinnati
Harrods, London
D.H. Holmes, New Orleans
J.L. Hudson Company, Detroit
Hutzler Brothers, Baltimore

Imperial Chemical Industries, Birmingham,
 England
Irving, Detroit

Gunther Jaeckel, New York
Jewel Togs, New York
A.D. Juilliard Co., New York

Omar Kiam, New York
E.J. Korvettes, New York

Lane Bryant, New York
Lenthéric, Inc.
Linker & Herbert, New York
Lightning Fasteners Ltd., Birmingham
Lloyd Blouse Co., New York
Lord & Taylor, New York

R.H. Macy, New York
I. Magnin, San Francisco
Ruth Maier
Philip Mangone, New York
Marshall Field & Co., Chicago
Marshall Snelgrove, London
Mattli, London
The Mennen Company, New Jersey
Sally Milgrim, New York
Miller & Cie, London

National Anyline, New York
Neiman Marcus, Dallas
H.J. Nicolls & Co. Ltd., London

Ohrbach's, New York

Pasternak's, Washington, D.C.
William Penn, Pittsburgh
Personal Products, Milltown, New Jersey
William S. Popper, New York

Revillon, New York
Roberts Dresses, Philadelphia
Russeks, New York

Saks Fifth Avenue, New York
Seeley Shoulder Shapes, Inc.
The Simpson Co., Toronto
Smith Pollack & Robbins, New York
Stewart Dry Goods Co., Kentucky

Herman Patrick Tappé, New York
Taylor Importing Co., New York
Jay Thorpe, New York
Tiche, Goettinger, San Francisco
Trollman & Masket Manufacturers

Victorine
Viyella, Nottingham, England

John Wanamaker, Philadelphia
Warren Featherbone, Atlanta
Albert Weiss, New York
Samuel Winston (James and Samuel Winston,
 Inc.), New York
Ben Wolfman

Zuckerman & Kraus, New York

Index to Lenders

The catalogue numbers cited indicate garments included in the exhibition.

Marit Guinness Aschan, London, England:
39, 363, 374.

The Brooklyn Museum, New York:
30, 31, 32, 36, 49, 51, 55, 58, 59, 67, 68, 70, 71, 72, 83, 91, 106, 112, 114, 121, 122, 123, 125, 274, 322, 377, 398, 400, 404*, 454, 455, 575, 605.

Chicago Historical Society, Illinois:
3, 85.

Fashion Institute of Technology, New York:
18, 37, 48, 113, 404*.

Mrs. William Randolph Hearst, Jr., New York:
80, 578, 588.

Charles James Archives, New York:
6.

The Metropolitan Museum of Art, New York:
54, 61, 81, 100, 103.

Museum of the City of New York, New York:
127.

National Museum of American History, Smithsonian Institution, Washington, D.C.:
118.

Museum of Art, Rhode Island School of Design, Providence:
126.

Anne, Countess of Rosse, Handcross, England:
44, 359.

Wadsworth Atheneum, Hartford, Connecticut:
325, 551.

** Two examples of this garment were included in the exhibition.*